Elizabeth Taylor

ALSO BY KATE ANDERSEN BROWER

Team of Five

First in Line

First Women

The Residence

Elizabeth Taylor

The Grit & Glamour of an Icon

Kate Andersen Brower

HARPER LARGE PRINT

An Imprint of HarperCollinsPublishers

HarperCollins books may be purchased for educational, business, or sales promotional use. For information, please e-mail the Special Markets Department at SPsales@harpercollins.com.

FIRST HARPER LARGE PRINT EDITION

ISBN: 978-0-06-326747-3

Library of Congress Cataloging-in-Publication Data is available upon request.

22 23 24 25 26 LBC 5 4 3 2 1

For Senator John Warner,
who wanted this story to be told
&
For Charlotte,
my very own fierce and exuberant girl

Contents

Elizabeth's Films and Family *xi*

Prologue 1

Introduction: Elizabeth the First 13

ACT I:
The Most Beautiful Creature 49
The 1930s, 1940s, and 1950s

Chapter 1: A Star Is Born 51

Chapter 2: Young Love 120

Chapter 3: Bessie Mae 134

Chapter 4: "He Will Kill Her" 145

Chapter 5: Love and Marriage 170

ACT II

Passion and Pain 185

The 1950s and 1960s

Chapter 6: Rock, Jimmy, and Monty 187

Chapter 7: Mike Todd: "He Was My King" 211

Chapter 8: Eddie Fisher: "He Kept Mike Todd Alive" 235

Chapter 9: Trailblazer 261

ACT III

Lavish Love 281

The 1960s and 1970s

Chapter 10: Le Scandale 283

Chapter 11: Crazy, Stupid Love, 1964–1973 325

Chapter 12: The Loot:
 Elizabeth's Extraordinary Jewels 391

Chapter 13: The End and
 a New Beginning, 1973–1976 411

ACT IV

Survivor 447

The 1970s and 1980s

Chapter 14: Political Wife 449

Chapter 15: Addict 493

Chapter 16: Building an Empire 523

ACT V
True Grit 545
The 1980s and 1990s

Chapter 17: *"Bitch, Do Something!"* 547

Chapter 18: Ms. Taylor Goes to Washington 579

ACT VI
A Legacy of Love 603
The 1990s to 2011

Chapter 19: Searching for Neverland 605

Chapter 20: Forgiveness 626

Chapter 21: Dame Elizabeth 649

Chapter 22: The Auction: "The Memory Always
 Brings Back a Stab of Joy, of Love" 670

Afterword: Lust for Life 680

Acknowledgments 701

Sources and Notes 707

Selected Bibliography 745

Elizabeth's Films and Family

FILMS

There's One Born Every Minute (1942)
Lassie Come Home (1943)
Jane Eyre (1943)—uncredited
White Cliffs of Dover (1944)—uncredited
National Velvet (1944)
Courage of Lassie (1946)
Life with Father (1947)
Cynthia (1947)
A Date with Judy (1948)
Julia Misbehaves (1948)
Little Women (1949)
Conspirator (1949)
Father of the Bride (1950)

The Big Hangover (1950)

Father's Little Dividend (1951)

A Place in the Sun (1951)

Quo Vadis (1951)—uncredited extra

Callaway Went Thataway (1951)—uncredited cameo

Love Is Better Than Ever (1952)

Ivanhoe (1952)

The Girl Who Had Everything (1953)

Rhapsody (1954)

Elephant Walk (1954)

Beau Brummell (1954)

The Last Time I Saw Paris (1954)

Giant (1956)

Raintree County (1957)

Cat on a Hot Tin Roof (1958)

Suddenly, Last Summer (1959)

BUtterfield 8 (1960)

Holiday in Spain (1960)—uncredited

Cleopatra (1963)

The V.I.P.s (1963)

Becket (1964)—uncredited extra

The Sandpiper (1965)

Who's Afraid of Virginia Woolf? (1966)

The Taming of the Shrew (1967)

Reflections in a Golden Eye (1967)

Doctor Faustus (1967)

The Comedians (1967)

Boom! (1968)

Secret Ceremony (1968)

Anne of the Thousand Days (1969)—uncredited extra

The Only Game in Town (1970)

Under Milk Wood (1971)

X, Y and Zee (1972)

Hammersmith Is Out (1972)

Night Watch (1973)

Ash Wednesday (1973)

The Driver's Seat (1974)

The Blue Bird (1976)

A Little Night Music (1977)

Winter Kills (1979)—uncredited

The Mirror Crack'd (1980)

Genocide (1982)—narrator

Young Toscanini (1988)

The Flintstones (1994)

Awards

Golden Globe Award (1957): Special Achievement Award

Golden Globe Award (1960): Best Actress in a Motion Picture, *Suddenly, Last Summer*

Academy Award (1961): Actress in a Leading Role, *BUtterfield 8*

Academy Award (1967): Actress in a Leading Role,
 Who's Afraid of Virginia Woolf?
Golden Globe Award (1974): World Film Favorites
 Award
Golden Globe Award (1985): Cecil B. DeMille Award
American Film Institute (1993): 21st Life Achievement
 Award
Academy Award (1993): Jean Hersholt Humanitarian
 Award
Designated Dame Commander of the Order of the
 British Empire in the Millennium New Year
 Honors List (2000)
GLAAD (Gay & Lesbian Alliance Against Defamation)
 Vanguard Award (2000): Elizabeth's stepdaughter
 Carrie Fisher presented her with the Vanguard
 Award at the 11th Annual GLAAD Media Awards
Presidential Citizens Medal (2001): Honored by
 President Bill Clinton for her groundbreaking and
 disruptive HIV and AIDS activism
Kennedy Center Honors (2002): Recipient of the
 nation's highest award for achievement in the
 performing arts

HUSBANDS

Conrad Hilton Jr. (1950–1951)
Michael Wilding (1952–1957)

Mike Todd (1957–1958 [his death])
Eddie Fisher (1959–1964)
Richard Burton (1964–1974)
Richard Burton (1975–1976)
John Warner (1976–1982)
Larry Fortensky (1991–1996)

CHILDREN

Michael Wilding Jr., b. 1953
Christopher (Chris) Wilding, b. 1955
Liza Todd Tivey, b. 1957
Maria Burton, b. 1961

Elizabeth Taylor

Prologue

*There are no coincidences and nothing happens
without a reason—I will find it.*

—LETTER FROM ELIZABETH TAYLOR TO
RICHARD BURTON

ROME
1987

The most photographed movie star in the world
stood alone on the terrace of the Villa Papa, a
ten-thousand-square-foot Roman mansion at 448 Via
Appia Pignatelli. The early afternoon light lit up her
raven hair, and those legendary blue eyes—that some
swore were actually an otherworldly shade of violet—
peered out onto the villa's eight acres, with its lush
gardens, crystal clear pool, and tennis court. Elizabeth
knew the house's current occupant, the celebrated di-
rector Franco Zeffirelli, very well. This was the home
where she had lived during the filming of the 1963

epic *Cleopatra*, where she began her passionate, all-consuming romance with her costar Richard Burton. At that moment, as she leaned over the balcony railing, she wished she could be standing anywhere else in the world. But something kept her there.

Her friend Aprile Millo, an opera singer who was in Rome with Elizabeth helping her prepare for her role in Zeffirelli's latest film, assumed that Elizabeth was reveling in technicolor memories of Richard Burton, the man she had married twice. Richard had died three years earlier, and even though they had divorced long before his death, the two talked almost every day on the phone.

Elizabeth walked through the primary suite and out onto the terrace. She turned back toward Millo and asked, "Can you give me a second, please?" After a few minutes, she walked back inside and seemed lost in her thoughts. Millo did not realize that this was also the home Elizabeth had shared with the singer Eddie Fisher, whom she was married to before Richard, and the place where she and Richard had been hounded by the press at a time when much of the world viewed her as a homewrecker. The house represented a time in her life before the darkness gave way to the light.

In the 1960s, Elizabeth and Richard had practically invented the paparazzi, the term for the aggressive

Roman freelance photographers who became famous in Federico Fellini's *La Dolce Vita*. Everyone knew the story: Elizabeth stole Eddie Fisher away from his wife, the actress Debbie Reynolds, and then she set her sights on Richard, whom she stole from *his* wife, Sybil Burton. Of course, it was not quite as simple as that.

Images flashed through Elizabeth's mind of being trapped inside the villa and hearing the photographers' ladders hitting its outside walls as they tried to get a photo of her through a window. She thought of the day when a photographer knocked on the front door pretending to be a priest, or another time when a photographer posed as a plumber. There were death threats against her children. One paparazzo punched her in the stomach to try to get a reaction and a higher price for the photograph. Nothing, it seemed, was sacred. One of their dogs was even stolen—and later returned.

Eventually, plainclothes officers guarded the villa whenever she was there and uniformed police officers walked the grounds as though she were living in a fortress. And no one, it seemed, was deserving of trust without proving themselves first. A publicist on *Cleopatra* used to wear her hair in an elaborate updo until it was discovered that she was hiding a small camera in her chignon when she visited the set. Before

the police got involved, one of Elizabeth's assistants had opened the front door and slammed it shut as soon as they saw a camera lens trained on them. Determined, the photographer on the other side tried to break the door down, and several people inside the house had to throw their backs against it to keep it shut. Memories of her children using rakes and water hoses to chase the paparazzi out of their garden came rushing back as she stood inside the house for the first time in two decades. Back then, she and Richard had tried to turn it into a fun game of cops and robbers so they could mask the reality that they were actually being hunted. In the years that followed, Elizabeth had tried not to dwell on the damage done to her family—and to herself.

In an envelope marked "ET PERSONAL—DO NOT OPEN" there is a private letter. It is from Elizabeth's archives, part of a meticulously catalogued collection of 7,358 letters, diary entries, articles, and personal notes, and 10,271 photographs. The letter tells the story of that day in 1987 when she went to visit Villa Papa. It is addressed to Richard Burton, who died in 1984, when he was fifty-eight years old. By that point in her life, she had married five other men and would marry once more.

"Richard, my always, forever love, This is really just for me, maybe you can hear and feel my soul," she

writes, "I think you probably always can, I think you are aware of everything that goes on in this odd brain of mine. It's always filled with you, but, of course, sometimes more than others. Right now, I am brimming with you, you so pervade my thoughts and my very inner mood that it's like you are in me. I have you, but holy God I don't! I'm not really bitching because I am one of the most fortunate women in the world—to love you and have you love me in return. But God, I miss your arms, your eyes that told me so many things, your voice that taught me to understand and appreciate so many fantastic and yes unknown things to me. I want your body next to mine tonight. I need you to hold me fast and hard and tender."

It is so much more than a love letter. It is a rare and deep plunge inward for a woman who did not believe in doing much soul-searching during her seventy-nine years of rapid-fire love and loss. One marriage ended because of physical abuse, another because of a plane crash, and yet another fell victim to alcoholism. Her two marriages to Richard would haunt her forever.

"Oh God. Richard, I loved you so and I will love you for the rest of my life, just let me say it to you and please hear my heart—I love you, I love you, I love you and I thank God for you. Please God, let him know. And please God . . . allow me to forgive myself for some

of the cruelties I was responsible for (and had so neatly tucked away) and let me make my amends to those I have caused such pain to."

But she would not have taken back those mistakes. "Without a sense of guilt and shame," she said, "I don't think one would be nearly as compassionate or understanding." And compassion is what would later come to define her life.

Elizabeth had weathered so many storms, and standing in that villa in Rome brought some of the worst of them back. There was nothing but devastation in the wake of the sudden death of her magnetic superproducer husband Mike Todd, who was killed in a plane crash in 1958. Feeling half dead, she fell into the arms of Eddie Fisher, who happened to be Mike Todd's best friend. Fisher was married to the actress Debbie Reynolds at the time, and he was one half of America's storybook couple. The scandal was the top story in *Time*, *Life*, and *Newsweek* in their September 22, 1958, issues. The *Life* headline read: "TALE OF DEBBIE, EDDIE AND THE WIDOW TODD."

Then came *Cleopatra*, and she and Fisher, who were newly married, moved with her children to Rome. It was there, on January 22, 1962, on the set of the most expensive movie ever made at the time (it cost $44 mil-

lion in 1963, the equivalent of $415 million today, and it remained the most expensive film for the next thirty years), that she started shooting scenes with the rakishly handsome Welsh actor Richard Burton, who was thirty-six years old. He had piercing blue-green eyes and pockmarks from bouts of childhood acne growing up in a Welsh coal-mining town. He was also married and well known for his habit of seducing his leading ladies. Elizabeth was on the cusp of thirty and at the height of her raw, smoldering sensuality.

Richard had cheated before, but he always went back to his wife. This time, with Elizabeth, it would be different.

In 1987, when she pulled up to Zeffirelli's opulent villa, Elizabeth, now fifty-five years old, knew that something was wrong. She thought she was going to a different house, the one she had shared with Richard when they were married and filming 1967's *The Taming of the Shrew*. She called that house "The Happy House." Instead, she found herself standing in "The House of Pain." The rooms had an "awful, heavy, humid, before-the-storm atmosphere," she wrote. The Villa Papa was along the Appian Way, a road constructed in 312 BC to transport military supplies and Roman troops to southeast Italy.

Still visible along the Via Appia Antica are indentations from chariots and parts of the same roads that St. Peter and Julius Caesar walked along. Before she set foot inside, Elizabeth turned to Millo and said, "I know this house very well."

Elizabeth wrote that 7-page handwritten letter to Richard in scrawling cursive on yellow legal paper. It looks like someone was emptying their emotions out in a hurry. Her brain, she wrote, "started flashing and sounds started popping in my head . . . letting in too much light, then too much dark, and I could make out in all this a fight that had taken place some twenty-five years before, with blood, bodyguards, gardeners, and waiters wielding rakes, planks of wood, pots and pans, hoses against the P [paparazzi], armed with anything they could get their hands on and those god damn cameras—trespassing, breaking and entering right in the front door and those awful sounds screaming down 25 years of a fun house slide with the echo of my babies fear still shrieking and howling behind that same door—closed now, and safe, just as they are and just as I will be when my beloved Franco opens the doors of 1987."

Being there, in the house, was a gut-wrenching shock, "like some awful mixed-up macabre joke," she wrote. "I thought I was going to the house we rented

during *The Taming of the Shrew*, the house Franco had spent so much time in, and that we had been so happy in. When I heard Franco had bought our old house, I naturally thought it was that one—and I was not at all apprehensive about seeing it. God, it held so many wonderful memories. Liza [Elizabeth's daughter with Mike Todd] riding on Pipo the donkey, the time the cat climbed too far up the tree, peed all over you, and as you finally grabbed him and threw him down, both the butler and I who had been holding the ladder let go to chase after the cat and leave you to fall out of the tree, and like an arrow finding its mark the end of the ladder with unerring accuracy found my running head and knocked me out. Your sprained ankle, scratched hands, my numbed skull and . . . [the] cat licking his mitts and straightening out his ruffled dignity—Oh God we laughed! . . . I started to think about the other house, and I can't write anymore tonight—I had no idea there is still so much pain in me. . . . I didn't realize how much I have buried, and now I have to let it out so that I can try and learn from it all."

She lived in the Villa Papa during the end of her marriage to Eddie Fisher, which she described as a "slow suicide." In an unpublished interview, Elizabeth talked about the trauma of their years together. Toward the end, Fisher was using shocking means

to try to control and manipulate her, and there were times when he would sit up all night with a gun by his side. "I'd take a sleeping pill to try and just fall off and forget it and go to sleep and he wouldn't let me. Every time I'd start to close my eyes and nod off, he'd stroke my arm and say, 'I'm not going to kill you. I wouldn't shoot you. You're much too pretty.' All night long. And then I'd stagger off and go to work. And come home to it. And he'd be unshaven and in his pajamas. And I'd go through the whole thing again at night time. And I ended up like a screaming lunatic . . . he used to tell me that I was his mother and that I couldn't leave him."

Elizabeth was one of the most famous celebrities in the world, but alone with her memories she was like anyone else, trying to figure out why fate had brought her there. She was writing for herself, for her children, and for Richard. It was Richard and Mike Todd, who was her third husband and her other great love, who had abandoned her with no warning. "You and Mike made me go on living without you . . . you bastard you married Sally when I had pneumonia and couldn't go on stage that night and half the audience left and rather than play to a half-empty theater you got drunk, flew to Vegas and got married. You son of a bitch, you know we should and would have married three times. But

that was near the end—Via Pignatelli [Villa Papa] was near the beginning, the real beginning."

Decades after that visit in 1987, propped up in bed by plush pillows in her primary suite on the second floor of her Bel Air home, Elizabeth still could not escape Richard's memory. She wanted it that way. She made sure that night-blooming jasmine was planted near her terrace, so that she could open her bedroom window and bring back memories of Richard and their escapes to their home in Puerto Vallarta, Mexico.

"I smelled Richard," she said in a quiet voice. "It was like he was there."

Her garden provided a peaceful sanctuary, but there were many days when Elizabeth did not leave her bedroom suite. "I decided that if I'm going to be sick, then I'm going to have a gorgeous bedroom," she said in 1997. It was her favorite room in the house, and it was decorated in shades of blue and white. She had a canopy bed with Pratesi and D. Porthault sheets. When she went to the hospital—which was quite often—she took her pillows, and sometimes those expensive sheets, along with her.

Her visit to Zeffirelli's house took her by surprise because, unlike the wafts of jasmine that made their

way up to her bedroom suite, the bad times came creeping in. Maybe fate brought her there to help her say good-bye to Richard one last time.

Later that night in her hotel room in Rome in 1987, she wrote the letter to Richard and drank a Brandy Alexander, even though she was on the wagon. Then, she did what she always did: She got on with it.

Introduction
Elizabeth the First

E lizabeth never thought of herself as being larger than life. And how could she? She could not remember a time when she was not famous. In 1944, when she was twelve years old, she played the lead in *National Velvet* and became a heroine to girls around the world. She was the last star created by the Hollywood studio system, and her global fame is rivaled only by a handful of other women: Jackie Kennedy, Marilyn Monroe, and Queen Elizabeth II. Jackie (who was fascinated by Elizabeth) withdrew into a private world, Marilyn collapsed under the pressure, and the Queen was buffered by the walls of Buckingham Palace. Elizabeth, by contrast, flourished. In 1963, when Elizabeth was just thirty-one years old, *The New Yorker* magazine's film critic Brendan Gill noted that she was "less

an actress by now than a great natural wonder, like Niagara or the Alps."

She made fifty-six films and ten television movies over nearly sixty years, but her lust for life has eclipsed her professional accomplishments. She was famous, even infamous, for her eight marriages to seven different men. By the time she was twenty-six, she was twice divorced and once widowed. Her stardom was organic and so much a part of who she was. Long after she stopped acting, the drama surrounding her personal life was on display on magazine covers at every supermarket checkout counter in the world. But beneath the psychic clutter of her own mythology was a bawdy woman, quick to laughter and self-deprecation. Her life was a soap opera that ended in a deeply meaningful way.

She was an early influencer and the original multihyphenate. She was the first to do so many things: she played daring roles, like Maggie the Cat, who voiced the suspicion of homosexuality, a verboten topic in the 1950s; she was the first actor, male or female, to negotiate a million-dollar contract, when she appeared in the epic film *Cleopatra*; she was the first celebrity to get treatment for her addiction to alcohol and drugs at the Betty Ford Center; she was the first major star to use her fame to change the course of history through

her bold and defiant HIV and AIDS activism; and she was among the first celebrities to create her own massively successful perfume line. Elizabeth was a "lady boss," long before the term was popular.

Still, she never saw herself the way other people saw her. Truman Capote described his first impressions of Elizabeth: "Like Mrs. Onassis, her legs are too short for the torso, the head too bulky for the figure in toto; but the face, with those lilac eyes, is a prisoner's dream, a secretary's self-fantasy; unreal, non-obtainable, at the same time shy, overly vulnerable, very human, with the flicker of suspicion constantly flaring behind the lilac eyes." She also shared Jackie's clear signs of post-traumatic stress disorder. Jackie sat beside her husband when he was shot to death in 1963 when she was just thirty-four years old. Five years earlier, in 1958, Elizabeth was twenty-six years old when her husband, Mike Todd, died suddenly in a plane crash and left her alone with three young children to care for.

"I don't want any surprises," she instructed her manager later in life. She had had too many that had left her reeling.

J. D. Salinger once called Elizabeth, who had indigo-blue eyes, which were often mistaken for violet, sable hair, porcelain skin, and a perfect profile, "the most beautiful creature I have ever seen in my life."

The photographer Bob Willoughby chronicled the lives of movie stars of Elizabeth's era, including Audrey Hepburn and Marilyn Monroe. "He loved Audrey and he was friends with her, but he was truly staggered by Elizabeth's raw beauty," said Willoughby's son Chris. "Once, he was standing close to her and he was looking into her eyes, which were just glowing, and he forgot to pick up his camera."

But in 1964, when she was thirty-two years old, Elizabeth described how she actually saw herself: "I think Ava Gardner is truly beautiful; I think my daughter Liza is. I think Jacqueline Kennedy is a beautiful woman—tremendous dignity. I am pretty enough . . . I'm too short of leg, too big in the arms, one too many chins, nose a bit crooked, big feet, big hands, I'm too fat. My best feature is my gray hairs." Other times she cited Lena Horne and Katharine Hepburn as true beauties; she never counted herself among them, even in her private, unguarded moments.

What she saw when she woke up every morning and looked in the mirror, she said, was a face that needed washing. Liza Minnelli knew Elizabeth well, and she said that she was never awestruck by Elizabeth's beauty—and neither was her mother. "Mama [Judy Garland] knew 'em all. They were all gorgeous. But the thing about Elizabeth is that she looked like

she didn't know that she was beautiful. And that could be an act, but I believed it, and you know I can figure things out like that because of mama."

But at the same time, Elizabeth could never deny her glamour. She admitted, "I don't pretend to be an ordinary housewife." And the public did not want her to be. They wanted to see diamonds dripping from her neck as she traveled around the world in her yacht on the arms of a different man every few years (or less). Her life scintillated and fascinated, and it offered a reprieve for the normal housewife, and she knew it. She also knew that her beauty was a double-edged sword; people sometimes underestimated her because of it. But she was shrewd and sophisticated, and she knew a good script instinctively. She was most proud of her work in the critically acclaimed films *National Velvet*; *Father of the Bride*; *A Place in the Sun*; *Giant*; *Cat on a Hot Tin Roof*; *Suddenly, Last Summer*; *Who's Afraid of Virginia Woolf?*; and *Taming of the Shrew*. But some of her movies she made purely to finance her lavish lifestyle. By the late 1960s, she and Richard Burton had a combined fortune of almost $90 million in today's dollars.

Elizabeth was a committed actress, even though people too often doubted her. September 15, 1965, was a cold, moonlit night near the campus of Smith

College in Northampton, Massachusetts, where Elizabeth and Richard were on location shooting *Who's Afraid of Virginia Woolf?* In the film Elizabeth plays Martha, a bitter and domineering middle-aged college professor's wife. In one key scene in a parking lot outside a bar she tells her husband, George, played by Richard, that she is tired of whipping him, and George seethes and calls her sick. "I'll show you who is sick," Martha says, in what the film's producer Ernest Lehman described as an "absolutely blood-curdling" performance. In the scene, Martha tries to hit George and George pushes her away so that, in real life, Elizabeth kept cracking the back of her head against the station wagon. Take after take after take.

"On one take it was so bad, that is the pain was so bad, that tears came to her eyes and she had to be led back to the roadhouse and the company doctor looked over her for a while," Lehman recalled. "Fortunately the wig provided some protection for her head and she came back and did it all over again so many times. Richard and Elizabeth were both so intent on giving the very best performances that they felt were in them, that even after Mike [Mike Nichols, the film's director] said, 'That's it. Thank you very much,' Elizabeth asked Mike to quickly shoot the scene once more because she felt she could do it better, and indeed she did."

People had undervalued her abilities as an actress, and though few dared to show it, Elizabeth was intuitive and she could feel it. In a late-night phone call in 1965, after they started filming *Who's Afraid of Virginia Woolf?*, Nichols told Ernest Lehman: "Here's what I think's going to happen. I think Sandy Dennis is going to be fine, I think George Segal is going to be fine, Richard is absolutely going to walk away with the picture, and everyone is going to say there never was a George like Richard Burton, but I just don't think Elizabeth is going to make it."

In the end, it was Elizabeth who won the Academy Award for her performance; Richard did not.

She was a lot of things: kind, creative, whip-smart, self-indulgent, empathetic, selfish, greedy, romantic, vulnerable, and childlike. "Elizabeth wasn't a movie star with you, except when she'd suddenly act like it, like going to Studio 54," recalled Liza Minnelli. "Then she'd sit down at a beautiful booth that was hers, and Steve Rubell [co-owner of the legendary disco], through Halston [the designer], would find out who should be in that booth too so she was comfortable." She was not judgmental, and though she was always one of the beautiful people, and surrounded by the best of everything, she could not tolerate snobs, so

that meant she wanted someone at her table who could make her laugh, not just someone who was famous.

Actors have to be vulnerable and in touch with their emotions in order to do their jobs, but they must also develop a thick skin so they can handle the criticism and rejection that comes with the territory. Elizabeth had been working for so long that she had learned how to build up her defenses when she was just a child. She refused to be cowed by anyone. Sometimes, with self-important people—but men in particular—she'd take great pleasure in putting them in their place. Her son Chris Wilding called her self-confidence "a splendid thing to behold."

"She moved through life as a spontaneous being, not as someone who overanalyzed or regretted past actions," he said. "She burned with a brilliant flame. I also think that is one of the reasons that her important and lasting romantic relationships were with men who could stand up to her, who were her equal in charisma and wattage, men like Mike Todd and Richard, whose mojo she felt eclipsed her own."

She demanded loyalty and she gave it in return. Months after Elizabeth and Eddie Fisher ended their marriage, and while he was feeding the frenzy surrounding Elizabeth and Richard, she still cared enough

about him to save his life. Elizabeth's mother, Sara, was staying with Elizabeth at her chalet in Gstaad, Switzerland when the phone rang in the middle of the night. She picked up the receiver so that it would not wake Elizabeth, because she had to be up before dawn for work.

"Hello," Sara said groggily. But there was silence on the other end. "*Hello*," she repeated.

Finally, Fisher shouted, "*Put Elizabeth on the phone!*"

"She's fast asleep," Sara told him. "It's two a.m. here."

But Fisher was insistent. "*Put her on the phone.*"

"I'll wake her at five in the morning. Call back then, Eddie."

Before she could hang up he screamed: "*That's too late!* I've got to have two hundred and twenty-five thousand dollars immediately or I'll be killed by some men here in Las Vegas for an overdue gambling debt."

It had been five months since their divorce, and Sara was unmoved. "Call her in the morning, Eddie," and she hung up.

The next morning when the phone rang, Elizabeth answered. She agreed to pay the $225,000, the equivalent of $1.9 million today. She cared enough about him to do that, even after he had demolished

her in the press at the same time that she was taking a beating from the critics over *Cleopatra*. She would not abandon him completely. Not when his life was at stake.

She never let her friends down either. When Lehman suggested that she ask a friend, who was an accomplished assistant director, if he would consider leaving his job on one project to work on *Who's Afraid of Virginia Woolf?*, she was happy to do it, and her friend was delighted by the offer. But she was livid when Lehman told her that she would have to rescind it because Mike Nichols had changed his mind. "What you asked me to do," she said during a heated phone call with Lehman, "is not very nice to *do* to a person. . . . *You bet your ass I'm angry!* . . . you just don't treat human beings like that." If her friend had been famous, she suspected, he would not have been treated so cavalierly.

She could not stand the veneer of authority, of religion, or anything that's supposed to be worshipped or put on a pedestal. She believed in asking questions. Above all, she was authentic; she had a wonderful vulnerability about her. And she was a survivor who went through more than forty surgeries over the course of her life.

Elizabeth led the most glamorous and colorful life of any movie star in the world. She lived decades longer

than Marilyn Monroe, the only other actress who approaches her phenomenal level of fame. Richard Burton wrote in his diary that he saw people actually "shiver" when they walked across a room to be introduced to Elizabeth. Her public life was defined by excess. Her motto was always *More is more.*

She was *excessively* married. She was *excessively* rich, in part because she knew how valuable she was to the movie studios, and she demanded to be paid what she was worth. She was *excessively* in love with extravagant jewelry (she had the most valuable private jewelry collection in the world, which included the Asscher-cut, 33.19-carat Krupp diamond and an enormous 51-carat pear-shaped pearl called La Peregrina, which was once owned by King Philip II of Spain). She packed *excessively*, rarely traveling with fewer than twenty-five pieces of luggage stuffed with dozens of nightgowns, fur coats, cocktail dresses, and handbags, and she was *excessively* late, almost always arriving hours after she was supposed to.

Barbara Davis, whose late husband, Marvin, was once head of 20th Century Fox, remembers sitting and waiting with Nancy Reagan for Elizabeth to walk down the aisle to marry Larry Fortensky, her last husband, at Michael Jackson's Neverland Ranch.

"Valentino [the designer Valentino Garavani] would

wait for hours," she recalled. "Everyone waited for Elizabeth."

Most of all, though, Elizabeth was *excessively* empathetic. The word "empathy" comes from the German *Einfühlung*, or "in-feeling"—translated first as "empathy" in 1909. It means mingling your own feelings and consciousness with someone else's experience, which had always come naturally to Elizabeth. She instinctively understood the precariousness and fragility of life. She possessed what her stepdaughter Carrie Fisher called "rampant empathy."

It is what led Elizabeth to devote the last three decades of her life to ending the stigma associated with HIV and AIDS, a disease that has disproportionately killed homosexuals, people of color, and drug users around the world. Elizabeth told the famous British broadcaster David Frost in 1972 that she had always considered acting to be "selfish." "It gratifies your own personal ego," she said. She wanted to do more with her life. When she declared, "I would rather be a good woman than a great actress," she meant it with every fiber of her being. And she knew that she could never please all the critics.

Merriam-Webster's online dictionary defines an icon as "a person or thing widely admired especially

for having great influence or significance in a particular sphere." Elizabeth never fit neatly into one sphere of influence—she was too big for that. She defined twentieth-century Hollywood for a global audience, both as an actress and as a cultural figure who, with each decade, reinvented herself to fit into a new generation. In the 1960s, she and Richard Burton were outlaws who captivated the world with their passionate and extravagant lifestyle, and at the same time she honed her skills as a serious actress, giving two Oscar-winning performances. In the 1970s, she tried out the role of Washington wife, and she occasionally indulged in the hedonistic nightlife of Studio 54. And in the 1980s, she built her unparalleled celebrity perfume empire and called out the cruelty and hypocrisy of the far right and the apathetic left in her fight to end HIV and AIDS and the pervasive and poisonous homophobia that it had exposed. It was during the 1990s and the 2000s that Elizabeth decided what mattered most in her life as a public figure: she was an activist first, a businesswoman second, and an actress last.

By the time she appeared in *Cat on a Hot Tin Roof* in 1958, Elizabeth was already a secular saint. She represented hedonism and scandal, captivating

beauty and pain, love and lust. She understood what she symbolized, and throughout her life there were times when she leaned into the world's caricature of a wildly self-indulgent movie star, a parody of herself that had reached its apex during her marriage to Richard Burton. There were times, too, when she refused to fulfill anyone's idea of who she was; she grew tired of their misconceptions. In her 1964 book, *Elizabeth Taylor: An Informal Memoir*, Elizabeth wrote, "I am disgusted by the amount of myth that now is accepted as fact." In her autobiography she seeks to set the record straight, but unfortunately she does not reveal too much of herself; she had become so accustomed to guarding her privacy that even her attempts to correct people's assumptions are self-censored.

The book is a winding conversation between Elizabeth and the journalist Richard Meryman. She comes across as intelligent and thoughtful and entirely self-aware, but she remains determined to keep her private world to herself while still offering some revelations, including pulling the curtain back on the painful isolation of child stardom. In 1977, more than a decade after her memoir was published, she wrote this note to herself: "I was born a baby—I have lived a very full and rich life, of which I will go into later at great detail. As I am still living it is my story to tell and

no one else's." She never let go of her agency, though that meant that she never wrote a full account of her marvelous life.

Unpublished interview transcripts that Meryman compiled for the book reveal much more. In one 1964 interview with him that was never published, Elizabeth said: "Nobody has the right to despise me that doesn't know me because they're despising an image that's been concocted by hundreds of other people, so they have no right to either approve or disapprove because they have no way of knowing whether it's true or false."

Separating herself from people's perception of her offered a level of protection from public scrutiny—of which there was always plenty. "I don't give a damn about what people think about me. I live my life the way I want to live my life, I'm responsible to and for people that I love."

Elizabeth was acutely aware that she was a uniquely valuable commodity; she understood that in order to survive in Hollywood she had to create space between the person she really was and the person the studio had created. "Elizabeth Taylor, the famous one, really has no depth or meaning to me," she said. "It's totally superficial. . . . I don't know what the ingredients are. It makes money. One is flesh and blood and one is

cellophane." But she fiercely guarded its value. When she was in Rome shooting *Cleopatra*, a publicist asked her which photographs she approved for publication (she had insisted on having photo approval). She took a pair of scissors off her dressing-room table and cut the ones she did not like into shreds "by way of making herself better understood, presumably," the publicist recalled. She, and no one else, controlled her image.

She understood her value. "She could make fun of herself," her friend and assistant of two decades, Tim Mendelson, said. "But the commodity of Elizabeth Taylor she fought tooth and nail for." At the time, Macy's was the premiere department store for a fragrance launch, and if her partners were placing her signature perfume anywhere else, she would demand otherwise.

Maintaining the value of Elizabeth Taylor the brand empowered her to help other people. Mendelson recalled one instance in the early 1990s when Elizabeth told him that she had read a newspaper article that had deeply disturbed her. It was a story about a woman and her young son who had been living out of their car and who were left homeless when their car was stolen. *Find this woman*, she told Mendelson,

buy her a new car, give her money for essentials, rent her an apartment for one year, and find a good school for her son. And she didn't want anyone to know who was behind it. Mendelson said that this act of generosity was not an uncommon request; Elizabeth wanted to help people who needed it most, and she had the means to help them because she had safeguarded her celebrity so expertly.

Elizabeth came into her full power in midlife, during a rare time when she was not married. In 1985, when she was fifty-three years old, she chaired AIDS Project Los Angeles's Commitment to Life fundraiser, which was the first major celebrity AIDS fundraiser in the world. She pressured then president Ronald Reagan into making his first speech devoted exclusively to the AIDS pandemic in 1987, six years after the first cases were reported in the United States. Trailblazer does not even begin to cut it.

She is well known as a founder of amfAR, the Foundation for AIDS Research, which was the first major nonprofit organization dedicated to supporting research on AIDS. But the extreme and heroic lengths that she went to privately to acquire illegal treatments to save her friends' lives, and also the life of her former daughter-in-law, who is living with HIV—her humanity

and empathy toward people who she had never met before—is astonishing.

She raised hundreds of millions of dollars for research and patient care over the course of her life. Dr. Anthony Fauci, who was the country's leading expert on the virus in its early days, recalled what it was like working with Elizabeth. "She was a little lady!" he said, referring to her five-foot-two frame. "But she was ferocious."

Elizabeth reveled in speaking truth to power. At the 8th International AIDS Conference in 1992, she called out President George H. W. Bush for a ban against HIV-positive people entering the United States. "I don't think President Bush is doing anything at all about AIDS," she said at a crowded press conference. "In fact I'm not even sure if he knows how to spell AIDS." The next day her rebuke was headline news around the world.

Many of her closest friends were gay men, including Rock Hudson, Montgomery Clift, James Dean, and Roddy McDowall, whom she became close to in 1943 when they were in Lassie Come Home together. Gay men had been a constant source of friendship and love in her life. "No one had explained it to me, but I knew it," she said. "Monty [Montgomery Clift] was in the closet, and I think I knew what he was fighting. He was tor-

mented his whole life. I tried to explain to him that it wasn't awful. It was the way that nature had made him."

When she accepted the Jean Hersholt Humanitarian Award at the Oscars in 1993, she wore an HIV and AIDS Awareness pin made of rubies and gold attached to a butter-yellow Valentino dress, with a stunning daisy diamond and chrysoprase necklace and earrings by Van Cleef & Arpels.

"I accept this award in honor of all the men, women, and children with AIDS who are waging incredibly valiant battles for their lives, those to whom I have given my commitment, the real heroes of the pandemic of AIDS," she said. "I will remain here as rowdy an activist as I have to be, and God willing for as long as I have to be."

Fighting for gay rights at a time when being gay was a felony in many states, including California, and fighting on behalf of HIV and AIDS patients, gave her life meaning and became her salvation when she was no longer acting. Tabloids had always made money off her, and she had no way to control whether what they printed was truth or fiction. Here was a way that she could do something important—and control the narrative. "If you're famous there's so many good things you can do," Elizabeth said. "If you do something

worthwhile you feel better. I spent my whole last fifty years protecting my privacy. I resented my fame until I realized I could use it."

People around her always knew that she was destined for more than movie stardom. Her second husband, the handsome British actor Michael Wilding, was struck by her courage. "I think the most important thing about Elizabeth is that she is very brave. Brave about actual physical things, afraid of no person and no animal, nor of any illness that may affect her person. And apart from physical dangers, illnesses, and such, she is undismayed by life." She almost died several times, including one famous battle with double pneumonia in 1961 that led to a tracheotomy—an incision made in her throat so that she could breathe. When she won an Oscar that year, she did not wear a bandage, so that the world could see what she had survived. Her brushes with death only added to her allure. Unlike Marilyn Monroe and Judy Garland, Elizabeth had come back from the dead, like a phoenix. And like the protagonist in Sylvia Plath's poem "Lady Lazarus," when Elizabeth came back from the brink of death in 1961 she vowed to reclaim her life and fight against the people who had objectified her. "Out of the ash," Plath wrote, "I rise with my red hair. And I eat men like air." The studio execu-

tives who once sought to control Elizabeth would not stand a chance.

In 1975, when she was forty-three years old, she had already lived a lifetime: two broken engagements, five husbands—the death of one of them affected her for the rest of her life—pneumonia too many times to count, a couple of international scandals, a broken foot, a twisted colon, three ruptured spinal discs, acute bronchitis, chemical thrombosis, phlebitis, sciatica, double pneumonia, a tracheotomy, three C-sections, and several alleged suicide attempts. "I've been through it all, baby," she said. "I'm Mother Courage. I'll be dragging my sable coat behind me into old age."

By the time she was sixty-five she'd had brain surgery to remove a benign tumor, and she'd been through back, eye, knee, and foot surgery, a partial hysterectomy, adult measles, dysentery, and three hip operations. And that is in addition to two visits to the Betty Ford Center, where she went to face her addiction to pills and alcohol. Such close encounters with her own mortality made her unafraid of death, but she was always fearful of physical pain.

She had been through such mental anguish. The deep resounding love she had for Mike Todd and Richard Burton came with soul-crushing loss. But she channeled her agony into something righteous. "I think the

level of compassion she had is parallel to the level of pain she experienced," said her friend Demi Moore.

Elizabeth grew up in the Hollywood studio system, where an actor's life was controlled by executives. She was under contract with Metro-Goldwyn-Mayer (MGM) for seventeen and a half years, from 1943's *Lassie Come Home* to 1960's *BUtterfield 8*, and at least on the surface, she handled the overbearing influence of her mother and the emotional abuse of the studio with grace.

She was born with scoliosis, a double curvature of the spine, and her chronic and sometimes debilitating back pain, which was exacerbated when she was thrown off her horse while shooting *National Velvet*, never left her. So much of her life was defined by her early years as a contract player. As a valuable object, her every whim was catered to and her every sickness became worldwide news. "She was a living, breathing chemistry set," said one friend. She learned that being sick was sometimes the only way she could get out of working, or get the attention of her family and the studio. When she was ill, she was a person and not a commodity. But she knew deep down that all the studio really cared about was money. "She could play

Dracula's daughter and still draw crowds," MGM co-founder Louis B. Mayer said of Elizabeth's box-office earnings.

"She knew how to get attention one way or another. The best way to get it was to walk out onstage and be this incredible character," said her one-time boyfriend George Hamilton. "The other was to take to the bed and be ill. She could fulfill her needs by getting attention through self-inflicted wounds." Her mental state, Elizabeth admitted, was deeply connected to her physical well-being.

It is not easy to feel sorry for a woman who had every material possession imaginable, from a 69-carat diamond ring to a yacht to a green Rolls-Royce, but even Andy Warhol, who surrounded himself with celebrities and studied fame, found Elizabeth's magnitude of celebrity jarring. In a diary entry from April 29, 1986, he described an HIV and AIDS benefit at the Javits Center in New York. When Elizabeth walked in she was mobbed by fans and photographers.

Warhol's friend wondered out loud: "What do you have to do to be that famous?" Warhol watched as the mob "dragged her across the room and then all the photographers rushed at her and smothered her and crushed her and when they had used her up, they just

dumped her and she was left standing there, alone, they'd gotten what they wanted. It was so strange to see." Warhol had used her too, of course; the iconic series of portraits he made using a publicity photograph of Elizabeth from *Suddenly, Last Summer* was a jewel-toned representation of female celebrity and had helped make him famous.

Elizabeth knew that actresses, especially the ones known for their looks, had short shelf lives in Hollywood. She knew that her youth and beauty were ephemeral, and she wondered what would happen to her when they were gone. A 1949 *Life* cover story examined the rush to sign young actors. "One studio that is less desperate than most is Metro-Goldwyn-Meyer [*sic*]," the story read. "That is partly because MGM has already turned up a jewel of great price, a true star sapphire. She is Elizabeth Taylor. . . . At 17, 5 ft., 4 1/2 in. [she was really 5 ft., 2 in.], 112 lbs, Elizabeth Taylor is a great beauty."

Her wariness of being used and her exuberance when she was in the presence of her true friends were all born from those days as a young girl who wanted, more than anything, to please her perfectionistic mother. Elizabeth's granddaughter Laela Wilding remembered watching *National Velvet* with her grandmother.

"At one point Grandma paused it and said, 'We had

to redo this scene because my mother was watching from behind the camera. She didn't like the way I was holding something because she thought that my hand looked fat.'" That was nothing compared to the years of taunting by Joan Rivers and skits on *Saturday Night Live* making fun of her fluctuating weight. "That's a lifetime of criticism and critique," Wilding reflected. "What does one have to do? You have to thicken your skin to survive, maybe prop up your own ego, maybe dull down some of the sensitivities."

"What a time to be a woman," said another one of Elizabeth's granddaughters, Naomi Wilding. "She had so many accolades, so much to admire, and yet to be constantly criticized for her appearance . . ."

The incessant attention was one reason why Elizabeth valued her privacy so much. "I don't have a lot of photographs of myself with Granny," said Naomi, who lived with Elizabeth in her Bel Air home from 2000 until 2002. "We didn't take pictures because we understood that she wanted to present herself in a certain way. You took your picture when she was ready for it. And that was a total act of respect for her, understanding the scrutiny she faced. It needed to always be on her terms."

Mike Todd and Richard Burton are referred to by their first names throughout the book because they

are among the most defining figures in Elizabeth's life, along with Sara and Francis Taylor, her parents, Debbie Reynolds, Montgomery Clift, Rock Hudson, and James Dean. Each marriage was a chance to reinvent herself. When she was Mrs. Nicky Hilton, she was a young, idealistic actress; when she was Mrs. Michael Wilding, she was a woman looking for shelter; when she was Mrs. Mike Todd, she was on an adventure of a lifetime; when she was Mrs. Eddie Fisher, she was trying to bring Mike back to life; when she was Mrs. Richard Burton, she was one half of the most famous celebrity couple of the twentieth century; when she was Mrs. John Warner, she tried to play the part of an obedient Washington wife; and when she was Mrs. Larry Fortensky, she was his teacher. She felt more secure when she was in a relationship, but in truth, she found her most powerful role when she was single.

She got the message so many of us never learn: Life is short and it should be lived to the fullest. Her friend John Travolta saw it up close: "She was unabashed about her feelings for her man—whoever that was at the time. She loved the man she fell in love with, and she didn't hide it. The people who are real feminists are not making an effort to be feminists, they just are. When you are at that level you don't have to exert

anything—it's effortless. You're the woman who's the best paid actress in the world, you're the woman leading the AIDS movement, you're the woman who's married and has children and wins two Oscars for Best Actress. You just own it."

Elizabeth had always believed in female agency, and she embraced the seismic shift of the 1960s, when women's rights and civil rights were becoming central to American culture. In 1964, Elizabeth and Richard joined Sidney Poitier, Duke Ellington, Lena Horne, and other prominent civil rights activists at the National Association for the Advancement of Colored People's (N.A.A.C.P.) "Freedom TV Spectacular." The nationally televised event commemorated the tenth anniversary of the Supreme Court's decision to outlaw the segregation of schools. The fundraiser was hosted by Ed Sullivan and Sammy Davis Jr. and raised funds to bail out civil rights demonstrators who were being arrested in the South. Elizabeth read a poem by Langston Hughes, a leader of the Harlem Renaissance. In 1970, she and Richard contributed to the Black Panther Legal Defense Fund, and her fight against the moral ostracism of HIV and AIDS patients in the 1980s was in keeping with her early adoption of norm-breaking ideas. These included her belief in the need for stricter gun control legislation in the United States. Decades

before school shootings had begun to upend (and eventually shatter) Americans' sense of security and safety, Elizabeth took out a full-page ad in the *New York Times* calling for action after Robert F. Kennedy's assassination in 1968. And she used her influence to get one hundred other celebrities to sign it. After President Ronald Reagan was shot and almost killed in 1981 she placed another ad in favor of gun control in the national newspapers.

Elizabeth was intuitively a feminist; she questioned the patriarchy at every turn, from studio heads to presidents, and she understood that the life of a housewife and mother was not every woman's ideal. For Elizabeth there was no performative flaunting of her sexuality, but she was a harbinger of the cultural changes that were to come. Before there was the sexual liberation of the 1960s, Elizabeth had sexual autonomy. She was not making the kind of outward proclamations that came to define the feminists of the post–World War II baby boom generation; instead she was living her life as a powerful woman thriving in a man's world. Like the feminist leaders Bella Abzug, who was a friend and whose political career Elizabeth supported, and the activist and writer Betty Friedan, Elizabeth supported equal pay for equal work, access to birth control, and the end of sexual harassment and domestic violence.

Feminists wanted to change archaic expectations, and Elizabeth was an example of a woman who pursued her passions, in her personal life and in her career. In Betty Friedan's 1963 bestseller, *The Feminine Mystique*, Friedan observed: "The problem that has no name burst like a boil through the image of the happy American housewife." Not all women were content staying home and taking care of their house and family, and in Elizabeth they saw a woman who wanted excitement and romance and who believed that everyone deserved to live their lives as they chose.

Perhaps it was because Elizabeth was forever being sized up and called out by people who had never even met her that she was so insistent on never judging anyone else. In 1963, one woman unleashed her fury at Elizabeth for leaving Eddie Fisher and falling in love with Richard Burton. The letter, which was addressed to the influential gossip columnist Hedda Hopper, is just one example of the onslaught of bitter criticism Elizabeth was getting at the time. The letter writer was a woman who seemed to resent Elizabeth for considering herself worthy of great love: "I am sure that these romances would not have progressed had Liz not done the encouraging, and when she saw what unhappiness she was causing she should have been the one to have ended the affairs. She has proved that the whole thing

rests with her. There have been far greater women than she who had to give up love because it was the right thing to do."

Hopper replied two weeks later: "You are quite right," she wrote. "She [Elizabeth] has done more to degrade the women of this world than any mistress of any king, and still she is being accepted as a great beauty and actress. However, I do believe she is genuinely in love, if she can be in love after so many loves."

Elizabeth had made mistakes, like everyone, including trusting the wrong people and falling in love with the wrong men. She had regrets, but she refused to dwell on them, because she understood that every full life is full of regret. "The most awful thing of all," she said, "is to be numb." Her humanity is what defines her life: she could be weak, but she had courage; she could be self-consumed, but she could also be selfless. She celebrated the life of the senses. "With Richard Burton," she wrote, "I was living my own fabulous, passionate fantasy." She loved eating fried chicken and indulging in decadent desserts and caviar, drinking champagne and sipping Jack Daniel's, being gifted extravagantly expensive jewelry and making love.

Elizabeth and Richard were the first celebrity couple with their own nickname, well before "Brange-

lina," and would be known as "Liz and Dick" for the rest of their lives. Richard's brother, Graham Jenkins, remembered how the couple spoke almost every day, long after they divorced. "He couldn't live with her and he couldn't live without her." Even when they had both moved on, when she was married to Senator John Warner and he was married to the British model Suzy Hunt, and later production assistant Sally Hay, he could not shake Elizabeth. "Elizabeth," he'd say, "bring a drink for my brother." Jenkins remembered cringing and having to remind Richard that that was *not* Elizabeth he was talking to.

"Yes," Richard said with an apologetic smile, "of course. That woman's always on my mind."

Sally Burton's perspective is quite different. It is clear that Elizabeth's plan going into the 1983 stage production of *Private Lives*, in which she and Richard star as a divorced couple who run into each other on their respective honeymoons with new spouses, was to get back together with him.

"She thought it was a war she was going to win," Sally Burton recalled. "Richard's Welsh family told me that Elizabeth told them that she was going to get Richard back. She believed that they would get married a third time. She was not going to let it go."

Elizabeth asked Richard not to marry Sally during

the run of the Noël Coward play. But he married Sally anyway—maybe to spite her. "Elizabeth in a way let her intentions be known, she threw down the gauntlet and I picked it up," Sally said in 2021.

The battle for Richard's heart was as fresh as it had been four decades earlier.

Elizabeth was a strong, smart woman who stood up for herself and other people, someone who didn't take any B.S.; someone with the lasting cultural relevance of a first lady, but who was more than a political spouse. She was someone who demanded to be the lead and not just a costar.

When she was married to Republican senator John Warner of Virginia, she was asked to join the 96th Congressional Wives Club. For years the Senate wives rolled bandages for the Red Cross and made puppets to give to children in area hospitals. It is difficult to imagine the most famous movie star of the twentieth century, a two-time Oscar winner draped in diamonds and emeralds, convincing herself to play a supporting role among the other Senate wives. But she tried.

The late John Warner, the last of Elizabeth's seven husbands to pass away, talked about how much Elizabeth still meant to him even after her death, and how badly he wanted the real story of her life to be told.

From conversations with her four children, to the celebrities who knew her well, including her last celebrity crush, the actor Colin Farrell, people who were close to Elizabeth knew there was more to her than anyone understood.

Elizabeth always made more money than her husbands, and she came from an era when working mothers were extremely rare. She was a lioness who wanted to guard and protect so many people—mostly those she saw as outsiders—that sometimes her own children were left feeling neglected. Her children's lives were, as her second son, Chris Wilding, put it, "set to the rhythm of her life" more than they should have been. When they were very young and she was married to Richard Burton for the first time, the children knew to be quiet on weekend mornings, aware that their mother and stepfather were most likely nursing nasty hangovers.

Elizabeth always said that she was no typical housewife, even though sometimes that was the life she craved most of all. Chris Wilding described a trip he took with her to a cabin in the woods when she was in her late sixties, and the delight she had in visiting a truck stop to use the bathroom.

"It was one of those places that had, in addition to gas and a truck wash, a restaurant, a very elaborate

mini mart, showers, and a chapel. And it was packed. I led her inside to the ladies' restroom, which had a fairly long queue backing up outside it. She gave me her handbag and Sugar (her dog) to hold, and I told her I would meet her in the market when she was done. I expected her to be awhile, so I tried to make myself invisible behind the tall displays of snacks—I felt I stuck out like a sore thumb in this bastion of burly Truckerdom, what with the handbag and wee fluffy designer doggie in my arms. Suddenly I heard her distinctive cackle/laugh rise above the din. I peered over my defensive snack tower to see her shaking hands and waving good-bye to some of the gals in the toilet queue. Upon recognizing her, they had of course let her jump the queue, and she was thanking her new friends on her way out."

When she joined him in the market, he said, she acted as though "she'd arrived at the gates of heaven." As she reached for bags of junk food, she exclaimed, "Let's get some of these! Oh, and we have to have a couple of these!" Soon the basket was overflowing. "For you and me, the experience of grocery shopping is a pretty perfunctory affair; get in, do the deed, and get out. Box ticked. For my mother, though, these were novel experiences, and even though I would inwardly roll my eyes at the way she elevated the mundane to the 'you don't know how much fun this is,' it did make me

appreciate what she had missed out on—even if it was the mundane—in her sheltered, insulated life."

She had an unmatched level of beauty, a raunchy sense of humor, and the ability to see beyond the bubble that she was placed in as a child. To Colin Farrell, who grew close to her during the last two years of her life, Elizabeth's acting was a reflection of who she really was: "She was honest and raw and brutal and grotesque and feminine and delicate and aggressive and soft and tender and warm and acerbic. She was *limitless*."

ACT I

The Most Beautiful Creature

The 1930s, 1940s, and 1950s

I know I'm lucky. I know when I wear a lovely Dior gown and jewels and a nice hair style that I'm bloody lucky.

—Elizabeth

Chapter 1
A Star Is Born

A note from Elizabeth to her mother in 1939 when she was seven years old, typos included:

Dear Mother

I hope you lick my song. Mother I did not mean to do what I did today BUT I am not going to tell you I am sorry I am going to showing you I am buy being a good girl because god will help me be good.
Oh I love you so so much.

<div align="right">

Love
Elizabeth

</div>

Elizabeth Rosemond Taylor was born in London on February 27, 1932, to American parents: Sara, an actress who took the stage name Sara Sothern, and

Francis, an art dealer. Elizabeth was named after Sara's mother, Elizabeth Ann Wilson, who was born in 1864. Sara had a flair for the dramatic—which she passed on to her daughter—and insisted that she was related to Mary Stuart, Queen of Scots.

Sara and Francis had a son they named Howard, born two years earlier, and this time Sara had been praying for a girl. She was a devout Christian Scientist, who believed that God was always there to listen to her prayers. When she was pregnant with their son, Sara's mother had advised her to fill her mind with "beautiful thoughts" so that she would give birth to a beautiful baby. She thought it must have worked. When Howard was born, Sara recalled, he looked like a "Botticelli angel," with blond curls and bright blue eyes. On that cold February morning in London in 1932, her prayers were answered—but not entirely.

"Is she perfect?" Sara asked.

"Yes, perfect," the nurse replied.

"Beautiful?" Sara asked.

"Yes, beautiful," the nurse told her.

"Does she have much hair? Is it light or dark?" Sara asked.

"Lots of hair—dark hair," the nurse said.

But when the newborn Elizabeth Taylor was

handed to her mother, wrapped in a cashmere shawl, Sara almost recoiled in horror. "Her hair was long and black. Her ears were covered with thick black fuzz, and inlaid into the sides of her head; her nose looked like a tip-tilted button, and her tiny face so tightly closed it looked as if it would never unfold." What was the use of all those "beautiful thoughts"? She wondered whether perhaps she hadn't given her second child enough attention in the womb and now she was being punished for it.

"From that day on," she wrote, "I held her in my arms every day and silently asked God, please not to let the hair grow in all the wrong places—not all over her ears, arms and back! To me she became the most beautiful baby in the world—and it annoyed me no end when friends looked at her and said, 'Poor little girl. Isn't it too bad she isn't the boy and Howard the girl?'" Elizabeth's eyes remained shut for ten days, her face stayed covered with black fuzz, and there were red splotches all over her torso.

Sara, who was more than a little superficial, prayed that her daughter's appearance would improve, and, of course, it did, and in the most extraordinary way. Elizabeth went from not talking until she was more than a year old—unlike Howard, who started talking before

he turned six months old—to talking and gurgling all at once. "The hair had long since disappeared from her arms, back and ears; now, all nature seemed bent on making her beautiful! Her eyes became larger," Sara wrote in a 1954 series called "Elizabeth, My Daughter" that ran in *Ladies' Home Journal.* "Double rows of long, black eyelashes made shadowy frames for those deep pools of blue." By the time she was a year and a half old, Elizabeth's transformation was complete. Sara made sure that her metamorphosis from a caterpillar into a butterfly was woven into the story of her daughter's life.

Elizabeth's beauty came to define and at times torment her. Her earliest childhood memory was of sticking her finger in an electric fireplace. "I was fascinated by the color red," she told David Frost in 1972, "and I approached it crawling on all fours and stuck my finger in it and realized that color and beauty wasn't all beautiful, that it did have pain connected with it."

Elizabeth's parents met in Kansas City, Kansas, and had been childhood friends. They lost touch when Francis moved to New York to work for his Uncle Howard Young, a multimillionaire art dealer with a well-known New York gallery, and Sara embarked on an acting career. She changed her last name from Warmbrodt to Sothern and got rid of the *h* in

"Sarah" after flipping through the phone book with her mother looking for suitable stage names. Her most successful role was playing Mary Margaret, a twelve-year-old homeless girl with a disability, in the play *The Fool*. Her character was healed at the end of the third act. No one seemed to mind that Sara was twenty-six. She treasured a 1924 letter from the royal household that said Her Majesty the Queen had enjoyed her performance. But, she later wrote, "My acting days and all thoughts of a career had ended, when I became Mrs. Francis Taylor, which was just as it should have been!"

She and Francis ran into each other in 1927 at the glamorous Mayfair Ball, held at the Ritz-Carlton in New York. Sara, who had large dark eyes and wore her hair in a fashionable bob, decided that evening that she had found the man she was going to marry. Within two weeks they were engaged. Sara was the one who had suggested it. When she asked Francis, who was meek by comparison, why he had not yet proposed, he said he thought that she was "too big a star."

The Taylors got married and lived an affluent lifestyle, thanks to the largesse of two benefactors, Uncle Howard and conservative British MP Victor Cazalet. Sara had shrewdly befriended Cazalet's sister when she was performing in a play in London. Cazalet even

gave them a weekend getaway house. Francis thought Sara was intoxicated by Cazalet's wealth and power and suspected an affair. When Francis's uncle asked his nephew to manage his London gallery, the Taylors moved abroad. They lived in Hampstead, a suburb of London. Their house was on Wildwood Road and faced Hampstead Heath, and came complete with a lush garden with three-foot-high yellow tulips, lavender violas, and a formal rose garden that terraced down to the heath and a tennis court. They called the house Heathwood.

Cazalet was named Elizabeth's godfather, and he helped provide them with their upper-class way of life, including a chauffeur, two maids, and a nanny. Elizabeth spent summers and weekends with her family in a charming sixteenth-century brick guest cottage covered in green moss and named Little Swallows. The house was located on Cazalet's Great Swifts estate near Cranbrook, Kent, sixty miles from London. Cazalet, who was also a Christian Scientist, shared a spiritual connection with Sara. They spent hours together reading the works of the church's founder, Mary Baker Eddy. Francis was not a Christian Scientist, and while Sara did not permit medicine for their children—Christian Scientists believe in the healing power of prayer over medicine—he sometimes snuck some into the house for

himself. Sara's devotion to Christian Science strength-
ened when Elizabeth, who was three years old, recov-
ered after spending several weeks in bed with a high
fever and a terrible ear infection.

Sara stayed with Elizabeth every night. When Eliza-
beth asked her mother if Cazalet would come into her
bedroom and sit with her, Sara remembered the healing
power of his prayers. "Victor sat on the bed and held
her in his arms and talked to her about God. Her great
dark eyes searched his face, drinking in every word,
believing and understanding. A wonderful sense of
peace filled the room. I laid my head down on the side
of the bed and went to sleep for the first time in three
weeks. When I awakened she was fast asleep. The fever
had broken."

That same year, when she was three, Cazalet gave
Elizabeth a New Forest pony named Betty. It was the
best time of Elizabeth's life, she said decades later,
because it was the only time she was allowed to be a
child. She loved riding through lush meadows and
"the isolation, the solitude, the companionship with an
animal . . . it's a marvelous therapeutic kind of thing."

That was when Sara knew that Elizabeth had a
special connection with animals. Once, Betty threw
Elizabeth and Howard off her back and into a patch of
stinging nettles. Elizabeth got up, Sara recalled, then

"flattened her body out on Betty's bare back, put her arms around her neck and kept on talking to her, as she rode off over the fields, while we stood there with our mouths hanging open. From that day on they were friends. This way she had of 'gentling' horses (or any animal) was the thing that led to her playing the part of Velvet," Elizabeth's breakout role as Velvet Brown in *National Velvet.*

It was those early days in the English countryside alone with her horse that Elizabeth treasured most. "When I was first acting I just liked playing with the dogs and the horses," she said. "Riding a horse gave me a sense of freedom and abandon, because I was so controlled by my parents and the studio when I was a child that when I was on a horse we could do whatever we wanted."

Elizabeth worshipped her older brother, and their friendship remained strong through the rest of her life. There were qualities they admired in each other; for Elizabeth, it was Howard's free spirit, and for Howard, it was Elizabeth's determination. She loved to watch her older brother box, and she squealed with delight when he landed a left hook on his opponent's jaw. She even convinced her parents to give her a pair of boxing gloves, and she asked Howard to practice on her before a match. She enjoyed playing the role of the

feisty little sister. "She would light into him with all of her strength and would be furious if he didn't give her a good wallop back," Sara recalled. "She would keep shouting, 'Harder, harder. Hit me harder, Howard!' He practically had to knock her out before she was satisfied." Still, he teased her like any older sibling, and she always hated the nickname "Liz" because she said that it sounded like someone hissing—Lizzzz—and also because Howard used to call her "Lizzie the Lizard."

Sara realized the effect Elizabeth's beauty had on people, and she made sure that her daughter was given every opportunity to mingle with the elite. She enrolled her in dance lessons at the prestigious Vacani School of Dance, where two generations of British royalty had gone. When Elizabeth was three and a half years old, she performed in a benefit recital held in Queen's Hall. In the audience was the other most famous Elizabeth of her era, the young Princess Elizabeth and her sister Princess Margaret.

Elizabeth and her classmates wore white tutus and butterfly wings, and at the finale Elizabeth did a deep curtsy with her arms spread wide and her fingers fluttering. She sat alone in the middle of the stage, after the other dancers had left, with her head bowed to the floor and her arms still outstretched, as though in a trance.

Sara was in heaven. Elizabeth could fulfill her

abandoned dream—she could become the star that Sara had always wanted to be. "The house went wild!" she wrote, remembering the curtain going up and down several times as Elizabeth sat there in the center of the stage. "I knew that day that there would come a time when she would want to follow in my footsteps. I could still hear the applause of the wonderful night ten years before when *The Fool* had opened in London at the Apollo Theatre and I, playing the part of the little crippled girl, had stood alone in the middle of the stage and had taken a dozen curtain calls, while a reputedly staid British audience called, 'Bravo, bravo, bravo!'"

For Elizabeth it was a personal revelation. She was naturally shy—often scared "bloody witless," as she put it—but she discovered that onstage she could take on the persona of someone else and free herself from her anxiety. "It was a marvelous feeling on that stage—the isolation, the hugeness, the feeling of space and no end to space, the lights, the music—and then the applause bringing you back into focus, the noise rattling against your face."

Then life changed suddenly and forever on the cusp of World War II. Elizabeth's childhood gathering primroses and bluebells and riding horses in the rolling green hills of the English countryside was over. If the war had not happened, Elizabeth later said, she

probably would have become an English debutante
and stayed married to one man with a solid job and
had lots of children. But fate decided otherwise. After
having tea with Winston Churchill, who was not yet
prime minister but who was a hugely influential poli-
tician, Cazalet took Francis aside and told him that
he should send Sara, Elizabeth, and Howard to the
United States immediately. Elizabeth's last time at
Little Swallows was Easter 1939. Like thousands of
other Americans who fled England, the Taylors were
literally running for their lives.

Sara boarded the SS *Manhattan* with her two young
children, with a plan for Francis to join them as soon
as he wrapped up business in London. During their
weeklong trip, Elizabeth watched *The Little Prin-
cess*, starring Shirley Temple, and fell in love with
the movies. Sara must have known then that she was
bringing her gorgeous daughter to the place where
their dreams could come true. By then, people were
already stopping Elizabeth on the street to admire her
beauty; her jetblack curls framed her perfectly sym-
metrical face, and her deep blue eyes were old beyond
their years. People said that she looked like Vivien
Leigh, the star of the 1939 blockbuster *Gone with the
Wind*, and that she should have auditioned to play her
daughter in the film.

Once they relocated to Los Angeles, Sara became singularly obsessed with making her daughter a star. Their opulent lifestyle belied their dwindling bank account. They were down to their last twenty-five dollars, and Francis, who was still in England, could not send them money because of the war. They cut down on living expenses, the biggest sacrifice being living without red meat, which was nothing compared to the deprivation some people faced during the war. It had been a narrow escape; just five months later England declared war on Germany. They lost their English accents and Sara became "Mother" instead of "Mummy." But Elizabeth was desperately homesick. She sat in her room listening to classical music and wept when she thought about England and the countryside she had loved.

Sara wanted to focus Elizabeth's energy on her career. She read to her from her Christian Science Bible nightly. Elizabeth underlined one particular passage: "Love inspires, illumines, designates and leads the way. Right motives give pinions to thought, and strength and freedom to speech and action." If this mother-and-daughter team wanted something bad enough, they would have it. Elizabeth had become Sara's reason for living. Each room in their new California home had between six and twelve photographs of her daughter.

When Francis reunited with them in Los Angeles, he must have been startled by what he found. At dinner, Sara spoke with Elizabeth about acting and film projects as Francis and Howard ate in silence. (Decades later, after Sara passed away in 1994, Elizabeth's lawyer, Barbara Berkowitz, went to Sara's home in Palm Desert, California, to help gather her belongings. "You would have no idea that she ever had a son," Berkowitz said.) Howard was arguably a more diligent and solicitous child, always catering to his mother, inviting her to spend time with him and his family and making sure to celebrate her birthdays. But Sara never treated him with anything like the kind of respect she reserved for Elizabeth.

Francis was growing more and more uneasy with Sara's singular focus on Elizabeth. She had Elizabeth play her role in *The Fool* again and again for practice. She taught Elizabeth how to cry on cue. Francis watched helplessly as Sara drilled Elizabeth on etiquette, hitting a mark, and finding her key light. "I gave up my career when I married Daddy," she told Elizabeth, "and all the king's horses and all the king's men couldn't have made me take it up again." The truth was that she had never achieved the professional success she had longed for and marriage and children had not filled the void.

Sara insisted that she tried to hold off having Elizabeth audition for movie roles, but it is clear that she was going to do everything in her power to make her daughter a major star. "Wherever she went, even as a very small child, people would follow her, saying, 'Look at those eyes. Did you ever see such beautiful eyes? Oh, she should be in pictures.'" She said she worked hard to keep Elizabeth from being aware of how beautiful she was. "Isn't it funny, people used to say the same things to me when I was your age," she told her young daughter. "It's just their way of being friendly." Elizabeth nodded and smiled back at people, just as her mother had directed her to.

Recalled Sara, "No matter what we did or where we went, it seemed predestined to follow us—or rather her. . . . Finally, there came a time when it was all so persistent that we wondered if we were interfering with what appeared to be her preordained destiny."

Sara and Francis leased a house in Pacific Palisades, and Elizabeth was enrolled in the same school as the children of powerful studio head and movie producer Darryl Zanuck and the children of the actress Norma Shearer. Weekends spent by the Zanucks' pool and afternoons with Shearer's family were more than usual playdates; they were about introducing Elizabeth to the powerful people in Hollywood. When that did not

immediately land her films roles, Sara took matters into her own hands.

According to Sara, she was out shopping with Elizabeth one Saturday morning and happened to stop by Francis's new art gallery in the arcade level of the Beverly Hills Hotel on Sunset Boulevard. The gallery showcased paintings Francis had brought with him from England before the war began. They stopped by to "see Dad" and ended up joining him for lunch with Reggie Allen, who was head of the story department at Universal Studios, and Andrea Berens, who was about to marry J. Cheever Cowdin, the chairman of Universal. Berens was at Francis's gallery because she had her portrait painted by the famous Welsh portrait artist Augustus John and knew that Francis carried his work.

After lunch, according to Sara, Francis excused himself to run errands. She stayed behind to show Berens the John paintings. Berens asked if there were any drawings, and Sara brought them and arranged them on the floor. In the end, Sara said, she sold twenty-one thousand dollars' worth of paintings and drawings that day, which is approximately four hundred thousand dollars in today's dollars. As the deal was being wrapped up, Sara made sure that Elizabeth and Berens

had time to talk. Before Berens left she said, "Cheever must see this child." Sara was all too happy to oblige, and she invited Cowdin and Berens to their home the following Sunday for tea. Now it was up to Elizabeth to make a good impression on Cowdin.

After tea in the garden, Sara led Berens inside to look at more Augustus John paintings, but she lost track of Cowdin—or so she said. "Looking outside, we saw that he was deeply engrossed and completely surrounded by dolls. Elizabeth, in 'looking after' him, had been trotting upstairs to bring all her dolls down. There were doll prams, high chairs, beds, kiddie cars, and wagons *full* of dolls—and Cheever, grinning like a little boy, was having a wonderful time." Sara described it as the turning point in her nine-year-old daughter's life, but Elizabeth's road to child stardom was not smooth.

"Cheever Cowdin and Andrea Berens begged us to allow Elizabeth to have a screen test taken at Universal," Sara recalled, feigning no role in the matter even though she was the one who wanted that screen test to happen most of all. "They were convinced that she was a 'natural' for pictures. Later I said to Dad, 'It's funny how this moving-picture thing keeps presenting itself. Perhaps it's meant to be; perhaps we haven't the right to stand in the way of her future.'"

The afternoon before she had her test at Universal,

Sara and Elizabeth sat with her Christian Science prayer book and Sara told her to think only good thoughts. That kind of thinking had transformed her daughter into a beauty, after all, and Sara believed it could make her a star. Soon after she tested at Universal, Sara took Elizabeth to a music class full of other children with well-connected parents. Her classmates included MGM chief Louis B. Mayer's granddaughters. Mayer was a Ukrainian immigrant and the most powerful star-maker in the business who ran the biggest of the Big Five studios. Another classmate was the child of Carmen and John Considine Jr., a successful producer. There Elizabeth sang "Blue Danube."

As Sara tells it, "Elizabeth's voice rose like a bird; she sang with all the joy of her heart." Applause erupted in the room when she finished. Carmen wanted Elizabeth to meet her husband, who was then at MGM.

When Sara told Carmen about the Universal test Carmen made her promise not to sign Elizabeth with Universal until she could audition for MGM.

The next day they went to MGM to meet Considine, and Sara played the piano while Elizabeth sang "like a bird, trilling and making up words."

Considine said, "Send for Mr. Mayer."

Before he left to catch a plane for New York, Mayer, who was an imposing and occasionally menacing

figure, absentmindedly glanced at Elizabeth and said: "Sign her." MGM offered her a seven-year contract at a hundred dollars a week (about nineteen hundred dollars today), with yearly options.

Sara, however, shrewdly decided to play MGM off Universal and told Cowdin what MGM had offered. He doubled the money to the then hefty sum of two hundred dollars a week, and Elizabeth signed a seven-year contract with Universal. Sara thought that because Universal was a smaller studio Elizabeth would receive more attention. But Elizabeth preferred MGM, where Katharine Hepburn, Lana Turner, and Clark Gable backed up its famous motto that it had "more stars than there are in the heavens." But those stars were propped up, promoted, and sometimes destroyed by Mayer himself.

Nevertheless, signing with Universal ended up being a very poor decision. In 1942, when Elizabeth was ten years old, she debuted in *There's One Born Every Minute*, with her co-star Carl Switzer, who played Alfalfa in *Our Gang*. The movie was not a success, and her role was hardly a challenge. "We played two brats," Elizabeth recalled years later, "and, as I remember it, all I did was run around and shoot rubber bands at ladies' bottoms."

A year later, Universal did not renew her option, and

she was out of work. Universal's casting director said, "The kid has nothing. Her eyes are too old; she doesn't have the face of a kid." She was ten years old and she could not sing like Judy Garland and she did not have the innocence of Shirley Temple. Sara was devastated, and Elizabeth was miserable. "She had only one thing on her mind," Sara said, "to get back to MGM. Every day she begged me to take her back to Metro. I didn't know what to do."

Sara told her friend Thelma Cazalet, Victor's sister, how distraught Elizabeth was, and Thelma used her connections to introduce Sara and Elizabeth to the gossip columnist Hedda Hopper. Hopper had once been a minor actress and was known for her quick tongue and tremendous influence—she had thirty-five million readers around the world. In the summer of 1942, after Universal dropped her, Sara brought Elizabeth to meet Hopper in the hopes of Hopper writing something positive about Elizabeth or introducing her to another studio head. Elizabeth sang her go-to "Blue Danube," but Hopper was unimpressed. Elizabeth's future, Hopper said, did not "lie in her singing." Hopper offered nothing more.

Elizabeth's income had helped the family immensely during the war, and they used it to finance their extravagant lifestyle. By then the Taylors had moved from

Pacific Palisades to a large Mediterranean-style home with a red-tiled roof on Elm Drive in Beverly Hills. Sara needed to find another way back into MGM. She found it through Francis, who was an air-raid warden in charge of patrolling the neighborhood in case the war came to the United States. He became friendly with Sam Marx, a fellow neighborhood warden. Marx happened to be a producer at MGM who was working on a movie called *Lassie Come Home*.

"It's almost finished, but the girl is too tall for Roddy McDowall," Marx told Taylor. "We're going to have to get a smaller child."

They needed a young girl with a British accent, but because World War II was raging in Europe they were having trouble finding one. There was tremendous pro-British sentiment in the United States as the Brits were allies in the war against fascism. Francis suggested his daughter, and Marx told him to bring her right away if she wanted a chance at the part. Twenty-five girls had already tested that afternoon, and the audition was over at 6:00 p.m. Sara and Elizabeth arrived at 5:45, and they were close to selecting one of the girls who had auditioned because no one was expecting much from Elizabeth. There was no way that Sara would let her daughter miss this opportunity, for she had seen how

quickly a dream could slip away. Elizabeth only had time to read the script once.

"I'm ready now, thank you," she said confidently. Elizabeth loved acting, and she saw films as an extension of the world of make-believe; she was playing dress-up and getting paid for it. She had no idea about the money, but her parents certainly did.

She sat on an empty soundstage and pretended to pet a collie that was in her imagination. "Poor Lassie, poor girl," she said sadly, with her hand in the air. When she finished the test, the director said, "She's got it—she's *perfect* for the part." When she arrived for her first day of work the cameraman looked at her and said, "Honey, would you mind going back to the makeup man to have him remove part of your makeup? You have on too much mascara and eye pencil." She blushed when she told him that she was not wearing any makeup at all.

Even though Sara was pushing her into it, Elizabeth loved the experience. "It was like magic," she said, "living out every young girl's fantasy." MGM gave her a long-term contract for seventy-five dollars a week, less than they had offered her before, but it was a start. Being Elizabeth's stage mother was Sara's full-time job: she accompanied her on the set and defended her when she thought she needed defending. For that, she

was paid from Elizabeth's salary. Ten percent of Elizabeth's gross pay was deducted and used to buy war bonds in Elizabeth's name. The rest of her compensation, according to a 1943 contract with MGM, "may be retained by said Elizabeth Taylor, and Francis Taylor and Sara Taylor, her father and mother respectively." That kind of wording gave the parents of child actors incredible leeway in terms of how much of their children's money they kept for themselves and how much they set aside for their children.

Though she was protected by her mother, who became known for waging war with studio executives on her behalf, Sara's attention could be suffocating. "[I was] so totally chaperoned that I never had a moment alone to ever think or be silent just by myself."

Lassie Come Home was released in 1943, and although Elizabeth had a small part, the film, which was shot in color—still rare at the time—was a raging success, and it cemented her career as one of MGM's child stars. Within a couple of years she would become the crown jewel of the world's largest entertainment company. But for Elizabeth, the most important thing to come out of the film was a lifelong friendship with fellow British actor Roddy McDowall, who was the movie's star and four years her senior.

McDowall would never forget his surprise at the way she looked when they met. "They brought this little girl on the set," he said. "I began laughing, because she was so extraordinarily beautiful. Very mature face for a child. The most astonishing-looking child I had ever seen."

Elizabeth came to view McDowall as an older brother, and he became one of the many gay men in her life who were like family to her. Years later, she described McDowall as "the perfect friend." "He makes you feel that you're terribly dear to him and even that maybe you're a dear person," she wrote. "He laughs at your jokes so you feel a bit funnier than you actually are. He makes you feel cherished and important. That's his genius."

Next she was "loaned" to 20th Century Fox to play a small uncredited part as the angelic Helen Burns in 1943's *Jane Eyre*, starring Orson Welles and Joan Fontaine. She had less than five minutes of screen time before her character dies, but she stole every scene she was in. She returned to MGM for *The White Cliffs of Dover*, playing opposite McDowall. It was then that Sara was called by the principal of Elizabeth's school and told that she had to find another school for Elizabeth to attend because she was becoming a distraction; the other students could not concentrate with her in

class. For Sara, this was an inconvenience, but it was also a clear sign: her daughter was becoming a bona fide movie star.

When Elizabeth was ten years old, her parents enrolled her in school at MGM, where she went for the next eight years. It would be the only school she ever knew. She felt isolated going to school on set and sometimes being the only person in her grade. She was required to complete only three hours of concentrated schooling every day, which had to be finished by 4:00 p.m. She longed for a normal school where the learning was stretched out over six hours and she could joke around with friends.

MGM was its very own universe. The studio was spread across 167 acres in Culver City and had its own hospital, its own lakes, a private zoo, and a commissary, where stars like Spencer Tracy, Fred Astaire, Lana Turner, and Greer Garson regularly ate lunch. "Every time Clark Gable walked into the commissary I dropped my fork," Elizabeth remembered. Louis B. Mayer was king, even the chicken noodle soup on the menu was his mother's recipe. Elizabeth especially loved the sweet smell of the pancake makeup the women wore. She once mustered up the courage to walk up to Katharine Hepburn's table and ask her to sign her autograph book, but Hepburn was distracted. "I was in such awe

of her—she was one of the really golden ones—all of a sudden I got ice cold and white hot and started shaking. She was perfectly nice, but that was the last autograph I ever asked for." Fifteen years later they starred in *Suddenly, Last Summer* together.

Actors dressed as cowboys and Roman soldiers would walk by the white schoolhouse, which had a picket fence and an American flag out front, according to child actress Margaret O'Brien. At the helm of the twelve-seat one-room schoolhouse was a teacher named Miss McDonald, who had to manage students who were as young as five up to eighteen-year-old high school seniors. Each of them was balancing full-time work with school. O'Brien, who was almost five years younger than Elizabeth, played with her often in the small schoolyard.

"There was no one to chat with about what classes you were taking. I was so isolated," Elizabeth recalled. "I used to go into the ladies' room and daydream for ten minutes because you were under such constant supervision." Elizabeth liked to imagine herself as the star of her own show, like *The Secret Life of Walter Mitty*, a film in which Danny Kaye played a man who led a boring life but who cast himself as the hero of every story created in his imagination. She was "Walter Mittying" one day, and she took longer than usual in

the bathroom. When Ms. McDonald reprimanded her, Elizabeth decided that the next time she went to the bathroom she would be more specific. On the blackboard she wrote in small letters: "E enters bathroom 10:03." After she walked back into class she wrote: "E exits the bathroom, 10:06, mission accomplished."

She thought about how wonderful it would be to do little things like looking over a classmate's shoulder to steal the answers to a test. "There was nobody's shoulder to look over because everybody else was in a different grade," she joked. There were only a dozen or so children in the entire school, and there was no one her own age.

Elizabeth also felt that there was something inherently dishonest about the entire setup. Years later she recalled how difficult it was to be both a wildly bankable star and a student. "On the set they would have a little black cubby hole and you would have your tutor and the minimum you could be in there was ten minutes. So you had to ram some facts in your mind in ten minutes, then go out on the set, do your lines, come back, pick up where you'd left out, go out, slip back into character. . . . It was not easy, I don't know why we weren't all a bunch of schizophrenics. Well, a lot of us were."

Legendary director George Stevens, who directed

Elizabeth in *A Place in the Sun* and *Giant*, said that MGM created "an artificial patriarchy" around her. "It took the place of her own retiring father. The studio, like a domineering parent, was alternately stern and adoring. All day long, some official was telling her what to do and what not to do. She spent all of her preadolescent and adolescent days inside the walls of Metro-Goldwyn-Mayer with no time to play and little contact with other children. Between takes, she was sent off to a vacant room somewhere to study."

She must have been bored by acting by the time she was in her late teens, he said, comparing acting to football. "You were on the team when you were twelve—you were quarterback, varsity, when you're twelve you must get so sick of football by the time you're in college." Beneath her pleasant smile there was "a tidal wave of desire to escape the whole business," he said.

He called her childhood at MGM "an extraordinary kind of confinement for youthful exuberance." Her later desire for marital love is more than it seems, he said, because for a woman like her, marriage and having children is "the acceptable escape."

"Escaping the studio, if you retire or take too many sleeping pills [Marilyn Monroe had just died a month before], you're hurting the labor unions, you're destroying the industry—a girl can't say 'I quit' really . . . so

what does she have, so she has to get married, then there's no argument, she wants to get married and have babies." Of course Elizabeth knew instinctively that Stevens was right—however unfair the expectations were for female stars of her era. She spent much of her life seeking a way to keep herself separate from the commodity she had become, and when she was old enough she found an escape route through marriage. Her contract for *Cleopatra* alone shows her signing at different points during shooting with three different names: "Elizabeth Taylor," "Elizabeth Fisher," and "Elizabeth Taylor Burton."

Before she married, Sara's control never let up. At lunch in the studio commissary, Stevens recalled how Sara would say things like "Elizabeth says" or "Elizabeth thinks" when Elizabeth was sitting right next to her. "I finally felt like shouting, 'Why don't you let Elizabeth say it herself?'" he recalled.

Elizabeth went to pool parties arranged by the studio or other stars' parents so that photographers from fan magazines like *Photoplay* and *Movie Gems* could take their pictures. Momentarily she would forget the cameras were there and take a deep dive into the water and emerge with water coming out of her nose, cackling with laughter. But then the moment would be over and she would be back in watchful mode, along with the

other young stars. The difference was, Elizabeth could not stand the phoniness. When one magazine photographer asked her to pose drying dishes she refused. "Oh, please don't take that one," she groaned. "They'll think I like drying dishes and kids everywhere will wonder what's wrong with me."

Russ Tamblyn, who played Elizabeth's little brother in the 1950 film *Father of the Bride*, remembered how teacher McDonald wore her dark hair parted straight down the middle in a tight bun and her shirt buttoned up to the very top button. "She was very strict," Tamblyn said, "and watched over all of us and a bigger room with a ping pong table." Elizabeth, however, did not play by the same rules. "She was very independent, she would talk back to Ms. McDonald," remembered Tamblyn.

In addition to the schoolhouse, the child stars had their own dressing rooms and private tutors on the lot. "They didn't overwork Elizabeth and they didn't overwork me," Margaret O'Brien said. And that was not out of the kindness of their hearts. "When Elizabeth and I were at the studio after Judy Garland had left school, the Board of Education came in and said that we couldn't work straight from nine a.m. to six p.m. Before that, with Mickey [Rooney] and Judy, child actors could work any hours the studio needed. Even if I wanted to finish a scene and it was a crying scene

and I didn't want to do it the following morning, Miss McDonald would come to the set and take us out. We were scared to death of her."

Elizabeth hated being treated like "a freak"; she wanted to go to college, but taking time away from her career was not possible. When she told her mother that she was thinking of applying to UCLA, Sara dismissed it offhand. "I bet all those girls going to UCLA wish they were Elizabeth Taylor."

Russ Tamblyn recalled going to her lonely graduation party in the sparsely populated schoolhouse. Elizabeth shared her cake with Tamblyn and the child stars Dean Stockwell and Jane Powell. But even with them she felt like an outsider.

One movie would turn Elizabeth from a talented child actress into a uniquely valuable commodity. In the fall of 1943, producer Pandro S. Berman was looking for a girl to play a very specific part: He needed a beautiful little girl with a perfect English accent who could ride horses, to play Velvet Brown, the main character in *National Velvet*, a film based on the 1935 bestselling novel by Enid Bagnold. Years earlier, Berman had envisioned Katharine Hepburn for the lead, but she was too old for the part now.

The film takes place between the two world wars

in England, at a time when a woman's role was limited and carefully defined. Her name was to appear in print three times: her birth announcement, her wedding announcement, and her obituary. Women were not allowed to inherit property, and they could not vote until 1928 in England (the Nineteenth Amendment to the U.S. Constitution was ratified in 1920, but it did not apply equally to all women, and in many parts of the country women of color still could not vote for years). Elizabeth plays Velvet, the daughter of a butcher in rural England, who dreams of winning a horse called The Pie in a lottery in her village. When she wins The Pie she fantasizes about riding her horse to victory in the Grand National Steeplechase, a horse race that only allowed male jockeys. Mickey Rooney, who was much more famous than Elizabeth at the time, plays the disillusioned jockey who helps Velvet realize her dreams of winning the race by being disguised as a boy—which was an incredibly gutsy and bold move. Even though she is disqualified once it's discovered that she is a girl, Velvet is overcome with pride knowing that she won the race. The movie is the story of female empowerment and the choices women are forced to make between their dreams and their families.

"Everyone should have a chance at a breathtaking piece of folly at least once in his life," Velvet's mother,

who once swam the English Channel, tells her in a scene that is at the heart of the film. "Your dream has come early. But remember, Velvet, it'll have to last you all the rest of your life."

It seemed like a perfect fit: *National Velvet* was Elizabeth's favorite book, she had been riding horses since she was three years old, and she had an English accent. And the story of a girl breaking the rules spoke to Elizabeth and to her free-thinking and free-spirited approach to life. But there was one seemingly insurmountable problem: Elizabeth was a very short eleven-year-old. She looked more like a six- or a seven-year-old in stature.

"I'm sorry, honey, but you're just too short," Berman told her. "No one would ever believe that you could get in through the jockeys' weighing room. You look like a child."

"Well," she said, undeterred, just like her mother had been when Universal let her go. "I'll grow up." Berman chuckled and patted the top of her head.

After they left Berman's office, Sara and Elizabeth made a plan. "Well, honey," Sara told her, "if you're going to grow like that, you'll have to eat more than you do. You'll have to eat lamb chops, steaks, vegetables, and drink lots of milk. You'll have to be in bed by six-thirty."

It would be one of Elizabeth's very first challenges, and she was absolutely determined. She believed she *was* Velvet Brown, and Sara knew the star-making turn the role would be for her. They prayed together from their Christian Science prayer book. Elizabeth was not going to let this chance slip away. Sara took her daughter to the Riviera Country Club in Pacific Palisades for three months so that she could ride and they could focus on getting her stronger—and taller. Elizabeth ordered two Farm Breakfasts at a restaurant called Tip's every morning, which included two hamburger patties, two fried eggs, hash-brown potatoes, and silver-dollar pancakes. She rode every morning for an hour and a half before school, she did forty jumps on her horse every day, and she swung from doorways believing that it would make her grow taller.

She fell in love with King Charles, the grandsire of Man o' War, the famous racehorse, who lived at the stables in Pacific Palisades. Elizabeth knew that he was wild, and had once even jumped over a car, but he was her favorite horse and she desperately wanted to ride him. At night she'd climb through an opening in the hay bin up to the highest bale of hay so that she could sit and talk to King Charles through a hole at the top of the wall of his pen. She told him that she loved him and that she would try to get him the role

of The Pie. One night she pushed herself through the opening and fell on his back; he reared, stomped, and snorted. She wrapped her hands around his neck and whispered to calm him down, which he did after a few minutes. She began sneaking in to see King Charles every night from 5:30 p.m. until it grew dark. When Sara found out, Elizabeth said, "Oh, please don't be afraid, Mother. He knows I love him, and he wouldn't do anything to hurt me."

"All right," Sara said, "only please come in before dark."

Eventually, his owner said that she could ride him, and Elizabeth asked her mother if the producers could come watch. King Charles, she said, was like "a fairy horse with wings on his heels!"

"They came, and when they saw that great horse, with such a *little girl*, flying over those high jumps, they realized that here was 'Velvet,' endangering her life every day, and *what* would happen to their picture [if she got hurt]," Sara said.

They told her she could not jump until they started filming, but still the part was not quite hers. That bad news was eclipsed by their other decision: King Charles would indeed play The Pie. After three months, Sara and Elizabeth went back to Berman's office so that Elizabeth could be measured. To their delight they dis-

covered that she had grown three inches. Sara saw it as part of God's plan—"There wasn't an atom of human will about it"—and Elizabeth saw it as a testament to her own strength. If she wanted something badly enough, she would find a way to get it. The story of how she got the part was woven into the narrative of Elizabeth's life; Sara knew it would make good copy.

But when she signed the contract with MGM to star in *National Velvet*, she became the studio's "chattel," Elizabeth said later. At the time, however, she was just thrilled to get the job. Sara said she was a nervous wreck during shooting, because so many of the professional jockeys ended up in the hospital. "Elizabeth loved every hair-raising moment of it!" And Elizabeth did most of the riding herself. She could jump six feet bareback on King Charles. She may not have gone to the hospital, but she did get thrown off King Charles, which caused a serious spinal injury that led to a lifetime of physical pain. She was worried that she would be replaced, so Elizabeth never let anyone know just how much pain she was in during shooting.

The legendary English actress Angela Lansbury played Velvet's older sister in the film, and like McDowall, she was stunned by Elizabeth's beauty. Elizabeth had an emotional vulnerability and depth to her performance unmatched by other child actors. "I

remember being, even at that time, dazzled by her coloring, which was so extraordinary, the violet blue eyes, the dark hair, the freckles, and the natural color in her cheeks. She was just the most glorious looking little girl I'd ever seen."

Still, the studio saw room for improvement; they almost always did. They wanted to remove the mole on Elizabeth's right cheek, which she later became famous for, and they wanted to dye her luxurious black hair, because they said that it looked too dark on-screen. Her response was always plain and simple: No. When she played Velvet, the studio also wanted to cut her hair, which Mickey Rooney does on-screen to help disguise her as a male jockey. Francis, who rarely voiced his opinion, objected, and Elizabeth wore a short wig over her real hair, which she tucked underneath. Elizabeth had also voiced her thoughts on the matter and cutting her long raven-colored hair into a boyish bob was non-negotiable. MGM's head hairstylist, Sydney Guilaroff, who became a close friend of Elizabeth's, created the short wig for her. He thought that Elizabeth had wanted to keep her hair long because she hated being treated like a child and long hair made her look more mature. She was twelve years old, and often the youngest person on any movie set, and she yearned to have the freedom to make her own decisions.

Francis and Sara also objected when the studio wanted to pluck Elizabeth's thick arched eyebrows, which also later became a signature of her appearance. There was even the suggestion of changing her name to Virginia, which her parents also squashed. Francis made it clear: Take her as she is, or you don't get her at all.

National Velvet was shot on Stage 27 on the MGM lot. Most of the scenes were supposed to be outside in the English countryside, so daylight was created inside using bright lights. "The heat was intense," Lansbury recalled. "The physical aspects of making movies was pretty darn uncomfortable." Sara was always on the set. Lansbury felt a kinship with the Taylors, because they were both expatriates from England. "They hadn't really been in this country very long and neither had I."

Sara was the very definition of a stage mother, and she embodied both the good qualities of such a presence, like defending her daughter at every turn, and the bad, which was the constant insertion of herself into her daughter's life. She was truly living her life through Elizabeth. She would sit in the corner during filming and make elaborate hand gestures to Elizabeth while she was performing: If she put her hand on her stomach that meant Elizabeth's voice was too shrill; if

she tapped her hand on her forehead it meant Elizabeth needed to stand up straighter and concentrate; if she placed her hand on her heart that meant Elizabeth was not delivering enough feeling in her performance; if she placed her finger on her cheek that meant Elizabeth needed to smile more, and if she put her finger on her neck that meant Elizabeth needed to tone it down.

Elizabeth had never had any formal training aside from her innate ability and Sara's coaching. There was one scene when Pie was sick and Velvet was taking care of him all night. In the scene, Mickey Rooney's character tells her that he doesn't think that the horse will survive, and Velvet is supposed to cry. Rooney, who was twelve years older than Elizabeth and already a seasoned star, offered her some advice.

"I think you should think that your father is dying and your mother has to work for a living and your little brother is out selling newspapers out on the street," he told her sincerely. "And he doesn't have shoes and he's cold, shivering, and think about your poor mother."

But instead of sobbing, Elizabeth, who already had a wicked sense of humor, started to giggle. She apologized and ran off when she could not stop. Elizabeth did not need to conjure up an elaborate story to cry. It took her a few seconds to summon the tears when she simply thought about King Charles dying. She was not

a method actor like her famous friends who followed the Stanislavski system: Montgomery Clift, James Dean, Paul Newman, and Marlon Brando. Elizabeth did not inhabit a character on- and offscreen. Instead, her acting style was to put herself in the shoes of the character she was playing.

"I tried to become them and think, *Well, now what are they upset about?* Not, *What would I be upset about?*, some hypothetical, imaginary disaster, but, *Why are they crying?*"

The 1944 film was an enormous hit, and it made Elizabeth a household name when she was just twelve years old. The *New York Post* raved, "Elizabeth Taylor is as natural and excellent a little actress as you would ever hope to see."

She was rewarded with a long-term MGM contract. Years later, she said, "I had no idea what I was getting myself into."

On her thirteenth birthday, the studio gave her King Charles and a $15,000 bonus, the equivalent of more than $245,000 in today's dollars. It was an investment MGM wanted to make in their newest star. Elizabeth's weekly salary surged from $200 to $750, $250 of which went to Sara for her chaperoning services. Elizabeth's ride to the top echelon of celebrity was at

lightning speed; it had taken five years for the studio to make Judy Garland into a star.

King Charles became Elizabeth's refuge. "Growing up on the MGM lot," Elizabeth reflected, "I always had people telling me to do this, do that. It was stifling. But I had a secret life. Every morning before I went to work I saddled up my horse, the one the studio gave me from *National Velvet.* Then I rode off into open country." It gave her a sense of "glorious independence" that most children take for granted but she learned to treasure. "If you've ever loved a horse as I love that horse, you'll understand—and if you haven't there's no use trying to explain."

Sara wanted Elizabeth's brother, Howard, to get into movies too. He was as handsome as Elizabeth was beautiful. But Howard was completely uninterested, which endeared him to his little sister even more. "He's totally un-superficial, totally unmaterialistic, the most real person I've ever known," she wrote. When Howard was a teenager Sara wanted him to audition for a part in a Western. He wanted a new car and working was the only way he could get one. Elizabeth's agent at the time, Jules Goldstone, wanted to take Howard to 20th Century Fox to audition.

"Jules had told us that 20th Century Fox was disappointed not to have Elizabeth under contract and

he mentioned to them how handsome Howard was and they wanted to see *him*," Sara wrote in her unpublished memoir *Taylor-Made Memories*. "We told Howard that it did not matter to us, we just did not want him to ever feel that his sister had a career and a Cadillac while he only had a jalopy. We wanted him to know that he had the same opportunity that she had to be in pictures—*if he wanted it.* We said, 'It's up to you, Howard, to go with Jules, *or not.* It's whatever *you* want to do.'

"He said nothing but 'Okay.' And to show that he wanted no part of motion pictures—he had his hair all shaved off, he was as bald as Yul Brynner. When he appeared in Jules Goldstone's office, the entire staff screamed with laughter, as we all did when he came home."

No one ever suggested acting to him again. Elizabeth loved Howard's rebellious streak, and she was even a little jealous of him. From the very beginning, Elizabeth had a bad feeling about Louis B. Mayer. She had of course heard how controlling he could be of his actors, and she started to see how ruthless he was firsthand. Margaret O'Brien, who to this day refers to Mayer as "Mr. Mayer," said that her mother had to speak up to him when she was going to do the 1944 blockbuster *Meet Me in St. Louis.* She said Mayer

wanted to keep her under contract with no additional money. He eventually agreed to an increase in pay after O'Brien's mother insisted. In the meantime, though, he strung O'Brien and another little girl along.

"Mr. Mayer always had a lookalike," she said, "a girl who looked like a star. He told my lookalike's family that she was going to do *Meet Me in St. Louis* and costumed her, all the while knowing that he would give me the part. Then he had to tell her family that she was not going to be in it. Her father had a nervous breakdown. The lookalike families always thought they would get it! They always held out hope. It was so brutal." Actresses like Judy Garland, whose mother went along with everything because her family needed the money, did what Mayer or his deputies told them to do. Elizabeth was not in that camp.

It was in this take-no-prisoners training ground at the world's most ruthless studio that Elizabeth learned how to stand up for herself. She vowed never to end up like Garland, who was ten years her senior. Garland was tormented by MGM's strict edicts, which included extreme diets, and became addicted to pills and cigarettes as a young girl. Even though she was young, Elizabeth could see the ways in which MGM ruled over their most bankable stars. She described Mayer as the "dictator" of the studio, who "alarmed" her. There was

a reason studio stars were said to belong to a "stable." They were controlled like animals, she said, and were considered studio property.

Mayer wore enormous glasses and looked at his actors in a way that "made you feel completely squashable," Elizabeth remarked, "but you also felt his enormous arrogance, his ego, his overbearing, driving personality. To know him was to be terrified of him."

On his birthday, all the MGM child actors went to Stage 30 to sing "Happy Birthday" to him. The big stars sat on the dais and the contract players were seated at tables while he held court at the podium. "You must think of me as your father. You must come to me, any of you, with any of your problems, no matter how slight they might seem to you, because you are all my children." He spread his arms out as though he were giving them all a hug. Then he had pictures taken with the child stars balancing themselves on his knee. Attendance was mandatory.

Mayer could not be challenged; he had punched more than one producer who tried. Elizabeth believed that he was "obviously slightly crazy." When she was filming *Lassie Come Home*, Elizabeth and Roddy McDowall experienced the studio's ruthlessness. The film's producer used unbleached corn flakes to look like snow. When the fans were turned on the small hard

pieces of cereal hit Elizabeth and Roddy in their eyes, causing them to flinch. Wincing was not the expression the producers were looking for from their young stars, so, as odd as it seemed, they had their faces anesthetized with several shots of Novocain.

Elizabeth's best friend, Norma Heyman, met her on a movie set in the 1960s and blamed Mayer for Elizabeth's lifelong reliance on pills and alcohol. "I remember her telling me about the number of pills that he'd [Mayer] make them take in the mornings so that they'd be bright and chirpy and another pill at lunchtime and then pills she was to take at home so she could sleep in order to get up at five in the morning to go back to the studio. These were children of eleven, twelve." Heyman said it "undoubtedly" fueled her addiction. That and the back pain brought on by falling off the horse while shooting *National Velvet.* "I do think that became a dependency, not all the time, but at the end, for the last few years."

If the studio needed their stars, they needed to make sure that their stars needed them too. And not just for the money. Mayer reportedly not only sanctioned the use of barbiturates (a common sleeping pill rarely prescribed today because of how easy it is to overdose on) but so-called "pep pills" (amphetamines). Garland was an addict by the time she was seventeen and filming

The Wizard of Oz. "They'd give us a pep pill," Gar-
land said, "then they'd take us to the studio hospital
and knock us cold with sleeping pills . . . after four
hours they'd wake us up and give us pep pills again . . .
that's the way we worked, and that's the way we got
thin. That's the way we got mixed up. And that's the
way we lost contact." Even though she was aware of
what was going on, Elizabeth was unable to stop it.

"It was so cruel," Heyman said. "I think these young
actors were punished if there was an infringement and
they'd be sent off to other studios . . . so Mr. Mayer
had his revenge." As she got older Elizabeth developed
a reputation for being able to "keep up with the boys"
and sometimes drink them under the table. She had a
very high tolerance for drugs and alcohol, which she
used later in life to justify the need to take even more
drugs and drink more.

Mayer created the Department of Special Services,
which was essentially the studio's publicity depart-
ment. It was the publicists who carefully crafted the
stars' images. After *National Velvet*, they encouraged
Elizabeth to show her love of animals, especially her
love for her pet chipmunk, Nibbles. The studio wanted
gossip columnists and reporters to cover Elizabeth as
a fresh-faced innocent; sometimes she played jacks or
jumped rope in the front yard. The publicity department

distributed photos of Elizabeth surrounded by her many pets to fan magazines. At one point she had a menagerie that included eight chipmunks, a golden retriever, a cocker spaniel, a black cat, King Charles, and a squirrel. *Lassie Come Home* and *National Velvet* capitalized on her wholesome image. She did not mind, because she clung to her pets as a reminder of a childhood that had ended much too quickly.

But there was much more to Elizabeth; she had a dry wit from a young age. When she attended her first adult cocktail party at gossip columnist Louella Parsons's house, she wore a black velvet skirt and had Nibbles balanced on her shoulder. When she was asked if she loved animals, as they had read, she said, "Of course. More than I like people."

Parsons was struck by Elizabeth, whom she called "a very unusual girl." "She is reserved and unemotional. But at the same time, she has great sweetness . . . her face was completely void of expression while we were talking. *She is an actress*, I thought. She can conceal her real thoughts better than most grownups."

Nibbles slept in a small log next to Elizabeth's bed, and the studio even allowed her to bring him to the commissary for lunch. She wrote a book in 1946 titled *Nibbles and Me* with drawings she did of her pet chip-

munk, and at school she let O'Brien, who was much younger, play with her chipmunks.

"My favorite memory is just playing in the playground of the school," O'Brien remembered. "The chipmunks would be on her shoulders, sometimes two or three at a time! I couldn't wait to go to school because Elizabeth would be outside at recess and she would have her chipmunks for fifteen minutes before Miss McDonald brought us back inside for school." The other actors O'Brien's age were boys, so she treasured the time she spent playing with Elizabeth.

Dore Schary took over MGM in the 1950s. His daughter Jill, who was a little younger than Elizabeth, remembered seeing Elizabeth when she visited her father at the Culver City set. "It was like she was a princess, a little girl from England who had a kind of elegance and superiority."

In 1946, when she was fourteen, MGM sent Elizabeth to Washington for an event at the White House. First, they arranged for her to visit a local children's hospital, where she sat with an eight-year-old boy who had been in an iron lung for more than a year. "He is so brave, and wonderful," she wrote. "The nurses said that in all the time he has been there, never once has he complained. And you could see that very courage

on his little face. It made my eyes fill up with tears, but I stood back, and wiped them away so he wouldn't see me," just as she would fight to hold back tears decades later during visits to AIDS hospices.

Afterward she went to the White House, where she met First Lady Bess Truman at an event to promote the March of Dimes. She wore her first fur coat, her first black dress, and her very first pair of long stockings. "When we finally did get there I felt as if butterflies were dancing or horses prancing inside my tummy," she recalled. Even though she was a screen star, Elizabeth was still a young girl who was not yet used to standing in dress shoes for a long period of time. There was a sea of cameras trained on them as Bess Truman sat at a desk at the front and Elizabeth sat at a desk behind her. Sara stood in front of Elizabeth behind the cameras as the flashbulbs went off. She started signaling at Elizabeth and pointing feverishly toward her feet. Elizabeth could not see her mother's frantic gestures because of the camera flashes. Eventually she realized that she was barefoot. She had taken off her shoes before she read her speech to the television cameras. She turned bright red. As the cameras rolled she tried to put them on surreptitiously, wiggling her feet in a circle under the chair, all while keeping a smile plastered on her face. Eventually she got one shoe on and with the tip of

her toe she found the other shoe as it went farther and farther under the first lady's chair.

"I began to panic because I thought I cannot all of a sudden disappear from sight and dive under her chair because it's almost by her foot. . . . I had to crouch on one leg. Fortunately, I had ballet training. . . . I hooked my toe around the heel and brought it back very slowly, and finally got my foot in it. Like one of the longest moments in my life." She was still a kid, after all.

There was a period between the time when she made *Courage of Lassie* and when she returned to the screen. During this hiatus, Elizabeth went to MGM every day—to go to school, to give interviews to reporters who had been prescreened by studio publicists, to eat lunch, and to have carefully posed photographs taken. This short absence from moviemaking was part of an effort by the studio to help her transition from a child star to an ingenue. Shirley Temple was not able to make a seamless transition, and the awkwardness of the early teen years had destroyed many a child star's career. MGM was determined to curate Elizabeth's image and make sure that any unsightly blemish, any awkward teen moment, was kept under wraps.

In 1947, Sara and Francis separated for four months. Francis was tired of being cut out of his daughter's

life. There were also rumors that he had romantic re-
lationships with men, which may have had something
to do with Elizabeth's lifelong ease with gay men.
Francis married Sara when he was twenty-nine years
old; in the 1920s, gay people were considered men-
tally ill or dangerous, so marriages of convenience
were commonplace. Life at home was tension filled.
Sara would not let Francis spend time with his daugh-
ter without her permission. On a rare day alone with
young Elizabeth, Sara reminded him: "Her hair needs
brushing hourly. And if she's touching her face too
much, simply say her name very loudly. She'll know
exactly what it means."

They eventually got back together, but Francis was
hoping to make a point. It did not seem to stick. Sara's
decision to secretly redecorate Elizabeth's bedroom
on Elm Drive was the beginning of Elizabeth's trans-
formation to womanhood, whether she liked it or not.
"I could see that Elizabeth was gently emerging from
horsy, shirt-outside-your-pants age," Sara wrote. "She
was daily becoming more conscious of clothes and of
her appearance. She began collecting perfume as well
as horse statues."

So she decided to help accelerate things. She re-
placed the wooden sawhorses, bridles, curry combs,
and racing saddles with a dressing table and white

quilted silk stool trimmed with chintz ruffles. She had Elizabeth's pearl-gray carpet stripped and dyed a deep shade of red, and she added a quilted headboard with a pattern of pink and red rosebuds with a matching bedspread and draperies. The walls were decorated with rose wallpaper.

In a rare moment of self-reflection, Sara recognized that she might have been pushing her daughter into something she was not yet ready for. "Looking back on it, I realize that it was an invasion of her privacy suddenly to remove all her treasures—her saddles, bridles, and so on. There was so little left of her room as *she* liked it; it was more her room the way *I* liked it."

The studio was turning Elizabeth into a teenage sex symbol, and they were being aided and abetted by her mother.

By the time she was sixteen or seventeen, studio executives reasoned, she would be ready to appear in another film. During this period they carefully released stories to keep her relevant. She was too young yet for marriage, so they chose more wholesome storylines beyond giving her King Charles and the release of the book *Nibbles and Me*. The strangest was their decision to give her a Ford convertible for her

fourteenth birthday—two years before she could legally drive. Nothing was done by accident, or without careful consideration and planning. Elizabeth was far too valuable a star. And in 1949, to mark her seventeenth birthday, *Life* magazine published a full-length color photograph of her to show that she had grown up.

Elizabeth knew the drill; she was schooled in the art of image making as a little girl. "L. B. Mayer and MGM created stars out of tinsel, cellophane, and newspapers," she said. Her first ingenue role came with 1947's *Cynthia*, when she was sixteen. It was the first time she wore makeup in a film, and it was her first adult on-screen kiss. The studio promised that moviegoers would see Elizabeth have her first *actual* kiss if they bought tickets for the film. "Her First Kiss" was plastered all over the movie posters. They were wrong, of course, but that did not matter, it was their way of reintroducing Elizabeth, this time as a full-fledged woman, even at fifteen.

"I think in real life I got my own first kiss about two weeks before," Elizabeth told Barbara Walters. "Oh, I was in a panic that I'd be kissed on the screen before I was kissed in real life, and that would have been such a terrible humiliation." That first real kiss

was, not surprisingly, choreographed by Sara. She ran into an actor named Marshall Thompson at MGM, and he asked if Elizabeth (and Sara) would like to go to the premiere of *The Yearling*. Sara agreed, and Thompson's mother joined them on a very formal date. Later, Elizabeth had her first kiss with Thompson in a rare moment when they were alone after they stopped at Wil Wright's ice cream parlor for a chocolate sundae. "She came rushing into my room on a pink cloud of wonderment and she exclaimed, 'Oh, mother, he *kissed* me!'"

Elizabeth may have found a boy to kiss, but she could not find one to date. She only knew the people on the studio lot, and there was no one her age in school. Sara's omnipresence intimidated even the most intrepid suitor. Sara and Francis rented a Malibu beach house and threw parties—Sara knowing the value of fixing Elizabeth up with someone she found suitable—but no one would talk to her.

"They came and stared at Elizabeth as if she were a thing apart," Sara wrote. They talked about school with its football games and proms, all things Elizabeth knew nothing about. She worried that she would never meet anyone. Elizabeth and television host Ed Sullivan's daughter, Betty, started a club. Elizabeth was president,

Betty was treasurer. They called themselves the Single Lonely Obliging Babes—in short, the "SLOB" Club.

Sara recognized that *Cynthia*, and later a movie made with Jane Powell, *A Date with Judy*, was the beginning of what she called the "glamour buildup." "Elizabeth was still a little girl—or an adolescent, at heart—prematurely being labeled a 'glamour girl.' No matter where she went all eyes followed her. She withdrew into a shell of reserve, and people said that she was snobbish when she was only trying to hide her shy embarrassment over being constantly stared at. She has more or less taken refuge in that shell of reserve ever since."

When she was fifteen, a magazine photographer told Elizabeth: "An editor just asked me who was the most beautiful woman I have ever photographed and I told him, 'Elizabeth Taylor.'" Sara was standing nearby and thanked him while Elizabeth giggled. Once they walked far enough away to be out of earshot, Elizabeth squeezed her mother's arm and said, "Oh, mother, did you *hear* him? He called me a *woman*!"

"You have nice eyes," Sara said, "but the expression behind the eyes is what makes them beautiful." Sara's hovering and constant attention might have saved Elizabeth from the casting couch, an abusive system with roles being handed out to actors and actresses

in exchange for sexual favors. "By the time I was old enough, no one dared," she said later.

As she grew older, Elizabeth wondered whether she wanted to keep acting. She and Sara fought all the time about it. Sara felt that she had given up her life for her ungrateful daughter, who now threatened to throw it all away. Elizabeth, ever eager to please her mother, eventually capitulated and apologized. She wrote a note to her mother: "My whole life is being in motion pictures. For me to quit would be like cutting away the roots of a tree—I'd soon wilt and become dead and useless. . . . Mom, I've made up my mind, and I promise you I'll never complain about being a very lucky girl, ever again. And another thing—I've made up my mind for *myself* so I'll take all the hardships and everything else that comes along—because I know (and I'll always realize) that I was the one who chose to stay *in*—and that I'm the one who must take them without grumbling, and wanting to quit."

Sara was relieved, but she still worried what people would think about Elizabeth's trouble finding a boy to date. A fan magazine threw a birthday party for Roddy McDowall, and Elizabeth was invited. She could not think of anyone to bring, so Sara approached Bill Lyon, who was handling Elizabeth's publicity at the studio, and confessed the problem to him.

"Well, what a situation," he marveled. "Here is this beautiful girl who has every male in the commissary turning to stare at her the minute she walks in worrying about a date."

"That's just it," Sara said. "They all stare wherever she goes, but that's no use."

"Don't worry. I know plenty of guys who would give anything to have a date with Liz," he said.

But he could not find anyone either; they were all too intimidated. Lyon ended up taking Elizabeth to the party himself.

Flirting with the biggest movie star in the world must have brought Elizabeth some solace. In 1947, Elizabeth took a transatlantic cruise on the *Queen Mary* with Sara. She received a mysterious note one day in her cabin. It read:

Beloved Miss. Taylor,

I overheard a charming lady saying she was going to see you tonight! And I have asked her to give you this note!

I am a man on crutches . . . Miss Taylor there is always a man in the world who wishes you only happiness.

Sylvester Mitchell

Not long after another note appeared:

Sept. 7, 1947 [on RMS *Queen Mary* stationery]

Would that I had the courage to walk to your table and say—"Elizabeth we will dance!" As I cannot do that—I make this appeal! I'll be wearing a blue flower in my coat—when you have had a good look at me and I hope decide favorable—will you cough three times—and out of a seat you will see a man leap! Please—please—Miss Taylor don't decide against me too quickly—please!

And I in the most subtle way have told you I am not much to look at!

But give me a chance—I know you will like me!

I am now going to the Catholic Church to pray for your favorable cough!

Please Miss Taylor

The notes were from Cary Grant, who was almost three decades older than Elizabeth, who was fifteen years old at the time. Still, she caught on quickly and she hid behind a potted palm and watched as the dining room maître d' handed this note to Grant:

Dear Mr. Mitchell,
 After the leap—then what?
 Elizabeth Taylor

Elizabeth got good grades because of her photographic memory, so good that on her sixteenth birthday her parents gave her a second car, a light blue Cadillac convertible, because she had "*earned* and *deserved*" it, Sara said. But Elizabeth, already forced prematurely into womanhood, preferred flirting to studying, especially with her costar Peter Lawford, who was a decade older than her and who played next-door neighbor Laurie in *Little Women*. Elizabeth played the vain and beautiful Amy, and Margaret O'Brien played the shy and sickly Beth. "She was so happy on that set," O'Brien recalled.

She was able to act out her crush when she played opposite Lawford in *Julia Misbehaves*, a film in which she elopes with him. In one scene, the script called for a passionate kiss, and Elizabeth was supposed to say, "Oh, Ritchie, what are we going to do?" and instead she kissed Lawford and said meaningfully, "Oh, Peter, what am I going to do?" People on set broke into laughter and Elizabeth's face turned scarlet red. They flirted and went out a couple of times, but Elizabeth felt betrayed that he did not want to be serious with her. She

wrote a poem about Lawford on March 5, 1948, the kind that was never meant to be read:

Deception.

How was I to know that you were deception?
Those tender moments when our hearts would beat as one,
Those lingering glances when
Your eyes made love to mine.
How was I to know?

MGM publicists were putting pressure on Sara to make sure that Elizabeth found someone to date for publicity purposes. And Elizabeth was clearly seeking romance. The studio was not satisfied with wielding influence over what their stars wore, they wanted to control the way they lived their lives too. And if an actor wanted to keep their job, they complied. If a star stepped out of line they were fined and money would be taken out of their paycheck. The transgression could be as small as being caught in public wearing a rumpled shirt. "They had to stay as pure as the driven snow," said the head of the studio portrait gallery, Ann Straus. "Metro girls didn't smoke or drink or swear, and Metro girls never *ever* had sex before marriage. Our girls could never have done that." Except, of course, they

did, it's just that when it became a troublesome public affairs situation they were punished for it.

Women were told whom to date, whom to marry, and when. Gay men were forced to marry women. Cary Grant, who is reported to have had sexual relationships with men, married five women and divorced four of them. While Elizabeth enjoyed joking around with Grant, she had a thoughtful perspective on fame and the toll it took on her fellow actors. In a 1964 unpublished interview she told journalist Richard Meryman, "I think he's [Cary Grant's] missing something in life because he's not living life, he's living make-believe. He's living an image. He's not living himself. . . . He's a caricature of a caricature now."

In 1934 Mayer told William Haines, Hollywood's first openly gay actor and the top box-office star in 1929, that he would have to get married if he wanted to stay at MGM. Mayer called Haines into his office and told him it was time to break up with his long-term boyfriend. Haines replied: "Sure—if you dump Mrs. Mayer." Haines's movie career was over.

O'Brien remembered the singer Johnnie Ray, who was going to do a movie at MGM but because he was gay the movie never got made. She remembered that Ray said, "'I'm not going to do the movie. My career is over now.' It was a terrible time."

Elizabeth's savvy as an adult was forged in this cut-throat world. In another unpublished interview with Meryman, Elizabeth recounted how as a child actress she saw the more famous actors maneuver bit players downstage out of the light, so that they could shine "like a diamond in the royal crown setting." She said that if you dared to step into "that golden circle of light," where the main star was standing, "you'd be cuffed behind the ears and you wouldn't even understand it." Elizabeth had resented the treatment so much that she made sure to do the opposite once she became a star.

Elizabeth was watching and absorbing all the cruelty and injustice around her, and she would never forget it. When she was fourteen, she and her mother went to talk with Mayer, or "Big Daddy," as she called him behind his back, in his office. Sara heard that Elizabeth was being considered for a role in a film called *Sally in Her Alley*. If the rumor was true, she would need to start training, because the part called for singing and dancing, which were not among Elizabeth's strengths.

Elizabeth described Mayer's office as being like Mussolini's. Visitors had to walk up a long white carpet to where he sat at a white oak desk surveying his subjects. Mayer was furious that Sara would dare question him. If Elizabeth was up for the role he would tell her when he felt like it. Foam formed around the corners

of his mouth and sweat dripped down his face as he turned white and stood up in a fury. Sara closed her eyes tight while Elizabeth watched him rage. "You're so goddamned stupid you wouldn't even know what day of the week it is," he shouted at Sara. "Don't try to meddle into my affairs. Don't try to tell me how to make motion pictures. I took you out of the gutter."

That was enough. Elizabeth stood up. "Mr. Mayer, unless you apologize to my mother right now I am leaving the studio. I am leaving your office and I am never going to come back. I would *love* to go to school, I would *like* to go to the prom, I'd *like* to go to basketball games, football games. And I'd *love* to go to school with children my own age." Her fury grew with each word. "I don't give a damn whether I ever act another day in my life. *You and your studio can both go to hell!*"

She ran out of his office. MGM executives heard the screaming and told her that she had to go back in and apologize or else she would most certainly be fired. "It's all right with me," Elizabeth told them. "I'm fine. There are things I'd much rather do than act." This became a theme throughout her life and a provocation to her critics: she would not retreat from her position, whether it was standing up to the tyranny of the studio or, decades later, to the bigotry of self-promoting evan-

gelical conservative activists like Jerry Falwell Sr. Sara stayed in the office for a while alone. Mayer never apologized to her and Elizabeth never once set foot in his office again. But she was not punished for her behavior. She was making MGM too much money.

"I learned a rather cynical lesson," she reflected later, "because I didn't get fired the next day and I realized that I must have some kind of intrinsic monetary value to them. . . . They needed me." She was a commodity, not a person.

In 1948, Dore Schary came to the studio, and Mayer was consumed with holding on to power. In 1946, the movie industry had been at its peak, but by 1953 the number of people going to the theater had been reduced by almost half because more and more Americans started buying televisions to watch at home. Having a television in one's living room became a point of prestige during the postwar economic boom. By 1951, Mayer was out. So were some of MGM's biggest stars, including Katharine Hepburn, Spencer Tracy, and Clark Gable.

Schary was the only writer in charge of a film studio, and he was determined to cut MGM's bloated budget. "Mayer was the czar of the studio," his daughter

Jill Schary Robinson said. "Each studio was its own palace. But my father never treated movie stars like merchandise."

High-paid executives took pay cuts of 25 to 50 percent a year, and MGM was revived for a period in the early 1950s. None of their films were nominated for an Oscar for Best Picture in 1947 or 1948, but for each of the next six years the studio had a film that was nominated. By late 1955, Elizabeth, Grace Kelly, Ava Gardner, and Debbie Reynolds were among the last MGM stars standing. Elizabeth was on the front lines for the end of the so-called Golden Age, where stars were groomed, molded, and controlled.

"When MGM seemed for a time to be dying," she wrote, "the death rattle was truly horrendous."

There would be no more seven-year contracts and no more "loan-outs," when stars under contract to one studio could appear in a film at another. Stars were set free, which was both liberating and terrifying. Actors could negotiate single-film deals or multiple-film deals with a specified number of films, but the studio would no longer own the star as it had when Elizabeth started out.

In a 2021 interview, her one-time boyfriend and companion George Hamilton reflected about how her childhood had shaped the trajectory of her life. She felt

used by the studio, and worse, by her parents. Being the breadwinner as a small child, Hamilton said, made her question her parents' motivations. Was her mother doting on her only because of the enormous paycheck she brought home every month?

She took care of everyone else, but she did not always take care of herself. "She had the strength of a lion and the ability to fight when it was for someone else," he said. "Along the way she found people who she related to who were victims. She related to that underdog as herself, any injustice, unkindness or inequality she was going to challenge. That's what she was rebelling against. Authority was something she didn't particularly like."

Ernest Lehman was the producer of Elizabeth's most critically acclaimed film, *Who's Afraid of Virginia Woolf?*, and in a 1965 journal entry during filming he wrote: "I told Irene [Sharaff], who knows Elizabeth very well having designed her costumes for *Cleopatra* and *The Sandpiper*—I told Irene how Elizabeth seemed to go at me with too many guns when she was arguing with me, I told Irene it seemed as though Elizabeth were seeing me as a threatening figure even in very simple little arguments. And Irene said that I must be aware of one thing about Elizabeth—that she has this tremendous need to shatter any man who appears to be a father

figure. To shatter him into many pieces and then to pick up all the pieces and put them back together again into a real relationship."

She seized the upper hand with Lehman, during a time when she was the world's biggest movie star, because she had been deprived of the ability to make her own decisions for so long as a child. The actor Robert Wagner was a lifelong friend; he and Elizabeth had once dated briefly. "Being with her was like sticking an egg-beater in your brain," he said. "I loved her, and I think she loved me." Elizabeth and Wagner's wife, Natalie Wood, were both child stars. "There was always this feeling, 'Do my parents love me and care for me because of who I am, or because of what I can do?' And if they don't give a good performance they could see that the behavior of the people around them changed. That has a tremendously profound impression on a young person."

Russ Tamblyn remembered sitting between Elizabeth and Jimmy Stewart at the Beverly Hills premiere of the 1974 film *That's Entertainment!* Someone came up to Elizabeth during the show and asked her if she would go onstage with her good friend Roddy Mc-Dowall and Lassie, and she said no. No one was going to make her do what she did not want to do. Not ever again.

It took decades for Elizabeth to reveal the truth of why she always bucked authority. And she never publicly revealed the extent of it.

"When I was a little girl my father was abusive when he drank and seemed to kind of like to bat me around a little bit, but when I left home and had my own child I started thinking about my father and how it must have felt for him to have his nine-year-old daughter making more money than he was," she told Barbara Walters in 1999, when she was sixty-seven years old. "All of a sudden shoot to fame when he had been this very proud, beautiful, dignified man. . . . I don't blame him at all. I know he was drunk when he did it, I know he didn't mean to do it, he didn't know what he was doing."

When she was in her early twenties, she called Francis one day and asked him to come to her house. They were at the kitchen table and she sat on his lap and put her arms around him and buried her head in his neck as they both sobbed. It was the first time they had really bonded since she was nine years old, when both of their lives had changed forever.

It was worse than Elizabeth would publicly admit. Elizabeth confided in a close friend that her father had punched her in the jaw so hard that it gave her TMJ, or lockjaw, for the rest of her life. She described how

Francis had grabbed her by her hair and swung her around the room in a violent rage before he hit her. It happened one morning before Elizabeth went to work. She explained it away—as she always had—saying that her father was embarrassed that Elizabeth was the breadwinner of the family and that he felt emasculated. The shame and trauma wrought by her childhood was real, and it would manifest itself throughout her life, especially when she experienced physical and emotional abuse by some of her partners. She never went to therapy, in part because it was not socially acceptable at the time and also because she did not believe in dwelling on painful memories; she was too busy looking ahead. Instead, her life, like so many others, became a private struggle for control over her career, over who she decided to marry, and over how much of herself she was willing to give away to the public. By the end she had almost seized command over her own life.

She was motivated by her childhood, Hamilton said, "for both good and bad."

"You couldn't force Elizabeth into anything for herself, yet all you'd have to do is let go and she would do anything for you. Anybody who wanted something would just open their heart and smile and they'd get it. But if they tried to outsmart her or trick her, oh my

God. Forget it. A lot of that went back to her parents, because she didn't want to be told what to do or to be bossed around."

She could make money easily and get her mother the fame and fortune she had craved since she was a young girl, and she would take care of her parents for the rest of their lives.

"She had this wonderful little heart that wanted to be embraced and loved for who she was as Elizabeth, not this diva that she had been made to play," Hamilton said. "She played many roles for many people. As a child all she wanted to be seen as was a *daughter*."

Once, Hamilton said, he asked her what she wanted most in life.

She told him in a small voice, "I just want to be a little girl again."

Chapter 2
Young Love

*Sixteen is kind of a dull age. I'd really like
to be a little older. Sixteen you're too young
to be treated like an adult and too old
to be treated like a child.*

—Elizabeth

By the time Elizabeth was sixteen years old the studio, and Sara, had succeeded in their "glamour push." Elizabeth's lush, velvet-black hair, ruby lips, and curvaceous five-foot-two frame were in full bloom. And they had finally found her a date.

Doris Kearns, who handled Elizabeth's publicity at MGM, and her husband asked if they could bring Glenn Davis, a handsome Heisman Trophy winner, to the Malibu beach house that the Taylors were renting.

Davis, who was a lieutenant in the army, and his friend "Doc" Blanchard were cocaptains of Army's football team and were known as the "Touchdown Twins." Davis was also the captain of West Point's baseball team, he played basketball, and he ran track. Elizabeth was impressed by the handsome twenty-four-year-old athlete. Prone to accidents, she first locked eyes with him after she fell face-first in the sand during a game of touch football. She was immediately interested, and the more she realized how modest and unassuming he was, the more intrigued she became.

Studio publicists did everything they could to generate interest in the beautiful young couple. To Elizabeth, it felt like an out-of-body experience. She knew she was not going to marry him, but she went along with the story knowing that it was good for her career. Davis gave her his small gold football charm, and she wore it on a chain around her neck. She told the press that they were "engaged to be engaged." But she only had seven dates with Davis before he was sent overseas to Korea. That did not stop the public from becoming obsessed with their relationship. "My God," Elizabeth recalled, "they think it's some big hot romance."

She was sent to London for five months to play

Robert Taylor's wife in *Conspirator*. She was sixteen and he was in his late thirties, more than twice her age. Every day, for three hours, she retreated to a room with a tutor from the Los Angeles Board of Education, who accompanied her to London. "How can I concentrate," Elizabeth said, "when Robert Taylor keeps sticking his tongue down my throat?" In order to make the romance between her and Taylor more palatable for moviegoers, MGM sent Elizabeth to New York in October 1948 to get her portrait taken by the famous photographer Philippe Halsman. "You have bosoms," he said, "so stick them out!" The photos were stunning, and this was the moment when she recognized her own power and her ability to control her image—even though she was still a teenager.

But the strange world she inhabited as a child actress, though a stunningly beautiful and overtly sexualized one, was jarring. Once again, her tutor would stop filming and more or less take her by the ear and lead her into a room to teach her mathematics. And then, once it was over, she would go back to the set and do a passionate love scene. "It really kind of made your eyes go crossed," Elizabeth said. "I was not prepared to be an adult. I'd been sheltered, protected. . . . The repercussions were that I made horrendous mistakes in my fight

to become an individual and responsible, and standing on my own."

Michael Wilding, a thirty-six-year-old British actor, was in London making a film at MGM the same time that Elizabeth was shooting *Conspirator*. He used to come to Elizabeth's table in the commissary to talk with her after lunch. Sara was never far away. "I noticed that every time he came Elizabeth's eyes lighted up," Sara remembered, "as if by a myriad candles. I knew that if it were not for Glenn Davis, Michael Wilding would be 'the man' in her life."

Wilding remembered how flirtatious Elizabeth could be. "Rather than ask the waitress for some salt, she'd walk clear through the commissary to get it from the kitchen, wiggling her hips. Then she'd wiggle her way back."

But she was still a child. Elizabeth finished filming *Conspirator* a week early, and she wanted to go shopping in Paris. The studio told Sara they would not permit it because there was a flu epidemic in Paris and they could not risk Elizabeth getting sick. Their star, by this age already so accustomed to having her every move carefully choreographed, decided that this was one thing worth fighting for. She went to the set designer, who made a long scroll of paper, and at the top of it Elizabeth wrote a petition:

We the undersigned agree with Elizabeth Taylor that she *should* be allowed to go to Paris on a shopping spree . . .

Inasmuch as she has promised

1. To be a good girl,
2. To shun all flu germs.
3. Not to contract even as much as a runny nose . . .

We feel that this Most Necessary Trip should not be denied her.

Signed:
Wm. Shakespeare
Lord Byron
Elizabeth Taylor
Lord Nelson
Scarlett O'Hara, etc.

Elizabeth and Sara were on their way to Paris the next day.

Then MGM hit a snag with their Glenn Davis match. Elizabeth had fallen for someone else, and this was another instance when she decided to fight back—at least at first. On vacation with Sara to celebrate her

seventeenth birthday in Miami Beach, Elizabeth stayed at her Uncle Howard's house and met millionaire William Pawley Sr., a former U.S. ambassador to Brazil and an aviation entrepreneur. She spent time poolside with Pawley's son, also named William, who had dark hair and bright blue eyes. Their chance meeting in the spring of 1949 was her first experience with real love. Elizabeth and Pawley sent more than sixty letters back and forth between his home in Miami and hers in Los Angeles. The first letter she wrote to him was on the plane ride home.

"My heart aches & makes me want to cry when I think of you, and how much I want to be with and to look into your beautiful blue eyes, and kiss your sweet lips and have your strong arms hold me, oh so tight, & close to you . . . I want our hearts to belong to each other through out eternity—I want us to be 'lovers' always . . . even after we've been married seventy-five years and have at least a dozen great-great-grandchildren."

The problem was, in the public eye Elizabeth was dating Davis. In her letters to Pawley she reveals the conflict. "It has been so awful since I've been home with all the reporters calling up & asking if Glenn

[Davis] & I have broken up. At first I just didn't know what to say, but then we all talked it over & decided to say 'Well, we're not engaged but we are still good friends and have not broken up.' If I say anything else it will become a national problem or something, and this way it can die a slow death without too much comment (I hope). But actually, Glenn & I have made an agreement just to go to social events together where there are some nosy reporters—like the Academy Awards and some big premiere next week—but otherwise we are completely through."

As the weeks went on it is clear from Elizabeth's letters that she was upset at leading a double life. When Davis accidentally broke a pair of earrings Pawley had given her she was livid. "I have never had such a strong desire to hit anyone with all my might in all my life—I could just have killed him," she wrote in a letter to Pawley. "He is so spoiled, & weak, & pouty. I've tried, honestly I have Bill, yet I might just as well have been batting my head against a brick wall. He hates me now, I know it—it's written all over his face—But actually, I guess it's best that way—at least he's not in love with me anymore." That evening, she gave Davis's football charm and All-American sweater back to him.

Davis did not hold a grudge. In a September 22, 1949, letter to Elizabeth he wrote: "I have never blamed you

for what happened between us—I know you think I do but I really don't, even though I was hurt more than I ever thought possible. It has taken me six months to get over it but now I can think straight and realize that regardless how much you love, if you are in two different worlds you can't change and live in the other's world and still be happy . . . all I want is to see you happy, even though I realize it can never be with me."

Elizabeth was trying to reclaim her life. "I don't care what they say anymore," she wrote to Pawley, "from now on I'm going to live my life the way I want to." But she must have known deep down that she never could. At least not for a long time.

Elizabeth and Pawley got engaged when he was twenty-eight and she was just seventeen. He was the first man to give her a diamond engagement ring. But it soon became clear that they wanted different things. "After a few weeks Elizabeth saw the pattern of her future life with Bill unfolding," Sara wrote. "The longer we stayed, the more homesick she became for California, the studio, her work, the old life she knew and loved. She was worried and confused."

The biggest problem was Pawley's desire for Elizabeth to leave the business. Sara was not going to let that happen, even though Elizabeth seemed intrigued

by the idea. She wrote to Pawley: "I am only too ready to say farewell to my career and everything connected with it—for I won't be giving anything up—but I will be gaining the greatest gift that God bestows upon man—love, marriage, a family—and you."

But soon she was distracted by her most challenging role yet, playing opposite Montgomery Clift in *A Place in the Sun*. The film was loosely based on Theodore Dreiser's 1925 novel, *An American Tragedy*, which is the true story of a man who murders his pregnant factory-worker girlfriend so that he can marry someone else from a wealthy family. Dreiser's work was a celebrated indictment of materialism, and director George Stevens changed the title to the less dire *A Place in the Sun*. Stevens considered the novel to be "the story of an inarticulate boy frustratedly fighting society and the economic system, attempting without success to find a place of respect for himself." Montgomery Clift played the main character, George Eastman, and Shelley Winters played his pregnant girlfriend, Alice Tripp.

Elizabeth was cast as the wealthy and beautiful temptress, Angela Vickers. The role of Velvet Brown brought her stardom, but Angela Vickers secured her place as a formidable actress. Stevens believed that Elizabeth represented "the girl on a candy box," a sweet girl who could also corrupt. Elizabeth fell in love

with the script. Vickers was a spoiled rich girl, yes, but there was depth to her character, particularly when she's confronted with George's death sentence for killing his girlfriend.

In October 1949, Stevens began shooting in Lake Tahoe, where the water was freezing and Elizabeth often sat on set wrapped in a coat over her bathing suit. Elizabeth was on the phone long distance to Pawley in Florida every night. When he came to visit her in California their engagement was over, at least according to Sara. "I think Elizabeth realized for the first time how much she really loved being in pictures. Not just for the glamour, or the money, or the fun of it, but because it kept her in touch with the world and people."

Pawley asked for his engagement ring back. Six months after her first love letters, Elizabeth wrote: "The beach is completely deserted, and it looks as lonely and sad as I feel. Oh Bill Darling, I do love you so very, very much, and I miss you so much that it feels like my heart were going to break. . . . And I know with all my heart and soul that this is not the end for us—it couldn't be—we love each other too much. I received your wire this morning about sending the ring and bracelet to New York—I have the ring on now—it is sparkling so beautifully in the sunshine—I suppose this will be the last time I have it on—for a while at

least—take good care of it, Darling, for my heart is embeded [*sic*] right there in the center of it."

More than fifty years after their engagement ended Pawley called Elizabeth at her Bel Air home to reminisce and maybe work his way back into her life. In a passionate note written on December 1, 2003, Pawley looked back on the forces that broke them up. He wrote about Joe Schenck, the chair of 20th Century Fox, who predicted that MGM executives would never let them get married because Pawley had said that he wanted Elizabeth to give up acting. She was far too valuable for them to let that happen. "I was a coward! I left the love of my life (an 18 year old girl) alone among the wolves that wanted to break up our marriage [plans] and destroy our happiness for their own profit," he wrote.

As Pawley remembered it, when he showed Sara the engagement ring he planned to give Elizabeth she told him that he needed to propose right away because, she said, "it will help us control who Elizabeth goes with." He proposed and had not even told his family before the news was broadcast to the world. At 7:30 a.m. the next morning Pawley heard a knock at the door of his father's house in Miami Beach and put on his bathrobe as he walked downstairs. He was stunned by what he saw: "The front door was wide open with big black electric cables coming into the living room, huge trucks

in the driveway, five or six camera men, sound men, and reporters in the living room asking when Elizabeth was coming down." *I am throwing them out now!* he told Sara, who had suddenly appeared downstairs.

"No, No, Bill, you can't do that because this is Elizabeth's publicity; you must not say anything!" If the level of control over Elizabeth's life by her mother and by the forces of Hollywood was not clear to him before, this moment crystallized it. Elizabeth would never be allowed to live a normal life; their engagement was part of the storyline being crafted for her.

For a while he went along with the dream, remembering how happy they had been when Francis offered to buy them any house they wanted on Miami Beach as their wedding present. "It seemed to me that our lives would be heavenly," he wrote, looking back. Schenck and his wife, who were maybe taking pity on him, quietly broke the news to Pawley over dinner at their home. "He wanted to warn me that our marriage would never happen. He said that Glenn Davis had become 'old news,' and I had been chosen to create 'new news.' I told him politely that Mrs. Taylor was 'all for' our marriage, and that Elizabeth and I were made for each other. I thought there was no way that either of us would permit any interference in our lives."

He was wrong.

Elizabeth returned to California to make *Father of the Bride,* and her mother wrote to Pawley telling him that there had been a change in plans; Elizabeth would not be moving to Miami. If he wanted to marry her he needed to move to California. But he had no job in California, and he bristled at the idea of Elizabeth supporting him. "Elizabeth," he wrote, "for years I have wondered at what point, or by what decision our break-up could have been avoided." Soon after that, Sara wrote him suggesting the wedding be delayed a year and he thought, *A year without my Baby? How could I stand it?*

Two months before Elizabeth ended their engagement, they had a bad fight. Elizabeth wrote an 8-page letter to Pawley's brother begging him to tell Pawley how much she loved him. "When anyone even touches my arm or tries to take my hand it just makes me shirk and want to run away and I can't possibly *conceive* or imagine anyone in this *world* but Bill." But during their engagement he flew to California to attend Jane Powell's wedding in 1949 and was stunned when Powell said, "Isn't it wonderful about Elizabeth's new contract?"

"I haven't heard about it," he said, "what contract is that?" He realized then that he had been shut out by Sara and Elizabeth was letting it happen. "I could fight

the studio, I could fight Mr. Taylor and Mrs. Taylor, or anyone else who came along, as long as I had you by my side. But you had deserted me," he wrote in 2003. When he confronted Elizabeth and she confirmed that she had signed a new deal, he left for the airport and flew back to Miami.

"I had, as Joe Schenck predicted, lost the love of my life. The studio had won!" He did not marry for twenty-five years, and he never had any children. He never forgave himself for not fighting harder for Elizabeth.

What Pawley was offering was simply another layer of control over her already overmanaged life. But there would come a time when she would not ask for approval from anyone about anything.

Chapter 3
Bessie Mae

We had a language that we understood,
we could read each other in seconds, even
on the phone. It was like an umbilical
cord that was transcontinental. We could
feel what the other was going through.

—Elizabeth, on her friendship
with Montgomery Clift

Elizabeth lost herself in her work and in a new transformative friendship. Montgomery Clift, known as Monty, was Elizabeth's mirror in many ways. They were both so lushly beautiful, Elizabeth with her oval face, deep blue eyes, dark arched eyebrows, and red bow lips, and Monty with his high cheekbones, green eyes, and thick dark hair, that pairing them together on-screen was electrifying. Monty shared Eliza-

beth's smoldering sensuality. Film critic Andrew Sarris called them "the most beautiful couple in the history of cinema." Their huge close-ups, he said, were like "gorging on chocolate sundaes."

Like Elizabeth, Monty began acting as a child. At fourteen he appeared on Broadway and was trained in the Stanislavski method. Unlike Elizabeth, who never had formal training, he was the epitome of a serious actor devoted to his craft. He wore his commitment like a hair shirt. He mostly played loners and characters outside the mainstream, like George Eastman. There was a sense of melancholy in his eyes, and Monty could be brooding and morose. He resented the trappings of Hollywood and rented a one-room bachelor apartment with a Murphy bed.

In 1949, before *A Place in the Sun* began shooting, Paramount executives decided that it would be good publicity to have Monty bring Elizabeth as his date to the premiere of *The Heiress*, another Paramount movie that he starred in. Monty knew all about the studio's penchant for setting their gay leading men up with starlets to conceal their sexuality. The absurdity of the charade infuriated him.

Monty was twenty-nine years old and he had no interest in taking seventeen-year-old Elizabeth, who had written *Nibbles and Me* just a few years earlier, and who

was quoted as saying, "I have the emotions of a child in a woman's body," to the premiere at the Carthay Circle Theatre in Los Angeles. He could not stand crowds, and he did not know Elizabeth. He didn't even own a tuxedo, he protested. He wanted to stay at his hotel and study the script for *A Place in the Sun*, but his agents told him he had no choice. Paramount wanted images of Elizabeth and Monty to whet the public's appetite for their new film and also to plant a seed that they could indeed be a couple.

Monty was in no mood to make small talk with some giggling, vapid teenage actress. Elizabeth Taylor, the commodity, represented everything he despised about Hollywood. But he begrudgingly agreed. When his limousine pulled up to Elizabeth's house, she opened the front door looking radiant in a white strapless gown with a full skirt. Sara wanted to get a peek at Monty sitting inside the limo, but Elizabeth pulled away from her mother.

Once she took her seat in the limousine, he realized almost immediately that his new costar was actually a foul-mouthed, witty, and intelligent force of nature. She was used to these black-tie affairs, and she was utterly relaxed. She put her fur wrap on the seat next to her and shocked him by swearing almost immediately.

It was always disarming for people to hear Elizabeth, who looked like a porcelain doll, swear. "I love four-letter words," she declared, "they're so terribly descriptive." She and Monty shared a self-deprecating and sarcastic sense of humor, making fun of themselves and everyone else.

"Why, you look absolutely lovely, Bessie Mae," Monty said, using a nickname he would call her for the rest of his life. He suggested they stop for a hamburger before they pulled up to the premiere. Elizabeth loved the idea of eating fast food in her evening gown. As they ate take-out burgers with paper napkins draped over their laps, Elizabeth helped calm Monty and he began to open her eyes to the world of a stage actor. She thought he would be intimidating, and she was delighted when she discovered how down-to-earth and fragile he was.

When they finally made their grand entrance, they walked past throngs of fans up to a radio announcer. Elizabeth took a moment to straighten Monty's tie before the interview, already acting like a maternal figure in his life.

"I see your escort is the very beautiful Elizabeth Taylor," the journalist said.

"Is she beautiful?" Clift asked, feigning surprise.

Once inside, Elizabeth noticed how Monty's mood changed. He could not stand watching himself on-screen, and he slumped lower and lower in his chair and squeezed Elizabeth's hand tight. "I'm so awful, Bessie Mae," he muttered, "I'm so awful." She shushed him. After it was over, he could not wait to leave.

"Let's get out of here, Bessie Mae," he said and pulled her toward the aisle.

"Why do you keep calling me Bessie Mae?" she asked him in the limo.

"The whole world knows you as Elizabeth Taylor," he said. "Only I can call you Bessie Mae."

They fell in love with each other, maybe romantically at first for Elizabeth, who would always be drawn to her gay costars. She was resigned to the fact that the feeling would never be completely mutual. Years later she reflected, "One doesn't always fry the fish one wants to fry. Some of the men I really liked didn't like women."

She wanted to take care of him and be close to him in any way she could. "I loved Monty with all of my heart and just knew that he was unhappy," she said. "I knew that he was meant to be with a man and not a woman, and I discussed it with him, introduced him to some really great guys." Years later Elizabeth told her assistant, Tim Mendelson, that she knew Monty

should be with a man even before she knew what being gay meant.

"Liz is the only woman I have ever met who turns me on," Monty said. "She feels like the other half of me." Eventually, she introduced Monty to Roddy Mc-Dowall and they dated for several months.

She and Monty had so much in common, aside from their physical beauty: They were child stars, they had overbearing mothers, and they knew the pressures of celebrity. More than anything, they could make each other laugh. Elizabeth's relationship with Monty outlasted several of her marriages. "He was the most gorgeous thing I'd ever seen," she said of their first meeting. "I remember my heart stopped when I looked into those green eyes, and that smile, that smile, that roguish, boyish smile."

They spent hours together working on scenes. Sometimes, the only way she could get away from Sara's hovering was by escaping into Monty's dressing room. "When I saw Monty preparing I thought, *My God, it wasn't all about just having fun.* And I think that's when I first looked at him and saw how involved he was. He could make himself shake and he couldn't stop after the director said 'Cut.' . . . And I thought, *I've just been playing with the toys.*" As George East-man, Monty was withdrawn and consumed by his

character's inner turmoil; he even visited Death Row in San Quentin to help him get into character. Elizabeth prided herself on never having had an acting lesson. She never cried during rehearsals because she thought, *Why waste it?*

But Monty helped her become more serious and it deeply affected her. "That's part of the rip and tear of being an actor because in your own life you must, to survive, build up the oyster shell layers. And when you're acting, you have to tear them away," she said, years later. "And then when you go home and hang your hat up, you have to let them melt away; you must, you cannot taken them home with you. Unfortunately, I'm afraid you do."

Elizabeth would sometimes invite Monty to sit on the edge of the bathtub, and instead of being distracted by her naked body they talked and laughed. She would have lost her virginity to him, she said, and they came close, but in the end he could not go through with it. Theirs was a forever impossible love, but she could not help wanting him.

It was confusing for her when she felt him pulling her close and then pushing her away. When she told him that she loved him he said, "I'm too old for you—I'm an old man," but when they were together sometimes Monty declared, "I've found my other half!" Monty's brother, Brooks, said that he was bisexual. Elizabeth

told journalist Tommy Thompson that Monty showed up one night at her house with a handsome young man and the next with an elegant young woman. It was as if he were saying, "Look Ma—I can—and I must—do both."

She loved to look at him, and to be with him, and maybe she was young enough to believe that she could turn him, but she always understood who he was. It must have been liberating for her not to have him staring at her body and instead focusing on who she was. (Although he did tell his friends about her "magnificent tits.") Monty did not feel guilty about his homosexuality, but he seethed about having to hide it and he turned to alcohol. Gossip columnists, like Hedda Hopper, were given special access to gay stars with the promise that they would not reveal their sexuality to the world. It was a repugnant form of blackmail. Monty always knew that he would not be accepted otherwise. So when Hopper wrote about an upcoming marriage between Elizabeth and Monty while they were filming, it was not unexpected, even though it was absurd.

A Place in the Sun took five months to finish, and it was the biggest challenge of Elizabeth's acting career up to that point. The film started shooting before *Father of the Bride*, but it was released a year later. The legendary director George Stevens was hardest

of all on Elizabeth. He had a reputation for looking at actors as puppets that he could manipulate. He insisted on constant retakes of her scenes with Monty, and when Stevens was not satisfied he would argue with Elizabeth until she exploded in anger.

Playing Angela Vickers, Elizabeth wrote later, "was my first real chance to prove myself and Monty helped me. . . . It was tricky because the girl is so rich and so spoiled it would have been easy to play her as absolutely vacuous, but I think she is a girl who cares a great deal."

When it was clear that they were not getting married, Elizabeth tried to mother Monty, whose alcoholism was sometimes debilitating. Elizabeth encouraged him to occasionally cooperate with the media, as she had since she was a child. "If you did, you'd not only be the biggest superstar in the world, you'd win an Oscar too," she said.

Stevens understood that Elizabeth had maternal instincts, even as a teenager. Because she was not yet legally an adult she had a social worker on set with her during shooting. In the pivotal scene when Angela and George reveal their love for each other, Elizabeth was astonished by the dialogue Stevens expected from her.

"Forgive me," she said, holding the script up. "*But what the hell is this?*" She was pointing to the most famous moment in the film, when George says, "Oh,

Angela, if I could only tell you how much I love you. If I could only tell you all."

And Angela replies breathlessly, "Tell Mama. Tell Mama all."

Stevens was not going to change anything, even though he understood that she felt silly saying the lines because she was so young. "This is what you have to say when you pull Monty toward you," he told her. The scene became legendary and pushed Elizabeth to see something in her own preternatural beauty that she had not understood before.

The critics raved. "The real surprise of *A Place in the Sun* is the lyrical performance of Elizabeth Taylor as Angela, the pampered rich girl who loves the boy and stays with him in his trouble," wrote *Look*. "Always beautiful, Miss Taylor here reveals an understanding of passion and suffering that is electrifying."

In reality, she was protective of Monty. When a scene was over and he could not get out of it, she tried to coax him out of character. "Monty, don't do this to yourself. You've got to release it when the scene is over." She would hold him and calm him. "Watching his intensity I learned not to let it kill you but that it wasn't a game. That you had to feel it in your gut and your guts had to get in an uproar."

But Monty did not conceive of any other way to act.

"I'll tell you the big difficulty," he once said. "Your body doesn't know you're just acting. It sweats and makes adrenaline just as though your emotions were *real*."

In New York, they liked to have dinner at Camillo's Restaurant, one of Monty's favorites. They had a quiet table in the back, and they leaned over it talking conspiratorially until the restaurant closed. Once they stayed so long that when the restaurant owner decided he wanted to paint the dining room, they offered to help. They kicked off their shoes and happily picked up a pair of paintbrushes. They painted until three in the morning. It was exactly the kind of mischief they craved.

Monty once told her, "You are the only woman I will ever love."

Elizabeth slumped down in her chair and muttered, "Baby, oh baby," again and again.

Chapter 4
"He Will Kill Her"

When you are young and you fall off your
cloud for the first time, you try to make
yourself believe everything is still beautiful.

—Elizabeth

The same night that Elizabeth said good-bye to Bill Pawley, after Jane Powell's wedding, she met the man who would become her first husband. Francis and Sara suggested that the wedding party go to the Mocambo nightclub in West Hollywood to hear Vic Damone sing. Elizabeth's eyes filled with tears as she sat at a cocktail table with her parents and Damone sang directly to her. After his set, Damone sat down next to Elizabeth. The next day newspaper headlines blared: "Off with the Old Love and On with the New."

Elizabeth was getting used to the ever-changing whims of the public. One minute people loved her, the next they raced to read articles like the one in the *London Sunday Pictorial* that suggested that somebody should "administer a series of resounding smacks behind the bustle of her latest Paris creation" for ending her relationships with Davis and Pawley.

But Damone was not the man who would become Elizabeth's first husband. "Unbeknownst to us, Nick Hilton was at Mocambo that night," Sara recalled. "He went home and told his father, Conrad Hilton, that he had seen the most beautiful girl in the world and that he had to meet her." And anything Nicky Hilton wanted, he got.

Soon after they met, twenty-two-year-old Conrad Nicholson "Nicky" Hilton Jr., the son of the founder of the Hilton Hotels chain, inserted himself into Elizabeth's life. Every week the Hilton family and the Taylors had dinner, alternating between the Hiltons' Bel Air mansion and the Taylors' Beverly Hills home. Sara said, "We couldn't have liked Nick more." And Sara surely approved of Elizabeth marrying into a fabulously wealthy and prominent family.

But after Elizabeth's first date with Hilton, Sara asked her if she had a good time. "I guess so," she replied listlessly. Back then Elizabeth did not smoke or

drink, so Hilton stopped too. At least in front of Sara and Francis. He attended Elizabeth's high school graduation ceremony, which was held at University High School because MGM did not give diplomas. On January 26, 1950, in cap and gown, Elizabeth sat on the platform trying not to notice the other students staring at her. She was just happy that Miss McDonald would no longer be in her life.

Elizabeth was in love with being in love, and she saw Hilton as a means of escape. She thought that replacing "Miss" with "Mrs." would automatically make her more mature. She wanted to move out of her parents' house as soon as she possibly could. When she turned eighteen, which under California law meant she was no longer a minor, she suddenly had access to her financial statements. She learned that her parents had spent much of her money and had not put aside what they should have for her. They had depended on Elizabeth financially and they had not tried to protect her. She felt especially betrayed by her mother, though she still clung to her identity as an obedient daughter.

The week before her eighteenth birthday, Elizabeth and Hilton announced their engagement. Elizabeth had to be convinced to wait that long. When reporters feverishly asked for details, such as what they had in common, she said, "We both love hamburgers with

onions, oversized sweaters, and Pinza." (Ezio Pinza was an Italian opera singer.) It was a flimsy foundation for a marriage.

Elizabeth called Monty, who lived in New York, to tell him about her new romance. She taunted him with it, but it would not change the fact that Monty was never going to want her in the way that she wanted him. "We're engaged," she said, hoping to make him jealous. "What do you think?"

Monty was not sure what to think. He had heard rumors that Hilton was violent when he drank, and he was worried. "Nothing, Bessie Mae, except, are you sure Nicky Hilton is the right man for you?" After he hung up, Monty poured himself a large glass of Jack Daniel's with ice and threw it down.

It was her second engagement and she had already appeared in more than ten films. But even with all that experience, and perhaps because of the cloistered world she grew up in, Elizabeth had absolutely no idea what she was getting herself into.

Before her marriage to Hilton, Elizabeth was being courted by another famous playboy, the eccentric multimillionaire moviemaker and airplane manufacturer Howard Hughes. *Motion Picture* magazine called Hughes the most eligible bachelor in the country. "If

you had a date with Howard Hughes, you'd have a date with a man whose fortune is in excess of $145,000,000; a man whose enterprises include controlling interest in TWA, Hughes Productions, Hughes Aircraft Corporation, Hughes Tool Company, and the largest brewery in Texas."

Unlike Ava Gardner, Katharine Hepburn, Lana Turner, and Ginger Rogers, all of whom had been wooed by Hughes, Elizabeth would have none of it.

When Hughes first saw Elizabeth strolling through the lobby of the Beverly Hills Hotel, he turned to his assistant, Johnny Meyer, and demanded, "Get me an introduction to that girl." Meyer knew many Hollywood starlets, but not Elizabeth. He also knew that he could not disappoint his boss. Meyer followed Elizabeth one day and watched as she walked into her father's art gallery, helping Hughes hunt his prey. Forty-four-year-old Hughes stopped by Francis Taylor's gallery with a proposition: He would buy all the paintings in it, but he would only do so if Sara and Francis would agree to have Elizabeth join him on his plane and fly to Arrowhead Lake for the weekend. When they said Elizabeth couldn't go, he reneged on the paintings.

"He had been telephoning Elizabeth for years," Sara recalled, "and she couldn't stand him." When she was invited to dinner parties, Elizabeth checked with

the host to see if Hughes was going, and if he was, she wasn't interested. His earnest desire for her turned her off. So did his arrogance.

He viewed women as trophies. "He is always on the telephone. He races from spot to spot," said *Motion Picture* magazine. "He's looking over their [his date's] shoulders with his thoughts a mile away." And Elizabeth would not be ignored.

In mid-twentieth-century Hollywood, a passionate young woman needed to be tamed. In the public's view she had broken the hearts of Glenn Davis and Bill Pawley, and during an era that was so ferociously puritanical, people needed to be convinced that she was a virgin, a "good" girl. In an interview with gossip columnist Louella Parsons, Elizabeth insisted, "Nothing comes off until the ring goes on."

Still, Sara harbored doubts about her daughter's virginity. Right before her wedding to Hilton, Elizabeth was taken to a doctor for a procedure to open her hymen. Sara wanted Elizabeth's hymen to be opened so that sex would be less painful the first time. She also had an ulterior motive: She wanted to make sure that her daughter was still a virgin. The unethical virginity test was something that stayed with Elizabeth her entire life, according to her assistant Jorjett Strumme,

who worked for her in the 1980s and early '90s. "She told me she was given a sedative to knock her out and the last thing she remembered was Sara asking the doctor to check if she was still a virgin." When the doctor confirmed it, Sara let out a sigh of relief and the surgery went ahead.

Elizabeth said that she was a virgin "not only physically, but mentally." In a 10-page letter to Pawley on April 1, 1949, she wrote: "If only I could find the words that tell of that much love—so I could let you know how I feel. Guess I'll just have to wait until I'm your wife, for then I'll be able to show you & prove my love to you." She ended with striking prescience about how much she would enjoy makeup sex: "Oh another thing honey—don't worry about our having a fight— I'm sure we never will but even if we do, think of the fun we'll have making up!!!"

It was conventional wisdom that a real lady should save herself for marriage, and it shaped the rest of Elizabeth's life. It also led her down the aisle an incredible eight times because she was taught not to sleep with a man she loved until she was married to him (though she gave in to temptation often later in her life).

Elizabeth's marriage to Hilton could not have come at a better time for the studio. She was starring as Kay

Banks, the young bride in the Vincente Minnelli–directed 1950 comedy *Father of the Bride*. Offscreen she would walk down the aisle four times during that decade. MGM paid for the elaborate wedding and included it as part of the publicity budget for the film. MGM asked Sara and Elizabeth to set the date of the wedding as close to the premiere as they could. The wedding date, May 6, 1950, was one month before the release of the movie and just two months after Elizabeth's eighteenth birthday. Seven hundred guests, including MGM stars Fred Astaire, Ginger Rogers, and Esther Williams, came to the ceremony, which was held at the Beverly Hills Roman Catholic Church of the Good Shepherd. A reception followed at the Bel Air Country Club.

Elizabeth walked down the aisle with a 4-carat diamond ring on her finger, which was much smaller than the rings subsequent husbands would give her, but still a sizable rock. She wore a white satin pearl-embroidered gown with a sweetheart neckline covered in a chiffon overlay and designed by her friend, the Academy Award–winning MGM costume designer Helen Rose. Her porcelain skin was radiant against her cropped raven hair set miraculously in place in the hundred-degree heat. She looked so very young. MGM policemen controlled the 2,500 fans who found out about the

wedding when news of it was "accidentally" leaked. Elizabeth grew up on movie sets and considered the crew part of the family, so she made sure that stage-hands, grips, and hairdressers were on the guest list. "I closed my eyes to any problems," Elizabeth recalled decades later, "and walked radiantly down the aisle."

Spencer Tracy played her father in *Father of the Bride*, and she adored him, calling him "Pops" on- and offscreen. Joan Bennett, who played her mother in the film, said, "Strangely, she didn't seem overly pleased, almost as though she understood the impending marriage might not be easy for her."

Bennett said that Taylor and Tracy "huddled for hours in his dressing room. He confided to me later that she had certain misgivings about Nicky Hilton. Spence delivered a rousing pep talk in an effort to convince her that young Hilton effused boyish charm and would make an excellent husband. I'm not sure he himself believed any of this." Russ Tamblyn, who was two years younger than Elizabeth and who remembered her helping him with his homework on set, was confused by the marriage. "There was word going around that he was extremely abusive. I remember thinking, *Here's this gorgeous woman, what does she see in this guy?*" Elizabeth's own misgivings proved correct. But MGM had already cast her in the role of blushing

young bride, and she saw no way out. Hilton seemed to understand what he was getting into from the moment they said their vows during the stage-managed wedding ceremony, even though he came to resent it. "I didn't marry a girl—I married an institution!" he said ruefully.

"I was terrified, so was Nick," Elizabeth said of their wedding day. "I remember taking out my handkerchief and mopping the sweat off his face during the ceremony, and then we drove away and there was a big reception, and for the first time in my life I had two glasses of champagne, and I had three glasses of champagne, and the time came to leave and I became more and more petrified." Her bridesmaids helped her change into her going-away suit. "I wanted to run," she said. "I really had no idea what was coming." She could remember the rice and confetti falling like hail as they raced toward the waiting car. And then they drank a bottle of champagne and got very tipsy. She went into the bathroom and changed into a nightgown, which was another Helen Rose creation. "I didn't want to unlock the door." When she finally did come out she was too scared to even touch Hilton. They did not sleep together for three days.

This was what nice girls did, she thought, *they got married and then they had sex.* "I always chose to think

I was in love, I didn't have my own yardstick. But I had been taught at home that love was synonymous with marriage. I had to get married. I couldn't just have a romance."

Their honeymoon was a spectacle too. A crowd saw them off at Los Angeles airport and they flew to Chicago, picked up a Cadillac, and drove to New York. The car was put on the *Queen Mary*, so they could use it during their extensive European travels. Elizabeth did nothing small; she traveled with seventeen pieces of luggage, a personal maid, and a poodle dyed to match the color of her eyes. When waiters accidentally called Hilton "Mr. Taylor," he bristled. She did not always get what she wanted. The bridal suite was already booked by one of the only other couples to rival Taylor and Hilton's fame: the Duke and Duchess of Windsor.

Their honeymoon in Europe was five months long, but in reality it lasted only two weeks. That was when Hilton started drinking again. He spent most of the rest of it drinking and gambling, leaving Elizabeth alone to cry and chain-smoke in their hotel room.

"Then came, yours sincerely, disillusionment," she said.

At the age of eighty-six, Sara decided that she would write the first authorized biography of her daughter's

life and "tell the truth about Elizabeth and the reasons for or causes of the heartbreaking failures of her [then] five marriages." It was never published, but the handwritten notes Sara made reveal how much she knew about Hilton and his reputation. "I had a premonition that all was not well with her—I had it all along and so had Daddy." Friends told them, "'Don't let her marry Nicky Hilton. He will kill her. When he is drunk, he is out of his mind. He had to be put in a straitjacket at the opening of one of the Hilton Hotels for trying to attack the governor of one of the islands [where the hotel was located].' These stories kept coming to us, and we talked to Elizabeth, but she was in love with Nicky and he with her."

According to Sara, Hilton promised he would never drink again, and during the six-month period when they were dating, Sara said, "He was like the boy next door." But on their wedding day, when Elizabeth was taking a bubble bath, she asked her mother to come in and asked her about sex—she had been so sheltered. "I could see the apprehension in her eyes," Sara scribbled in her notes. "I looked at her scrubbed clean beautiful little face, my heart ached . . ."

For the first few days of their trip everything seemed fine, and Elizabeth sent happy postcards to her family. Then the postcards stopped arriving and there was

ominous silence. "While in Paris, Elizabeth wrote us a beautiful letter in which she thanked us for all the years of love, kindness and devotion we have given her. That was the last letter we received from her." Soon newspapers began reporting early signs of trouble.

When her parents called her, Elizabeth insisted that she was fine. "You know the first year is the hardest. We'll work this out. Don't worry—please don't worry." But when they returned to New York in late August, Elizabeth was a shadow of herself. She had lost twenty pounds.

Elizabeth knew that there was no way she could stay married to Hilton. Back in LA she stayed at her agent's house and at the home of her stand-in, Margery Dillon, anywhere but with her parents. Sara's notes show that she did not understand the trauma her daughter was experiencing—or did not want to accept it.

"When I saw her in California, I couldn't believe it. She no longer confided in us about anything. She was struggling to keep what she had gone through from us because she was still in love with Nick and because she did not want to worry us." It is true that she did not want to look like she was running home to her parents, but it is also true that she did not want to listen to her parents encourage her to work through a marriage that was untenable. One of the worst things imaginable

had already happened, and she did not know how far Hilton's abuse could go. In a violent rage during their honeymoon, Hilton had kicked her in the stomach and caused her to miscarry.

In 1999 she recalled her horror. "I thought, 'This is not why I was put on earth. God did not put me here to have a baby kicked out of my stomach.' I had terrible pains. I saw the baby in the toilet." She did not know that she was pregnant until that awful moment.

A friend of Elizabeth's recalled how different she seemed. On the phone she was unusually guarded and acted as though the line were being tapped. When they met for lunch, Elizabeth showed up in an unusual outfit for a warm Southern California day. "She was wearing a white blouse buttoned up to the chin and down to the wrist," her friend recalled. "It had a kind of thin material on the sleeves, and I could see the marks all the way up her arms."

By early December, seven months after their wedding day, Elizabeth decided to end their marriage. It was the first major decision she made on her own. But the more she pushed him away, the more Hilton wanted her. He showed up unannounced at friends' houses where she had sought refuge. He sent her roses and pleaded with her to take him back.

The last straw took place when she was with Hilton

and her parents at her Uncle Howard's Connecticut estate when they were still married but no longer living together. She was appalled at the idea of divorce, especially after less than a year of marriage, but she knew that there could be no chance of reconciliation. She was sitting with Hilton alone in the living room as he begged her to take him back. She held her ground and told him no, but that she hoped they could be friends. Hilton went into the pantry, found a bottle of Gordon's Gin, and raised it to his lips. He drank the entire bottle in a couple of enormous gulps, gagging and spitting along the way. He threw himself through the swinging pantry doors and into the living room, where he plunged into the corner of a console table and cut his back. He was lying on the floor, blood seeping through the back of his shirt, and Elizabeth still found herself wanting to take care of him. She placed a pillow under his head and then helped him up to a chair.

"You have to go upstairs and lie down. You'll kill yourself doing something like that," she said. It was then that he kicked her in the stomach again. She screamed as she fell backward. Sara came running downstairs and she started yelling at Hilton, who unleashed a torrent of verbal abuse at her. That was too much. Elizabeth got herself up, hauled back her arm, and slapped him in the face so hard that blood began

trickling down his cheek. He lunged at Sara, but Sara, Elizabeth, and the cook helped fight him off before he passed out cold. It was over and he knew it.

She did not ask for alimony. All she wanted was her freedom, which she was learning was priceless. On December 14, 1950, the legal department at MGM released a statement on Elizabeth's behalf. "I am very sorry that Nick and I are unable to adjust our differences, and that we have come to a final parting of the ways. We both regret this decision, but after personal discussions we realize there is no possibility of a reconciliation."

On January 29, 1951, the divorce was granted. Her first marriage ended after eight months. It was a whirlwind nightmare that began sixty-eight days after her eighteenth birthday and ended twenty-nine days before she turned nineteen. "When I married Nick," Elizabeth said later, "I fell off my pink cloud with a thud."

But she was still a hopeless romantic. Her favorite film, 1937's *Make Way for Tomorrow*, is about an elderly couple who want to stay together after they lose their house, but they can't because none of their children will take them both in. Elizabeth wanted to be married to one man for the rest of her life, and she never gave up on that dream.

Hilton died in 1969 of a heart attack at just forty-two years old. When his second wife sued him for di-

vorce she accused him of "repeated acts and threats of physical violence."

After the divorce, Elizabeth was homeless and consumed with anxiety. She would not go back to live with her parents, and not only because she worried about the public perception that she was running home to her mother, but because she had tasted freedom and was not willing to part with it just because of one, albeit huge, mistake. Her agent, Jules Goldstone, suggested that she hire a secretary-companion and put her in touch with Peggy Rutledge, a woman who had once worked for Bob Hope's wife, Dolores. They met in Goldstone's office.

"I asked Elizabeth what we should talk about," Rutledge remembered.

"She said she hadn't the slightest idea. Then, she suddenly asked if I could make coffee; it turned out neither of us could cook. Finally I said, 'Well, let's try sharing an apartment. If you don't like me, I'll leave. If I don't like you, I'll also leave.'"

In March 1951, they moved into a five-room furnished apartment on Wilshire Boulevard. It was a month and a half after her divorce from Hilton, and Elizabeth was free from her mother's suffocating control and her husband's violence. But the trauma of the

abuse led to a severe case of colitis, and she was ordered by her doctors to eat nothing but baby food.

At that moment, she needed a sympathetic ear and found it in Stanley Donen, the director of her new film, *Love Is Better Than Ever*. But the studio—and her mother—were not happy. Donen was Jewish and therefore, in Sara's mind, off-limits. He was also still married, though he was separated from his wife. Sara made it clear to Elizabeth that Donen, who was the acclaimed director and choreographer of *On the Town* and *Singin' in the Rain*, was not fit to be her second husband. Of course that made Elizabeth want him even more. She brought him to meet her parents at their house in Beverly Hills, and Sara would not allow him inside. This time the studio decided to let the romance play out. Donen was keeping her working and they would intervene if they had to. "A number of us thought that Donen was a fine guy, but not for Elizabeth," a studio executive said, revealing his own anti-Semitism.

After filming was over, Elizabeth and Donen remained dangerously close. The studio decided they needed to protect Elizabeth from herself—no matter how much she cared about him—and play the card they had been saving. "We agreed that the best way

to separate them was to send her abroad to make a picture," said an executive. "She got the role of Rebecca in *Ivanhoe* and she left for London that June."

Before she left, she reveled in her new independence in New York when she checked into an elegant suite at the Plaza Hotel, which was owned by her former father-in-law, Conrad Hilton. She spent hours on the phone rekindling her flirtatious relationship with the six-foot-one, blue-eyed Michael Wilding, who was shooting a film in London. She was planning to stay in New York for five days, but when she was led to an elegant suite and told it would be complimentary, she decided to stay for six weeks. She spent her time going out with friends, including Montgomery Clift, who lived in New York, and Roddy McDowall. When she got the bill, which was $2,500 (the equivalent of $27,000 today), she was floored. It turned out that only her first week was complimentary. She called Monty, outraged. She knew that if anyone shared her taste for mischief it was him, and she wanted revenge.

McDowall and Monty came by to help her pack so she could relocate to a less expensive hotel. They ordered a pitcher of martinis and flung flowers around the room; petals and stems were everywhere. Monty walked around the suite hanging all the paintings

upside down and stealing the bath towels. When she unpacked her things she discovered a shower nozzle and bath mats in her suitcase.

Elizabeth felt a pang of regret the next day and called the Plaza and asked to speak to the head housekeeper on the sixth floor to apologize. Guilt-ridden, she sent flowers and perfume to the housekeepers at the hotel.

During this brief period, she also found herself taking on the unlikely role of subject of an FBI investigation. She had received an anonymous call from someone threatening to bomb her hotel room. Once, the FBI even ransacked her hotel suite looking for a device when she was out. If the person called her again, she was told, someone else in the suite should pick up the other phone and contact the FBI agent on the switchboard. Her job was to keep the suspect talking so that they could locate him. When a call came through, Monty was in the living room and he ran into the bedroom to call the authorities. Elizabeth stayed on the phone for twenty minutes as the man described, in pornographic terms, what he wanted to do to her and the way he was going to murder her. Finally the police tracked him down, and he was sent to Bellevue Hospital for psychiatric examination and diagnosed with schizophrenia.

Later, she was flying from London to the south of

France in an eight-passenger plane during a break from shooting *Ivanhoe,* when she had a strange feeling that someone's eyes were staring intensely at the back of her head. Over the next several days she saw the same man everywhere. At one point he even insisted on buying her a bottle of champagne. He handed her traveling companion a letter to give to her: "Dear Miss. Taylor, quite clearly you do not remember me. I am the man you had thrown in jail for six months and deported from the United States of America. I think you owe me something and I intend to collect." It was then that she remembered a man who was caught climbing over the wall of the back garden of her Beverly Hills home. The police discovered charts in his motel room with dates and times tracking who she had been with and where she had gone. He was put in jail for several months and was deported home to England. But he had somehow hunted her down on vacation. She never heard from him again, but she never forgot his threatening message.

The incident takes up several pages in the 154-page FBI file on Elizabeth. It is full of threats, including letters from people asking her to send them money, others vowing to kill her, and many calling her a "whore." One note was written in 1949, when she was just seventeen years old, telling her that she was acting like "the

girl who hangs around bars and lets men get what they want out of her." Several men were taken into custody over the years for stalking her. At one point, when she was a teenager, police offered Elizabeth protection, and her parents were advised to put a gun in the glove compartment of their car.

She knew that she was a commodity that could make all sorts of people—agents, producers, studio executives—rich, but she lived with the terror of also knowing that made her a target for violence. Jorjett Strumme said that Elizabeth told her about a man who had written to her, telling her how he was going to dismember her like "the Black Dahlia," an aspiring actress who was brutally murdered. Fame came at a very high price.

After her divorce from Hilton, Howard Hughes saw his chance to finally convince Elizabeth to fall in love with him. This time he developed an elaborate plan: He knew that she was staying at a house in Palm Springs as she tried to find her footing after the divorce. As she sunbathed by the pool with some friends, she placed a wet towel over her bathing suit to stay cool. Suddenly she heard the loud whirring of a helicopter, which landed violently on the lawn, blowing leaves from the

palm trees. Hughes stepped out and walked over to where Elizabeth was lying.

"Come on," he said, "get your clothes on. We are going to get married."

She squinted up at him. "*What?* Are you out of your mind?"

He reached into his coat pocket, grabbed a handful of loose diamonds, and dropped them on top of Elizabeth. She roared with laughter and flipped her towel, sending the diamonds flying all over the carefully manicured lawn. A few of them landed in the pool. She ran into the house and told her friends, "This is a madman." Hughes stayed behind, on his hands and knees, picking up diamonds from the lawn and fishing them out of the pool.

But he did not give up. Not long after that, he sent Sara a telegram with a proposition: If she could convince Elizabeth to marry him he would write her a check for $1 million. "Or," he added, "you can write your own check for as much as you want." According to Sara, she and Elizabeth were enraged by the offer. She said her telegram back to him was clear: "Mr. Hughes," it read, "my daughter is *not* for sale at any price."

(Years later, in the 1960s and 70s, Elizabeth traveled with an Italian photographer named Gianni Bozzacchi,

during her marriage to Richard Burton. Bozzacchi remembered something odd: Every time they got to a hotel room, three dozen red roses would be there waiting for Elizabeth. He assumed they were from Richard and was surprised to find out they were actually from Hughes. All those years later, when Elizabeth and Richard were the most famous couple in the world, Hughes was still infatuated with her.)

Once, Hughes's lawyer, Greg Bautzer, called Elizabeth and asked her if she would agree to marry Hughes, and she broke into laughter. Bautzer said that Hughes was in love with her and he insisted that Hughes was serious. What did she need for him to prove it to her?

"I won't say yes or no," Elizabeth replied. "Tell Howard that if he wants to prove his intentions are serious, he must send me two million dollars in cash."

Two hours later, there was a knock on the door of Elizabeth's hotel suite. When she opened the door, a man carrying two suitcases stuffed with cash was standing there. Elizabeth picked up the phone and called Bautzer.

"Please, thank Howard on my behalf and tell him I'm flattered," she said, "but I'm afraid money will never keep me warm at night."

She might have been annoyed by Hughes, but she never wasted a chance to tell the men in her life about

his tireless efforts. Elizabeth's seventh husband, John Warner, said Elizabeth loved to rehash Hughes's obsession with her. After their divorce, she would tease Warner and say, "Howard Hughes offered me two million dollars to marry him and I didn't get a dollar out of you!"

Chapter 5
Love and Marriage

He didn't know yet that I was an oddity,
some kind of a side show.

—Elizabeth

Single with an FBI file, Elizabeth was still weak and on a diet of pureed food to treat the ulcers and colitis that she had developed after her marriage to Hilton when she reconnected with the handsome British actor Michael Wilding while she was working in London. She'd had a crush on Wilding since she was sixteen.

"At the sight of him I decided to forget my baby food," she said. "I ate everything I liked, and in a month I was cured of my ailments." Wilding invited her out to dinner, with Peggy Rutledge joining them. He worried that she was too young, but as Wilding described her, Elizabeth was "a seething mass of feminine wiles," and

not long after that dinner she convinced him that they were a perfect match.

She told her father how wonderful Wilding had been to her during the making of *Ivanhoe* and how they had so much in common, "just like you and mother." She considered Wilding, who was twenty years older than she was, an island of safety, an "oasis."

One evening at dinner in LA he looked across the table at her and said, "Darling, you should wear sapphires to match your eyes." The next morning she brought him along to look at several sapphire engagement rings she had her eye on. When she showed her mother her sapphire engagement ring they held each other and cried. At twenty years old she had already lived a lifetime, and she was not about to let Wilding go.

But she was harboring a secret fear that her dream of a happy marriage and a house filled with children might be impossible. She had been to see a doctor in New York who had told her that she could have children but that she would be prone to having miscarriages before she could give birth to a healthy child.

"You don't really have to marry me," she told Wilding in tears. "I can't have children. The doctor told me so."

"Never mind," Wilding told her. "I love you and I'm marrying you."

They got married on February 21, 1952, in a ten-minute ceremony in the registrar of London's Caxton Hall Registry Office. Once again, Helen Rose designed her wedding-day outfit, except this one was very different from the elaborate and traditional white gown Elizabeth wore to her first wedding. This time she wore a gray wool suit with white organdy cuffs. The low-key wedding was a signal that she was approaching this marriage differently. Even as she tried to make it a private affair, as always with Elizabeth, it could never be anything approaching normal. Three thousand people gathered outside waiting for the new couple to emerge. When they did, one excited fan grabbed her hat off her head. Elizabeth had to be picked up and lifted over the crowd into the limousine to head to their small wedding party at Claridge's, where only fourteen guests were invited. They had a short honeymoon in Switzerland before going back to work.

Elizabeth looked to Wilding for emotional support and found herself feeling helpless without him. Once, at a party, Elizabeth came out of the powder room and ran into Humphrey Bogart. She asked him the question she always asked when she was not with her husband: "Where's Michael?" Bogart looked at her disgusted. She was *Elizabeth Taylor.*

"Let me talk to you, kid. It's damned stupid for you

to keep following your husband around. You should be asserting yourself. Be something in your own right. Stop being a shadow."

Back in Los Angeles, she and Wilding bought a two-bedroom ranch house that cost $75,000 ($800,000 in today's dollars) situated on top of a mountain. To her great relief she got pregnant quickly (proving the doctor wrong) and she worked until she was five months along, doing her best to conceal it from the director and producers of her new film, *The Girl Who Had Everything*, because she knew that she would be penalized for it. "I resented that, even as a kid I guess there was a certain 'woman's libness' about me. I didn't like being told I had to act a certain part if I didn't like that part. . . . And if you were feminine enough to become pregnant, then immediately you were on suspension. So you were penalized for doing what a woman does naturally. And I resented that so much. . . . Why should a woman be penalized for becoming pregnant?"

As soon as she finished filming in 1952 she announced her pregnancy. As she had anticipated, she was immediately put on suspension. Wilding was a successful leading man in England, but he signed with MGM when he moved to California, and he was having trouble finding work.

Elizabeth was under a lot of pressure to make money,

and she was up against an extraordinary amount of sexism. "I remember a time when I went down on my knees to an executive at MGM who shall remain nameless. I was married to Michael Wilding and was pregnant and they put me on suspension. We had bought a house and we desperately needed ten thousand dollars—or else we would lose it. I begged him to loan me ten thousand dollars. It seemed the end of my world."

He said, "You didn't plan things very well, did you?"

Elizabeth replied, "I'm truly sorry I'm making a baby instead of making a picture, all I'm asking for is a loan."

The studio executive pulled out his wallet, which was crammed with hundred dollar bills. "He held it before me to humiliate me," Elizabeth recalled. "He dressed me up and down and made me realize I was nothing to him but one of the cattle. I got the money only on the condition that I would make an exhausting tour—pregnant, mind you—to promote a picture. I vowed then and there that I would never have to ask anybody for anything again."

She was the one in the marriage who was making most of the money, and yet Wilding was acting like a paternal figure in her life. "Don't treat me like a baby! I'm your *wife*!" she screamed at him. They were both uncomfortable with the power dynamic, and their

twenty-year age gap became more and more of an issue. She had MGM as a pseudo father figure and she was not looking for anyone else. "After a while," she said, "we had nothing to talk about other than what happened at the studio that day."

But she brushed her frustration and anger aside and reveled in her pregnancy. "When I was pregnant I was absolutely idiotic with pride. You would have thought I was the only woman who had ever conceived and carried a child. . . . I've never felt so beautiful." Michael Howard Wilding was born via Cesarean section on January 6, 1953, at Santa Monica Hospital. The always-hovering Sara called Elizabeth a "born mother," but she did not always approve of how she raised her children. When Sara saw one of the dogs licking baby Michael's hand, she was horrified. "Why, how can you feel that way, mother?" Elizabeth said, asserting herself. "You know a dog's saliva is the purest thing in the world—it's a disinfectant. That's nature's way of taking care of animals and their babies."

Elizabeth needed to get back to work. While shooting publicity photographs for the forgettable 1954 film *Elephant Walk*, Elizabeth and the other stars, including actor Peter Finch, were sitting in a Jeep as a wind machine blasted air at them. As her hair blew luxuriously, she felt something hit her right eye. Every time

she blinked she felt a painful scratching sensation. When she went to see a doctor she was told that she had a "foreign object" in her eye. She said, trying to make light of her situation, "Anybody I know?"

She enjoyed sharing gory medical details, and the eye operation was one that she shared with friends the rest of her life. "They can't knock you out because you have to keep your eye open and stare at a certain spot on the wall. They have a needle with a tiny knife at the end and you can hear them cutting your eye. It sounds rather like eating watermelon on a minor scale." The doctor bandaged her eye and she was warned to be very careful, but once she was home, baby Michael hit her in the eye and the damage was so bad that she needed another surgery. She worried she might actually lose her eye.

During the weeks she spent recuperating, she considered whether she would retire. After *A Place in the Sun*, she thought she would be offered more challenging roles, but she found herself typecast as the spoiled rich girl in a parade of lackluster films. She decided that she wanted more and she would find a way to get it.

Being the most famous actress in the world and a mother was a balancing act that Elizabeth could never quite master, no matter how hard she tried. "Part of

me is sorry that I became a public utility," she said. Later in life, after a few drinks, she would apologize to her adult children for not being around as much as she would have liked. She worried about the effects of her fame, her many marriages, and their nomadic lifestyle.

When Michael was one year old, she became pregnant with her second child. The couple decided they needed a bigger home and found the "most beautiful house," Elizabeth said, that she had ever seen, in the Hollywood canyons overlooking Los Angeles and the Pacific Ocean in the distance. The architect wanted the owners to feel like they were outside surrounded by nature. The house had floor-to-ceiling windows in the living room looking out onto the pool, which had rock formations in it. There was a wall made of bark covered in orchids, mosses, and ferns. Sara told Elizabeth that the architect, who was a family friend, had designed it using Elizabeth as his inspiration. She had to have it.

Christopher Edward Wilding was born on his mother's birthday, February 27, 1955. The family of four had a menagerie of pets, including a golden retriever, a wirehaired foundling, two poodles, four cats, King Charles (her beloved horse from *National Velvet*), and a duck whose favorite place in the house was perched on Elizabeth's shoulder.

Unlike most women of her generation, Elizabeth

was never taught how to cook or clean because she had no need to learn. From her earliest days, she got every material thing she had ever wanted. Perhaps showing a crack in their marriage, Wilding talked publicly about his wife's faults and eccentricities, of which there seemed to be many. "Elizabeth had very little of the housewife in her," Wilding said. "She's vague about household things. Forgets to order dinner. The dinner hour strikes. 'Oh, my gosh,' she groans. 'We haven't anything to eat.' She never learned to cook and I have no reason to believe she's going to learn now."

And she did not do housework. She grew up with nannies and housekeepers who cleaned up after her. Never mind that she was one of the highest-paid actresses at the time and was largely supporting her growing family. Her inability to put her clothes in the hamper began to get to him. The one consistent characteristic that remained throughout her life was her inability, or disinterest, in being on time. Whether it was to meet a head of state or take her wedding vows, she was *always* late. "She was *born* without a sense of time!" Wilding quipped.

Part of Elizabeth's constant and extreme lateness— often hours late to the set or to a dinner party or even to board a plane—was because she spent so much time "Walter Mittying," or daydreaming. She developed a

rich inner life out of necessity when she had no one her own age to talk to in school on the MGM lot. And then, later, there was the pressure to always look flawless.

"I do all my Walter Mittying when I'm doing my making up," she said. "I sit with lipstick in hand reliving a scene that took place last week, wishing I'd said this instead of that."

If she was being asked to do something by the studio, her rebellious streak would come out and she would do anything to keep from pleasing them. Sometimes, being late along with being sick were the only cards she could play.

She eventually took Humphrey Bogart's advice and became more assertive with Wilding. Their arguments grew more frequent. Wilding was a British gentleman and not the dominant lover she longed for. She wanted someone strong who was her equal, not someone telling her what to do just because he could. She had been abused by Hilton, and the men she married after him were sometimes physically abusive too; she often hit them back. But Wilding was not one of those men.

She picked fights with him that ended with only Elizabeth doing the screaming, and there was no passionate makeup sex, which she craved. "I'm not your daughter. I'm your wife," she shouted. She was stronger than she had been when she was freshly divorced

from Hilton; she no longer needed Wilding, and he could not stand it.

"I know of only a few marriages that are happy when a wife is a star," she said years later. It did not help that in 1955, *Confidential*, the magazine that took great pleasure in scandalous gossip, published a story while Elizabeth was away on location for a film. The headline read, "When Liz Taylor's Away, Mike Will Play," and dished about strippers Wilding and a friend had brought home one night. Elizabeth said that the story did not bother her, but she recognized the need for damage control. Not long after, in 1956, she gave a rare and candid interview.

"We don't pick and quarrel but we do fight—it's garbage to say we don't," she said. "Until a year ago, we didn't; we always counted to ten. But I think it's healthy to blow your lid now and then. What infuriates me about Michael is that he can be so underplaying. My temper is Irish and when I blow, I blow. But while I'm shouting in an Irish temper there he is, blasé and unruffled. Finally I yell at him, 'Oh you-you-you *Englishman.*'"

Eddie Fisher, who eventually married Elizabeth, said that she was unfulfilled and frustrated with Wilding. By then she had abandoned the old-fashioned expectation of waiting for marriage before having sex. "She

was a woman who loved men as much as they loved her. She told me that she'd had an affair with Frank Sinatra while she was married to Wilding and had gotten pregnant with Sinatra's child. According to Elizabeth, she wanted to divorce Wilding and marry Sinatra, so she called him and asked him to marry her, but he didn't want any part of that. . . . Frank's manager put her in a limousine and drove her to Mexico . . . where she had an abortion."

Understandably, she would never forgive Sinatra.

Chris Wilding resented the "frenzied presence" of the paparazzi, who usually traveled in a pack. The moment they stepped outside, Elizabeth's children were being watched. If they opened a window there was a chance that an overzealous photographer would be lurking next to it. "Imagine being followed around by a number of adult strangers whose purpose was to document your every move," Wilding said. "Major buzz kill."

When he was about ten years old, Wilding and his brother Michael and his sister Liza decided to go skating on a small ice rink that belonged to the nearby school they were attending in Gstaad, Switzerland, where Elizabeth had a house in the 1960s (a house she

kept as a refuge for decades). They passed by the usual photographers camped out at the bottom of the driveway and their hearts sank when they realized that one of them had decided to follow them.

"We asked this guy several times on the walk down to the skating rink if he would please leave us alone, but he was unmoved," Wilding recalled. "When we arrived at the rink, he took up position on the wooden bench situated at one end, camera in his lap. We tried to ignore this unwelcome presence, but it was difficult; the situation was awkward. He just watched us, not even taking any photos. Suddenly I slipped and went down, splitting my chin on the ice. There was a lot of blood and the tears inevitably followed. Suddenly the photographer picked up his camera and started clicking away like mad. It was incredibly embarrassing, and I was flushed with shame and anger. That this parasitic voyeur—a stranger!—had been patiently waiting to profit from my moment of unguarded misfortune made me feel personally betrayed and infringed upon, as if this man had broken and violated some sort of unspoken taboo. Because this incident affected me personally and amounted to one of those individual bricks that eventually becomes the wall separating childhood and adulthood, it stayed with me."

Decades later, the same photographer approached Wilding outside a hotel near Michael Jackson's Neverland Ranch, which was the site of his mother's wedding to construction worker Larry Fortensky. "I heard a cockney voice rise up above the clamor of clicking and flashing: 'Christopher! Christopher! I have something for you!' A manila envelope was thrust into my hand." Back in his hotel room Wilding opened the envelope and pulled out a black-and-white 8 x 10–inch photograph of himself at ten years old, standing on a skating rink, trying to hold back tears and using a mittened hand to stanch the bleeding from a deep cut on his chin. "Curious indeed that the photographer would have thought that this 'gift' would create a positive point of connection between him and myself, or that it might somehow grant him special access to the upcoming nuptials." All it did was bring back the painful memory.

Sometimes Elizabeth's sons came home with black eyes and bloody noses after defending her from classmates who teased them about their glamorous sex-symbol mother.

Elizabeth preferred to think that they remained unscathed, even though she must have known the pressures they faced. She was not the mother she wanted to be,

and she knew that one day they would realize how different their lives were from everyone else's. While they were young, though, she indulged in the fantasy.

"To my kids I'm not Elizabeth Taylor at all," she wrote in 1964, "I'm not anybody other than 'Mommie.' Michael and I were once walking along the street in Puerto Vallarta. He said, 'Mommie, everybody's looking at you because you're so pretty.' I thought that was so sweet, so dear. He really *can* believe that."

ACT II

Passion
and Pain

The 1950s and 1960s

*I've always admitted that I'm
ruled by my passions.*

—Elizabeth

Chapter 6
Rock, Jimmy, and Monty

All of my life I've spent a lot of time with gay men, Montgomery Clift, Jimmy Dean, Rock Hudson, who were my colleagues, coworkers, confidants, my closest friends, but I never thought of who they slept with, they were just the people I loved.

—Elizabeth

Angela Lansbury, who played Elizabeth's sister in *National Velvet*, did not see the dark side of the studio's control over Elizabeth. "She made the transition so effortlessly because MGM supported her through those years," she said. "Suddenly she emerged and there she was. . . . She just took off, just like a lovely bird."

But in truth, Elizabeth felt like a prisoner. She made a series of films between *A Place in the Sun* and *The Last*

Time I Saw Paris that were beneath her acting ability: *Love Is Better Than Ever* and *Ivanhoe* in 1952; *The Girl Who Had Everything* in 1953; and *Rhapsody*, *Elephant Walk*, and *Beau Brummell* in 1954. She judged her films honestly, and she knew when her performance elevated a film and when it did not.

"Rather curiously," she recalled, "a not-so-good picture, *The Last Time I Saw Paris*, first convinced me I wanted to be an actress, instead of yawning my way through parts. That girl was offbeat, with mercurial flashes of instability—more than just glib dialogue."

In an unpublished interview, a journalist asked Elizabeth how being famous at such a young age made her think differently about her career compared to an actress who makes it in her twenties. Her answer was revealing. She described her performance in *National Velvet* as accidental, even though she had worked hard. A string of poor reviews for films after *National Velvet* hurt, but they did not destroy her. "After reading reviews that said I was a vacuous but pretty face, that quite clearly I couldn't read a line upside down," she gave up trying to please everyone. Another exception came with *A Place in the Sun*. "I was bitten, and I loved the possibility of acting. I loved being given the chance of maybe becoming an actress. And I took it, I took it between my teeth, like a horse does. And I ran,

and it seemed to work. Then I went back to my home lot and I was given such a piece of shit that you would choke on it. And then it kind of made me sink. I died inside because I realized that it was like walking in molasses, that no matter how hard I tried to get out of that MGM teenage dream, I couldn't. That they were going to keep me stuck in that sort of quicksand molasses, syrupy saccharine image of a teenager. And it's hopeless, so I gave up."

But she did not give up for long. She had a keen eye for good writing, and when she saw the script for George Stevens's *Giant,* she knew she needed to be in it. "I don't know how or why," she said, "but I thought maybe I'd start to fight then. And I'm afraid I haven't stopped fighting yet; in truth, actually, I'm still fighting."

Existing in a state of perpetual warfare to get what she wanted, she got the part of matriarch Leslie Benedict in the sweeping film that reunited her with George Stevens, who had directed her in *A Place in the Sun.* She knew that Stevens wanted Grace Kelly, so she worked hard to convince him that he would not regret casting her instead. She felt a sense of "hero worship" toward him.

The multigenerational saga was based on the bestselling book by Edna Ferber and played out over the course of three decades. It told the story of how the

source of one millionaire Texas family's wealth changed from cattle to oil. At the end of the film, Elizabeth, who was twenty-three, plays a fifty-year-old woman who is the mother of nineteen-year-old Dennis Hopper. On the set in Marfa, Texas, in 1955, she became close friends with Rock Hudson and James Dean, who she called "Jimmy."

The Reata Ranch, with a large Victorian house as its centerpiece, was built in the small West Texas town, and the cast had little else to do in their off hours but drink in each other's rented houses. She told Rock about her struggles with stardom, and he talked about his romantic relationships with men.

For Elizabeth, the best thing to come out of *Giant* was not her moving portrayal of a woman who pushes her husband to improve the conditions on their ranch for the mostly Mexican-American staff, but the friendships she formed with Rock and Jimmy. She was intrigued by Jimmy, who was shy and devilishly handsome. And she and Rock immediately connected, sometimes sneaking off the set alone, whispering to each other like children on a playground.

Rock lived with the constant threat of his sexuality being exposed by magazines like *Confidential*. His sudden marriage to his manager's secretary, Phyllis Gates, who said she initially had no idea that Rock

was gay, was the only way to quell rumors that could destroy his very lucrative career. When they divorced three years later, in 1958, Gates recalled the power she had over Rock during the court hearing. It was a scene repeated hundreds, if not thousands of times. "Rock wore a dark suit, which contrasted with the paleness of his face. He seemed petrified." And, Gates said, he had "good reason to be. . . . In the next few minutes I could destroy Rock's multimillion-dollar career with what I knew." She told the judge instead that Rock had hit her twice and that he once tried to choke her. She was granted a divorce on the grounds of "mental cruelty." Physical abuse was not career damaging at the time, but revealing Rock's sexuality would have been.

In a 2000 interview Elizabeth said, "After being blamed for so many years for a behavior that was perfectly natural, that they were born with, to say hey, 'It's all right my love. That's the way God made you, and don't fight it. God made you to love.'"

Rock—who Elizabeth said was not taken seriously at times because of his physical beauty, something she could relate to—and Elizabeth would sneak away when they were not needed on the set to drink tequila in Ojinaga, a town near the United States border with Mexico. They told each other everything and stayed up talking late into the night. Once, when the hail coming

down was the size of golf balls, Elizabeth and Rock ran outside and collected some to use in a new drink: the chocolate martini: ice, vodka, Hershey's syrup, and Kahlúa. Elizabeth remembered it being the most delicious drink she had ever tasted.

Carol Burnett, who was friends with both Rock and Elizabeth, said that they were like brother and sister. "They adored each other. He called her 'Betty.' One name she never wanted anybody to call her by was 'Liz.' She hated that."

Jimmy and Rock did not get along, though they both loved Elizabeth and competed for her attention. Like Monty, Jimmy was a method actor, whereas Rock was more of an instinctive actor, like Elizabeth. According to Rock's wife, Phyllis, Rock was jealous of Jimmy before they even began shooting. He did not care that Jimmy had a smaller role than his. Rock played Jordan "Bick" Benedict Jr., the owner of the ranch, and he was the star of the film. Jimmy played local rancher Jett Rink, who makes it big when he strikes oil. Once they started filming, Rock complained privately that Jimmy was getting all the close-ups. Jimmy was a year older than Elizabeth, who was twenty-three at the time, and five years younger than Rock. He had a full head of sandy-blond hair, a chiseled face, and a deeply sensual

smile. There was an air of mystery about him that enhanced his looks.

"It was the first time in Rock's career that he had faced a real threat from another actor," Phyllis wrote in her memoir, "and he was disturbed by it."

Jimmy was holding on to his own secret.

Jimmy, who was twenty-four years old, liked to drive his Jeep deep into the desert alone and shoot jackrabbits. On set, he kept his Stetson hat low over his eyes and spoke in the Texas drawl ex-rodeo star Bob Hinkle had taught him. He idolized Monty, which made acting opposite Monty's friend Elizabeth even more nerve-racking. He kept messing up his lines. After several takes, he turned around, walked one hundred feet away from Elizabeth, unzipped his pants, and peed in front of hundreds of people. Then he zipped up, walked back to his mark, and shot the scene. He told costar Dennis Hopper that he had done it because of Elizabeth. "I can't get over my farm boy upbringing. I had to pee, and I tried to use that, but it wasn't working. I was so nervous that I couldn't speak. So, I thought, if I could pee in front of all those people, I could work with her."

Elizabeth loved Jimmy in a different and more

maternal way than she loved Rock. She felt like she needed to take care of him, the same way that she felt about Monty. An intimate photograph shows the two of them lying down on a sofa during a break from shooting while Jimmy reads a copy of *Look* magazine with Elizabeth and her two infant sons on the cover: "I'm getting a houseful of men, but it's all right with me," the headline read. "I like boys and now I've got one for each arm." Jimmy is scrunched down on the sofa, and Elizabeth, in a white button-down shirt and black pants, is contentedly curled up asleep at his side.

"There was an intensity that you felt coming out of him. He'd come over to my house sometimes at nighttime and we'd sit and talk until three in the morning," she said years later. "He would reveal to me things that you only reveal to a very good friend." But after their long talks, she would see him the next morning on the set at 7:00 a.m. and he would walk right past her as if he did not even know who she was. At first she was hurt and said, "Jimmy, *Jimmy*, are you all right?" Then she realized what was happening. It was as though he had exposed too much of himself to her the night before, and he needed to put his guard back up.

What he revealed to her was devastating. She told the journalist Kevin Sessums what they were talking about, but she made him promise not to publish it

until after she died. "When Jimmy was eleven and his mother passed away, he began to be molested by his minister. I think that haunted him the rest of his life. In fact, I know it did. We talked about it a lot. During *Giant* we'd stay up nights and talk and talk, and that was one of the things he confessed to me." Elizabeth's relationships with Monty, Jimmy, and Rock helped redefine her life's purpose decades later. They were her colleagues, coworkers, confidants, and best friends.

For Elizabeth, filming *Giant* was an enormous professional challenge. Elizabeth idolized Stevens, but he was difficult to work with. He called for many retakes, he declared sudden halts to production until he figured out the solution to a perceived problem, and he never settled for mediocre performances. When Stevens finished shooting *A Place in the Sun*, he brought four hundred thousand feet of film home with him, most of which ended up on the cutting-room floor. But on the set of *Giant* he pushed Elizabeth too far. Stevens was a bully, she said, and he alternated between picking on Elizabeth and Jimmy. Once, Jimmy went on a three-day strike over a disagreement with Stevens.

Elizabeth had her own problems coming to the *Giant* set. She was exhausted after having a second Cesarean section for the birth of her second son, Christopher, and she was concerned about the state of her marriage to

Michael Wilding. On the set, she felt an undercurrent of second-guessing and disrespect for her acting decisions. When she told Stevens she thought her costume for one scene was too informal and unlike anything her character would wear, Stevens exploded in front of the entire crew.

"All you care about is how you look! You'll never become an actress because you're so concerned with being glamorous."

To prove that she was weighing in on a creative decision that had nothing to do with how she looked in the film, she took a towel and wiped off all of her makeup and put her hair in a messy ponytail and tied it with a rubber band. They did the scene, both of them having been defeated. Her back was causing her great pain on set, and Stevens thought it was all in her head. Later, after Elizabeth married Mike Todd and had a back operation, Mike sent Stevens X-rays of her spine as a Christmas card to prove that her pain was indeed real.

The worst showdown happened in the spring of 1955, when Elizabeth's character, Leslie Benedict, leaves her bullying husband's ranch in Texas and returns to her family home in Maryland. There she is the maid of honor at her sister's wedding, and the powerful scene shows her standing next to the bride and feeling her husband, played by Rock, standing behind her. He has come back

to apologize, and as the vows are read it is as if the two of them are renewing their own vows to each other. The characters do not speak, but they convey a complicated mix of guilt, sorrow, and love in their eyes.

They rehearsed the scene and took a break for lunch. Elizabeth went to her dressing room so that her dress could be pressed, and she sat with her makeup artist and hair stylist. She heard the seventy-five extras being called to the set after an hour, but no one ever came for her. So she sat and sat. Finally, she walked out on set, and all the extras were standing and Stevens was sitting despondent in his director's chair. The set was dark.

"What's going on? What's happened?" she asked him.

"*Who the hell do you think you are?*" he bellowed back at her.

"What?"

"We have been waiting here for over an hour. *Just who the hell do you think you are to keep these people waiting?*" She looked at the crew and the extras, who were silent, and her face turned crimson.

"I didn't know you were waiting for me," she said, the heat rising to her cheeks. "Why wasn't I called?"

"Don't give me that," he said. "Just how far do you think you can go? Just how much do you think you can get away with? What did you do when you came back from lunch?"

"Well," Elizabeth said, "I had my lunch hour and I came back, I fixed my makeup, they ironed my dress and I've been waiting in the dressing room."

Stevens said, "I suppose you think that your makeup is more important than those people's makeup. I suppose you think your costume is more important than their costumes. Well, I have news for you. It isn't."

Elizabeth was embarrassed, but just as it had been when she stood up to Louis B. Mayer, she was not about to let him talk down to her. "That wasn't what I meant. I've been waiting in there. No one called me."

Stevens glared at her and she began to unravel. Hot tears poured down her cheeks.

The person responsible for telling her that it was time to come back on set never did. Eventually, Stevens found this out, but he still did not apologize. He may have been putting her through the emotional roller coaster to prepare her for the scene they were about to shoot. In it she had to cry.

Not long after, she cried again; this time because of a devastating personal loss.

It was nighttime on September 30, 1955, and Stevens, Elizabeth, and other members of the cast were screening rushes in the projection room at Warner Brothers. The phone rang and Stevens answered.

"*No—my God!*" he screamed. "*When? Are you sure?*" Stevens put down the receiver, stopped the film, and flicked on the lights.

"I've just been given the news that Jimmy Dean has been killed," he said. No one said a word. It did not make sense. Four days earlier Jimmy was in Marfa wrapping up his final scenes. Jimmy was so young, just twenty-four, and so vital. Elizabeth had just given him a Siamese kitten as a good-bye present, and she was the last person on the set with Jimmy before he left.

Elizabeth was the first to speak. "I can't believe it, George, I can't believe it," she murmured. She could not believe that Jimmy's 1955 silver Porsche 550 Spyder had collided with a car on a road near Paso Robles, California.

"I believe it," Stevens said harshly. "He had it coming to him. The way he drove, he had it coming."

"I just can't believe this awful thing has happened," she cried. "Not to Jimmy—he was so young, so full of life."

When Rock found out about the accident he was home in California and he burst into tears. When his wife asked him why he was so upset, he said, "Because I wanted him to die."

"But why would you want anyone to die?" she asked as she held Rock's shaking six-foot-six body.

"Because I hate him," he said. "I was jealous of him because I was afraid he was stealing the picture from me." Rock felt guilty for days afterward; it was as though he thought he was somehow responsible for Jimmy's death.

The next morning, Stevens called Elizabeth and insisted that she come back to work and finish a scene. She said her eyes were swollen because she had been crying all night. He was unmoved.

"George was not very kind to her," Rock recalled. "Elizabeth is very extreme in her likes and dislikes. If she likes, she loves. If she doesn't like, she loathes. And she has a temper, an incredible temper, which she loses at any injustice. George forced her to come to work after Dean's death. He hadn't finished the film. And she could not stop crying."

She complied; she was used to being told what to do by directors and studio executives. But that did not mean that she wouldn't call him out on it. "*You are a callous bastard!*" she screamed at Stevens when the scene was finished and she could go home for the day. "*I hope you rot in hell!*" Throughout her life her emotions would influence her physical health in profound ways, and the next day she had such severe stomach pains that she collapsed and had to be taken to the hospital, where she stayed for two weeks. She knew she

still had some work left to do and her absence happened to be a brilliant way to punish Stevens.

When *Giant* was released it was advertised as "a story of big things and big feelings." It was a critical and commercial success, and Stevens won his second Oscar for directing. The movie deftly touches on themes of racism, class warfare, and gender inequality, and it was decades ahead of its time. Jimmy was praised for his work. "It is James Dean who gives the most striking performance and creates in Jett Rink the most memorable character in *Giant*," said the *New York Times*.

Dean symbolized the post–World War II teen rebel who smoked and wore leather jackets and blue jeans. *East of Eden*, based on John Steinbeck's famous novel, was the only film released before his death. Subsequent films, including *Rebel Without a Cause* and *Giant*, made him a legend. He was as handsome as Clark Gable and Cary Grant, but he was fragile and brooding. "You're an odd one, aren't you?" Elizabeth's character says in *Giant*. To Elizabeth, he would forever remain the young boy she wanted to protect.

Elizabeth received the kind of reviews she had been longing for—even if they sometimes came across as backhanded compliments. "Miss Taylor, whose talent and emotional ranges have usually seemed limited, turns in a surprisingly clever performance that regis-

ters up and down the line," said *Variety*. "She is tender and yet stubborn. Curiously enough, she's far better in the second half of the film, when her hair begins to show some gray, than in the earlier sequences. Portraying a woman of maturity, who has learned to adjust to a different social pattern, Miss Taylor is both engaging and beautiful."

Elizabeth's marriage to Wilding continued to unravel. Not long after she finished shooting *Giant*, she planned a relaxed dinner party that she hoped would take her mind off her personal life. On May 12, 1956, she called Monty and begged him to come, but he kept declining. Finally, she guilted him into it.

Monty had defied Hollywood's studio system, and he refused to sign a long-term contract because he knew that it would make him a prisoner, just as it had Elizabeth. He chose to play unusual characters in *Red River*, *The Search*, *From Here to Eternity*, and *I Confess*. He and Elizabeth were shuttling back and forth to Danville, Kentucky, where they were in the middle of filming *Raintree County*, a Civil War drama that MGM was hoping would be the 1950s version of *Gone with the Wind*. The three-hour adaptation of Ross Lockridge Jr.'s 1948 Civil War novel was nowhere near as gripping as the American classic, and Monty

was feeling depressed about the film. Producers hoped it would capture some of the magic between Elizabeth and Monty in *A Place in the Sun*, but the script was nowhere near as compelling. Elizabeth said she thought filming was going well—even though she had collapsed under the strain of the heat and her seventy-five-pound corseted antebellum gown.

The night of Elizabeth's dinner party was foggy, and Monty hated driving to Elizabeth's house in Beverly Hills, off Benedict Canyon, in the dark. The narrow canyon road was treacherous, even in bright daylight. Rock and his wife, Phyllis, were there; so was Monty's old friend, the actor Kevin McCarthy. Elizabeth emerged from her bedroom half an hour late looking radiant in a white satin cocktail dress. She sat next to Monty on the sofa and they spoke in whispers. Michael Wilding lay on another sofa fending off a back spasm.

It was a somber evening, with warm wine and restrained hosts, even though Elizabeth was doing everything in her power to keep the conversation light and happy. Monty was in one of his miserable moods that made her worry about him. "Elizabeth and Monty had an incredible relationship," said Eva Marie Saint, who was their costar in *Raintree County*. "I always felt it was like a mother-son relationship."

Elizabeth understood Monty like no one else. "He

was a very quiet person and bashful," Saint recalled. "Before we were scheduled to shoot our first love scene together, I invited him to lunch. I wanted us to get together and to feel more at ease. Well, lunch was awkward as we ate in silence, and he never said a word. However, after lunch we filmed our first love scene, and he was wonderful. As long as we were in character, Monty felt comfortable."

In a recent interview, Saint says that she did not think that Monty was openly gay at the time of making *Raintree County*. "If the actors I worked with felt they had to hide their sexuality, I wasn't aware of this. It wasn't discussed." And that was the issue; it was so deeply hidden that it was not acknowledged, even off-camera.

At dinner Elizabeth talked about the beautiful costumes the designers had made for her for *Raintree County*. Even the petticoats were being made with the best material. "All they'll see is your tits, darling," Monty said. After dinner he excused himself to use the restroom. Monty did not drink much that night, but when he went into the bathroom a little after midnight he took some downers. He hoped they would help him fall asleep once he got home. But when he came out of the bathroom he was glassy-eyed. When Wilding asked him how he was feeling, Monty replied, "None too gorgeous."

Elizabeth thought that meant he was getting depressed, and she tried handing him another drink. "Don't look so sad, I want everyone, most of all *you*, to be happy with me."

"I'm always happy with you, Bessie," he muttered as he careened past her. "You'll have to excuse me, sweetie," he repeated. "Not feeling too gorgeous, you understand."

McCarthy was getting ready to leave, too, and Monty asked if he could follow him down the winding canyon road to Sunset Boulevard. McCarthy sensed something was wrong immediately as they made their way down the dark twisting street: "He was following me, and he'd come up behind me very fast and very close to my bumper—and these roads were treacherous. His lights were coming up awfully close. At first, I thought that he was pulling a prank, trying to bump into my car. It was the kind of thing he would do. . . . I was afraid for him, but I was afraid for myself too. If he were to bump me, my car could easily tumble off the road.

"All I could see in front of me was what the car lights showed. Blackness on either side of me and his headlights in my rearview mirror coming closer and closer. I sped up to distance myself from him as much as I could while I kept an eye on his car in the rearview mirror. I made the first turn very quickly, I thought,

Whew . . . Made it! The second turn was a real hairpin turn, treacherous. Before turning, I checked the rearview mirror again, I saw his headlights were swerving from one side of the road to the other. Dust was flying. I thought, *Maybe, he passed out behind the wheel and the car was driving itself."*

After he made the second sharp turn, McCarthy waited for Monty. "Suddenly, I heard a crash. Monty's lights were no longer in my rearview mirror, but I could see a cloud of dust. I turned my car around and drove back one hundred yards or more, where he was." Monty's car had hit a telephone pole. In the pitch black the smell of gas hung in the air. McCarthy got out of his car and at first he could not see Monty. He reached through the broken window and turned off the ignition, afraid that the car would blow up. He strained to see a figure slumped in the front seat. Monty's body was under the dashboard. "I was terrified he might be dead," McCarthy said. He couldn't open the door, so he got back in his car and drove to Elizabeth's house.

Back at the house, Rock and Phyllis were having a glass of brandy with Elizabeth and Wilding. McCarthy rang the doorbell.

Wilding opened the door and McCarthy screamed, "Monty's dead! Monty's dead!"

"Oh, come on now, Kevin . . . ," Wilding said, assuming he was joking.

Elizabeth ran to the door and took one look at him and knew that he was serious.

She ran back to her guests. "*It's Monty!*" she screamed. "He crashed his car at the bottom of the hill. Kevin doesn't know whether he's dead or alive."

Elizabeth, Michael, Rock, and Phyllis raced to their cars in the driveway and went down the hill, where they found Monty's car, which had turned into a heap of smashed metal. McCarthy had already called an ambulance, and without hesitating, Elizabeth tried prying the car door open herself. She was always running toward danger and devastation, never away from it.

The driver's-side door was jammed, so she opened the back door and crawled into the front seat, where she sat next to him. "His face, so handsome minutes before, was now a pulpy mask," Phyllis wrote. Elizabeth held his head in her lap, and her white dress was covered with his blood.

She stroked his head. "I'm here. I'm with you, baby," she whispered as she smoothed strands of his black, blood-soaked hair off his face. Shards of broken glass were everywhere. He stirred in her arms and moaned. His nose was broken in two places, his right cheekbone

was shattered, his jaw was broken in four places, his sinus cavity was crushed, he had a severe concussion, his upper lip was split completely in half, and he had lost four teeth.

"I was just holding him like a baby and rocking him," Elizabeth remembered. "He opened his eyes and saw me. His eyes looked the color of a bright red rose."

Suddenly there was a flash of light. Photographers had somehow gotten word of the crash.

"*Get that damn camera out of here!*" she screamed. As more of them showed up, determined to sell photos of the accident scene and Monty's bloody body, Elizabeth's maternal instincts toward Monty spilled forth.

"*You son of a bitch*," she screamed. "*I'll kick you in the nuts! If any of you dare take a picture of him like this, I'll never let you near me again! Get out of here, you fucking bastards!*"

Shocked, the photographers lowered their cameras. No photograph of Monty from that awful night exists. She knew that her value to them was far greater than a few photographs.

Monty was moaning again and Elizabeth moved her head closer to his bloody lips so that she could hear him.

"What is it my love? What is it baby?" she asked.

"Could you pull my teeth out? My teeth . . . are . . ." And he began to choke. He pointed toward his throat

to show her that something was lodged in it. Elizabeth reached into his throat and pulled the teeth out. Years later, McCarthy compared her to a pioneer woman, acting without hesitation and without any ounce of squeamishness.

The ambulance took forty-five minutes to arrive, and Elizabeth rode with Monty to the hospital. By the time they got there, she said, his head was so swollen that his eyes were no longer visible. Because of nerve damage, he would barely be able to move the left side of his face again. Only once, when he was on the operating room table, did Elizabeth allow herself to weep. It was not only the pain of seeing her friend suffer and the damage the accident had done to his gorgeous face, but she also felt guilty for inviting him to her house that night. If she had not insisted that he come he would be all right. The smell of his blood made her nauseous, and she could not get the sight of his broken face out of her mind. Night after night she had nightmares about his face, which looked like a "giant red soccer ball" as they raced to the hospital.

The most beautiful man in Hollywood could no longer recognize himself. In the hospital, no one offered him a mirror and he wisely did not seek one out. He underwent months of surgeries and physical therapy.

Raintree County producers were worried that the footage that had already been shot of Monty would not match his new face. But Elizabeth stood by him, as always. She was terrified that if he was fired from the film he would commit suicide, so she threatened to quit if he was let go. Monty cynically believed that the film would do well simply because people would want to see his new face. The movie did end up being released with him in it, and without Elizabeth having to break her contract to support her friend. Even though she absolutely would have without hesitation.

Chapter 7
Mike Todd:
"He Was My King"

Mike's love was his legacy to me.

—Elizabeth

The first time Elizabeth saw Mike Todd she was sitting in the commissary at MGM. *He's good looking, for a producer,* she thought to herself. She knew him like everyone else did, as a fast-talking, brilliant showman who did not consider it over the top when people referred to him as "Todd Almighty." She remembered seeing pictures of him in *Life* magazine with a giant cigar in his mouth. More than two decades older than Elizabeth, Mike was larger than life and could match her huge personality.

He was born in Minneapolis in 1909, a date that may

have been a year or two after his *actual* birth date. His given name was Avrom Hirsch Goldbogen, and he was the grandson of a Polish rabbi. He was a high school dropout who made his fortune in an unusual way: he ran illegal lottery and bookie joints, and he produced burlesque shows. At eighteen he was a self-made millionaire, and a year later he went bankrupt. He got his big break in 1933 at the Chicago World's Fair as the producer of the "Flame Dance," featuring a barely clothed woman running into a burning building. He was a controversial figure who wanted to make burlesque mainstream, and he was reckless with money.

His passion, energy, and love for life matched Elizabeth's. "Poverty is a state of mind," he said. "When you start thinking with your wallet, you're always wondering what you *can't* do instead of what you can do, and you're never going to get off your back."

Elizabeth went to a party with Wilding and ended up sitting on opposite sides of a divan by the pool with Mike, their backs inches apart. "I remember that gave me a weird but overpowering feeling. It was as though my spine were tingling," she recalled. "I finally got up and moved. Later I found out that the same kind of feeling was going through his back."

Her marriage to Wilding was already over, but she and Mike were emotionally involved with each other

before it was official. On October 3, 1956, Elizabeth and Michael Wilding announced their divorce. She did not ask for alimony, only $250 a month for child support. Because they shared two children, and because they genuinely cared for each other, they would remain in each other's lives forever.

The day after their divorce was made public, Elizabeth got a call from Mike. He needed her to come to the MGM lot. When she arrived, he grabbed her arm and rushed her down a corridor. They went into an elevator to another floor and down another hallway, where he steered her toward an empty office. They sat across from each other as he spoke urgently for half an hour.

"I see that you have decided to shed that guy," he said. "Now understand one thing and hear me good, kid. Don't start looking around for somebody to latch on to. You are going to marry only one guy, see, and his name is me!" He told her he loved her and that their marriage was inevitable. Elizabeth was attracted to him, but she thought that he was "stark raving mad." She went on location to shoot *Raintree County* and he called her every single night. She liked his strength and the way he forced people, and the world, to bend to his will—including her.

As with most things in his life, he talked her into it. She started wearing a 29.4-carat emerald-cut diamond

that she called a "friendship ring," while she was still finalizing the details of her divorce from Wilding. It was her first major piece of jewelry, and she called the big diamond her "ice skating rink."

He had gotten what he wanted. "I loved it when he would lose his temper and dominate me," she said in an unpublished interview with Richard Meryman. "I'd start to purr inside because he had won and I hadn't."

On February 2, 1957, Elizabeth married Mike in a small ceremony at City Hall in Acapulco. Helen Rose designed her dress for the third time: a simple and elegant hydrangea-blue cocktail dress. Eddie Fisher was one of Mike's best men and Debbie Reynolds and Elizabeth's sister-in-law, Mara (Howard's wife) were Elizabeth's attendants. Her father made a rare statement to the press: "I wish for my daughter the same thing that every father wishes—that she will find happiness. I hope that this time her dreams will come true."

Mike was forty-seven and Elizabeth was twenty-four years old when they got married. The more than twenty years between them did not seem to be of much concern, because Mike Todd was an entirely different man than Michael Wilding. Elizabeth found his energy irresistible, especially on the heels of a marriage to Wilding, who was such a maddeningly

proper English gentleman. Mike gave her the passion and the drama that she was missing. When a journalist asked if she liked to fight, she said yes, without any hint of embarrassment, "and it always ends up in love-making."

Mike was the antidote to Michael Wilding. He was overpowering and sexy, not sweet and loving. Debbie Reynolds once came across Mike Todd and Elizabeth fighting, which for them was a prelude to sex. Debbie was appalled.

"She was in my house one night having dinner with Mike Todd and he hauled off and slugged her and knocked her out of the chair. And I almost fainted, I never saw that in my whole life and so I ordered him out of the house. . . . She said, 'Debbie, we're just playing.' I said, 'Well that hurt me. I think you both need to go somewhere else and slug it out.' . . . She clobbered him back. . . . I was in the south of France with them once and she got upset with Mike and she slapped—slugged him—and then they ran upstairs and jumped in bed, or just in the pool and did it there too. They had a good time."

Sara and Francis did not immediately understand that Mike was Jewish. Sara assumed he was Italian and was stunned to discover that his birth name was Goldbogen. When they met, Mike had already produced more than

twenty musicals, strip shows, and burlesque revues. He had been bankrupt twice and had been married twice and had a son who was two years older than Elizabeth.

Life with Mike was thrilling. They flew around the world before flying was common and traveled in grand style to promote his hit film *Around the World in 80 Days*. She especially liked going to Moscow with Mike in 1957, during the Cold War, because she could be anonymous there. "Usually, I am watched so I can't watch in return because then it becomes either a challenge, or an insult, or something on a peculiar level." All she wanted to do was to sit and observe people. And, as it turned out, there was intrigue during the trip, because Mike had been sent there by the State Department and, she said, he was "quite clearly being followed."

Elizabeth had always suspected that her new husband was working as a spy for the U.S. government. During World War II, he was a consultant to the Special Services branch of the U.S. Army. One afternoon during the war, the FBI called him and asked for seats to his sold-out show because they had gotten a tip that German spies were attending that evening. Todd convinced several people to give up their tickets and gave them to the FBI. During intermission, agents apprehended the spies. He always said that he would tell her

why he was sent to Moscow in a couple of years. Everywhere they went Mike asked people, from their drivers to servers at restaurants to the cleaning staff at the hotel, what their country was like to live in, how the economy was doing, and which politicians they supported. Elizabeth said that he took long walks with the U.S. ambassador to the Soviet Union, as it was known at the time, because they knew that the U.S. embassy was bugged so it was dangerous to talk inside.

Even if it was not entirely true, Mike certainly would not have minded Elizabeth believing that he was a spy. It went along with his larger-than-life persona.

During an interview with celebrated journalist Edward R. Murrow, Elizabeth and Mike sat in front of masterpieces by Monet and Pissarro in their elegant apartment on New York's East Side. Murrow, cigarette in hand, asked her, "Are you going to continue making movies or just be a housewife?" Elizabeth replied, "I couldn't really care less about making movies, to tell you the truth. I consider it much more important to be a good woman than a great actress."

Mike, however, celebrated her professional work and said, "Now look, Ed, this woman is not only a great woman, she's a great actress. . . . I saw *Raintree County* and this is going to probably be her last picture for a long time and she is so good in it and this is not

because I'm making like a husband. In fact it's vulgar she's so good, she almost overdoes it. It'll be very difficult to get her to darn my socks and mend my shirts and do the dishes after seeing it." But they had already agreed that she would stay home and focus on her life as a wife and mother.

She liked feeling taken care of, and he enjoyed buying her presents as much as she enjoyed receiving them. On her twenty-fifth birthday, he bought her a mink coat, a Renoir, and a diamond tennis bracelet. When he wanted to mark their six-month wedding anniversary he had two mink coats brought to Elizabeth and asked her which she wanted. *"Both!"* she squealed with delight.

When they were in Paris walking through the Place Vendôme she was struck by a pair of chandelier earrings in the window of a jewelry shop. "Mike!" she said, "Oh God, oh Mike, couldn't I please, please, please? I can't go home without them! Couldn't we at least go in and look at them?" She tried them on and turned her head from side to side so that he could see the earrings reflected in the light. "Of course you can have them," he told her. They were not real diamonds, but she loved them just as much as if they were the real thing.

"A couple of months later we were back in New

York, and I went to put on those earrings," she recalled. "They were in a different box, but I didn't give it much thought. I opened the box, and the earrings looked all polished up, and I put them on. But there was something different about how they fit. And I said, 'Mike, there's something wrong with my earrings. They're not quite the same.' Well, he just chuckled, and told me he had taken the paste ones and had them made up with real diamonds!"

The most exquisite gifts were a jewelry suite from Cartier: a Burmese ruby-and-diamond necklace, earrings, and bracelet that he presented to his young bride while they were on vacation in August 1957. They were staying at Villa Fiorentina outside of Monte Carlo. The exquisite exuberance of the moment when he gives the stunning pieces to her is captured in a 20-second home video.

"Wait a minute," Mike said, as she swam up to the side of the eternity pool at the bottom of the garden. He had already given her an antique diamond tiara that she was wearing in the pool. She always wore her most expensive jewelry, even in her pajamas. Elizabeth said that when her husband opened the Cartier box in the sunshine, "it was like the sun and the rubies merged and it was this red fire that just lit up the south of France."

The video shows Mike delicately draping the necklace around Elizabeth's neck. She is wearing a strapless bathing suit, her skin bronze and glowing during her first trimester of pregnancy with their daughter Liza. She shakes her head from side to side to show off the dazzling earrings with a giddy expression on her face. Mike's best friend, Eddie Fisher, is in the pool, squinting up into the sun, watching Elizabeth shower Mike with affection.

After the necklace, earrings, and bracelet were on, she wanted to see how they looked in a mirror, but there was no mirror. "I had to look into the water, and I had to get closer, so I got into the pool. I said, 'Come in, Mike! Just take off your clothes and come in.' Which he did, but nobody could see for miles. We got into the pool, me wearing my tiara and I'm pregnant."

Mike told Murrow that he had "never had so much fun spoiling anybody and I'm going to keep it that way. . . . It's too wonderful."

But he treated her like the greatest gift he could receive, which complicates their story. It was as though she was the ultimate status symbol and proof that he had made it. "With me," he said, "I just wanted to grow up and marry Elizabeth Taylor. And I did."

He threw a party at Madison Square Garden, the single most ostentatious, attention-grabbing location

for a black-tie party, to celebrate the first anniversary of his hit film *Around the World in 80 Days*. Eighteen thousand guests showed up and millions more watched the extravaganza on television.

The film had won five Oscars, including Best Picture, and at the far end of the arena floor stood a twenty-four-foot Oscar made of gold-colored baby chrysanthemums, and in the middle was a cake fourteen feet high and thirty feet wide. A replica of the hot-air balloon from the movie hung above the cake. There were thousands of prizes for the crowd, including a Cessna airplane with flying lessons included, and six Vespa motor scooters. The evening began with a circus that paraded along Eighth Avenue and then could not get through the crowds into the arena. *Life* described the scene as "a colossal hodgepodge of bagpipers, folk dancers, Philadelphia Mummers, Russian wolfhounds, oxen, Siamese cats, elephant, clowns, and fire engines."

Elizabeth was the hostess for the evening and wore a deep-red velvet gown and the matching Cartier ruby-and-diamond necklace and earrings Mike had given her. And like a queen—she had always said that Mike was her "king"—she wore her diamond tiara. Her main job was to cut the cake, which she did with gusto. When they got home they laughed at the chaos they had created.

"The party taught me a lesson," Mike said. "Eighteen thousand gets unwieldy."

She had worn the tiara to the 29th Academy Awards in 1957. "Doesn't every girl have one?" Mike said to Hedda Hopper. According to Helen Rose, Elizabeth kept her jewels, including the tiara, in a big brown paper bag and she good-naturedly referred to her collection as "the loot."

In October 1956, when she was not yet twenty-five years old, she talked seriously about her desire to retire for the first time. "The blending of a career with marriage does not seem to work out satisfactorily," she said. "So retirement from maximum activity is the most desirable thing." Yet, as much as she loved being Mrs. Mike Todd, she could not resist taking the part of Maggie in the much-anticipated movie based on the Tennessee Williams play *Cat on a Hot Tin Roof.* After she finished filming, her long MGM servitude would be over, she thought, because Mike made a deal that it would be her last film. They planned to retire to his Westport, Connecticut, estate and raise a family there. She was considering converting to Judaism.

Mike never sat still; there was always something more to do, and Elizabeth was along for the ride. During a yacht trip in the Bahamas while she was pregnant, she

slipped and landed on her tailbone as she was walking belowdeck. "I fell six steps and landed on my fat ass," she joked. The injury exacerbated the earlier damage to her back. She was in terrible pain and checked into Columbia-Presbyterian Hospital in New York, where they discovered that she had crushed three spinal discs. She was put in a back brace, and the fetus pushed up under her ribs and put pressure on her back. Doctors told her she may never walk again if she did not have an abortion, but she refused.

Mike made sure that her time in the hospital rivaled a stay at the Ritz. "My room really was the typical hospital room—a sort of pale vomit green," she recalled. "When Mike saw it, he went out and bought me a Renoir, a Pissarro, and a Monet to hang there."

She was in an oxygen tent for two weeks, and she felt faint all the time. When the doctors decided they had to deliver the baby, she begged them to wait and let the baby grow, but the situation was too dangerous—both the baby and Elizabeth were at risk. On August 6, 1957, Elizabeth (Liza) Frances Todd was born via Cesarean section and weighed four pounds fourteen ounces. Doctors told Mike that Elizabeth should have a tubal ligation as a means of permanent birth control, because they told him that giving birth to another child could kill her. She was unconscious when Mike agreed to the

surgery and after Elizabeth woke up and was told what had happened, she said, "It was the worst shock of my life—like being killed." She wanted more children, and the right to make that choice had been taken away from her, but Mike had been left in a difficult position.

Baby Liza was premature and had to spend the first two months of her life in an oxygen tent. "To Mike she was a total miracle. He was quite convinced that when he went to see her, right after her birth, and she was in an incubator and really breathing for her life, well, evidently, in some sort of gastric spasm a little hand came up and made a sort of sign. Mike was totally convinced, and told everyone in the world that would listen to him, that she was waving at him and that she looked him right full in the eyes and that she recognized and waved to him. And from there on in he said that she was the most brilliant child and certainly going to be the first female president of the United States, and, of course, the first Jewish president of the United States."

On March 22, 1958, Elizabeth's entire world fell apart. She and Mike had been married for thirteen months, they had a daughter, and they had traveled all over the world together. Mike was, of course, working on another film. His vision this time was Don Quixote, with Elizabeth playing Dulcinea, Quixote's

idealized woman. Pablo Picasso had already done a thematic drawing for the film.

But forty-eight days after they celebrated their first wedding anniversary, Mike was dead. He was flying to New York, where he was being honored by the Friars Club as "Showman of the Year." He took his small plane, which was named "The Liz," and was accompanied by his biographer, Art Cohn. Elizabeth was supposed to go with him, but she stayed home with a 102-degree fever. Before he left for his evening flight, Mike played with Michael and Christopher as Elizabeth sat up in bed watching her little family. Life was as close to perfect as she had ever known it to be.

Mike hated being alone, and he asked several friends to join him, but all of them, including the directors Joseph Mankiewicz and Richard Brooks, turned him down. Mike's friend Kirk Douglas was also slated to go on the flight with a stop in Independence, Missouri, to visit his idol, former president Harry Truman. But Douglas's wife, Anne, said that he should fly commercial because she had a premonition that something bad was about to happen. An Associated Press reporter named James Bacon had originally agreed to join Mike, but he had changed his mind because of the bad weather. "It was the worst night I ever remember in Southern California—thunder, lightning, and tor-

rential rain. Takeoff was scheduled for around ten p.m. Mike called me around nine to report that the trip was on, weather or not. I told him I wasn't going. 'You bastard,' Mike said. 'You're not going because Elizabeth is not going.'"

Elizabeth remembered they both had a strange feeling that night. They had barely been apart their first year of marriage. "We're too happy; I've never been so happy in my entire life. I'm terrified something is going to happen," he said as he smothered her with kisses. Before taking off, he called her from the airport in Burbank and said he would call her from Tulsa, where the plane would have to refuel. He said they were planning to pick up Jack Benny in Kansas City after a performance and bring him to New York.

Elizabeth could not sleep. The rain pounded against her window and the thunder was earth-rattling. When it was 4:00 a.m. and there was still no call, she tried to reassure herself that he did not want to disturb her. At around 5:00 a.m., the children's nanny came in and gave her an alcohol rub to help lower her spiking temperature. Terrible thoughts raced through her mind. She called her trusted secretary, Dick Hanley, at 6:00.

"It's so strange that Mike hasn't let me hear from him," she said, the rain still beating against her

window. "It's the first time since we were married that he hasn't sent word to me some way. Do you think anything could have happened? It was such a miserable night." Hanley reassured her that he was probably fine, and they hung up. A little later, a colleague from the AP who worked in Albuquerque rang James Bacon. When Bacon answered the phone, his friend exhaled loudly and screamed, "*Thank God! It's you!*" A small plane had gone down and Bacon's name was on the passenger list.

Bacon called Hanley, who had just finished telling Elizabeth that everything was fine. Hanley got her doctor, Rex Kennamer, on the phone, and they rushed to Elizabeth's house. By then it was 8:30 a.m. They walked to her bedroom together and stood in the doorway saying nothing. They could not find the words.

She let out a blood-curdling scream. "*No!*"

"Yes," was all they could say.

She screamed "*No!*" again and again and raced frantically through the house in her nightgown. Her face was stained with tears, and she plugged her ears as though she could protect herself from the truth by refusing to acknowledge it. If anyone got close enough to talk to her, she screamed. Finally, Kennamer got ahold of her and gave her a tranquilizer.

Mike's plane had crashed in the Zuni Mountains,

ninety miles west of Albuquerque. There were no survivors.

A friend said later, "If it wasn't that she thought of the children, she would have killed herself." The love of her life was dead. He was not the dashing heir to a fortune, like Hilton, or a sophisticated actor, like Wilding, but he was a self-made man whose strong arms she felt supported by. And now she was alone. Rex Kennamer and her brother, Howard, stayed with her. So did her friend, MGM's lead hair stylist, Sydney Guilaroff, whom she met when she was a little girl. He recalled sitting beside her as she lay in bed. "When her screaming finally stopped, Elizabeth retreated into stony silence. She sat for hours without moving a muscle, staring straight ahead, her lovely face absolutely devoid of expression, the inner agony she was enduring visible only in the immobility of her features."

Decades later Elizabeth told her security guard, Moshe Alon, that Mike's death destroyed her. "When the plane crashed, I crashed with it."

He was dead after 414 days of marriage. Her friend Shirley MacLaine remembered visiting Elizabeth a few hours after she learned that Mike had died. "She was drinking orange juice and vodka and very upset with God. 'How do you explain it? Why wasn't I on the

plane too? Why didn't I die too? Why did he have to go?' And [she] raged at God."

Eva Marie Saint, who costarred with Elizabeth in *Raintree County,* said that she had gotten a call that Elizabeth wanted to see her and her husband. "We went to her home and met a few other friends waiting to see her. Finally, she appeared halfway down the stairway but couldn't face any of us. She turned around and went back upstairs to her room. It was such a sad moment for all of us."

Elizabeth had been shooting Tennessee Williams's masterpiece *Cat on a Hot Tin Roof* for two weeks before Mike died. The film's director, Richard Brooks, went to visit her when he found out what had happened. She was in her bedroom in "a state of absolute screaming nerves," he said. And she lashed out at him.

"You asshole!" she screamed. "You're just like the rest of them! You've come down here to find out when the hell I'm coming back to work, haven't you? That's what you're here for, isn't it?"

"It's a movie," Brooks told her. "That's all it is, it's a movie. It doesn't mean a goddamn thing compared to what you're going to face now. You want to come back to work, come back to work. You don't want to come back to work, don't come back to work."

Elizabeth was just twenty-six years old and alone

with three small children. Liza was six months old when her father was killed. Everyone told Elizabeth not to go to the funeral, which was to be held outside Chicago. They said that she was in too fragile a state, but she knew she had to go. Debbie Reynolds stayed in Los Angeles and watched her children. Howard Hughes gave her one of his big TWA planes so that she would not have to fly commercial and deal with people staring at her. She was joined by Howard, Dr. Kennamer, Helen Rose, Mike's friend Eddie Fisher, and Dick Hanley.

On the cold March day in Zurich, Illinois, twenty thousand fans stood on the route to the funeral and thousands more waited inside the Jewish Waldheim Cemetery. The six-car funeral cortege was escorted by two police cars. It was an odd scene, with people drinking soda and having full-fledged picnics at the cemetery as though it were a carnival. "I remember seeing bags of potato chips in the wind. And empty Coca-Cola bottles. And children crawling over tombstones," Elizabeth said. The crowd was treating it like a movie premiere. She was sedated during the funeral, but she still felt violated.

Elizabeth got out of the car and covered her face with a black glove. Dr. Kennamer; Michael Todd Jr., her twenty-eight-year-old stepson; and Howard physically

held her up. Like Jackie Kennedy, who mourned the sudden death of her husband five years later, Elizabeth was glamorous even in her grief. She wore dangling diamond earrings, a hat with a veil, and a black mink on her arm. There was a carpet covered in roses surrounding the grave, and people lunged at her as she made her way from the car to her husband's casket. Sometimes people would reach out to touch her so that they could prove to themselves that she was real. "I had a fur coat and they were ripping the hairs from the coat . . . they would like pinch and grab me and get me at the same time . . . like tentacles with claws. . . ." When she saw the casket, which was covered by a tent for privacy, she put her arms around it and cried, "I love you, Mike. I love you."

As the Jewish prayer for the dead was read, the crowd screamed "*Liz! Liz!*" louder and louder. By the time she walked out of the tent the throng had grown and they surrounded her, pulling the veil from her face and reaching for her hair. Howard once again held her up. "I became totally hysterical," Elizabeth remembered, "[from] the grief and the fact that it felt like my brains and body were being clawed by birds. I came undone."

Howard yelled, "Get back!" as he tried to protect his little sister. Once inside the car, fans were on the

hood as they tried to get photos of her inside. Some pressed their faces against the glass. There were so many people she could not see out the window. The car began rocking back and forth, but the chauffeur would not move because he was afraid he might hurt someone. "For God's sake, get this thing moving!" Elizabeth yelled, unable to even begin to process her grief during such mayhem.

She said that Mike had made her feel complete, and now he was gone. Home in Los Angeles, she put Mike's pajamas under her pillow and asked the housekeepers not to change the sheets. She wanted his smell to linger as long as possible.

She told Mike junior that she had dreams about his father every night. In one dream she's in their apartment on Park Avenue. Mike approaches her and says, "You thought I was dead, didn't you? But I was just laying low until things got straightened out." Other nights she dreamed that she was on the plane with him and she could feel herself plummeting toward the ground. On those nights, she would be screaming so loud that she'd wake up the entire house.

"I kept thinking that my waking moments were really a dream and that I would wake up and Mike would return, he was only just away . . . and I felt this

sense of loss because we'd never been separated. It was the fourth time literally that he'd ever been away from me for any period of time at all." Until she met Richard Burton years later, she dreamed that Mike was still alive every time she closed her eyes.

After the shock of Mike's death and the years of feeling used by her parents, she became an insomniac and began taking sleeping pills, a habit she was never able to kick. George Hamilton, her friend later in life, said that she had "psychoscopic pain."

"I think she had enormous pain from her childhood," he said, "she was told to get beyond it. If you can act you can get through this. But alone in the night by herself I think she revisited those demons and I think that she wanted that to stop. She didn't know where to go to stop that. There were temporary moments of relief, but I think it was always chasing her."

She was living every young mother's nightmare. A week after Mike died, she went down the circular staircase and found her son Michael Wilding Jr. in the living room staring out the window and chanting in a monotone voice: "Mike is dead! Mike is dead! Mike is dead!" It was like a scene from a horror movie.

Worse still, in 1977, robbers went to Jewish Waldheim Cemetery, nineteen years after the plane crash, and dug up Mike's body. They were looking for a diamond ring

that he was rumored to have been buried with. All they found was bits of burned clothes, ash, and fragments of a seat belt, bringing the nightmare and terror of his death back to Elizabeth again and again.

But there was so much beauty and romance to remember. From time to time, Elizabeth took out the Cartier ruby-and-diamond suite Mike had given her and laid it on her bed to admire in the sunlight. "Each piece is such a deep wound for me in many ways and the memory always brings back a stab of joy, of love. When I wear that piece after not wearing it for a long time or wearing it yesterday, it's like, *My God, I loved him.*"

Chapter 8
Eddie Fisher: "He Kept Mike Todd Alive"

He's very vulnerable, I'm afraid,
a rather weak person.

—Elizabeth

Mike Todd represented security and pure un-adulterated love and protection. And that had vanished in one horrifying moment. Elizabeth would have to find all that he represented within herself, but she was only twenty-six years old, and she was not yet strong enough. She had three kids to raise, and she was now on her own.

Mike's financial affairs had always been strained, and his life insurance did not cover his death because there was a clause that excluded payment if he died in

a small-plane accident. It is clear, looking back, that Elizabeth was suffering from post-traumatic stress disorder. She could not eat—she lost eight pounds over the course of three weeks after Mike's death—she could not watch television or read, or concentrate for any length of time. The medical examiner had to use dental records to identify the bodies on the plane, and the one piece of Mike's that was salvaged from the wreckage was his wedding band, which was twisted in the fire.

"I'll wear it always," she said defiantly. "They'll have to cut off my finger before they get it off my hand." She took to pinning it to her underwear when she could not wear it in a film. She wanted so badly to feel him close to her again.

She went to her brother's house in La Jolla and stayed with his family for a while. It was a much more modest home than what she was used to, and she took long walks on the beach and slept in a sleeping bag for fourteen or fifteen hours a night.

"After Mike died I felt so empty," she said. "It's like I had nowhere to turn. I had no faith, I was lost."

After some time had passed, she thought about their mysterious trip to Russia and how now she would never know if he really was a spy. But she had more pressing real concerns; she was emotionally fragile and cash poor. "I had seventeen-thousand dollars in the bank to

maintain myself, rent a house, a nanny, a cook, a maid, because I was working, and I had to sell very precious things, which broke my heart. It made me very determined to sort of say, 'Screw you world, I'm going to get out of this.'" The hardest piece to part with was the 29.4-carat emerald-cut diamond engagement ring Mike had given her.

The studio only gave Elizabeth two weeks to recover—an entirely inadequate amount of time—but having that project to complete gave her a sense of purpose, and she said that, in a way, it had rescued her. She was only comfortable when she was Maggie, the gorgeous, calculating, and sexually frustrated character she played in the film. "I couldn't tolerate what I was, and it gave me somebody else to become." She continued to struggle, though, and she sat alone in her dressing room between takes as if in a trance. She had trouble speaking her lines and developed a stutter, which she never had before, that came and went throughout her life during times of stress, a clear sign of trauma.

But she needed to come back to work not only for the paycheck but also for her mental health. All that suffering, Richard Brooks said, had changed her forever. "It helped her grow up. Death and anguish were things that she read in a script and she tried to emulate from

seeing other performances. . . . After all, she was a kid, not much had happened in her life to the extremes and here was something that was happening to her at that time and she was enough of a pro and enough of an actress to know that this was something that you use, that you use honorably."

Burl Ives played Big Daddy, who controls the southern estate, which he says is "twenty-eight-thousand acres of the richest land this side of the valley Nile." He is also dying of cancer and in denial over his son Brick's sexuality. Brick is played soulfully by Paul Newman. During her first day back on the set, Brooks decided they should shoot Big Daddy's birthday party because it was a scene in which Elizabeth had little to say. In the scene, the actors are sitting at a long table covered with food. Normally the food would have been sitting for hours and it would have been covered in fly spray to protect it. But Ives and Brooks decided to have fresh ham, sourdough bread, and vegetables on the table ready for each take so that Elizabeth would be forced to eat real food, instead of pretending. She ate hungrily, for the first time in days, and she never forgot this small act of kindness.

On April 18, 1958, less than a month after Todd's death, Elizabeth wrote a note to Brooks and crossed

out "Mrs. Michael Todd," which was written in elegant cursive on her stationery. That was not her identity anymore.

> The flowers you sent me upon my return to the studio were lovely—thank you so much for your thoughtfulness. It is good being back working again with you.
>
> Most Sincerely,
> Elizabeth

Any scenes having to do with Big Daddy's impending demise were particularly difficult to shoot. In one scene, Judith Anderson, who played Big Daddy's long-suffering wife, said, "Nothing's ever the way you plan, is it?" Elizabeth nearly lost it, but she soldiered on. Her performance was electrifying, playing a sexually starved woman trying to get through to her alcoholic, tortured, and closeted gay husband, who lives in the past and refuses to communicate with her. The film was released in 1958 and was a huge success.

Mike had negotiated a deal with MGM that *Cat on a Hot Tin Roof* would be Elizabeth's last film with MGM, after almost twenty years. But once Mike was gone, the studio had no intention of honoring the deal.

One day on the set, one of the vice presidents, some-one Elizabeth knew quite well, handed her a manila envelope.

"Well, honey," he said, "here's your next project."

"What are you talking about?" she said, barely able to get the words out. "You have one more film under your contract," he said. According to the contract, MGM had three years from the end of production of *Cat on a Hot Tin Roof* to decide how they wanted to use her for her last role before terminating her employ-ment. She could pursue projects at other studios in the meantime—and she did when she made *Suddenly, Last Summer* with Columbia Pictures—but she was still bound to MGM when she thought she was free.

"You and Mike shook hands that this would be my last film," she said.

He shook his head; she could not get out of it.

She tried to gather herself together, but she was so furious that the words came tumbling out. "Don't you bastards have any sense of honor? Doesn't a handshake mean anything to you?"

"No," the executive said unapologetically. "It has to be on paper, dear."

Inside the manila envelope was the script for *BUtter-field 8*. MGM threatened to sue her if she did not make it.

To add insult to injury, she loathed the script and

thought the studio was punishing her by casting her as a high-class call girl. During filming she barely spoke to the director. "It was a very weird time in my life, because I was so young and I had three children and I had to assume the role of husband, wife, mother, father, breadwinner."

Elizabeth did not shy away from confrontation, and she went to speak with Sol Siegel, head of MGM production, and asked him a question she already knew the sad answer to: "Is this the way to end a seventeen-year relationship?"

"Fortunately or unfortunately, Miss Taylor, sentiment went out of this business long ago."

Elizabeth was rudderless. Singer Eddie Fisher was so popular at the time that Queen Elizabeth II and President Eisenhower considered themselves fans. He loved being followed by gaggles of young girls, making lots of money (he made $7,500 per week headlining at New York's Paramount Theatre), staying out late, and gambling. He looked up to people like Frank Sinatra and Mike Todd, who lived lavish lifestyles. Mike called Fisher "my boy."

Fisher worshipped Mike so much that when he and Debbie had a son three weeks before the plane crash, he gave him Mike's last name. Elizabeth and Fisher

were the two people who loved Mike most in the world, and they grieved together. Elizabeth went with Debbie and Fisher to the Las Vegas opening of his show at the Tropicana in June. It was her first public outing since her husband's funeral. On Fisher's thirtieth birthday in August, Elizabeth called to tell him that she had a present for him. It was the engraved money clip she had given Mike with a saying that both she and Fisher had heard Mike say hundreds of times: "Being poor is a state of mind. I've been broke lots of times, but I've never been poor."

When she handed him the present, Fisher was moved by the look on her face: "Elizabeth's eyes . . . I can't ever forget how they burned into my heart that day. I felt her need for me from the depths of my soul. My feelings were identical to hers."

Two weeks later, she flew to New York, where Fisher was filming his television show for Coca-Cola. She needed him to remind her of Mike. They made no real attempt to hide their romance. They spent Labor Day weekend at Grossinger's, a resort in the Catskills where he had begun his career, which also happened to be where he and Debbie got married in 1955. Returning to Manhattan, they ate at the chic restaurant Quo Vadis and danced at the trendy Blue Angel nightclub.

Photos of them leaving the Blue Angel separately ran in *Life* magazine, along with a photo of them reuniting in the backseat of a Cadillac with their friend Eva Marie Saint. The problem was, Eddie was still married to the cherub-cheeked, innocent Debbie Reynolds, who had won over America with her performances in *Singin' in the Rain* and *The Tender Trap*. Onscreen, she was upbeat and witty and optimistic. Worse, the Fishers and the Todds had gone on countless trips together. Debbie was Elizabeth's matron of honor at her wedding to Mike, and she even washed her hair before the big day. Debbie had watched Elizabeth's children when she and Fisher went to Mike's funeral.

Elizabeth was immediately portrayed as the scarlet woman; she had done the unthinkable in the 1950s, when Republican Dwight D. Eisenhower was president and women's sexuality was a verboten topic. Elizabeth's publicist, John Springer, said that she told him their relationship began because she felt sorry for Fisher. Late one night he came crying to her, devastated by Mike's death. "And this boy that was kind of in the family came and said he needed me . . . thank God people like Monty and Rock never said they needed me or I probably would have married them too."

Debbie and Fisher's daughter, Carrie, became

friends with Elizabeth later in life and asked Elizabeth if she had ever loved her dad. Elizabeth replied, "He kept Mike Todd alive."

Debbie was genuinely shocked by the betrayal. "I was at a party with Edie Adams and Dean Martin and a whole lot of friends and everybody kept whispering. But then they'd stop, and I'd come over and they'd go, 'Oh gosh, well, how's everything? What did you do today, Deb?' I said, 'Why are you whispering? What's going on? Tell me what's happening because I love gossip.' And they'd say, 'We're not whispering, nobody was whispering.'"

When she got home she called Fisher's hotel, but no one answered. Finally, she decided to call Elizabeth's room, and again there was no answer. Then she called the front desk and imitated Dean Martin's voice and asked to be connected to her husband's room. "Eddie picked the phone right up. He had been asleep. Then I heard another little voice saying, 'Who is it, dear? Who's calling?' I said, 'Eddie, would you turn over, I'd like to talk to Elizabeth?'"

Debbie left to go to the airport early the next morning because her husband was due back to Los Angeles. She came home without him. He had decided to extend his time in New York with Elizabeth and had not bothered to let her know.

Elizabeth and Eddie denied everything, and Debbie stayed silent. It seemed everyone in the country had taken a side. And most people sided with the wronged wife. *The Saturday Evening Post* described Eddie and Debbie's union as "THE SWEETEST LOVE STORY EVER TOLD," before Elizabeth crashed headlong into it. In the main branch of the Brooklyn Public Library every color photograph of Elizabeth was ripped out of every single magazine.

So many reporters camped out on the Fishers' front lawn that MGM publicists even served them hamburgers and ice cream. They wanted to capitalize on the real-life drama. When Fisher returned to Los Angeles, he and Debbie made intermittent appearances to talk to the press between screaming matches overheard inside their house. One reporter thought they heard Debbie yell, "What's the matter with you, anyway?"

Publicly, though, Debbie laid the blame squarely at Elizabeth's feet. An image of Debbie with diaper pins attached to her blouse was carefully crafted and encouraged by MGM. Debbie called a press conference, and television stations across the country interrupted regular programming to televise it. "Elizabeth has stolen my husband," she declared, teary-eyed. What better way to market the blue-eyed strawberry-blonde than

casting her as a woman scorned. Debbie went from making $125,000 a picture to $250,000.

"I am still in love with my husband. I hope this separation will iron out the difficulties and we can get together and be happy," she said. "I am deeply shocked over what has happened. We were never happier than we have been in the last year. While Eddie was in New York he called me every day." Elizabeth, she said, was "a friend, never a good friend." In another cutting remark she said that Elizabeth did not have many close girlfriends. Fisher, she argued disingenuously, "is a great guy. Do not blame him for what has happened."

In a precursor to reality television, at one point Fisher emerged from the house and said, "Debbie and I are having a misunderstanding. Married people do have arguments and misunderstandings." Not long after he went inside, Debbie reemerged on their front lawn. "It seems unbelievable to say you can live happily with a man and not know he doesn't love you." She went back inside and they both came out, but this time neither felt like performing for the cameras and they ran and jumped over a garden wall to a waiting car.

The truth was that their marriage had been in trouble almost from the beginning, and they had been to see a marriage counselor, who had not been able to

help them. With Fisher, Elizabeth thought, *Somebody needs me, maybe I can make somebody happy.*

"My mother was a Nazarene, she would never have left my father," Todd Fisher said. The Nazarenes are a strict fundamentalist Christian sect that did not believe in divorce (though Debbie would go on to get divorced two more times in the course of her life).

When Elizabeth returned to Los Angeles, her limousine was surrounded by reporters at the airport. "Miss Taylor," one of them asked, "won't you please say something?"

"Hello," she said primly as her limo pulled away. She hid in her agent Kurt Frings's home. Six months after Mike's death, she made the poor decision of giving an interview to the powerful gossip columnist Hedda Hopper. Hopper had been an acquaintance of Elizabeth's ever since Sara cozied up to her when Elizabeth was a child star.

Hopper considered herself the moral arbiter of Hollywood; Elizabeth had been an actress for eighteen years and she knew that she needed to do something to quell the public furor. She told Hopper that the Fishers' marriage was over. "You can't break up a happy marriage," Elizabeth said. She was stunned when Hopper turned on her and said that Mike must be "turning over in the grave."

"Hedda, Mike, unfortunately for me, was killed. He's dead! And there's nothing I can do to make him become alive. I tried, but I can't. And it's sick. I am left alive. I am left alone and alive. And I have a responsibility to live. And I've got to live." The quote that Hopper used though, was incorrect and made Elizabeth sound heartless and defiant: "Well, Mike is dead and I'm alive!"

One Chicago reader wrote, "Liz Taylor is a no-good mother. Why doesn't she stay at home and take care of her children? She is a disgrace to motherhood and women."

Later, in her bungalow at the Beverly Hills Hotel, Hopper begged Elizabeth for forgiveness. "Forgive yourself," Elizabeth shot back. She knew then that no one in the media was her friend. The press, like vultures, were always circling. What is it like to have your life so documented, a reporter once asked Elizabeth. "Not documented," she replied, "*dominated* . . . you always have to be on your best behavior."

Elizabeth learned an important lesson from Hopper: "The public puts you up on that pedestal, then they wait like vultures to tear you down."

In 1959, she was nominated for an Academy Award for her portrayal of Maggie the Cat in *Cat on a Hot*

Tin Roof. It was her second nomination, she had been nominated in 1958 for *Raintree County*. But she suspected that she would not win because she had been a "bad girl." She was correct; she lost to Susan Hayward, who won for *I Want to Live!* The Theater Owners of America punished her by canceling plans to name her the "Star of the Year" and issued a scathing statement. "The movie industry is at the mercy of public opinion," it read, "and to award Miss Taylor the honor at a time like this was out of the question."

Fisher left Debbie and moved into Elizabeth's rental house in Bel Air, where guards stood outside. She and Fisher rarely went out; most of their friends had abandoned them. They were truly radioactive, at least socially. People still flocked to the theaters to see *Cat on a Hot Tin Roof*, and if anything, the mystique swirling around the couple helped the movie's bottom line. Moviegoers wanted to see what made Elizabeth so seductive.

And she delivered. On set, the studio implemented the Production Code, enforced by uptight censors who demanded only the most wholesome moviemaking. Passionate kissing, nudity, and suggestive dancing were banned. So were depictions of interracial marriage. The powerful censors could derail a movie by threatening a boycott organized by Roman Catholic Church groups.

Elizabeth, who reveled in her femininity and sexuality and who could not stand dishonesty, was not going to acquiesce to such censorship. There always seemed to be particular attention paid to Elizabeth's cleavage, and during one wardrobe test a man whose job title was actually B.I., short for "Bust Inspector," took one look at Elizabeth in her low-cut dress and immediately asked for a stepladder.

He climbed up the ladder and peered down. She was showing too much cleavage, he said. She needed a much higher neckline on her dress if they wanted to keep filming. Everyone knew that he had the power to stall production, so costume designer Helen Rose walked over to Elizabeth and pinned her dress with a brooch. But the moment the "B.I." left, Elizabeth pulled off the pin and continued working.

She had too much to consider in her personal life to care whether she offended moviegoers with her plunging necklines. As this scandal was swirling around her, Elizabeth's fifteen-month-old daughter, Liza, whose sharp features and wide-set eyes looked so much like Mike's, was rushed to UCLA Medical Center with double pneumonia. After three days in the hospital, her condition improved. "If she had died," Elizabeth wrote, "that really would have been the end. I don't think I could have borne that."

Elizabeth remained unapologetic about her personal life. The syndicated political columnist Max Lerner said that Elizabeth told him that she and Fisher spent four days and nights mostly in bed together. "She said that was how Eddie got her out of her grief."

When Lerner commended the couple in the *New York Post* for their "joyous candor," which he said was better than "a hypocritical show of virtue," they asked to meet him in London, where Elizabeth was filming *Suddenly, Last Summer.* When they did, Elizabeth told Lerner that she and Fisher had had sex "three and a half times" the night before. "They were definitely reveling in their sensuality," Lerner said.

She and Lerner, who was in his late fifties at the time, began their own affair, which lasted until 1961. They met in London pubs and hotel rooms, where she told Lerner that things were already breaking down between her and Fisher. "I thought I could keep Mike's memory alive that way, but I have only his ghost."

She spent the rest of her life looking for men who had something in common with Mike. Lerner graduated from Yale University and was a professor of American Civilization at Brandeis University; she called him her "intellectual Mike Todd."

She loved sex, and she knew that she could get almost any man she wanted. And she was unapologetic

about occupying space in a man's world. Lerner said that she could be narcissistic. When he told her that he could not wait to introduce her to dignitaries and heads of state he planned to invite to their house for dinner parties once they were married, she snapped at him. "*Fuck you!*" she yelled. "I see these people now without you. I attract them myself. I sure don't need you to attract them for me."

When Fisher found out about her relationship with Lerner he was furious. Even though she knew that Fisher would never be what she needed, she did not want him to abandon her. She had been traumatized by Mike's death, and she clung to him for a sense of security. And she thought that her three small children needed a father figure in their lives, so when Debbie eventually agreed to a divorce, Elizabeth pushed to get married as quickly as possible. She also thought that their story would be much less intriguing to the press once they were married.

And Elizabeth was finally free to make a big professional decision. She was offered the lead in the film version of Tennessee Williams's *Suddenly, Last Summer.* Gore Vidal adapted the macabre gothic play with themes of homosexuality, incest, and cannibalism for the screen. Her business advisers told her not do it, but she loved the controversial script and considered her

character, Catherine Holly, an irresistible challenge. Holly is a traumatized woman who fights back against doctors who declare her mentally ill as a way to silence her. The film was a rebuke to the medical community and the elite who, in 1949, had awarded the Nobel Prize in Physiology or Medicine to the inventor of the frontal lobotomy—which was often used to silence unruly women like Catherine. "Insane is such a meaningless word," says Dr. Cukrowicz, the young surgeon in the film who is portrayed by Montgomery Clift and who is being bribed to lobotomize Catherine. "Lobotomy," Catherine replies, "is a very specific one." Plus, Elizabeth reasoned, *Cat on a Hot Tin Roof* was proof that Williams's plays were bankable at the box office.

Suddenly, Last Summer began filming in May 1959. Elizabeth would be reunited with her beloved Monty for the film, and she would get to act with Katharine Hepburn, whom she had idolized and who had once frostily signed her autograph book at MGM. Hepburn played Mrs. Venable, an eccentric and incredibly rich older woman who volunteers to give money to a struggling state-run asylum if the doctor, played by Monty, will agree to lobotomize her niece, Catherine, played by Elizabeth. Mrs. Venable is worried that Catherine will expose the reason for her son's death, which is tied to his homosexuality.

An iconic image from the movie shows a stunning Elizabeth, as Catherine, wearing a transparent white one-piece bathing suit with a plunging neckline and kneeling on the beach, her lips parted seductively. (There were allegations of concern on the set that Elizabeth had put on too much weight, to which the film's producer, Sam Spiegel, actually issued a rebuttal telegram: "Sorry to disappoint your informant but nobody is mad at anybody and if Elizabeth Taylor is overweight I for one am at a loss to suggest what there should be less of.") In the film, Catherine's cousin Sebastian forces her to wear the skimpy bathing suit in order to attract the attention of the boys on the beach. In its appraisal of the script, the Production Code warned that the bathing suit "should not be transparent." But it is teetering right on the edge; Elizabeth must have relished upsetting the censors yet again.

As with everything at this point in her life, she did what she wanted to do and she kept her personal life moving at lightning-fast speed. Before she began shooting *Suddenly, Last Summer,* she would adopt a new religion and get married for a fourth time.

On March 3, 1959, a year after Mike's death, Elizabeth officially converted to Judaism at Temple Israel in Hollywood. It was a way to keep him close and to

find meaning during her grief. Raised as a Christian Scientist, she felt a deep connection to the Jewish faith and its people, especially having seen how they were persecuted during World War II. Her Hebrew name was Elisheba (the Hebrew word for "Elizabeth") Rachel (who was the favorite wife of Jacob).

When Mike was killed, a rabbi named Dr. Max Nussbaum of Temple Israel came to visit Elizabeth. She kept asking him why Mike died, and Nussbaum told her that he did not have an answer. As the pain got less excruciating, she wanted to find out the answer herself, and she went back to see Nussbaum again. He gave her books about the philosophy of Judaism, the meaning of Judaism, excerpts from the Bible, the history of the Jews, even the bestselling novel *Exodus*. "In seven months, I knew that I had found what I had been searching for, for many years," she said. "Neither Mike Todd nor Eddie Fisher did anything to urge me to become a Jew." She wanted to make it clear that no man did this for her, she had found her new faith herself. At a Friars Club dinner she pledged to buy a hundred thousand dollars in Israel Bonds.

In Israel she saw a country offering sanctuary to displaced and traumatized people from around the world. Her desire to protect and defend vulnerable people was central to her character. Elizabeth never

forgot being a little girl, safe and sound in Southern California, listening to radio reports about the violence being perpetrated in Europe during World War II against the Jewish people, and the Nazi bombardment of her beloved United Kingdom. Her relationship with Israel ultimately lasted longer than any of her marriages, but her support for the small country came at a very high price. Elizabeth's decision to purchase Israel Bonds led every Arab country in Africa and the Middle East to ban her films. Egypt prohibited her from filming locations for *Cleopatra* in 1962 and announced that "Miss Taylor will not be allowed to come to Egypt because she has adopted the Jewish faith and supports Israeli causes." The ban ended in 1968, when Egyptian president Gamal Abdel Nasser saw *Cleopatra* and allowed the movie to open in major cities in Egypt.

On May 12, 1959, fourteen months after Mike Todd's death, Taylor and Fisher were married at Temple Beth Sholom in Las Vegas. Elizabeth wore a belted green cocktail dress, designed by Jean Louis and not her go-to Helen Rose, with a diaphanous cape draped elegantly around her head. Her three children had a new stepfather. Michael Wilding Jr. was six years old, Christopher Wilding was four, and Liza Todd was just two.

Their marriage did help quell some of the press coverage, as she had hoped, because now everything was out in the open. Still, some columnists were disgusted and most directed their vitriol at the bride and not the groom.

"This monument to busting up other people's homes, this solid statue to the ignoring of the ordinary tenets of widowhood and girls' marriages—especially when great female friendships were involved—seems a little gamey for a Temple," wrote the columnist Robert Ruark.

Elizabeth did what she always did and kept on going. After their honeymoon cruise on the Mediterranean, she began shooting *Suddenly, Last Summer* at Shepperton Studios in London. "*Suddenly, Last Summer* was in every way a gratifying experience for both of us," said director Joseph Mankiewicz. It made Elizabeth a better actress. In the last act, Catherine is given truth serum and delivers a famously long monologue about what really happened to her cousin Sebastian. After four or five takes, Mankiewicz was not getting what he needed, and he called a break. Elizabeth sat on the floor and sobbed bitterly.

"Elizabeth had quite simply been brought to her knees by her own demands upon herself," Mankiewicz said. "Her talent is primitive in its best meaning; she

hadn't the technique for rationing herself; her emotional commitment was total each time." He sat down beside her and suggested that they go home, rest, and try again in the morning. Elizabeth's reaction to the unspoken challenge to her acting ability was exactly what he wanted to provoke. She pulled herself together, got to her feet, and said, "No. *Now!*" The next take was perfect.

The *Saturday Review* called the film "fascinating and nauseating, brilliant and immoral," and said that Elizabeth "works with an intensity beyond belief; hers is unquestionably one of the finest performances of this or any year." The *Los Angeles Examiner* called it a "malignant masterpiece . . . Elizabeth Taylor plays with a beauty and passion which make her, in my opinion, the commanding young actress of the screen . . . she tears the heart out of you." In 1960 she was nominated for an Academy Award, her third nomination in three years, but again she lost. She had not yet won back the public's approval.

When *BUtterfield 8* began filming in January 1960 in New York, Elizabeth told her costar Laurence Harvey, "This is going to be a rough one, but don't take it personally."

The movie was her final commitment to MGM, and

she could not wait to get it over with. The film is based on the novel by John O'Hara, and the plot centers loosely on the life of Starr Faithful, a New York prostitute during the Jazz Age. Elizabeth called the script "pornographic," and her character Gloria Wandrous "almost a prostitute." She was on edge during production. When she was shooting on location in Greenwich Village, a group of inmates from the House of Detention for Women yelled at her, and Elizabeth, dressed as an elegant call girl, shouted back, *"Ah, fuck you!"*

If she was going to be forced into it, she would get what she wanted: Helen Rose for her costumes, Sydney Guilaroff for her hair (his fee: $1,100 a week and $600 a week for expenses), and Eddie Fisher would have a role in the movie. Plus, there would need to be script changes, though there were not enough to satisfy Elizabeth. In one overwrought scene with her mother, Gloria, played by Elizabeth, yells, "Mama, face it. *I was the slut of all time!*" After her mother slaps her, she says angrily, "If only you'd done that before—every time I came home all soaked through with gin." She found some of the dialogue laughable.

Time said, "The script reads as though it had been copied off a washroom wall." Fisher's performance was slammed, but Elizabeth came out looking like an actress who had transformed bad writing into brilliant acting.

Variety called her "the picture's major asset" and commended her "torrid, stinging portrayal with one or two brilliantly executed passages within. *BUtterfield* is a picture thoroughly dominated by Miss Taylor." *BUtterfield 8* grossed more than $8 million (or $73 million in today's dollars). She was nominated for an Academy Award for the fourth consecutive year. The film she'd viewed as punishment was winning her accolades.

When the film wrapped she had completed her contract and walked off the lot that had been her home for nearly two decades. When she left MGM for the last time she expected flowers to celebrate, or at least a good-bye, but she got nothing.

"I cleaned out my dressing room and said good-bye to the policemen on the lot and the ones at the gate and the ones that I could count on. I just turned around and said, 'Bye, you bastards.'"

The most famous scene in *BUtterfield 8* is when Gloria writes "No Sale" in pink lipstick on a mirror. When Elizabeth saw the movie, she took out a tube of lipstick and wrote her own message on the screening room's wall: "Piece of Shit."

Chapter 9
Trailblazer

Eddie came back and said through the door, he said, "Okay, it's a deal." (Laughter) I just screamed and dove under the water. Inhaling more water because I was laughing so hard.

—Elizabeth

The producer Walter Wanger declared that Elizabeth was a modern-day Cleopatra, getting what she wanted and never apologizing for it. He had first approached Elizabeth about the role when she was married to Mike Todd, but she told him she needed to talk to Mike because they never wanted to be apart. After Mike's death, Wanger ran into Elizabeth at the Polo Lounge, the famous restaurant in the Beverly Hills Hotel once known as "Hollywood's commissary," and left her a copy of *The Life and Times of Cleopatra*.

When she read the script she hated it, but she wanted to play the woman who had conquered empires. She thought it was the greatest role that could ever be written for a woman.

As *BUtterfield 8* was going into production, 20th Century Fox was commissioning research on ancient Egypt and Rome. After two years, staffers produced fifteen thick, bound, and indexed volumes. *Cleopatra* would almost certainly bankrupt one of the biggest studios in the world, and it would change Elizabeth's life in unexpected ways.

But before she took on *Cleopatra*, Elizabeth was busy playing the role of Mrs. Eddie Fisher. In Las Vegas, where Fisher opened at the Desert Inn, Elizabeth walked in late and all eyes were glued to her as she sauntered to a ringside seat. At the end of his performance, Fisher would look at her and say, "I feel so lucky that she's here tonight. I think you know how I feel. I'd like to present Mrs. Eddie Fisher."

Elizabeth would stand and wave, letting the audience take in her radiant beauty. Fisher would blow her a kiss as she took her seat again. He'd end the night singing directly to Elizabeth as though they were the only ones there. "Those eyes, those lips, that fabulous smile," he crooned. Night after night.

Elizabeth's agent, Kurt Frings, submitted the script for *Cleopatra* to two of his clients: Elizabeth and Audrey Hepburn. Both were interested. Paramount would not release Hepburn for the role, so it was Elizabeth's. But it came with a high price. When 20th Century Fox studio boss Spyros Skouras approached her, Elizabeth came up with the audacious $1 million fee (or $9.7 million in today's dollars); her usual salary at the time was $125,000 per film. No actor, man or woman, had ever been paid that much for a film; at almost the exact same time Marlon Brando inked his contract for $1 million for *Mutiny on the Bounty*. When Wanger called to tell her that there was no way they could pay that much money, Elizabeth called their bluff and walked away. To put her bold demand in perspective, Natalie Wood, a fellow star who waged her own battles with studio executives and who would receive three Oscar nominations by the time she was twenty-five years old, was paid $250,000 ($2.4 million in today's dollars) for her role in the blockbuster 1961 film adaptation of the Broadway musical *West Side Story*. Elizabeth was asking for four times what Wood was making. Audrey Hepburn was getting $750,000 ($7.2 million today) for 1961's *Breakfast at Tiffany's*.

But Elizabeth seized the moment and asked for more. She knew her value and she was never afraid to ask for what she wanted—and to walk away if her demands were not met.

But Fox would not give up. While in London, she was taking a bubble bath in their luxurious Dorchester suite when the phone rang. Fisher answered it, knocked on the bathroom door, and told Elizabeth it was the studio—again. Elizabeth repeated her demand: $1 million and 10 percent of the absolute gross. Fisher relayed the message, and a minute later Elizabeth heard another knock on the door: They had finally relented. She screamed with laughter and dove under the water. She was to be paid $125,000 for sixteen weeks' work and $50,000 for every week after; $3,000 a week for living expenses, and 10 percent of the absolute gross. The film would be shot in Todd-AO, a high-resolution widescreen film format created by Mike Todd, and first-class round-trip airfare would be provided for her entourage, including her three children. She and Fisher lived like members of the royal family at the Dorchester Hotel during filming.

When she insisted that Sydney Guilaroff once again do her hair, it caused an uproar with the British labor union, so it was decided that he would do her hair in the early mornings but he would not work on the Pinewood

set, where only British hairdressers were employed. Forty dresses and headdresses were designed for Elizabeth to wear. Fisher was given a job too; he was being paid $1,500 a week ($14,500 in today's dollars) just to make sure that Elizabeth showed up to work. And she later insisted that her close friend Roddy McDowall have a role in the film (he played the calculating Octavian). Stephen Boyd was cast as Mark Antony and Peter Finch would play Caesar.

Cleopatra ultimately cost $44 million to make (about $425 million in today's dollars), and the star's extravagant lifestyle, including chauffeurs and villas, added to its expense. But without her, Elizabeth knew, the studio had nothing. In the 1980s, when someone on her staff drove her to an AA meeting near Century City, a massive development that is home to agencies and law firms, he asked her if she knew it. She looked at him and said, "*Know it? Honey, I built it.*" Fox had to sell its 260-acre backlot to pay for the massive expense of *Cleopatra*.

The movie depended on her totally—even where it was being filmed was ultimately her decision. She wanted to shoot abroad so that she could get a tax break. The British government offered subsidies to foreign companies shooting in England, so studio head Spyros Skouras decided that they would shoot there,

even though its fog and cool temperatures were nothing like Egypt.

The gargantuan set was built on nine acres at Pinewood studios outside of London. They had enough construction material to build at least 40 houses, including 300 gallons of paint, 142 miles of tubular steel, 20,000 cubic feet of timber, and 7 tons of nails. The interior of Cleopatra's white marble palace was twice as high as Grand Central Terminal. The six-hundred-thousand-dollar set included temples, ponds, and pools. Seven hundred extras occasionally got lost in the nine acres of ancient Alexandria when London fog rolled in.

From its earliest stages, Fox was hemorrhaging money. The studio had lost $22.5 million in one fiscal year alone, and *Cleopatra* was an albatross around Skouras's neck. Elizabeth was constantly blamed for delays in shooting. The *Daily Mail* said the reason was because she was "too plump" to appear on-screen. Fox's press department actually issued a denial—her weight being an ongoing object of public fascination. Elizabeth sued and settled for a "substantial sum" and "sincere apologies." She would not be victimized by the press any longer.

The truth was, the dismal weather in London was taking a serious toll on Elizabeth's delicate health. On

September 30, 1960, for instance, Wanger noted that the temperature hovered at a mere forty-five degrees, and there were two minutes and twenty seconds of sunshine. Elizabeth had called out sick that day because of a sore throat. Skouras blamed Wanger for insisting that Elizabeth be the star of the film.

"You're such a stubborn sonofabitch," Skouras berated Wanger. "You've ruined us by having that girl in the picture. We'll never finish the picture with her. I wish to hell we'd done it with Joanne Woodward or Susan Hayward—we'd be making money now." But Wanger would not give up on Elizabeth, even though Lloyds of London, the company with the largest insurance stake in the film, had publicly suggested Marilyn Monroe, Shirley MacLaine, or Kim Novak for the role.

Elizabeth herself was not personally insured because no one would take the risk. In the meantime, Fox was losing forty-five thousand dollars a day.

After two huge revisions to the script, Elizabeth thought it was still not working. Because she had been reading scripts since she was nine years old, she was an astute critic and she could tell almost immediately when a script worked and when it didn't. "I hate most historical-period films, with their wooden figure characters and their awful dialogue," she said. "If we can

capture, in a realistic and human way, the three characters of Cleopatra, Mark Antony, and Julius Caesar, then we'll have an interesting picture."

Elizabeth's honesty, combined with her mesmerizing beauty, was endearing. She knew she could get away with saying things no one else could. Once, at a dinner party with Skouras, Elizabeth said, "What do you care how much *Cleopatra* costs? Fox pictures have been lousy. At least this one will be great—though expensive."

Truman Capote remembered visiting Elizabeth during the making of *Cleopatra*. She was staying in a penthouse suite at the Dorchester with "the busboy," a nickname her friends had given Fisher. Capote described the suite being "crowded with shedding cats and un-housebroken dogs and [a] general atmosphere of disorderly paraphernalia."

Fisher sat on the couch rubbing his eyes, disinterested in their conversation. "What's the matter? Why do you keep rubbing your eyes?" Elizabeth asked him.

"It's all that reading!" he complained.

"All what reading?"

"That thing you tell me I gotta read. I've tried. I can't get through it somehow."

She turned away from him and toward Capote,

disgusted. "He means *To Kill a Mockingbird*. Have you read it? It just came out. I think it's a really lovely book."

Capote had absolutely read it; the author, Harper Lee, was a close friend from childhood. He told her it was loosely based on their childhood.

"You see," she told Fisher, "I may not have had a particular education, but somehow I knew that book was true. I like the truth."

After Capote left, Elizabeth got very sick with a fever that hovered around 103 degrees and would not break. On March 4, 1961, her private nurse was so concerned by her labored breathing and her blue-tinged nails that she called the front desk at the Dorchester to ask for a doctor. Luckily, there was a party down the hall from Elizabeth's suite, and one of London's top anesthesiologists was a guest. When he examined Elizabeth, he concluded that she was being suffocated by the congestion in her lungs.

She was unconscious and unresponsive, and even when he gouged at her eyes to try to evoke a response (she remembered thinking, *What the fuck are you doing?*), there was nothing. Out of desperation, he picked her up by her feet—he was six foot four—and shook her as though she were a doll, hoping that some of the congestion in her chest would loosen. He pounded

his hands hard against her ribs, but she was still blue and unconscious.

He took out a thin tube and put it down her throat and attached one end to an oxygen tank, and after several minutes she was conscious again. She was rushed in an ambulance to the London Clinic. She needed a tracheotomy so that she could breathe. When she was lying on the operating table unconscious, she felt herself drifting toward a warm and welcoming white light. She saw shadowy figures crossing each other's paths, until suddenly, there was Mike Todd. He came to her and held her in his arms. She was home. She was crying out with pure happiness and relief.

Elizabeth recounted every detail in an unpublished interview she did for her 2002 book *My Love Affair with Jewelry*: "No baby, you have to go back," he whispered in her ear. "I'll be here waiting for you, but you have something to do, something very important, and you can't come over yet. When your time is right I will be here, but you have to fight with all your life, what's in you now, gather up your strength, your will, your love, and turn around and fight with all the determination you're fighting to stay here and go back."

"But I don't want to," she pleaded.

He took her by the shoulders and turned her away from him. She could see herself lying on the bed and

the people feverishly working on her in the hospital. She felt his touch, just as she had remembered it. She woke up, against her will. She had been with him for five minutes and she would never be afraid of death again. It was being alive that frightened her.

When she tried to scream no sound came out, only air through the hole that was cut in her throat so that she could breathe more normally. Nobody could hear her. She was in a panic. She grabbed her throat and men in green hospital gowns had to strap both of her arms down.

She struggled to tell the eleven people in the room what it was like being in the tunnel, being bathed in the warm, white light, and being reunited with the man she had loved with all her heart. She missed Mike so much, and she had come to realize that Fisher could never take care of her the way he had.

At the hospital she was diagnosed with acute pneumonia. She was put in an automatic respirator, which was like an iron lung. During her hospitalization, she slipped in and out of consciousness. Fans and reporters gathered outside the hospital. Flowers and presents were sent from around the world. At one point Elizabeth's death was even reported. Skouras called Wanger on March 6 in a panic when he read the news. *"My God, how did it happen?"*

When Elizabeth was close to death, the studio asked Joan Collins, who was already under contract with Fox and who was originally being considered for the role when the film was going to be done on a much smaller scale, if she would be ready to come to London. Elizabeth, they said, might not make it. "I was appalled," Collins recalled. "I said, 'How could they think of doing such a thing? Elizabeth is a friend of mine, I mean she's not a close friend, but she's a friend, and I couldn't possibly.' That's like walking on somebody's grave."

Wanger had to reassure Skouras, and everyone else, that Elizabeth was still very much alive. Fourteen days after her illness began, the congestion in her lungs started to clear and color was returning to her face. Eddie Fisher, playing the role of manager/husband, made a declaration: "Elizabeth is not going to do *Cleopatra* in England. She thrives on sun and she must have it. That means no more work in England or New York, or anyplace else where the weather gets bad."

"I appreciate," he added, "what Skouras said—'No Liz, no *Cleopatra*'—but without good weather it will be no Liz." The next day, 20th Century Fox complied with Fisher's demand: *Cleopatra* would be filmed in Italy or Egypt or Hollywood. The enormous set in London was abandoned, and while Elizabeth recovered

a new one was erected in Rome at Cinecittà, the largest motion-picture studio in Italy. It was nicknamed "Hollywood on the Tiber," and it is where the real drama began.

Elizabeth had changed forever. "When I came to that last time, it was like being given sight, hearing, touch, sense of color. . . . I knew that I wanted more in my life than what I had."

She was twenty-nine years old, but she felt like she was just coming out of the womb. She knew that she had to transform her personal life, but she also wanted to rethink her professional life. "I once thought acting was a hobby and a chore, it was chic to be bored," she told an interviewer. "Now I think it's a waste of time to be bored. It's a *sin* to be bored."

Capote, who had just visited Elizabeth and her "busboy," was relieved when Elizabeth was well enough for him to visit her in the hospital. She was almost breathless as she walked him through every gruesome detail. "My chest and lungs were filled with a sort of thick black fire. They had to cut a hole in my throat to drain out the fire. You see," she said as she pointed to the wound in her throat and the rubber plug that held the hole closed. "If I pull this out my voice disappears," and she pulled it out. She was laughing

but Capote could not hear any sound coming out until she put the plug back in. She seemed to enjoy the shock of it, but it made him very uneasy.

"This is the second time in my life that I felt—that I _knew_—I was dying. Or maybe the third. But this was the most real. It was like riding on a rough ocean. Then slipping over the edge of the horizon. With the roar of the ocean in my head. Which I suppose was really the noise of my trying to breathe. No," she said dramatically, as if replying to a question, "I wasn't afraid. I didn't have time to be. I was too busy fighting. I didn't want to go over that horizon. And I never will. I'm not the type."

Then she nodded toward a bottle of Dom Pérignon chilling in a bucket next to her hospital bed. "I'm not supposed to have any. But ★★★★ that. I mean when you've been through what I've been through . . ." She laughed and took out the rubber plug again. Capote poured them each a glass of champagne.

She took a sip and sighed, "Hmm, that's good. I really like only champagne. The trouble is, it gives you permanently bad teeth. Tell me, have you ever thought you were dying?"

"Yes," Capote replied. "Once I had a burst appendix. And another time, when I was wading in a creek, I was bitten by a cottonmouth moccasin."

"And were you afraid?"

"Well, I was only a child. Of course I was afraid. I don't know whether I would be now."

She thought for a moment and said, "My problem is I can't afford to die. Not that I have any great artistic commitments. Before Mike, before what happened to him, I'd been planning to get the hell out of movies; I thought I'd had enough of the whole damn thing. Just financial commitments, emotional: what would become of my children? Or my dogs, for that matter?" He poured her another glass.

"Everyone wants to live. Even when they don't want to, think they don't. But what I really believe is: Something is going to happen to me. That will change everything. What do you suppose it might be?"

"Love?" he wondered.

"But what kind of love?"

"Well. Ah," Capote stammered. "The usual."

"This can't be anything usual," she said.

"Then perhaps a religious vision?"

"Bull!" She bit her lip, pondering. Then she laughed and said, "How about love combined with a religious vision?"

When she finally left the clinic at the end of March, she flew home to Los Angeles and her Rolls-Royce

was mobbed at the airport. This time, instead of people spitting at her, as they had when she arrived in London, they smiled and waved. On March 24, 1961, Elizabeth made her first public statement since her illness: "I didn't know there was so much love in the world."

When she arrived at the Santa Monica Civic Forum for the 33rd Academy Awards on April 17, 1961, 2,500 fans sat on bleacher seats hoping to catch a glimpse of her. She had been nominated for her least favorite film, *BUtterfield 8*. She wore Dior couture with a mink capelet, white gloves, and long diamond earrings set off by a tan she had acquired during a quick trip she and Fisher took to Palm Springs after they returned from London. "We love you!" the crowd screamed. When Yul Brynner was opening the envelope to announce the winner for Best Actress, Elizabeth turned to Fisher and whispered, "I know I'm not going to get it." But to her shock she won, and Fisher helped her to the stage during a long standing ovation. Her left leg was bandaged from a blood clot the month before, and she was still weak from her battle with pneumonia.

"Oh," she sighed, utterly surprised. She thought *BUtterfield 8* was far inferior to her work in *Suddenly,*

Last Summer and *Cat on a Hot Tin Roof*. As she accepted, she looked out on a sea of familiar faces, fellow celebrities and powerful producers, some of whom had completely abandoned her when she and Fisher were considered radioactive.

"I don't really know how to express my gratitude for this. And for everything—I guess all I can do is say thank you. Thank you with all my heart." She did not wear a necklace that night, or do anything to cover the tracheotomy scar. It was a battle scar and she was proud of it. "She is really saying fuck you to the world," Joan Collins remarked.

Suddenly the world that had hated Elizabeth decided to love her again, because, as she said, "There's no deodorant like success." Gossip columnist Louella Parsons published one of the many fan letters that were streaming in. "I used to hate her. This morning, in church, I prayed that she be spared for her husband and children, for her parents, for all us fans whose uneventful lives have been enriched by her beauty and talent."

The Oscar was a sympathy award and everyone knew it. Shirley MacLaine, who was nominated for her performance in *The Apartment*, said, "I lost to a tracheotomy." Elizabeth had actually gone to the cere-

mony fully prepared to accept the award for MacLaine, who was on location filming.

"Hell," Debbie Reynolds said, "I even voted for her."

At a banquet held at the Beverly Hilton to raise money for a new medical center, Elizabeth sat next to then attorney general Robert F. Kennedy. She was invited to speak as an example of the miracle of modern medicine.

Dying, as I remember it, is many things—but most of all, it is wanting to live. Throughout many critical hours in the operating theater it was as if every nerve, every muscle, as if my whole physical being were being strained to the last ounce of my strength, to the last gasp of my breath. Gradually and inevitably that last ounce was drawn, and there was no more breath. I remember I had focused desperately on the hospital light hanging directly above me. It had become something I needed, almost fanatically, to continue to see, the vision of life itself. Slowly it faded and dimmed, like a well-done theatrical effect, to blackness. I have never known, nor do I think there can be a greater loneliness.

Then it happened.

First there was an awareness of hands—how

many I could not tell. Pushing, pulling, pressing, lifting; large, rough hands and smaller, gentler ones, insistently manipulating my body as if to force it to respond.

Then the voices from a great distance at first, but ever so slowly growing louder. Like the hands, some were gentle, some harsh; some pleaded with me; some shouted, cajoled, and commanded. They said I was to bring myself to cough . . . to move . . . to breathe . . . to look . . . to *live*.

At that moment, my life was nothing more than those hands and those voices. But I was no longer alone.

I coughed, I moved, I breathed, and I looked. The hanging lamp—the most beautiful light my world had ever known—began faintly to glow again.

The audience pledged more than $7 million that evening and the *Motion Picture Herald* named her the top box office star of 1961. She was back and burning brighter than she ever had before.

Elizabeth and Walter Wanger were the only people left on the sinking ship that was *Cleopatra* after filming was called off in London. Only twelve minutes

of useful footage had been captured. Stephen Boyd would no longer play Mark Antony and Peter Finch was no longer Caesar. The director, Rouben Mamoulian, was let go and replaced with Joseph Mankiewicz, who had directed Elizabeth in *Suddenly, Last Summer*. Mankiewicz later referred to *Cleopatra* as "the toughest three pictures I ever made."

For Elizabeth, the man who replaced Stephen Boyd as Mark Antony was the only person she had ever met who could rival the vibrance of Mike Todd, and she was not about to lose that feeling again. When they resumed shooting in Rome and Elizabeth locked eyes with the brooding Welsh actor Richard Burton, her marriage to Fisher was already doomed. "From those first moments in Rome," she said, "we were always madly and powerfully in love."

ACT III

Lavish Love

The 1960s and 1970s

I love him deeply and truly and forever and always.

—Elizabeth

Chapter 10
Le Scandale

According to the code of ethics today, I was, I suppose, behaving wrongly because I broke the conventions. But I didn't feel immoral then, though I knew what I was doing, loving Richard, was wrong. [But] I never felt dirty, because it never was dirty.

—Elizabeth

At the actor Stewart Granger's stylish Los Angeles mansion in the 1950s, a young Elizabeth sat languidly by the pool looking gorgeous in a bikini and reading a book. She was used to industry parties with celebrities and their hairdressers, publicists, screenwriters, and studio executives mingling. It was a Sunday morning and the guests were drinking Bloody Marys and highballs. Richard Burton was nearby nursing a

Scotch on the rocks. Elizabeth heard his booming voice from across the pool, lowered her book, and pushed her sunglasses to the tip of her nose. He could sense her looking at him and felt as though she were looking right through him. He smiled, and after a few seconds she smiled weakly back at him. She took a sip of her beer and returned to her book. This was the first time the most celebrated Hollywood couple of the twentieth century ever met, and things were not looking at all auspicious.

Richard awkwardly made the rounds, this being his first time in California and his introduction to a life that was so different from his years spent onstage in London. Elizabeth spoke to no one and sat quietly on the deck chair. But he was mesmerized. "She is a secret wrapped in an enigma inside a mystery. . . . Her breasts were apocalyptic," he wrote later. "Indeed, her body was a miracle of construction and the work of an engineer of genius. It needed nothing except itself. It was true art, I thought, executed in terms of itself." Elizabeth's outward beauty, he said simply, was "too bloody much."

As morning turned into afternoon, Elizabeth got up from her chair and took a swim in the pool. Afterward, Richard got close enough to her so that he could hear her trashing a producer at MGM using a multitude of

swear words that both shocked and fascinated him. No one expected to hear vulgarity coming from such a perfect mouth. The Scotch had made him brave.

"You have a remarkable command of Olde English," he told her.

She looked at him with her big blue-violet eyes, and he put his hand up to his pockmarked face and felt a burning like he had never known in his cheeks.

"Don't you use words like that at the Old Vic?"

"They do," Richard said, "but *I* don't. I come from a family and an attitude that believe such words are an indication of weakness in vocabulary and emptiness of mind. . . . Despite Jones's [British artist and poet David Jones] writing that in times of acute shared agony and fear, as in trench warfare, obscenities repeated in certain patterns can at times become almost liturgical, almost poetic . . ." Richard faltered, Elizabeth's friend looked away.

"Well, well, well," Elizabeth said coldly. He had been dismissed.

Richard Burton was born Richard Jenkins Jr. on November 10, 1925, in Pontrhydyfen, South Wales. He was the twelfth of thirteen children in a Welsh mining family. Elizabeth loved that about him, that he won scholarships based on his mind and not his fam-

ily wealth, like Mike Todd, and not like Nicky Hilton. Without his brain, and his great love for language and Shakespeare, he would have been a miner like his father. His mother died when he was two years old, and he was raised by his older sister, Cecilia (who he affectionately called Cis), whom he worshipped.

His teacher, Philip Burton, became his mentor. Richard spoke only Welsh and Burton taught him the King's English and saw something in him that he could mold into a serious Shakespearean actor. Richard took his name, abandoning the surname of his alcoholic coal-mining father.

"My real father gave me his love for beer," Richard quipped. "He was a man of extraordinary eloquence, tremendous passion, great violence. I was greatly in awe of him. He could pick you up with one hand by the seat of your pants. My adopted father is the exact opposite. A pedant, a scholar, meticulous in his speech, not given readily to passion. I'm still frightened of him. He still corrects my grammar."

Richard began drinking and smoking at twelve. "Sometimes," he wrote in his diary, "I am so much my father's son that I give myself occasional creeps. He had the same gift for damaging with the tongue, he had the same temporary violence."

Richard's longtime friend Lord David Rowe-

Beddoe, who is from Wales and a member of the House of Lords, said that Cis kept the family together. Richard, Rowe-Beddoe recalled, "was aware of his beginnings and he didn't try to hide them in any shape or form, and he wouldn't have been allowed to because his brothers and sisters would have punched the hell out of him if he got cocky with them. He played his role and his role got bigger and bigger."

Richard went to Oxford for a year on a scholarship and he served with the Royal Air Force from 1945 to 1947. In 1949, he married Sybil Williams, a fellow Welsh actor who had appeared in one of his first films. They had two daughters, Kate and Jessica. He worked in London and New York theater and was influenced by his friend Sir John Gielgud. He thought serious acting could only be done on the stage.

Though he got rid of the family name, he could not escape his father's addiction. Richard was an alcoholic too, and once, when performing in Shakespeare's *Henry IV*, he peed himself onstage after drinking all day. His chain-mail costume took him thirty minutes to get off, so he did not even try to do it.

He had a ruggedly handsome, pockmarked face from a childhood case of chicken pox. Kind critics called him "Britain's Brando" and unkind ones "the Poor Man's Olivier." Richard was notorious for sleeping with

most of his leading ladies (including the actresses Jean Simmons, Claire Bloom, and Susan Strasberg, among others), and Sybil was resigned to his cheating as long as he came home to her. Burton's entire family, which included ten surviving brothers and sisters, loved Sybil.

Once Hollywood came calling, he was nominated for an Academy Award for his performance in *The Robe* and offered a $1 million contract for ten films in ten years, a hundred thousand dollars a year, by Darryl Zanuck at 20th Century Fox. He declined.

In 1954, Richard returned to London and the prestigious Old Vic Theatre, where he made $140 a week and performed in *Hamlet, The Tempest,* and *King John.* He went through a period of professional disappointment, until he was offered the role of King Arthur in *Camelot* on Broadway, for which he was highly praised. Richard was even handpicked by Winston Churchill to be the narrator of *The Valiant Years* television documentary based on his memoirs. Hollywood took note again, and Richard was offered the role of Mark Antony in *Cleopatra.* This was only after Mankiewicz pleaded with Spyros Skouras to "withdraw his objection" to Burton, who Skouras argued did not match Elizabeth in terms of star power. "Apart from his physical attractiveness and impressive personality," Mankiewicz wrote, "Richard Burton is a magnificent and experi-

enced actor with the technical resources and dramatic power I can draw upon not only to sustain but to realize completely that all-important second half." (Mankiewicz conceived of the film in two halves: Cleopatra and Julius Caesar, and Cleopatra and Mark Antony). Richard's salary was $250,000 for three months, plus overtime. He barely knew his leading lady at the time—remembering that the only time he had met her it had not gone well—and he had no idea that she was about to change his life forever.

In September 1961, *Cleopatra* started shooting, this time in Rome. Filming was six days a week, Monday through Saturday. When they were shooting, Elizabeth, still fragile after her near-death experience, was treated like a queen. Her script was specially bound in Moroccan leather, and her chair, a gift from Mankiewicz, was made of California redwood and Russian leather. When she saw her dressing room, which was a five-room building she nicknamed "Casa Taylor," she exclaimed, "It's a little bit much, isn't it?"

On September 1, 1961, Taylor and Fisher moved into their palatial home in a secluded park on Via Appia. It was a few minutes from the set, and it cost the studio a then outlandish three thousand dollars a month. Elizabeth brought along Michael Junior, Christopher, Liza,

their nanny, an assistant, and seven animals: a St. Bernard, a collie, three terriers, and two Siamese cats. Her personal doctor, Rex Kennamer, was a guest for six weeks. Elizabeth had a chauffeured Cadillac every day to and from work (Fisher had a separate chauffeur who drove him around the city in a green Rolls-Royce that was a gift from Elizabeth). She had a household staff, including four maids, a laundry person, a chef who made sumptuous meals, and a maître d' who took care of their every need. But one member of their large staff became particularly problematic when he embezzled money.

"I realized you can't really have an escaped con as your majordomo," she said. After he was fired, he sold stories about his time working for her. She knew not to trust the press; now she knew she could not even trust her staff.

The script was a mess. Mankiewicz would stay up all night rewriting it and shoot during the day. He was such a nervous wreck that he wore white gloves to protect his nails, which he was gnawing at constantly. In a private letter to Mankiewicz dated April 8, 1961, Skouras made it clear just how much was at stake: "You must approach this project courageously, completely disregarding the past; for any talk of past mistakes in the history of this picture is purely detrimental to the

future reputation of this production. . . . I must advise you that in this production the world will be looking for something unusual and out of the ordinary. . . . Now this is the most dangerous part of the whole project—will you be able to give such a picture to the world . . . a picture that will fully reach the expectations of the people? If we achieve this, I can assure you that in the history of the motion pictures to date no picture will ever be shown such attention."

Skouras was trying to transform the reputation of the film, already famous for its vast expense, into a creative masterpiece. But the movie seemed cursed, as plan after plan fell through. Fox rented Prince Borghese's private beach at Anzio for $150,000. They were planning to build the Alexandria set there until they discovered that Allied soldiers had landed on the beach during World War II and there were still land mines. A bulldozer struck one and demolition experts had to be brought in to get rid of live ammunition. Another problem: the beach was next door to a NATO firing range, and their shooting schedule would have to be built around times when the range was not in use.

When she was working, Elizabeth spent at least two hours doing her own makeup, including her elaborate and exaggerated catlike eye makeup. She applied spangles on her lids, gobs of eyeshadow, and thick black

eyeliner. It was a fantastical version of a glamorous queen completely in control of her sensuality.

When she wasn't working, Elizabeth embarked on adopting a fourth child. She wanted at least six children, and because she had given birth three times via Cesarean section and had had a tubal ligation, she could not give birth to another child.

She decided that she and Fisher would adopt, and since celebrities without stable homes were not seen as solid candidates, her agent, Kurt Frings, asked his client Maria Schell, who was Austrian, if she could inquire about adoptions in Germany.

Schell found six babies who needed homes. Elizabeth went to Schell's house and saw an eight-month-old baby girl lying in a wicker laundry basket. "She was suffering from malnutrition and abscesses all over. I had three days off and I took care of her before I had to fly back to Italy," she recalled. "She didn't laugh or cry or let her demands be known, but finally, after three days of loving and caring for her, she began to awaken and make all the other natural noises an eight-month-old baby should make—quite demanding when she was hungry, all of which made me love her desperately."

When she gave her a bath and bounced her up and down, Elizabeth noticed that her left hip would col-

lapse. "But by this time she was my child and I was facing that problem as any mother would." Schell had arranged for Elizabeth to see other babies who were perfectly healthy, and when the adoption papers were being finalized, a judge begged her to reconsider, because they wanted her to have a "perfect baby." But it was too late, Elizabeth said, she was in love. She named her Maria, after Maria Schell. Baby Maria had one major operation to fix her hip, and she was in various body casts for five years.

The adoption took place as her fourth marriage was unraveling. Fisher considered his job to be her chaperone, manager, and minder, which was not terribly romantic. He instructed the household staff: "Remember that there isn't anything more important than the sleep and rest of Elizabeth Taylor." His own career had floundered and he was becoming more and more like an overprotective brother than a lover. And she was getting bored. The same thing had happened with Michael Wilding.

When an interviewer asked her whether she liked "a strong man," Elizabeth did not hesitate to say, "Definitely. I couldn't live with a weak man." She had hated being controlled by the studio, and now she was being controlled at home. Fisher watched how much she ate, how much she smoked, and especially how much she

had to drink. Even though Fisher was getting regular injections of liquid vitamins and methamphetamine—prescription speed—from the infamous Dr. Max Jacobson, he disapproved of her heavy drinking.

The first day Elizabeth saw Richard on set he came up alongside her and said, "Has anybody ever told you that you're a very pretty girl?" She was not at all impressed. "Here's the great lover, the great wit, the great intellectual of Wales, and he comes out with a line like that." She ran back to her dressing room to tell her hairdresser all about it. She knew Richard's reputation. ("Richard, you'd screw a snake, wouldn't you?" Joan Collins once said to him. "Only if it was wearing a skirt darling," he replied.) Elizabeth did not want to be another notch on his belt.

But that changed on January 22, 1962, when Elizabeth and Richard shot their first scene together. Richard had gone on a bender the night before, drinking everything he could get his hands on, including drinks that people had left behind at the bar. It was five o'clock in the afternoon, and he had not slept for two nights. He got a cup of coffee, but he could not bring the cup to his lips because his hands were shaking so badly. He asked Elizabeth for help.

"Hold this, love, will you hold it to my mouth?" She held the cup up to his mouth and started to giggle.

"He was such a slob," she said later, "he was such a mess, and I looked into those green eyes that were twinkling and smiling at me and he drank the whole mug and we kept staring at each other." She remembered, being so close to him, seeing the grog blossoms—the burst blood vessels on the face of a heavy drinker—and falling for him then.

Richard had come across as so arrogant, but she was caught off guard by his actual vulnerability. He would memorize all his lines, and everyone else's, and had this big booming theatrical voice that made Elizabeth sure she would be intimidated by him, when in reality he had shown her that he needed her. Her heart, she said, "*cwtched*" for him, which means "hug" in Welsh. When he forgot one of his lines she fell for him even more.

He was as magnetic as Mike Todd and as brilliant as Max Lerner. She was infatuated from the moment she saw him. "I get an orgasm just listening to that voice of his," she said.

And he felt the same. "I fell in love at once. She was like a mirage of beauty of the ages, irresistible like the pull of gravity."

Producer Walter Wanger stood on the set and watched amused as the two of them huddled together talking during their first days of filming. Elizabeth was wearing a yellow silk gown and Richard was in a knee-length Roman toga. When they were called to start filming, they pulled away from each other and went to their places, but an invisible rope always seemed to draw them back together.

Richard began to point things out to her about the way she was living her life, like how strange it was that she only wore Mike's wedding ring and often left the one Fisher gave her behind. He said that she seemed to be stuck four years in the past. "He was like Prince Charming kissing the sleeping princess," she wrote.

Fisher stopped coming to the set when Richard and Elizabeth had a scene together; their flirtation was too obvious and too humiliating. "Burton-Taylor on set are so close you'd have to pour hot water on them to get them unstuck," remarked one Fox publicist.

Still, Fisher and Sybil acted as though everything was fine, even though it was hard to overlook the attraction between Sibyl's husband and the leading lady.

A woman on set would call Sybil at home and warn her, anonymously, whenever she saw Richard and Elizabeth together when they weren't filming. Their marriage had survived many affairs before, and Sybil

believed that an affair with Elizabeth would be no different.

One evening Richard and Sybil and Eddie and Elizabeth went out with another couple, and Fisher kept saying they'd better call it a night. It was only 9:30 p.m., and Elizabeth was happy to be out, sitting across the table from Richard. Richard, always the center of attention at a party, kept talking, and he kept refilling his wine and covertly giving it to Elizabeth so that she had several drinks that Fisher hadn't noticed.

She tried to stay with Fisher, but it was getting harder and harder. Richard brought her life into focus, and because of him she saw that Fisher was dull and needy; she spent most of her time mothering him. Fisher appropriately described himself as "the doormat to her stiletto heels."

Every night she still dreamed either that she was in the plane crash with Mike or that he was alive. "I was married to a ghost and the ghost was more alive to me than any human being, which was not very healthy," she said later.

Truman Capote felt sorry for Fisher. "He was so much in love with her and she was so rude to him." She threw a dinner party at their villa and Richard was among the guests. As he was regaling everyone with a story, Fisher got up and went over to the piano to belt out a song.

"*Shut up!*" Elizabeth yelled. "We can't talk." Fisher slammed the top of the piano down and went into another room, where he started blasting his records. She covered her ears, enraged. Uncomfortable, Kurt Frings got up to leave. "All right, Elizabeth, we'll go now."

Elizabeth was miserable. On February 13, 1962, Fisher went to a ski chalet they had just bought in Gstaad, Switzerland. The next day Elizabeth was upset on set, and Wanger and Mankiewicz asked her what was wrong. Fisher, she told them, had called Sybil Burton before his plane left for Switzerland and told her that his wife and her husband were sleeping together. Of course, Sybil knew that already, and she decided to leave Rome and go to the United States, which only fueled the global curiosity surrounding their affair. News reports that Elizabeth had tried to throw herself through a window of her villa were in the morning papers. When Wanger and Mankiewicz went to see her, she was being treated by a doctor, and though she looked all right physically, she was clearly unwell mentally.

"I feel dreadful," she told Wanger during a long conversation in her living room; she sat in a gray-blue Dior nightgown, looking pale and exhausted. "Sybil is such a wonderful woman." It did not help that her very good friend Roddy McDowall was also one of Sybil's

closest friends. In fact, Roddy may also have told Sybil the truth of what was happening between Richard and Elizabeth. The guilt and shame were beginning to eat away at Elizabeth, not because she cared what people thought of her, but because she worried about what she was doing to Sybil and Richard's two daughters.

Wanger tried to calm her by talking about the tides of life and how everyone goes through different phases. She said, "Funny you should say that. Richard calls me 'Ocean.'" She said that she needed to go upstairs to her bedroom and rest until around 5:00 p.m. Wanger went into another room to confer with the half dozen other people who were trying to manage the situation. They were all worried that the affair could derail the rest of filming.

When Wanger went to check on her, Elizabeth was in bed and said she had taken some sleeping pills. He said she should have something to eat, and when he came back upstairs panic set in. Elizabeth had fallen asleep and no one knew how many pills she had taken.

They sent for an ambulance, and because some members of the household staff were being paid to inform photographers, the paparazzi were already gathered at the Salvatore Mundi Hospital before they arrived. Eddie Fisher and Richard Burton both came running to Elizabeth's side—though Richard decided

not to visit her in the hospital because it would cause an even bigger scene. He released a statement saying that he and Elizabeth had been "close friends for over twelve years," which was not true, but it gave the press a way to include him more, perhaps strategically, in a news story. And maybe he wanted it that way.

Richard was a respected stage actor before, but once he was linked with Elizabeth he became world famous, and he was enjoying it. When Laurence Olivier asked him if he wanted to be "a household word or a great actor," Richard replied, "Both!" The moment their affair became public, his agent began asking for half a million dollars per film. Everywhere he went, even when he was alone, he was followed by dozens of paparazzi. "Maybe I should give Elizabeth Taylor ten percent," he told columnist Sheilah Graham. But when Graham asked him if he would ever marry Elizabeth, he replied flatly: "No."

Their affair ushered in an era of decadence and glamour never seen before. He bought her gifts at Bulgari's store on the elegant Via Condotti and presented them to her, even while Sybil was visiting him in Rome. "Bulgari is the only word Elizabeth knows in Italian," Richard quipped. Elizabeth suggested that he buy something for Sybil from Bulgari too, and he ended up getting her something worth about a quarter

of the value. On set Elizabeth showed off her new jewelry while Richard agonized over whether Sybil would find out.

When filming moved to the shores of the Mediterranean, Richard marveled at Elizabeth's sense of humor. She would climb a ladder from her yacht to Cleopatra's barge, where Cleopatra is planning world domination, and she would wear her heavy costume over her bikini. In between takes, she would take off the costume and sunbathe on the deck of the yacht in her full Cleopatra eye makeup. In one scene, Cleopatra uses miniatures to plot a battle in her effort to conquer the world. When she messed up a line, Elizabeth joked, "Antony, Antony, you *schmuck*, can't you see you're walking into a trap?" She was able to block out the sightseers in their boats trying to get a better look at her because she had spent her whole life doing just that.

She was madly in love with Richard, and when he flirted with other women—which he never stopped doing—she was confused. "My heart feels as though it is hemorrhaging," she told Wanger. She needed to reach an understanding with Richard about how serious their relationship was before they continued filming together; he was too enamored with his sudden ascent into the upper echelons of celebrity to take her inner turmoil seriously.

Their stormy relationship helped fuel their performances as the scandalous Mark Antony and Cleopatra. Once, when Richard flaunted a blond showgirl in front of Elizabeth, she shot him such an icy glare on camera that he took her aside and said, "Don't get my Welsh temper up." A story ran on March 8, 1962, saying that Richard was never going to leave Sybil. And while Wanger and Skouras worried that their affair could put the movie in jeopardy, they were not above recognizing the ways in which Elizabeth's personal life could improve their acting. That same day, Elizabeth had to shoot the scene in which Cleopatra discovers that Mark Antony has abandoned her. She goes into his bedroom and with a knife cuts all his clothes in a rage. Elizabeth's own emotional upheaval was so believable that she actually hurt her hand, and a doctor needed to be called to the set to examine it.

The log of her on-set schedule reads like a soap opera. Several days she showed up late, or not at all, due to illness. It is clear that the tumult in her personal life was affecting her ability to work. An entry from March 21, 1962, reads: "Miss Taylor was having great difficulty delivering dialogue. She said she had not slept the previous night and would be unable to continue working. She was dismissed to see the Dr. . . . Later that evening Miss Taylor—at her Villa—got

makeup glitter in her eye and Dr. Pennington visited her." The next day, March 22, the log reads: "Miss Taylor did not show up. Cast and Crew stood by on stage until 11 a.m. awaiting official word from Dr. Pennington. Dr. stated Miss Taylor damaged her eye [the] previous evening and was still sleeping at home. Expected back tomorrow. WRAPPED 11 a.m. NO SHOOTING."

By late March, Richard and Elizabeth were back on. They were going out to dinner on the fashionable Via Veneto in Rome and staying out until three o'clock in the morning. When photos of them ran with headlines like "LIZ, BURTON GO ARM-IN-ARM ON ALL NIGHT ROMAN DATE" and "LIZ AND BURTON FROLIC IN ROME; KISS, DANCE," Richard was incredulous. "I've had affairs before," he told a publicist at 20th Century Fox. "How did I know the woman was so fucking famous? She knocks Khrushchev off the front page."

But they were obsessively in love with each other. One especially passionate letter is in an envelope to Elizabeth marked "Very Private and Personal." Richard once wrote to her: "Read my diary. There's a little bit in it about you, I thought you might like to know what it feels like to fuck you." Their romance launched a worldwide media frenzy that marked the beginning of

modern celebrity culture. Richard called their relationship "Le Scandale," and he and Elizabeth were very much aware of the excitement their presence created wherever they went. They did not seem to be hiding from the cameras when, between shooting scenes of *Cleopatra*, an iconic photograph was taken of them on a boat off the coast of Ischia, when they were both still married to other people. Photographs of them kissing on yachts in the Mediterranean and dancing at nightclubs on Rome's Via Veneto not only knocked the Cold War off the front page, stories about their romance also supplanted John Glenn's orbit of the Earth in 1962.

No celebrity couple had ever gotten this much attention. Fox's head of American publicity, Jack Brodsky, could not walk into a café in Rome without being surrounded by members of the paparazzi trying to bribe him for photographs of Richard and Elizabeth on set. Everyone around the world wanted to know more about this gorgeous and decadent couple; the only time the Associated Press's Rome bureau had received more requests for stories was after a pope died. Photographers camped out in trees around Elizabeth's and Richard's respective villas and made sources of household staff. Fox hired nine plainclothes police officers to guard the set, knowing that at least one of the stagehands would probably end up working with the press. But there was

nothing they could do about it; Elizabeth and Richard were making the paparazzi's jobs easy.

Richard continued to deny their relationship even with their displays of public affection on Rome's most famous street. "I just got fed up with everyone telling us to be discreet," he said. "I said to Liz, 'Fuck it, let's go out to fucking Alfredo's and have some fucking fettuccine.'"

He was not interested in hiding anymore because, he told Mankiewicz, he was falling more and more in love with Elizabeth every day. During one love scene between Cleopatra and Mark Antony, when Mankiewicz yelled "Cut!" Elizabeth and Richard stayed in each other's arms. He repeated, "*Cut!*" and still nothing. Finally, he told them, "I feel as if I'm intruding."

Their affair was such enormous news that even the Vatican was paying attention. In an April 1962 open letter in Vatican City's weekly newspaper Elizabeth was charged with "erotic vagrancy" because she was sleeping with Burton while still married to Fisher. The Vatican talked of "this insult to the nobility of the hearth."

Her decision to adopt Maria with Fisher was reconsidered by the same publication after she started seeing Richard: "Don't these institutions think before handing children to somebody? Don't they request moral

references? Was it not better to entrust this girl to an honest bricklayer and to a modest housewife rather than to you, my dear lady, and to your fourth ex-husband? The housewife and the bricklayer would have worked harder and would have seriously made sacrifices for their child. You, instead, have other things to do." For the rest of her life she feared nuns and priests, and she was haunted by the Church passing judgment on her.

Someone translated it into English for Elizabeth and read it to her when she was in the dressing room on the set of *Cleopatra*. "The day after that somebody was out in the studio trying to blow me up with a bomb, so the Italian FBI were out there for five days." Ed Sullivan joined the angry mob: "You can only trust that youngsters will not be persuaded that the sanctity of marriage has been invalidated by the appalling example of Mrs. Taylor-Fisher and married man Burton."

"My life," she said several years after she met Richard, "has lacked dignity, let's face it, for the most part." The adjectives she used to describe her public image at the time are undeniably harsh: "scarlet woman," "untrustworthy," "fairly unstable," "completely superficial," "lame-brained." She said that perhaps the most damning thing was this: She may be considered physically beautiful, she said, but people thought that "inside [was] not too pretty a picture." The public had

always been consumed by her physical beauty; ever since she was a teenager she was called "luscious Liz" in the press. But that beauty had been imbued with a certain darkness. She filed lawsuits against six fan magazines for portraying her as "an experienced and shameless courtesan."

Elizabeth was kick-starting the sexual revolution of the late 1960s and '70s in the United States that would drastically shift the cultural landscape and would expand the agency that women had over their own bodies. A 1964 5,000-word unbylined cover essay in *Time* magazine questioned the changing morality of the era, "in which pleasure is increasingly considered an almost constitutional right rather than a privilege, in which self-denial is increasingly seen as foolishness rather than virtue. While science has reduced fear of long-dreaded earthly dangers, such as pregnancy and VD, skepticism has diminished fear of divine punishment. In short, the Puritan ethic, so long the dominant moral force in the U.S., is widely considered to be dying, if not dead, and there are few mourners." Elizabeth was certainly not grieving for the moralizing of the 1950s, a decade when heterosexual marriage was inextricably linked to the American dream, when premarital sex was considered sexual deviousness, and when homosexuality was thought to be a mental illness. During the 1950s, there

was "good" and "bad" behavior, and the kind of moral certitude that Elizabeth found repellent. She never lived her life in black and white; to her there were always many shades of gray and reasons why people make the decisions they make.

But this massive shift took time. The FDA did not approve the birth control pill until 1960, and it was not until 1965 that Planned Parenthood of Connecticut won the U.S. Supreme Court case *Griswold v. Connecticut*, which rolled back state and local laws outlawing the use of contraception, even by married couples. Journalist and playwright Clare Boothe Luce declared, "Modern woman is at last free as a man is free to dispose of her own body, to earn her living, to pursue the improvement of her mind, to try a successful career."

The problem for Elizabeth was that she was just a little too early. When her passionate affair with Richard riveted the world, many women did not yet have access to the pill (it was not until a 1972 Supreme Court case that birth control became legal for all women, married and single), and the morals of the 1950s were still very much intact. In 1962, after the Vatican had denounced her, Elizabeth was to shoot *Cleopatra*'s grand entrance into Rome. She was terrified, because she assumed the six thousand Italian extras hated her. They were likely Catholic, after all.

In the scene, Cleopatra arrives in Rome on top of a giant gold sphinx three floors high, with her son, Caesarion, at her side. Her magnificent costume includes a 24-karat-gold gown and a fifteen-pound headdress that was two and a half feet tall. There were twenty-six snake dancers, thirty-six trumpeters riding white horses, one hundred and fifty Roman senators, and fifty archers shooting arrows into the sky. Elizabeth was uncharacteristically afraid. "I don't think I can do it," she told Richard when they arrived on the set. Studio executives were worried too. They dispatched a group of sharpshooters from Rome's police antiterrorist squad to rooftops in sight of the *Cleopatra* set. Other officers were disguised as extras. There was palpable fear on the set that something might go wrong.

"Being pulled through that mob," Elizabeth confided in Mankiewicz, "alone up there—who knows—they'll jeer at me and they'll throw rocks at me."

As the enormous sphinx approached Caesar's throne, the thousands of extras were supposed to shout "Cleopatra! Cleopatra!" *Here it comes, Bessie,* she thought to herself. Instead they cheered and said, "Leez, Leez! *Baci, baci!* [Kisses!]" She started weeping. Mankiewicz stopped rolling the cameras and someone handed her a microphone. She had been hazed before: loved and hated, cursed and celebrated, and the

hot tears were pouring down her cheeks. "Thank you very much," she said in Italian.

But in the United States, a Georgia congresswoman named Iris F. Blitch tried to stop Elizabeth and Richard from ever entering the country again because of their affair.

"It is my hope," Blitch said, "that the attorney general, in the name of American womanhood, will take the measures necessary to determine whether or not Miss Taylor and Mr. Burton are ineligible for reentry into the United States on the grounds of undesirability." New York congressman Joseph P. Addabbo joined Blitch in self-righteous disgust. Antony and Cleopatra "were angels compared to what is going on in Rome between Elizabeth Taylor and Richard Burton," Addabbo declared. The media outrage is hypocritical and deeply sexist, especially given the lengths that the mostly male press corps went to hide President John F. Kennedy's extramarital affairs taking place at the same time.

Over Easter weekend, Elizabeth and Richard fled to Porto Santo Stefano, but the weekend ended abruptly when Elizabeth suffered severe injuries to her face and had to be sent to the hospital for treatment. Rumors swirled that she had tried to commit suicide again, or that Richard had hit her, but she said that her chauffeur slammed the brakes and she had hit her head. In

any case, the studio was keeping a close eye on how the relationship was affecting their filming schedule, and even Walter Wanger, who adored Elizabeth, was frustrated.

Cleopatra was threatening to take down 20th Century Fox. Skouras's job was on the line. In the summer, Fox executives flew to Rome and fired Wanger. But Wanger kept working on the film as a producer without pay. Cleopatra's arrival in Tarsus to meet Antony was one of the most elaborate scenes in the movie, and it had not yet been filmed. She arrived on a 250-foot-long barge with a 100-foot mast as forty handmaidens scattered rose petals on the water and seventy-five swimmers dove for coins thrown by dozens of other handmaidens. The scene was lavish and incredibly expensive, including a bill for chopped fish to get seagulls out of the scene. The total cost was $1,100 ($10,000 in today's dollars).

On May 17, 1962, Wanger got a call from Elizabeth's secretary, Dick Hanley, informing him that Elizabeth could not work because she had swollen eyes. She had cried all night after getting into a fight with her parents.

She had asked them to come to Rome. They had never met Richard, but they did not want the world turning against their daughter—again. Sara described that evening. "One night we were having dinner with

Elizabeth when after dinner she showed us a beautiful huge diamond-and-emerald brooch, which Richard had just given her. It cost $93,000 and it was the most expensive piece of jewelry she owned up to that point. Richard, the son of a Welsh miner, had never bought anything that expensive before. Daddy was furious and made Elizabeth sit down while he lectured her and told her she could not keep it, that she had to give it back to Richard." Elizabeth began sobbing, and Sara started to cry seeing her daughter in such pain. When Richard met Francis and Sara on the set, he shook her father's hand and said, "Mr. Taylor, I want you to know I understand perfectly how you feel. If she were my daughter, I would feel exactly the same way."

That summer Elizabeth and Richard went on a yacht to Capri. Halfway through lunch Elizabeth had a strange feeling that she was being watched; she had grown so accustomed to that feeling that she recognized it immediately. Richard told her that she was being paranoid, but she could hear the sound of a video camera rolling. She noticed a bulge behind the curtain on the deck.

When one of their friends went up to the curtain and pulled it back, they found cameras trained on Elizabeth and Richard. There was no place to hide, not even on board a yacht with friends.

When Fisher returned to New York, he decided to hold a press conference at the Hotel Pierre to deny everything. About Richard he said, "He is a friend of mine. We're not close friends—I haven't known him long. He is an amusing, pleasant, charming guy and a very fine actor." When reporters asked if Elizabeth would make a statement denying rumors that they were separated, he said, "I think she will—yes."

He called Elizabeth in Rome during the press conference. The scene was playing out in real time. He told her to tell the press that the news out of Rome was not true.

"Well, Eddie," Elizabeth said, as though she were talking to a child. "I can't do that, because there is some truth to the story. I just can't do that."

"Wait a minute," he said, "what do you mean you won't do that?"

"I can't say that because it's not true. There is a foundation to the story."

"*Thanks a lot!*" he screamed before he slammed down the phone. He returned to the press conference and meekly explained that Elizabeth would actually not be issuing a statement. "You know you can ask a woman to do something, but she doesn't always do it," he said, trying to get a laugh. Headlines screamed: "LIZ TURNS DOWN EDDIE'S OCEAN PHONE

LOVE PLEA." It was over; she refused to lie. A bitter Fisher went back to work, and in his nightclub act he included the song, "I'm Cleo, the Nympho of the Nile." (Richard once rated Elizabeth's husbands and called Fisher "deplorable.")

But Fisher, of course, had reason to despise Richard. One night before Fisher finally left for New York, Elizabeth and Richard returned to Villa Papa drunk, and they sat with Fisher for a six-hour blistering conversation.

"Elizabeth, who do you love? *Whooo do you love?*" Richard said.

She looked at Fisher and then at Richard and replied, "You."

Richard snapped his fingers and said, "That's the right answer." His face hardened. "But it wasn't quick enough."

Fisher said that he had heard that Richard had punched her and kicked her out of the car when they were in Porto Santo Stefano, and that is why her face was bruised. He admitted that he could never be the possessive, domineering husband that Elizabeth wanted. Slowly he was coming to accept the reality that was unfolding before him.

The sympathy the public bestowed upon Elizabeth after the tracheotomy had now evaporated. A sick woman is far more sympathetic than a woman who

enjoys sex and leaves her husband. Rome's *Il Tempo* declared her "an intemperate vamp who destroys families and devours husbands." Another publication asked, "Does Liz Need a Spanking?"

"Poor Debbie" turned into "Poor Sybil."

Elizabeth even felt self-conscious when she talked about Richard with her friends. Shirley MacLaine recalled a conversation when they were drinking champagne, and Elizabeth thought her friend was judging her. "She lifted the glass of champagne and she looked straight into my eyes and her eyes welled up with tears, and she said, 'Richard has taught me how'—and the tears spilled over and she put the glass here so that the tears would fall into the champagne—'how to love.' I started to cry, I thought, *Listen, she loves this man whatever I've heard about him*. She had it so poetically described to me so that I would approve."

Richard moved into the elegant Villa Papa, where she and Fisher had lived. When they weren't working they escaped to a small one-room apartment on the beach. "I'd barbecue," Elizabeth recalled, "and there was a crummy old shower and the sheets were always damp. We loved it—absolutely adored it."

Elizabeth asked that her last day of filming not be publicized. She was terrified that once she was done with *Cleopatra*, Sybil would come back to Italy and

reclaim her husband. On that final day, she came off the barge at Ischia Ponte and was helped into a small launch at the edge of the pier, kissed Mankiewicz, and was off. She cried later.

After more than two hundred days of shooting, Elizabeth's part in the cinematic quagmire was over. She was unable to accompany Richard to film the final two weeks in Egypt because of her very public conversion to Judaism and her support of Israel. (She deplored discrimination and anti-Semitism. Once, when she tried to buy a co-op in New York, she said that because she was Jewish the members of the board did not initially want to let her in. "They said, 'We'll make an exception for you because you're Elizabeth Taylor.' And I said, 'You can take your building and you know where to put it.'")

Elizabeth fled to Chalet Ariel, the secluded home she and Fisher bought in Switzerland, which would become her refuge and her only real home for years. Six months of "Le Scandale" had left Elizabeth both consumed by her love for Richard and tormented knowing how many people they had hurt. Eddie Fisher was not of particular concern, because she thought of herself as more of a maternal figure by that point than his lover. But Sybil, and Richard's daughters, were weighing on Elizabeth's mind. Her guilt was compounded by the

fact that his younger daughter, Jessica, had been diag-
nosed with schizophrenia and autism. (Decades later,
in 1980, Elizabeth still felt so guilty that she tried to
visit Jessica.) All told, ten people's lives were being af-
fected by their decisions, including Sybil and Fisher,
her four children, and Richard's two children. For a
time, Richard went back to his family.

Elizabeth may have felt guilty, but she would not
apologize. She had seen what happened a little more
than a decade earlier when the actress Ingrid Berg-
man was exiled because of infidelity. She was a sexual
being, and she was not about to capitulate and say that
meant she was a seductress with an insatiable and reck-
less desire for sex. She simply enjoyed it.

The time she spent with her children in a quiet resort
town off-season was lonely. Her children tried to buoy
her spirits. "I prayed to God last night that you and
Richard would be married," an eight-year-old Chris
Wilding said to his mother, making her weep.

She began divorce proceedings with Fisher. She came
to loathe him, and she could not escape the memory of
one particular night in Villa Papa when he'd held a gun
to her head. Fisher had removed the doorknobs to the
bedroom and was caressing her head with a gun while
they lay together in bed. That was the terrifying night
when he told her that she was "too pretty" to kill. She

always kept in touch with her exes, "except Edna," she said many times over the years, using her nickname for Fisher.

Elizabeth was in the depths of her misery shortly before Marilyn Monroe overdosed. She said later that Monroe's problem was that she was terrified of getting old. She felt sorry for her, knowing that she never had a stable home. She knew that she was stronger, though she never would have said it.

"Marilyn allowed herself to wear the very heavy burden of sex symbol. I watched Monty, born a free spirit, allow his wings to be clipped just because of studio pressure and the heaviness it brings. Not me. I refused to wear any sense of responsibility to anything or anyone other than me."

In an off-the-record conversation with Richard Meryman in August 1965, she said that she only met Monroe two or three times. "She was so sweet and friendly, and kind of trying to be outgoing. . . . Each time I felt so depressed and sad because I myself couldn't reach her and she was a generous and sweet girl."

Elizabeth was pitted against Monroe in the press because they were considered the most beautiful, sexiest movie stars of the 1950s and early '60s, and everyone likes a catfight, no matter how fictitious. But in reality they were never rivals.

In 1962, when 20th Century Fox was nearly bank-rupt because of *Cleopatra*, the studio fired Monroe from her final film, *Something's Got to Give*, which was never completed. Monroe thought Fox fired her because they were spending too much on Elizabeth and her overbudget epic. Monroe was being paid $100,000 compared to Elizabeth's $1 million salary for *Cleopatra*.

Twenty years later, Elizabeth told a friend that she had called Monroe and offered to quit *Cleopatra* and only return if Monroe was rehired. Marilyn was touched by the offer, but such a public act of defiance against the studio would probably only hurt them both, she said.

Elizabeth understood. She had been in the busi-ness much longer and she had seen everything. She left Marilyn with this advice: "No matter what they write about me, Marilyn, I never deny it. I never confirm it. I just keep smiling and walking forward. You do the same." (This was advice that Spencer Tracy, who never addressed reports of his long affair with Katha-rine Hepburn, had given her.) Marilyn did not have the emotional support that Elizabeth did, and she suc-cumbed to the pressures of her life on August 4, 1962.

Elizabeth knew that she had advantages that Marilyn did not, including a mother who was overzealous but

who also protected her. In an off-the-record conversation in 1964, when a journalist asked Elizabeth about the transition from being a child star to an adult on-screen, Richard interrupted and said: "I think she was lucky because she's a girl. I think it's much easier for girls to make the transition, except that I can't think of any other girls who've made it. Oh yeah, Judy Garland made it from juvenile to senile." Richard and Roddy McDowall laughed. Elizabeth did not.

"Richard!" she said. "It's a lousy . . ."

McDowall stopped her and said, "You love it."

"I don't!" Elizabeth said. Even off-the-record she would not get down in the mud with them.

Elizabeth was actually asked to play the self-destructive character based on Marilyn in the film version of Arthur Miller's play *After the Fall.* "I would like to take that man [Arthur Miller, Monroe's ex-husband] and kick him where it hurts . . . how base, how base, how low, how despicable." She screamed at the producer who offered her the role. "You've never heard such a stream of abuse over the telephone from my purled lips."

Elizabeth did not want to be a sex symbol like Monroe, because to her it was inauthentic. "I would rather be a symbol of a woman, a woman that has made mistakes, a woman that loves. A woman that

has children. . . . Sex is real. It's something you can touch and feel and smell. And it's your wife, or your husband. . . . Sex is love!"

She hated being sexualized. "Maybe because of my personal life, I suggest something illicit, but only suggest because I am not illicit and I am not immoral. I have made mistakes. And I have paid for them."

Richard had a unique take on the differences between the three major bombshell beauties of the era. "Sophia's Mama Mia, you know, gorgeous Mama Mia. Marilyn was this innocent. And Elizabeth is wild," he told Meryman. "She's queen-like, princess-ish. And it's no accident that she's called Elizabeth. . . . I mean, *Suddenly, Last Summer*, when you're standing in the room at the very beginning, it's distant, like, 'Don't touch.' Whereas Marilyn was shoving her whole body at you, saying, 'Touch.' It's a totally different kind of personality."

Elizabeth and Richard spent two months apart during the summer of 1962. Her parents were staying nearby, and Richard was less than a two-hour drive away in Céligny, a small Swiss village near Geneva. One day Richard called and asked her to lunch at Chateau de Chillon on Lake Geneva at two o'clock. They were coming from opposite directions, and she rode

in the back seat of the car with her parents. They had not seen each other since *Cleopatra* wrapped, and there he was, green eyes bright against a deep tan.

She grabbed her father's arm and then her mother's. "I don't know what to do, I'm scared."

"Have a lovely day, baby," Sara said as she wrapped her arms around Elizabeth. Sara and Francis must have known how unhappy she had been without Richard, and whatever apprehension they had about the relationship was diminishing. Richard had spotted them and walked over to the car to say hello, at which point Francis gave his daughter a gentle push. When she got out, she and Richard awkwardly shook hands as her parents drove away.

At lunch, they stammered and talked over each other. He drove her home without even a single kiss. They retreated to their separate Swiss chalets, where they lived to avoid taxes, and reconvened for lunch every few weeks.

She missed Richard so much that she decided she would be available to him whenever he needed her. She would be content living as his mistress because, she reasoned, it was better than nothing at all. They spent fifteen months in this awkward dance while Richard was deciding whether he should leave Sybil. She told Dick Hanley that without Richard she had the feeling

of "scenes missing," a term in the business for a title code indicating that there are more scenes to be added to a movie. She was forever a daughter of Hollywood.

Elizabeth's children carried their own trauma from this period in their mother's life. Michael and Christopher did not see their father much, Liza's father was dead, and Maria did not really know Eddie Fisher. Richard adopted Maria in 1964 after he and Elizabeth got married, and she is the only child of the couple. Maria remembers going to a dinner party in New York in the early 1990s and sitting across from Eddie Fisher. She had not seen him since he and Elizabeth had divorced. He looked at Maria with tears in his eyes and said, "You were meant to be one of my children." It was such a heavy moment that she did not know what to say.

Every day Elizabeth's children asked where Richard was. Sometimes, when he came to visit them in Gstaad, he seemed depressed.

"He is sad," Elizabeth told them, "because he loves his own children and he loves you. And he loves Sybil and he loves me. He loves us all, but unfortunately he can't be with us all."

Occasionally, when Richard stared off into space, she told them not to worry, that he was not mad at them. She called his dark moods his "Welsh hour," a "Celtic

melancholy" that she said was common for the Welsh. Best to give him space, she told them.

Maybe, Elizabeth thought, *after twenty-five or fifty years of marriage all this pain that we went through and that we inflicted on others would be worth it.*

When she was with Richard she finally felt like she could stop searching. She mused to her friend Truman Capote, "What do you suppose will become of us? I guess when you find what you've always wanted, that's not where the beginning begins, that's where the end starts."

Chapter 11
Crazy, Stupid Love,
1964–1973

Well, first of all, you must realize that I
worship you. Second of all, at the expense
of seeming repetitive, I love you. Thirdly,
and here I go again with my enormous
command of language, I can't live without
you. Thirdly, I mean fourthly, you have
an enormous responsibility because if
you leave me I shall have to kill myself.

—Undated letter from Richard to Elizabeth

After *Cleopatra* wrapped, Elizabeth and Richard were in London making *The VIPs*, a film that Elizabeth knew was not destined to be a cinematic masterpiece; it was simply a way for her to be with

Richard. And that was all she cared about—and so did he. Richard had been asked to read the script for the film, which is about a group of jet-setters who find themselves cooped up at Heathrow Airport when their plane is grounded. Richard did not like the script, but Elizabeth sensed that it would make them a lot of money. Once she found out that Sophia Loren was slated to play Richard's wife, it was settled. "Tell her to stay in Rome," she said. "I'll do it." Elizabeth had a lifelong rivalry with Loren, whose beauty and sensuality were as smoldering as her own.

Richard kept a diary and wrote a huge number of notes and letters to Elizabeth that show a man completely enthralled. He ends one with: "Would you, incidentally, permit me to fuck you this afternoon?" and in another he wrote: "I love you badly like a disease. I dream of you curled up asleep. I'm even jealous of the bed. . . ."

In another letter, he laid bare his feelings for her using poetic language. He was a frustrated writer who channeled his pent-up creative energy into letters. Many times he left notes behind for Elizabeth to read in their hotel suite when they were separated from each other over the course of a matter of hours. There's a sense of urgent passion in his letters to her:

Dearest Elizabeth,

You asked me to write to you the truth about us. . . . Prometheus was punished by the gods forever and is still suffering *in all of us* for inventing fire and stealing it from the gods. I am forever punished by the gods for being given the fire and trying to put it out. The fire, of course, is you. I cannot put you out . . . you will always be like some ineradicable, ineluctable, sulfur in my inadequate and vulnerable hands.

He called her "probably" the best actress in the world, but there is a sense from his letters that he never completely trusted her. When she acted with other men he grew jealous: ". . . remember, no kissing with open mouths or breathless excitement and all that stuff otherwise I will be down at the studio and certain girls [Elizabeth] will have a very rough time."

The drama that surrounded *Cleopatra* continued, even after filming had ended. Skouras was no longer president of Fox, in large part because of *Cleopatra's* exorbitant price tag, and he was replaced by Darryl Zanuck. Mankiewicz showed Zanuck a rough edit of the film, and Zanuck decided to fire him, depriving him of the chance to put the finishing touches on the

project that he had labored over for years. Eventually, they reached an agreement, and Mankiewicz agreed to shoot some additional scenes. The final shots were completed in March 1963. Mankiewicz cut the film down to eight hours and kept pushing for a two-film release: *Caesar and Cleopatra* would be the first and *Antony and Cleopatra* the second. Zanuck would not allow it. People wanted to see one big blockbuster movie and that is what Fox had been brought to its knees to give them.

Elizabeth and Richard stayed in separate suites at the Dorchester in London while filming *The VIPs*. Elizabeth was separated from Fisher, but Richard was still living a double life and visiting Sybil at their home in London. He had to make a choice. "I love Sybil, my first wife, but in a different way," Richard explained. "My love for Elizabeth is more complete, more . . . more necessary, I suppose." But his decision came at a high price. "I didn't see either of them [his two children] for two years after Sybil and I separated; it was a nightmare time. How Elizabeth put up with me during that period I don't know. I couldn't think of anything else. My dreams were shot with pictures of Kate [his eldest daughter]."

Kate was five years old when he and Sybil divorced, and Jessica was even younger. Sybil had held on as

long as she could, hoping to reconcile and willing to put up with her husband's double life, but eventually it became too painful. In April 1963, Sybil left for New York with their daughters. She filed for divorce on the grounds of "abandonment and cruel and inhuman treatment" and added that her husband was "in the constant company of another woman." They were divorced in December, and Sybil won custody and received a $1 million settlement.

Richard's guilt about abandoning Sybil and his daughters was impossible to shake, especially given the amount of time that he spent with Elizabeth's children, including her daughter Liza, who was Kate's age. His diary entries show his admiration for Liza's determination and intelligence. "Understand that I love both children [Kate and Liza] to the point of idolatry," he wrote in 1969. In the back of his mind he felt like a fraud who had left Wales and his working class coal-mining family behind and made a Faustian bargain to pursue a lucrative career in Hollywood with Elizabeth over his dream of becoming a respected writer. All of this worsened his drinking, and it became apparent that Richard had an inescapable problem. Once he started, he could not stop. "He knew full well that he had a problem with booze, though he would try to legitimize it by pointing to noted historical figures,

especially among the literati, who had gloriously gone down in alcoholic flames," said Chris Wilding, who grew up with Richard as a father figure. "Writers the likes of Dylan Thomas were Richard's real heroes, and I think that it ate at him that he didn't believe he had it in himself to be a recognized writer rather than an actor."

Chris remembers how difficult it was growing up the child of the world's most famous actress, especially in her early days with Richard, when the children lived in a separate suite on a different floor at the Dorchester. They also spent much of their time at boarding school, being cared for by Elizabeth's close friends Norma Heyman and Liz Smith (not the columnist, whom Elizabeth also knew) and by nannies. "She really was an earth mother but it extended to the entire universe," Wilding said. Sometimes Elizabeth's friends and staff got more attention than her own children did. Sara had smothered her, and Elizabeth wanted to give her children the freedom to make their own choices and their own mistakes. Later in life she would allude to the fact that she hadn't been there enough for them.

On one Saturday afternoon, Richard went to Cardiff, the capital of Wales, to watch a rugby match, and when he returned to Paddington Station he was beaten

up by a group of young men. They kicked him as he fell to the ground, and they would not stop kicking him. He was black and blue and had to wear a patch over one eye.

Wilding, who was nine years old, remembered hearing about it ten days later—that was how little of Richard and Elizabeth they saw. "Richard once told me," Chris continued, "'I'm not trying to take your dad's place.' My dad was sweet, maybe passive, but my mother needed more. She could go one of two ways with the men who chose to be in her life; the ones that worked were the men who could be her equal and the ones who could call her on her shit."

The first advertisements for *Cleopatra* showed Elizabeth and Richard in costume but did not mention the name of the film or even their names. They were the first major celebrity couple so well known that no identification or explanation was needed. It was the same with *The VIPs.* Movie posters showed the two of them with just the words "She and He . . ." People were voyeuristic about going to see Elizabeth and Richard acting together; they wanted to know if their sexual magnetism would be visible on the screen.

When *Cleopatra* premiered at the Rivoli Theatre in New York City on June 12, 1963, ten thousand people

were at the theater, a record crowd for a New York opening. And Elizabeth was not even in attendance. Reviews were mixed. The *Herald Tribune* said, "The mountain of notoriety has produced a mouse." The *New York Times* called it "one of the great epic films of our day."

The Legion of Decency, a Catholic group that identified what they deemed to be unacceptable content in movies, was not pleased with the final result. They declared the film a "pretentious historical spectacle which is seriously offensive to decency because of its continual emphasis upon immodest costumes throughout its four-hour running time. Boldly suggestive posturing, dancing, and situations compound the offense." Once again, Elizabeth's sexuality and femininity seemed to be on trial.

Rex Harrison, who played Caesar, came away with the best reviews, while Elizabeth and Richard were alternately praised and humiliated. Elizabeth's reviews were the most scathing, as though the critics were personally offended by her performance. She was objectified, a bitter reality she shared with Marilyn Monroe. She would be punished for perceived moral failings, a standard no male star had to live by, and her refusal to apologize only further infuriated her critics.

"Overweight, overbosomed, overpaid, and under-talented, she set the acting profession back a decade," said television talk show host David Susskind.

Elizabeth knew what it took to make a good movie, and she had predicted the blowback when she read the script back in 1959. She wanted Cleopatra's motivations to be more obvious; she knew the challenge that she faced portraying the world's most famous female ruler as a shrewd politician and a woman who was also ruled by love.

Elizabeth had spent several years of her life on *Cleopatra* in an acting job she came to call an "occupational disease." She threw up in the Dorchester bathroom when she got back from seeing the film for the first time. Richard claimed never to have seen it at all. Mankiewicz called it "the most humiliating experience of my career."

"The picture was conceived in a state of emergency," he said, "shot in confusion, and wound up in blind panic."

But *Cleopatra* was the highest grossing film of 1963 and it was nominated for nine Oscars, though Best Actress was not among them. It turned a profit in 1966 after ABC bought the television rights for $5 million.

Elizabeth had brokered such an unprecedented deal

for herself that when she voiced her opinion that Fox was getting an unfair amount of the initial gross, the studio shot back: "Miss Taylor failed to appear for work on at least forty working days in Italy, which cost the company between $150,000 and $175,000 a day." The gloves were off, and Elizabeth sued Fox to get the agreed-upon cut, and Fox sued both her and Richard for a combined $50 million: $20 million alone against Elizabeth for her absences and by opening herself up to "scorn, ridicule, and unfavorable publicity as a result of her conduct and deportment, during and after production and while the film was being distributed, so as to become offensive to good taste and morals and to depreciate the commercial value of the film."

Richard was guilty of the same offense, according to Fox, but they only sued him for $5 million. The remaining $25 million was essentially their punishment for having an affair. Never mind that studio head Darryl Zanuck was notorious for abusing his power and pressuring young women to sleep with him with the promise of stardom. The suit eventually fizzled out in a series of out-of-court settlements, but it plagued Elizabeth for years.

She dealt with the onslaught of negative reviews and lawsuits in stride. When *The VIPs* was released in September 1963, the reviews were nearly as scathing.

Her million-dollar fee was the issue. The public had expected more from Richard and Elizabeth because "Le Scandale" had made them notoriously wealthy and powerful. The *Daily Mail* spat, "If this king's ransom was being paid for her acting ability, then in this film at any rate, she has got away with monetary murder."

Even as her professional life was unraveling, Elizabeth's personal life was coming into focus. By April 1963, Richard and Sybil were officially separated, and in March 1964, Elizabeth's divorce from Fisher was complete. It took so long because Fisher was demanding more of the gross from *Cleopatra*, and at one point he even asked for $1 million in exchange for agreeing to a divorce. He dragged out the process when he later said that their divorce was invalid. He went to the press and accused Elizabeth of being a bigamist, to which she replied, "He's got to be joking."

Elizabeth and Richard were finally married in Montreal on March 15, 1964. She was thirty-two and Richard was thirty-eight, he was her fifth husband and she became his second wife. They flew in a chartered plane from Toronto, where Richard was doing *Hamlet*, to Montreal, because flying commercial would have alerted the paparazzi. They married in an eighth-floor

suite at the Ritz-Carlton. Elizabeth walked alone from one room to the other, where Richard was waiting for her. This might have been her most meaningful marriage, but it was also one of her least extravagant ceremonies. Elizabeth and Richard did not need to show the world that they were in love; everyone knew it already. Their passion was obvious.

Elizabeth wore a long-sleeved, low-cut, bright yellow chiffon Empire dress designed by Irene Sharaff, who had done her costumes for *Cleopatra*. She chose yellow because that was the color she had worn when they met and fell in love in Rome. She donned small white flowers in a long braid that ran luxuriously down her back and the emerald-and-diamond Bulgari brooch, the first piece of jewelry Richard had ever given her.

The Unitarian minister started the ceremony by saying, "You have gone through great travail in your love for each other." No truer words were ever spoken. They had been hounded and harassed, pilloried and praised.

They stayed up talking, laughing, and crying until 7:00 a.m. "I'm so happy you can't believe it," she said.

She and Richard hated crowds and worried that someone might hurt them; Richard was especially concerned that someone would throw acid at their

faces. Elizabeth had a recurring dream that she was trapped in a crowd and somebody lifted up a gun and shot her.

When they arrived in Boston at the Sheraton-Plaza Hotel for Richard's performance in *Hamlet*, three thousand people crowded into the lobby and spilled out onto the street. They were completely under siege.

"See if she has her wig on!" someone in the crowd yelled as someone else tugged at Elizabeth's hair and ripped some out in the process. There were only a few police officers in the lobby to protect the couple. One person's leg was broken in the crush with bodies so tightly packed together. It felt like an eternity as they waited for the elevator to arrive and bring them upstairs. Once the elevator came, Richard pulled her inside as someone else in the crowd was holding on to her other arm. "I really thought that Richard was going to end up with one half and this stranger would have the remnants of the other. Finally, the whole tangle sort of fell sideways, and I slid, half horizontally, to the elevator, trembling."

Her publicist, John Springer, who had also represented Marilyn Monroe, said that he had never gone through anything as terrifying. "I thought I was gonna die. . . . This was a very friendly crowd, but they were uncontrolled, and an uncontrolled friendly crowd can

be just as menacing as the most dangerous mob. . . . I thought I was going to pass out because it was a such a crush. . . . I just shook, literally shook, for an hour afterward. Elizabeth, of course, practically collapsed when we got up to the room, and we got a doctor for her right away."

Comparing Monroe's celebrity with Elizabeth's, Springer said, "One thing Marilyn could do and Elizabeth can't do is walk on the street by herself. Marilyn could put on dark glasses or a dark wig or something, she could walk on the street." Once, Elizabeth decided that she wanted to go to Central Park for a walk on a Sunday. She wore a sweater and a skirt, dark glasses, and a straw hat with her hair piled up under it, and Richard wore sunglasses. Richard told her that they would never make it. They went out the garage door of their hotel on Sixty-Fourth Street toward Madison Avenue, and some people started to recognize them. "Between Madison and Fifth Avenue, it was like the pied piper, they had attracted such a group following them," Springer said. "And by the time they got to Fifth Avenue, but before they could get into the park, they were so surrounded that they had to be rescued by the police and put in a cab."

In the late 1960s, they were on the Manson family's list of celebrity targets, which included Steve McQueen

and Frank Sinatra. Susan Atkins, who confessed to killing Sharon Tate, said that she planned to gouge out Elizabeth's signature blue eyes with a hot knife and castrate Richard Burton.

Elizabeth and Richard hired private security guards to protect their children, who were spread out across Europe attending different boarding schools. They followed their mother's whereabouts in the press. According to FBI records, in 1978 Elizabeth became entangled in a plot to extort money from several other famous women, including Jackie Onassis, who was the only woman alive with the same caliber of celebrity (other than Queen Elizabeth II). Onassis had received a letter that demanded she tell Farrah Fawcett, Elizabeth Taylor, and Cornelia Wallace, who was married to Alabama governor George Wallace, to send twenty-five thousand dollars or else they would all be killed. "Read this letter," it said. "If you don't, I will shoot you to death." Onassis turned over the letter to the FBI. All four women were interviewed by the authorities. Onassis, who was famously private, made a special request to the FBI: local New York police were not to be told, so that the story wouldn't leak.

Being a public figure was nothing new to Elizabeth, but the attention she got with Richard was like nothing else she had known. Roddy McDowall took some of

the best candid photographs of Elizabeth during that frenzied time. One shows a mob of people surrounding the Burtons after a performance of *Hamlet*. McDowall told Elizabeth that he was going to stand on top of the building next door to capture the scene. She told him that she would wear white gloves so that he could see her, anticipating that the crowd would be so dense that he would need a way to spot her. Once, when Liza was with them, Richard had to hold her over his head and hand her to his older brother so that she would not get trampled by the crowd.

Truman Capote recalled riding in the limousine with Elizabeth and Richard as they were trying to leave *Hamlet*. "Damp, ghostly faces were flattened against the car's windows; hefty girls, in exalted conditions of libidinous excitement, pounded the roof of the car; hundreds of ordinary folk, exiting from other theatres, found themselves engorged among the laughing, weeping Burton-Taylor freaks. The whole scene was like a stilled avalanche nothing could budge, not even a squad of mounted policemen badgering the mob, in a rather good-natured way, with their clubs."

Richard, Capote noted, reveled in the attention. "It's just a phenomenon," he said, smiling. "Every night Elizabeth comes to pick me up after the show, and there are always these . . . these . . . these . . ."

"Sex maniacs," Elizabeth interrupted.

"These enthusiastic crowds," he said, "waiting . . ."

"To see a pair of sinful freaks," she said. "For God's sake, Richard, don't you realize the only reason all this is happening is because they think we're sinners and freaks."

Just then an old man had climbed onto the hood of the car yelling something inscrutable at them. He slid off and under the hooves of a police officer's horse. Elizabeth gasped. "That's the thing that always bothers me. That someone is going to get hurt."

Richard was oblivious. "Sinatra was with us the other night. He couldn't get over it. He said he's never seen anything like it. He was really impressed."

In Mexico, they discovered the quiet seaside village of Puerto Vallarta. When Elizabeth was still legally married to Fisher she stayed in a Mediterranean-style home on a hillside overlooking the Pacific Ocean named Casa Kimberly, which was across the street from a casita where Richard stayed. They had a bridge built connecting the two homes, creating an elegant compound. The bridge was designed as a replica of the Bridge of Sighs in Venice, and it gave them the privacy to travel between the two houses without attracting attention. There, in their sanctuary, they kept the windows of Casa Kimberly open and reveled in their

relative anonymity. They escaped to Mexico as often as they could.

"If I'm away from Richard I feel like half a pair of scissors," she said.

They lived a famously decadent life and traveled with an enormous entourage that accompanied them around the world: makeup artist Ron Berkeley; personal photographer Gianni Bozzacchi; chauffeur Gaston Sanz; Elizabeth's hairdresser Claudye Bozzacchi (Gianni Bozzacchi's wife); Richard's assistant, Bob Wilson; Richard's personal secretary, Jim Benton; and Elizabeth's secretary, Dick Hanley. Her four children occasionally joined the group. And she often requested that her favorite restaurant dish, Chasen's chili, be flown in from California to wherever they happened to be.

Richard enjoyed the money and power, but the lack of privacy and Elizabeth's extravagant approach to life was wearing on him—he began referring to their combined fame as "diabolical." Their fights were so legendary that when they stayed in hotels fans would try to get rooms below theirs and stand on chairs with glasses to their ears so they could hear them screaming at each other. Their relationship got worse and worse—they were earning their nickname, the "battling Burtons." She gave as good as she got. Elizabeth described their

arguments like "a small atom bomb going off—sparks flying, walls shaking." Once, when Richard came home after someone booed his performance in *Hamlet*, he was infuriated by Elizabeth's indifference. It was late and she was watching television in bed, and he bellowed, in his deep booming voice, "*Turn that thing off! I was booed tonight.*"

"Oh, darling," she said, "it was just some idiot; don't pay any attention to that." She turned her attention back to the TV.

"It was only one person," he said as he took off his shoes and socks. "But I was booed."

When she said nothing, he walked over to the television set and kicked it; it hit the wall and fell to the floor. He kicked it again and the knobs fell off. Enraged, he kicked it a third time. A large metal screw cut his big toe to the bone, "which I must say had me absolutely hysterical," Elizabeth recalled darkly.

Initially, he refused a doctor. He was a hemophiliac and bled all over the bedspread. Eventually, he needed stitches. He had to walk on the side of his injured foot, which, he said, made his performance better.

So much of their fighting was fueled by alcohol. "It's like a fire," said Guy Masterson, a great-nephew of Richard's. "As long as there's an ember glowing, someone will blow on it. And they blew on each other's

embers all of the time. And they didn't allow each other's embers to go out."

In a diary entry from November 1966, Richard wrote, "Smoked myself furiously to sleep and before doing so told E she was not to come with me to London. Leave me alone I screamed as I slammed doors. Give me some peace! What nerves and booze will do. I couldn't go on without her."

But even after several years together, they still lusted after each other. "I still sometimes get a thrill, as I did this afternoon in the dining room, because Richard went upstairs to get something and I really broke out in sort of goose bumps and shivered slightly when I saw him walking across the dining room toward me because—I love to look at him. . . . Every once in a while he looks so bloody handsome and desirable, and for a second I think how would I feel if he were not my husband and I just saw him walking through my dining room—would he have the same effect on me?"

Some time, she dreamed, in their late forties they would retire and have one main home, and put an end to their frenetic lifestyle. Richard would become a writer—she thought he had too much talent not to— and she would stop acting and take care of their home and entertain their friends.

Douglas Kirkland was a photographer at *Look* and remembered watching the two of them. "She always loved having his arm around her which was a big powerful Welsh arm. He said, 'You know what I want to talk with you about Elizabeth, I want to talk about what we're going to do when this is all over. When we don't have all these people and lights around us all the time. Let's think of what it would be.' And he said, 'You know what I would like? I would like to be a professor in some school, Oxford or Cambridge maybe.' And she looked up at him with such a radiant smile, like a child hearing such beautiful words that they wanted to hear." She lit up at the mere idea, it gave her such pleasure to think of what it would be like to live a quiet life. It was a beautiful fantasy.

But in the 1960s and the early '70s, Elizabeth was still gracing magazine covers, except this time it was with Richard. They found something in each other that they could not find anywhere else. In a 1969 love note from Elizabeth to Richard, she wrote, "As long as he loves her everything is O.K: pimples, stupid hips, double chins, and all—She loved him more than her life and always will.—Wife."

Their relationship was fundamentally flawed, but it is undeniable that Elizabeth and Richard loved each

other passionately and they also made each other better actors. When they did their first scene in *Cleopatra*, Richard was unimpressed. Elizabeth's facial expressions seemed too subtle, her emotions too tightly controlled. But once he saw her on-screen he discovered that she was doing so much more than he could see when he was standing opposite her. She knew exactly where to look and how much to give away. In the theater, an actor's voice has to be booming to be heard, but on-screen every movement can be much less obvious, and the camera picks it up.

Men had often underestimated her. Paul Newman went to the director Richard Brooks when they started filming *Cat on a Hot Tin Roof* and complained, "I don't think she knows what she's doing, I'm getting nothing." Brooks replied, "Why don't you watch the rushes tomorrow?" When he did, Newman realized something other costars would learn: "There I was giving a terrible performance," he said, "and she was brilliant."

Decades later, Arthur Allen Seidelman, the director of a television movie Elizabeth starred in in the mid-1980s, recalled how skilled she was as an actress. Her character had to be in a certain position standing next to a table. "She knew how to get herself there and it was completely natural," he said. "There are times

when you have to direct and there are times when you just get out of the way. And with Elizabeth, you got out of the way."

Philip Burton, the man who Richard considered a mentor and father figure and whose name he adopted, was on the faculty of the American Musical and Dramatic Academy. He asked if Richard and Elizabeth would do a poetry reading to raise money for the school. He was surprised when they both said yes. Elizabeth was eager for the challenge. She had not performed on-stage since she was a little girl in London. She needed to prove to herself that she could do it.

"She is highly intelligent, deeply sensitive, and abrasively honest," Philip Burton wrote. "She knew that many in the audience would come for the ghoulish joy of watching a high-wire artist working without a safety net."

She trained for six weeks for the show on June 22, 1964, called *World Enough and Time*. The readings included the works of D. H. Lawrence, Shakespeare, and John Lennon. Even though she had a microphone, Burton wanted her to learn how to project her voice so that someone sitting in the very back of the theater could hear her. When Elizabeth walked onstage wearing an Irene Sharaff dark-blue gown, and her hair in a

dramatic updo with diamond earrings dripping from her ears, she received a standing ovation. She looked out at a sea of famous faces that included her friend Montgomery Clift and Eunice Kennedy Shriver.

She was so nervous that when she messed up a line at the start of a serious poem she said, "I'll begin again, I screwed up." Richard was nervous too, and he started reading her lines, which made them both laugh so hard that they had to turn away from the audience. It could have gone very badly from that moment on, but Elizabeth proved herself to be a versatile actress who could conquer the stage as well as the screen. One audience member turned to a friend and said, "If she doesn't get worse soon, I'll be leaving." She recited the words with feeling, and she overcame one of her greatest fears—performing before a live audience. It paved the way for the most challenging character she would ever take on: Martha in the film adaptation of Edward Albee's critically acclaimed play, *Who's Afraid of Virginia Woolf?*

Elizabeth knew she deserved the credit. When one interviewer suggested that Richard had helped her become a better actress, she snapped, "What you're trying to say is that most people thought I was the village idiot before he got me in tow. Well, he hasn't been my Svengali, but he has widened my scope."

And as time went by and Sybil remarried, Richard began to spend more time with his daughter Kate (though he rarely saw Jessica, who spent her life in an institution). Kate Burton, who became an actor and appeared in *Scandal* and *Grey's Anatomy*, remembered one night when Elizabeth tried to make dinner for her, Michael, Christopher, Liza, and Maria. "Elizabeth was not exactly put on the planet to cook dinner for you at night. Thank God, because we would all be in the hospital. One night we were in Switzerland, I think I was about ten. Elizabeth decided that she was going to cook on the grill, and she got the steaks, and they were of course the best money could buy, and she had her hair wrapped up in some kind of scarf, and she was sweating and huffing and puffing, and my father was getting into an extremely bad mood. The steaks are now burning, the baked potatoes were on fire."

She looked at her stepsiblings, who were equally amused. "I think we had to go out for dinner that night."

Once *Hamlet* wrapped, Elizabeth and Richard took a cross-country train ride from New York to California, with a stop in Chicago, where Elizabeth placed a rose on Mike Todd's grave. On the train she read the script for *Who's Afraid of Virginia Woolf?* She was

so consumed by it that she could not fall asleep. The film's producer and screenwriter, Ernest Lehman, knew it was an unorthodox choice, but he wanted her for the lead.

The problem was that the bitter and shrill Martha was forty-five years old, overweight, and plain. Elizabeth was thirty-two years old and gorgeous. German-American stage actress Uta Hagen originated the role on Broadway, and she was more than a decade older than Elizabeth. Rosalind Russell, Bette Davis, and Patricia Neal were also contenders. Elizabeth knew that she had been typecast because of her looks, and she wanted to be accepted as a serious actress. A frumpy, alcoholic, and deeply unhappy housewife on a New England college campus was the perfect way to prove herself.

"Maybe you don't have the power [for the role]," Richard told her bluntly. "But you've got to play it to stop anybody else from playing it."

Before they began shooting, Elizabeth and Richard met with Lehman in an elegant hotel suite in Paris, where they talked for hours as they nibbled on caviar and drank two bottles of champagne. "Liz gets passionate, even a bit angry, at *any suggestions* that she personally doesn't know exactly how she's going to do the role," Lehman recalled in his diary. "She says *she does*, and says it forcefully."

Richard, Lehman recalled, called her "lazybones." "He said she's never really worked hard enough, said she damned well better work harder in this one. She resented his statement, but I think she got the message."

Henry Fonda and James Mason were being considered for the part of George, Martha's soft-spoken husband who is a midcareer college professor. George's lack of ambition is a source of her seething contempt.

Of course Elizabeth wanted Richard to play George. Richard worried that he could not pull off the American accent, he said, but he was more concerned about what playing a couple locked in constant combat would do to their own marriage. "I've had nightmares about this picture," he wrote. "I wake up shaking. I told Elizabeth, 'No matter how intelligent one is, the part rubs off. It's going to be a rough ride for us.'"

Elizabeth and Richard were given the unusual authority to select their director—which is very rare for any actor—and they chose Mike Nichols, who they both knew and admired. Richard called him "enthrallingly brilliant" and Elizabeth instinctively knew that he was the right director and that they should take a chance on him. She had never played by the rules, and Nichols was an unconventional choice. He was a satirist who had directed three very successful stage comedies: *Barefoot in the Park*, *Luv*, and *The Odd*

Couple. But he had never directed a movie before, and like Elizabeth, he was thought to be too young and too lacking in gravitas to pull off one of the decade's most important screen adaptations of a play. He was just a year older than Elizabeth. But he had lobbied them both for the role, and the studio wanted to make their two stars happy. He had spent time with Elizabeth in Rome when she was working on *Cleopatra*, and Richard, who was a friend, asked him to keep her company because he had to go out of town to finish filming *The Longest Day*. Nichols was surprised by her honesty.

"We're surrounded," she told him as they sat in Villa Papa.

"Put a thing on your head, a kerchief," he said, and they left through the back door. They got in his rented VW and spent the rest of the day peacefully at the Villa d'Este, a luxurious hotel overlooking Lake Como. The only time their reverie was broken was when someone recognized him and not Elizabeth, which they both found amusing.

Nichols marveled at how little privacy she had when she was not in disguise. He watched as people ogled her everywhere she went.

"Is it ever a pain in the ass being so beautiful?"

"I can't wait for it to go," she told him.

Nichols adored Elizabeth and told people who were skeptical of whether she could really pull off Martha to just wait and see. She was going to stun them. Nichols, like Lehman, knew that part of the film's allure would be moviegoers paying to see whether Elizabeth could manage it. The playwright Edward Albee was among the critics who thought she was too young for the role, but he had no creative control.

"People know how Uta Hagen played it," Lehman said. "They certainly know how Bette Davis would do it. But they wonder how Elizabeth Taylor will do it."

Nichols told her that she needed to gain twenty pounds ("that was one of the nicest orders I've ever been given," she joked), take voice lessons, and wear prosthetics and padding. She had to transform herself into a screeching, unfulfilled "lunatic," as she described the character.

But first she had to shoot *The Sandpiper* (she was paid $1 million) in Carmel, California, and Paris. She was eager to work with the great director William Wyler on the film, and when he pulled out she convinced Vincente Minnelli, who had directed her in *Father of the Bride*, to take over. When Burt Lancaster, who was to play her love interest in the movie, dropped out of the project, she decided that Richard should take his place. Even though he was starting to doubt whether

they should work together so often—"Look, baby," he told her, "if we do any more films together they'll think we're Laurel and Hardy"—he agreed to the role. He was paid half as much as she was for his work.

Elizabeth played a single mother who is an artist in Big Sur. On the set, Morgan Mason, who played Elizabeth's young son, remembered chatting with the paparazzi positioned at the fence built around the set to protect the Burtons. One of them told Mason, then eight years old, that he could take his camera on the set and play with it. "I innocently took a few behind-the-scenes photographs and returned the camera. When I told a producer, the publicist demanded that the photographer not publish the images." Photographers had no qualms about taking advantage of a child if it meant getting a valuable photograph.

The film was released in July 1965, and the critics tore it to shreds, which was devastating for Richard, who was coming off his triumphant performance in *Hamlet. The New Yorker* called it "a huge, soggy, wooly, maundering, bumbling, expensive movie."

Elizabeth, who was thirty-three, had already had a rough year. Earlier in 1965, when she was with Richard in Dublin while he was filming *The Spy Who Came in from the Cold,* she came to the aid of her longtime friend and chauffeur Gaston Sanz. His teenage son had

apparently committed suicide in their village in the south of France.

Rock Brynner, Yul Brynner's son, was visiting Elizabeth and Richard in Dublin and watched Elizabeth leap into action. (Yul was married to Elizabeth's good friend Doris.) "Gaston himself was on the brink of suicide, and now Elizabeth focused all her care upon him. Despite her understandable terror of small planes since Mike Todd's death, she chartered a private prop plane from Dublin to the remote French village. She found a local mortician and made arrangements for the Catholic service (notwithstanding the condemnation the pope himself had loosed upon her). And she filled her purse in advance with French francs, ready to bribe every local official if necessary, to avoid an official verdict of suicide, which would rule out a funeral in the Catholic cemetery."

Elizabeth stayed with Sanz for three days and made sure that everyone, from the coroner to the priest, would declare the death an accident. It was Elizabeth who had to look at the boy's face to decide if he could have an open-casket funeral. She walked with Sanz for the procession in the village and for the church ceremony and burial.

When she returned to Dublin, she learned that burglars had broken into their hotel suite and stolen

jewelry, including the wedding ring she had given Mike. It was the only means of identifying him after the plane crash, and she wore it all the time. It was the single most treasured piece of jewelry she owned.

Then there was a flap over Elizabeth's citizenship. Elizabeth was born in London and kept her British citizenship her entire life. Because her parents were American citizens she had dual citizenship since birth. After she married Richard, she wanted to give up her American citizenship. The step would save her from paying hundreds of thousands of dollars in back taxes, and she always felt a deep kinship to the country where she was born. In 1964, she went to the U.S. embassy in Paris, and there executed an Oath of Renunciation of the Nationality of the United States. She objected to the phrase "and abjure all allegiance and fidelity to the United States of America" that appears in the form, so a separate document eliminating the phrase was presented to her and she signed it, but the United States refused to recognize it because of the new wording. She gave the consulate her U.S. passport.

She was then barred from entering the United States, because she showed her British passport but was still considered a U.S. citizen. She was forced to again renounce her citizenship, this time in Rome, so that she could gain entry into the United States, this

time as a British citizen. Asked about it in 1965 as she was leaving a London club with Richard, she said: "It is true I am trying to give up my American citizenship and become completely British. I want to become more British than anything else. I like the British best of all."

Her lawyer, Aaron Frosch, explained: "She had been an American citizen since birth and she should not be required to sign anything that is false or which would in any way indicate disloyalty to the United States, to which country she still feels a deep sense of allegiance, loyalty and gratefulness." She was a British citizen for the rest of her life, even though she spent most of her time in the United States.

Things improved considerably once she got to work on *Who's Afraid of Virginia Woolf?* She was frightened by the challenge, but she knew that she was ready for it. Nichols insisted on shooting the film in black and white. "Here's the thing about black and white," he said. "It's not literal. It is a metaphor, automatically . . . that's the point: a movie *is* a metaphor. If you're in black and white, it's partly solved—it's already saying, 'No, this is not life, this is something *about* life.'"

The entire film hinged on Elizabeth and Richard.

Ernest Lehman recalled how everyone tried to woo them before filming began. "Mike Nichols sent a pound of caviar to the Burtons' home and I hear that their agent, Hugh French, sent a quart—I repeat—a quart, to their dressing room on Tuesday."

Even studio heads were in awe. During rehearsals Lehman wrote, "Jack Warner came down on the set and shook hands with everyone and kissed Elizabeth about eight times and made her turn around as if she were a model, and told her she looked just great." The pressure, Elizabeth knew, was mostly on her—it always was.

Night scenes were filmed on the bucolic New England campus of Smith College in the small town of Northampton, Massachusetts. They sometimes did not begin shooting until three or four a.m. because the movie takes place late at night, and Nichols wanted to capture the moonlight perfectly. In the opening scene, Elizabeth walks in, turns on the light, throws her coat on a chair, missing it, and slurs, "What a dump. Hey, what's that from? *What a dump.*" When George says he doesn't know the answer, she gets frustrated. "Some goddamn Bette Davis picture . . . some goddamn Warner Brothers epic. . . ." She opens the refrigerator, which is crammed with half-eaten food, pulls out a drumstick, and eats it hungrily. She is snarling, she

has unkempt salt-and-pepper hair and dark bags under her eyes. She is nothing like the beautifully coiffed and expertly made-up commodity of Elizabeth Taylor.

Seventy security guards stood watch as the night scenes were filmed. They spent a month in Massachusetts, and one night when Elizabeth got antsy she went out to see *What's New Pussycat?* and ten policemen had to accompany her.

The five-month shoot was grueling. Lehman recalled how concerned she was about taking care of her eight-year-old daughter, Liza, who they had brought along with them. "It appears that Elizabeth would like to find a reliable sleep-in babysitter, because she does not think it right that her daughter be kept up until 4:00 in the morning just to be with her parents because they feel it would be safer for her. And yet Elizabeth knows the danger of taking strangers into her household who might turn out to be unofficial newspaper people or unreliable personnel who might later on spill all about the private lives of the Burtons to someone else. Meanwhile, Richard Burton apparently does not share her view—he feels that Liza should stay with them, stay up as late as they do, and he does not want a babysitter."

The set became a family affair. Her brother Howard's son Tommy Taylor spent time with his aunt and

his cousins when Richard and Elizabeth were rehearsing for the film. Elizabeth said she caught herself saying things like, "For Christ's sake shut up, I'm not finished talking yet!" during filming. "Sometimes it was hard to tell if they were actually having a real argument or practicing their lines," Taylor said. "That's how real it was. . . . They were drinking a lot and becoming the drunken, aggressive characters of the movie. There was tension that summer from all the drinking." Chris Wilding remembered sitting at the dining-room table with Elizabeth and Richard, who were explaining why they would not be able to see the film until they were older. They ran through a scene to show them exactly why.

"They didn't hold anything back, and it certainly made an impression! Happily they assumed their normal demeanors immediately thereafter, and we were much relieved. (I think my mother held on to a sliver of her Martha character for the rest of her life, pulling it out of reserve for those occasions when she really needed to get a point across with someone who probably deserved it.)" Wilding did not remember the unusual amount of tension that his cousin described, but, he said, that might be because he had grown accustomed to "tiptoeing around the house on weekends

or after a night of entertainment. . . . Richard liked his personal space, especially when hungover."

Deep down Richard knew that he was on borrowed time. One evening Elizabeth and Richard were eating dinner with the crew, and Elizabeth did not have her Martha wig and makeup on and she looked young and vibrant. Richard kept looking adoringly at her and told her that he couldn't wait until she got to be Martha's age and had beautiful salt-and-pepper hair. He said, "I'll be fifty-four years old at that time; that is, if I can make it to then."

Watching *Virginia Woolf* is like being in the room during a couple's most vicious and private fight, except it's clear that this is not an abnormally bad evening for George and Martha. In one of the most emotional scenes in the film, she berates him, "I hope that was an empty bottle, George! You can't afford to waste liquor, not on YOUR salary!" And he humiliates her. "You're a spoiled self-indulgent, willful, dirty-minded, liquor-ridden . . ." Some of the crew were so disturbed by the onslaught of vitriolic dialogue that they actually walked off the set.

Once again, the Production Code was not happy. Their first edit was at the beginning of the script with "Jesus H. Christ" and every "son of a bitch" and

"goddamn" was marked for deletion. An even stricter harbinger of decency was the National Catholic Office for Motion Pictures (also known as the Legion of Decency). Elizabeth was all too aware of how powerful these organizations were; she had been dealing with them since she was a teenager. A production seal of approval was withheld even after several "Jesus Christs" were changed to "Oh my Gods." Finally, they granted approval after "friggin'" and "screw you" were deleted. If the film had been condemned by the Legion of Decency, or if it was denied a seal of approval from the Production Code, that would mean that it could not be shown in many major cities.

She had been so intimidated by the stage, but now Elizabeth was helping her colleagues work in film. "Here were four stage people—Richard, George, Sandy, and me—and we were all awed by Elizabeth's knowledge of film acting," Nichols said. "[We] watched her very closely and learned from her. The main thing that Richard learned was to do as little as possible." Nichols was in awe when he noticed that Elizabeth even left room in the scene for the music, something she did subconsciously after so many years in front of the camera.

Elizabeth was worried about whether she would be able to cry on cue, and Nichols had told her to save the

tears for the end of the scene. "She finally did it, just perfectly, this thing that had frightened her, and then, in the middle of the scene, there was snoring. Some crew member up on a catwalk had gone to sleep and was snoring so loudly that I had to cut. And the first thing she said, the only thing, was 'Please don't fire him!'"

Nichols was not surprised by her reaction. "There are three things I never saw Elizabeth Taylor do: Tell a lie; be unkind to anyone; and be on time."

The film opened on June 21, 1966, at the Pantages Theatre in Hollywood. The ads were mysterious: "You are cordially invited to George and Martha's for an evening of fun and games. . . ." Elizabeth told Lehman that she expected to get torn apart by the critics. "I told her I didn't think she would be, but she said that they always blast her. I said, 'Why don't you screen the reviews and not read the bad ones? Have somebody sift them out.' She said, 'No, I won't do that. I'm not a masochist but I do want to read everything that they say about me, even if it's bad. Perhaps I'll learn something about myself from what they say.'" But criticism always stung, no matter how much she tried to protect herself. Elizabeth's friend Johnny Cash wrote her a letter in 1980 revealing their shared sense of vulnerability: "After all these years in the business, it still hurts when they say something bad, doesn't it."

This time she had nothing to worry about. The movie was a huge critical and commercial success, and Richard was praised for his portrayal of George, the henpecked professor resigned to a life of quiet suffering. The *New York Times* called it "one of the most scathingly honest American films ever made." But it was Elizabeth who earned the highest accolades. The *Times* called it the best work of her life. *Life* magazine said that it was "an honest corrosive film of great power and final poignancy. Elizabeth Taylor is a revelation."

Richard was nominated for Best Actor at the 1967 Academy Awards and Elizabeth was nominated for Best Actress for their work in *Who's Afraid of Virginia Woolf?* They were in France at the time filming *The Comedians*, a movie based on Graham Greene's novel about Haiti's despotic leader Papa Doc Duvalier. Elizabeth was done shooting her part, but Richard had to stay and finish his. She was planning on attending the ceremony, but Richard told her that he had a nightmare that her plane crashed, and he made her feel guilty about going in the first place so she stayed by his side. He knew that she would likely win and he would not—she had already won the National Board of Review and New York Film Critics Circle awards—and he must have sensed it. He was right; she won and he lost. Anne Bancroft accepted the award on her behalf. The chance

of winning as a husband-and-wife team would never come again. She was not only more famous than he was, she was also being lauded as a better actor. He was competitive, and he gnashed his teeth many times during *Virginia Woolf* when she had upstaged him. Her Oscar only complicated their tenuous marriage, which was mired in Richard's profound guilt over leaving his family, the pressure that comes from immense fame, and Elizabeth's strength. "Maybe I'm jealous of her power or something, I don't know," Richard once admitted.

Lehman remembered Elizabeth, Richard, and Mike Nichols arguing over a particular scene and how it revealed Richard's deep insecurity and resentment of his wife: "We went back and forth on it and her eyes were really flashing, as the saying goes, and at one point I told her that I felt her argument was a rather intellectualized one and she said, 'Why, thank you, Ernie, for calling me an intellectual.' . . . Mike agreed with her on a certain point and said, 'I'm not saying this just because you're the star,' to which Richard said, 'She's not the star, *I am*.'"

Their next film was almost as intimidating for Elizabeth. She was to play Kate in *The Taming of the Shrew*, one of Shakespeare's most famous plays. It

was the first movie for director Franco Zeffirelli, and he was originally thinking of Sophia Loren and Marcello Mastroianni for the film, but once he saw Richard in *Hamlet* he had to have them together. Zeffirelli could not afford to pay Elizabeth a million dollars, but she and Richard thought it was worth it to coproduce the film and defer their salaries. It was the first time they'd worked in Rome since *Cleopatra*.

In a 1970 interview with journalist Charles Collingwood for *60 Minutes*, Elizabeth and Richard sat beside each other and she said, "I was absolutely terrified because I was in the company of old Shakespearian actors, not necessarily old"—she put her hand on Richard's shoulder—"But you know, they've been there for a long time. . . . And here was I, a Hollywood schmuck, trying to sort of keep up with them. And I said, 'Richard, what am I going to do?' and he said, 'Get out of the nest baby. You do it on your own.' And I said, 'Thanks a bloody bunch.'"

Meanwhile, her friend Monty was sick. Marilyn Monroe starred in *The Misfits* in 1961 with Monty and said that he was "the only person I know who is in worse shape than I am." Monty did some of his best work after the terrible car accident, including *Judgment at Nuremberg*, also in 1961, for which he received an Oscar nomination, but his addictions consumed him.

As she was filming *The Taming of the Shrew* in Italy, Monty died. It was July 1966, and he was only forty-five years old. Elizabeth heard that Monty was found dead of a heart attack in his New York townhouse. He had been an addict much of his life and had suffered many illnesses, including chronic colitis and dysentery. Elizabeth did not attend Monty's funeral; she preferred to keep her grief private. Elizabeth had known him since *A Place in the Sun*, and they had made three films together in fifteen years, but more than anything, they were close friends. She sent two large chrysanthemum arrangements to St. James's Church in New York with a card that read: *"Rest, perturbed spirit."*

She must not have been surprised by the news. He was taking too many painkillers, she said (so was she). Truman Capote told her what it had been like Christmas shopping with Monty and how, after he had a couple of martinis at lunch, Monty excused himself to go to the restroom and returned a different person. "While he was in there he must have taken something, because about twenty minutes later he was flying. We were in Gucci, and he had picked out and piled on the counter perhaps two dozen very expensive sweaters. Suddenly, he grabbed up all the sweaters and sauntered outside, where it was pouring rain. He threw

the sweaters into the street and began kicking them around. The Gucci personnel took it calmly. One of the attendants produced a pen and sales pad and asked me, 'To whom shall I charge these sweaters?' The thing was, he really didn't know. He said he wanted some identification. So I went out into the street, where Monty was still kicking the sweaters around (observed by amassing voyeurs) and asked him if he had a charge card. He looked at me with the most manic, far-gone hauteur, and said, 'My face is my charge card!'"

Capote said that Elizabeth's eyes, normally "liquid with life, acquired an additional mistiness" when he told her the story.

"He can't go on like that," she said. "It will kill him."

She had never stopped fighting for Monty. When she agreed to 1967's *Reflections in a Golden Eye*, she had one major demand: Monty would play her husband in the film. He had not worked in four years because he was considered uninsurable. She knew what that felt like because many studios felt the same about her. "Bloody hell!" she said, "I'll put up the insurance money!" So she put up her million-dollar salary as a guarantee that Monty would finish the movie. Bessie Mae would always be there for him. She loved him.

After his death, Monty was replaced with Marlon

Brando. "To me, they tap and come from the same source of energy," Elizabeth said. "They both have this acute animal sensitivity."

Elizabeth had known Brando for years. He had picked up her New York Film Critics Circle Award at her request and hand-delivered it to her on the set of *The Comedians* in Cotonou, a city in Benin in West Africa, where she was working. "If you please," Richard teased in his diary. Brando visited the set as Elizabeth was getting her makeup done and he cupped her bottom with both of his hands. "Marlon!" she squealed. Richard was skeptical of Brando and his intentions, and he ran over to him and they got into an argument that devolved into each of them throwing punches at each other.

Richard and Elizabeth possessed and craved each other one minute and could not bear the sight of each other the next. "We were like magnets," Elizabeth said, "alternately pulling toward each other and, inexorably, pushing away." It was a love too all-consuming to last. Its sweetness was pure, but so was its rage. Even as early as 1965 Richard described their excruciating love: "Strange love affair this afternoon. Tolerable agony. Agonizing Love. Lovely pain."

Their personal life was for public consumption, which is what created the lucrative "Liz and Dick" show and what would ultimately lead to its destruction.

"Elizabeth and I both suffer from feelings of insecurity," Richard said. "We feel particularly unsure of ourselves when we are at a party because no one really wants to know us. They simply stare as if we are prized animals. What we do when we go to parties is drink to kill the icy isolation."

In the *60 Minutes* interview they did together, Elizabeth said, "I must say we enjoy fighting. I think that fighting with somebody you love, and are really sure of, and if you're really sure of yourself in your love, I think having a fight, an out-and-out outrageous, ridiculous fight is one of the greatest exercises in marital togetherness."

"Especially if you have no really weak points," Richard said. "You see, you do not attack the weak points, they're perfectly obvious in Elizabeth and myself . . . so when I insult Elizabeth, which I frequently do, I do not attack that soft spot in the underbelly."

"My double chin," she chimed in.

Burton nodded. "Double chin."

"You bloody well have," she said. "His pockmarks, you know."

When Charles Collingwood asked Elizabeth whether she thought that Richard dominated her, she said, "He sure does."

Richard said that was not true. "I would say offhand that when the bludgeon is out, which Elizabeth employs with remarkable efficacy, that I'm afraid I have to withdraw. . . . If there is a hen peck around the place it's me."

Richard wrote in his diary almost every day and left it out for Elizabeth to read and occasionally write in herself. In a diary entry from April 1966 he complained about having to work the next day, to which Elizabeth wrote: "You ill-tempered bastard! So do I, at least you'll be out of my hair!"

Their private love was more tender and playful than what they said to each other in public. He signed one letter: "Your blindly devoted Idiot Husbs."

But there were times when the fury spilled over, and they did actually hit each other. Richard alludes to it in his diary, when he became enraged over the clutter in one of their homes. In an entry on September 9, 1969, he wrote: "I went mad which ended up with Elizabeth smashing me around the head with her ringed fingers. If any man had done that I would have killed him, or any woman either, but I had sufficient sense to stop

myself or I most surely would have put her in hospital for a long time or even into the synagogue cemetery for an even longer time."

Todd Fisher, the son of Debbie Reynolds and Eddie Fisher, remembers being shocked when he saw Elizabeth and Richard fighting during a cocktail party that his mother and stepfather threw. Debbie and Elizabeth had mostly made up by then, and his mother occasionally invited Elizabeth and Richard to her house.

The two got into "a yelling, screaming, top-of-their-lungs, mutual bitch-slapping fight, and they were oblivious to the discomfort of a houseful of other guests." Debbie escorted them upstairs to her bedroom and left them there.

After several minutes of shouting, there was silence. Twenty minutes later, they came back downstairs, "happy and in love again as they descended the grand stairway and rejoined the party as if nothing had happened. That night was the first time I had ever heard the phrase *makeup sex*," Fisher said.

Alcoholism was obviously the third partner in their marriage. So many of Richard's letters to Elizabeth include apologies for whatever happened the night before. "I shall be good today and surprise you," he wrote on October 9, 1972. "Thank you for taking care of me yesterday. You are a good girl and indeed much

too good for me and to me." In another, he wrote: "I am tempted to wake you but don't think it a good idea since I give you enough sleepless nights as it is."

When Richard was drinking he went through four stages: tipsy, when he was the kind and sober intellectual; buzzed, when he was funny; drunk, when he was cruel; and really drunk, when he passed out. His hands would shake so badly sometimes that he developed a makeshift pulley using his belt. He would take it off his waist and tie it to his wrist and then he'd pass it around the back of his neck, hold the glass with the hand that was tied to the belt, and pull the other end of the belt with his available hand in order to raise the glass to his lips.

Sir Michael Caine, who was costarring with Elizabeth in a film, remembered seeing Richard at a wrap party just before Christmas. "Merry Christmas, Richard," Caine said.

"Why don't you go fuck yourself?" Richard said, his words slurred.

In a 1969 note Elizabeth wrote: "I hope you're feeling better—but if you *do* feel like losing your temper—everyone else—just not me—please!"

Elizabeth's own growing problem with alcohol was easy to overlook because Richard's was so debilitating. "You don't notice that the flames in a barbecue are

too high when the house behind it is a fully engulfed, raging inferno," said Chris Wilding. "It's probably true to say that prescription pain meds were her poison of preference—if she could only choose one substance to take to a desert island, I think the pain meds would have won out over booze. Booze was what you shared with friends at social events; drugs were what you took in private."

"For the last month now, with very few exceptions she has gone to bed not merely sozzled or tipsy but *stoned*," Richard wrote in his diary on January 13, 1969. "And I mean stoned, unfocused, unable to walk straight, talking in a slow, meaningless baby voice utterly without reason like a demented child. . . . The awful thing is that it's turned *me* off drink! . . . the boredom, unless I'm drunk too, of being in the presence of someone to whom you have to repeat everything twice is like a physical pain in the stomach. If it was anyone else of course I'd pack my bags, head for the hills and go and live in a Trappist monastery, but this woman is my life."

When she had a couple of drinks and then took a "pink" pill (Richard's code name for her painkillers) or a sleeping pill, he said that she had a false sense of joy and became sentimental. Worse still, he said, she

began to sound like her mother, whom he could not stand.

And Elizabeth called Richard "a bore" when he did not drink. "You're damned if you do and you're damned if you don't," he wrote.

There was no escape for them. In Puerto Vallarta, their sanctuary, they quarreled too. Richard wrote from there in March 1969 of the "nightmare" the prior few months had been. "We grated on each other to the point of separation."

On the set of *Boom!* everyone drank vodka, straight up on ice in a tall glass, and they started drinking when work began at noon. There was a man whose only job was to sit near Elizabeth on set while she worked and make sure that her glass was always full.

When Elizabeth was drunk she did not get mean, she got loud, and when she was high on whatever pain medication she was taking at the time it was not as evident as Richard's drunkenness. In a diary entry from December 1968, Richard wrote, "I became very drunk and abused people a great deal and insulted E a lot on the telephone when I arrived. One might call the last few days 'The Diary of a Dipsomaniac.' I miss Elizabeth terribly already. I wish I didn't love people. And I wish I didn't shout at people." When apart, which was

rare, they spoke on the phone five or six times a day. "I miss her like food," Richard wrote. But his dark moods overwhelmed him, and the family.

After one particularly rough night Elizabeth wrote:

Richard,

There have been times that I have loved you more than my life—and more than my children.

Something must be very wrong with the two of us if I'm put in the position of having to take sides—having to choose between you or my kids.

Your behavior tonight has sickened me and I think made my children not like you very much— not that you give a fuck. But they do care about each other and I care about *them*.

Sorry about you.

Liza, in a recent interview, called the letter "ammunition." She said, "Those words would hurt more than anything. We might have been shocked by his drunken behavior, but I don't recall anybody saying they didn't like him. That's a grenade. They were both very volatile people and if you're hurt you want to hit back."

Gianni Bozzacchi remembered Elizabeth being afraid of Richard when he was drunk. Once, she asked him to take her out when Richard was already near

passing out. "When we came back to the hotel, she asked if she could come and stay with me."

The "battling Burtons" continued to earn an enormous amount of money—tens of millions of dollars over the next decade of making movies together. They spent most of it maintaining their extravagant lifestyle, which included an enormous entourage, lots of jaw-droppingly expensive jewelry, travel, a jet, and a yacht.

But in five years they appeared, either separately or together, in five flops: *Reflections in a Golden Eye*, *The Comedians*, *Doctor Faustus*, *Boom!*, and *Secret Ceremony*. In 1961 Elizabeth was on the Top Ten Box Office Stars list calculated by the *Motion Picture Herald*, but after 1968 she never appeared on the list again.

Boom!, released in 1968, is a cult classic, but it was a commercial and critical failure. It was based on Tennessee Williams's *The Milk Train Doesn't Stop Here Anymore*, which never did well on Broadway and did even worse at the movie theater. Elizabeth plays Flora Goforth, the world's wealthiest woman, who is dying slowly on her breathtaking Mediterranean island. Richard plays a drifter who happens to befriend wealthy women right before they pass away. The gorgeous

scenery attests to the fact that director Joseph Losey spared no expense. The movie was shot in an enormous white villa in Sardinia on a cliff two hundred feet above the Mediterranean. Because it was so exposed to the elements, the house was battered, and during one particularly violent storm, Elizabeth's dressing room trailer tumbled into the ocean. Thankfully, no one was in it.

Boom! also marked Elizabeth's brother Howard's only acting experience. It was a happy accident. Howard and his wife, Mara, and their five children happened to be visiting, so when an actor did not show, Howard stepped in. He plays the bearded boat captain who escorts Richard to Goforth's island and kicks him off the boat so he has to swim to the shore.

Simeleke Gross, Howard Taylor's adopted daughter, said that her father "realized it's not his life, but he also really admired Elizabeth's talent and ability to be comfortable with that life." Elizabeth's and Howard's children played on the yacht along with Elizabeth's close friend Norma Heyman's kids, while Richard and Elizabeth worked. One day, when the kids spotted the launch coming back, they could see that Richard did not look happy. The boat pulled up to the yacht and Richard got on board, and as soon as he saw the pandemonium he screamed at everyone to get off the boat. Chris Wild-

ing, who was around twelve years old at the time, said, "We were like lemmings. We all leapt off the boat to swim to shore and poor little David [Norma's son David Heyman], who was like five at the time, didn't know how to swim. One of the sailors must have jumped in after him to save him."

Friends and family were constantly caught in between them. One evening Elizabeth was making drinks for friends, and Richard, who had given up drinking for a few days, pointed at her and said, "There's someone who could never give up drink."

"I hate your guts," Elizabeth said.

"Ah," her close friend Norma Heyman intervened, "but you do love him, don't you?"

"*No*," Elizabeth replied, "and I wish to Christ he'd get out of my life. It's been growing on me for a long time." She looked at Richard and said, "*Piss off, out of my sight.*" Richard left to go record what happened in his diary. He was especially stung because, though she had talked like that before, she had never once talked to him like that when she was sober.

Their inability to have a normal life was one reason for their unhappiness. Once, Elizabeth's small dogs got tar stuck in their paws, and she was upset and crying and so someone sent for a veterinarian. But when he walked into the house and saw Elizabeth Taylor and

Richard Burton sitting on the floor and Elizabeth hunched over her dogs in tears, he just stood there frozen. It might as well have been Mark Antony and Cleopatra sitting there. Ultimately he could not do the job because his hands were shaking so badly, and Elizabeth grabbed the scissors and did it herself. She was a mythic figure in those preinternet days, like Jackie Onassis or the Queen of England. Seeing her in the flesh was almost hard to believe.

While they were filming *Boom!*, Elizabeth asked Bozzacchi to drive her to a town in Sardinia so that she could visit a jewelry shop. He asked if they should bring security and she said, "No, let's go on our own." They went in his white Fiat instead of her conspicuous Rolls-Royce but, after a sharp turn, both lanes of traffic were blocked by a car in the middle of the road, and Bozzacchi pulled the handbrake hard. Two men stood in front of them holding hunting rifles. Suddenly more men with guns emerged, and Bozzacchi backed the car up fast and sped away, back to the hotel. They never discovered if it was part of a kidnapping plot, although Bozzacchi suspected that someone in the hotel had tipped them off.

Elizabeth worked with Joseph Losey again when he directed her in *Secret Ceremony*, a bizarre film that costarred a young Mia Farrow and explored themes

of rape, mental illness, and incest. Elizabeth appreci-
ated Losey's unconventional artistic vision, and she re-
spected that he had been blacklisted because of his ties
to the Communist Party. He had fled Hollywood for
Europe because of Senator Joseph R. McCarthy's witch
hunt. Throughout her life Elizabeth was drawn to art-
ists like Losey, who defied authority.

While in London shooting *Secret Ceremony*, Eliza-
beth and Richard stayed on their yacht, moored in
the Thames. She always wanted to be with her dogs,
and she could not bring them on British soil because
of quarantine protocols. So instead of having her dogs
quarantined, she came up with the lavish idea of in-
stead living with them on board their luxurious yacht.

But no amount of money, luxury, or fame could save
their doomed marriage. Farrow said, "It wasn't always
pleasant between the two of them by any means. I
sometimes thought he was mean to her; that was my
perception. She would take it with such good humor.
'Oh Richard!' I would have just dissolved. It seemed
like he was being Welsh, morose, a poet, and artist and
maybe having a bit of a mean streak or maybe being
angry at himself. . . . It was not just a joke."

In the summer of 1968, Elizabeth went into the hos-
pital to have her uterus removed in an attempt to ease

her chronic backpain. The surgery ended her dream of having a biological child with Richard. Three years earlier she wrote a message in his diary while he was filming *The Spy Who Came in from the Cold*:

"Husband was sweet to me. And I know how much he hates 'ill people' and avoids any and *all* signs of pain in someone he likes and loves. But he has been wonderful with me. Spoiled me like mad!! I adore it!! Maybe—(they told me) after another operation [having her tubes untied] I could give him a baby. I want that more than anything in the whole world. *Please* let him *know* nothing will happen to me. *Please* make him say 'Yes.' (Please God.)"

But, like their fantasy about one day living a normal life, she knew that she could not give birth to another baby. Before she went in for the procedure Richard wrote of his deep fear in his diary. She wrote a note to him: "*Bach gan*, I love you." "*Bach gan*" means "boy" in Welsh.

But her back pain would not let up and a Jack Daniel's on the rocks was sometimes the only thing that would lessen it. She wore a back brace throughout the shooting of *The Only Game in Town* with Warren Beatty.

Richard thought that Elizabeth trusted her doctors too much and that she wanted "shots, shots, shots and

pain-killers" instead of trying to exercise and be altogether healthier. When he was in one of his bad moods, he would accuse Elizabeth of being a hypochondriac. Once, he told her she was only sick when she wanted to be.

When she was working, Richard was possessive and jealous. He worried that she and Beatty were getting too friendly on the set.

"My Darling Husband," she wrote, teasing him in his own diary, "just to let you know that going to bed with W.B. (Warren Beatty) hasn't changed my love for you at all—increased it if anything—Aren't you thrilled? All my love, Wife [Elizabeth Taylor's hand]."

A year before *Boom!* she did *The Comedians* with Richard, for the same reason that she did *The VIPs*. She did not want Sophia Loren to get the part because she didn't think she could trust Richard. Elizabeth loved and admired many other actresses, including Audrey Hepburn, but she felt threatened by Loren.

"They conned me," she said. "I was told that Sophia Loren was going to do the role—and you wouldn't want anyone else to do those kissing scenes with Richard, would you?"

Richard was always the one who was more likely to cheat. When he was shooting the 1972 film *Bluebeard*

with glamorous costars Raquel Welch, Joey Heatherton, and Nathalie Delon, there were rumors that he was sleeping with all of them.

According to Bozzacchi, Richard and Welch were getting very close. "At around 3 in the morning, I got a call from Richard. He was sobbing, as if heartbroken. Elizabeth and Claudye [Bozzacchi's wife] had left on a trip, and I was terrified that Richard was crying because their plane had gone down! I dressed and raced upstairs to Richard's apartment. He was drunk and weeping uncontrollably. I opened the door to his bedroom and I saw Raquel Welch passed out on his bed, naked. 'Gianni!' Richard sobbed. 'I should never have done this to Elizabeth!' I have no idea what really happened, I'd never seen anyone more drunk. He couldn't stand up. I shook Raquel awake, helped her dress, and took her to her room. Richard never told me what did or didn't happen that night, quite possibly because neither he nor Raquel could remember a thing about it."

On September 13, 1971, Richard wrote in his diary that he apologized to Elizabeth "for breaking my contract to look after her forever, for letting her down with a bang (hysterical pun intended) . . . and for not realizing and demonstrating my full potential as husband, provider, lover and all."

His days began with a large vodka and orange juice

and sometimes he was so drunk that he needed to be carried from his Rolls-Royce to his dressing room. He was struggling with the sudden death of his older brother, Ivor, and he was generally unhappy with his career.

"He was a piece of work," said Joan Collins, who said Richard tried to sleep with her before he was with Elizabeth. When she rejected him he said, "You've now broken my record."

She said, "What is that?"

He said, "I've slept with every one of my leading ladies except you."

"He couldn't leave women alone," she said.

He hated himself for cheating. He wrote to Elizabeth apologizing: "I know I'm a terrible liar sometimes but please believe that I have never betrayed either in word or deed the physical you or the mental you. I simply love you too much. I flatter and I'm flattered and both too easily. It's only a question of booze." He signed the letter: "Husbs. (I Hope)"

We were "mutually self-destructive," Elizabeth said. "Maybe we have loved each other too much." But they realized that their unstable relationship was its own valuable commodity, and they continued to profit from it. In 1972 they agreed to do *Divorce His, Divorce*

Hers, a television movie about the breakup of a marriage. It alternated between the husband's and wife's perspectives, and it was filmed in Rome and Munich. That was because neither Richard nor Elizabeth stayed in Los Angeles or London for more than ninety consecutive days, because they did not want to pay taxes on the revenues from their films.

Waris Hussein, the thirty-four-year-old director of *Divorce His, Divorce Hers,* found himself walking into the most chaotic moment in the relationship between the most famous couple in the world. Elizabeth had not even read the script; she had agreed to do it only because of Richard, who was on the board of Harlech TV, a Welsh television station financing the film. She was doing it as a favor to him and he was doing it as a favor to Harlech.

Elizabeth asked for Edith Head to design the costumes, and Hussein met with Head to discuss Elizabeth's character. She was a well-read, well-educated, and elegant woman. She and her husband live well, but not as well as Richard and Elizabeth. Head just smiled sympathetically and said, "Have you met Elizabeth yet?"

Hussein shook his head and said, "No." Head said that she would bring sketches to Elizabeth, and when she came back with the sketches a red pencil had been slashed violently through each neckline. Every high-neck dress was eliminated.

Hussein said, "Oh, I guess this is what we're going to deal with."

Head replied, "Yes, I'm afraid you are. Elizabeth loves her jewelry and that's why it's got to be seen."

When Hussein finally met Elizabeth, she showed him the jewels she was planning to wear, including the enormous La Peregrina pearl.

He said, "Elizabeth, excuse me. I know the history of this pearl. The character you're playing would never in a million years be able to afford this."

She said, "I'm going to wear it anyway because my public wants to see me in my jewels."

He joked, "When you bend down to kiss your kids goodnight on-screen you're going to knock them out with this pearl." She did not think it was funny at all.

They did a night shoot on Via Condotti, where Richard had bought Elizabeth jewelry at Bulgari a decade before. "Suddenly," Hussein recalled, "the whole scene explodes into flash photography, lots of paparazzi, as Elizabeth gets out of the car and it's like the Red Sea parting." She was two days early. She sat wrapped in her fur coat on set and asked where Richard was.

The problem was, Richard had disappeared. "An hour later we found him and he had managed to find a bottle of vodka," Hussein recalled. "So the sober

Richard I had been dealing with prior to her arrival was incapable of walking straight down the street."

Elizabeth rushed toward Richard and said, "Oh my God, Richard. Are you okay? Can I help?"

"She was very possessive of him even though they were fighting," Hussein said. "Here was this woman who was incredibly sympathetic to a lot of people, but she chose the people she wanted to be sympathetic to. And she also chose the people who she was indifferent to. And I'm sorry to say I fell into the latter category. I was maybe a bit too soft, a bit too subservient, a bit too accommodating. She liked to be told to 'fuck off.' Richard behaved abominably with her. She liked the strength in the men around her, unless she was ordering around her makeup man or her hairdresser. She was the empress and she had her cohorts around her."

Hussein said he knew that he was no Mike Nichols, and he knew that she hated the film they were making.

"These are two people who met with a bang on the set of *Cleopatra*, and they were now ending with a whimper. And this subject matter, which was about a couple that was separating, was hardly the right subject matter for them to do. It was so psychologically insane."

But they kept up the show of being a glamorous couple. Richard and Elizabeth hosted long lunches

for friends from noon to three with four courses and drinking, which meant that little work was done after lunch. Once, Hussein was shooting a breakfast scene and Elizabeth was pouring coffee into cups with no steam coming out. He asked to speak with the person in charge of props.

"Why isn't it hot?" Hussein asked.

"It's not coffee. It's scotch."

Elizabeth did not want to be involved in what was basically a mirror image of their lives. It was a very complicated form of penance and revenge.

"I think that Richard realized that he had sold his soul," said Hussein. "He got the Faustian legend very much in his head. Elizabeth was, in reality, his Helen of Troy."

He once drunkenly told Gianni Bozzacchi that he was a millionaire, not because of Elizabeth, but because of what he had accomplished on his own. Bozzacchi joked that he too was a millionaire—in Italian lira. Richard was already too far gone to appreciate the joke. He got out of his chair and tried to punch Bozzacchi and hit the mantelpiece with his hand instead, hurting his wrist badly. He remembered nothing about it the next day.

On the set, Hussein watched their marriage unravel before his eyes. The man that Elizabeth had married

was no longer there. "He called her bitch, boobs, fatso. Their affection for each other was laced with acidity."

Divorce His, Divorce Hers aired on February 6 and February 7, 1973, to the worst reviews imaginable. *Variety* wrote that watching it "holds all the joy of standing by at an autopsy." The *Hollywood Reporter* called it "a boring, tedious study of the crumbling marriage of two shallow people." It was their eleventh film together—and their last.

In March 1973, Richard wrote: "Despite the fact that we have been together for 10 years or so I still regard you as an uninvadable and inviolate presence. You are as secret as the mysterious processes of the womb. . . . I have treated women, generally, very badly and used them as an exercise for my contempt except in your case. I have fought like a fool to treat you in the same way and failed. . . . We are such damned fools. Unfortunately we know it." Signed: "Ravaged love and loving Rich."

Chapter 12
The Loot: Elizabeth's Extraordinary Jewels

Elizabeth: Going to bed with jewelry is so much better than going to bed with a man.

Her friend: Why?

Elizabeth: The jewelry will be there in the morning.

Elizabeth's jewelry is like a scrapbook that tells the story of her life and the fierce undeniable love that she and Richard shared. Even when their relationship was at its worst, she had incredible pieces from him to hold on to; maybe she knew they would not stay together forever so she wanted something she could touch and feel to always remind her of him. When Roddy

McDowall asked her why she loved jewelry so much, she said, "That's a very silly question, Roddy. Why does any woman like jewelry?"

Her passion for jewelry began when she was a little girl. When she was twelve years old she spotted an ornate colored-stone brooch in the window of a boutique in the Beverly Hills Hotel, near her father's art gallery. She wanted to buy it for Sara for Mother's Day. She asked the person who worked at the store to hold the pin for her until she had enough money to buy it. And, a master negotiator even then, she asked for a good price. Elizabeth's allowance was, for years, twenty-five cents a week; eventually it was increased to fifty cents. It was around what most of her friends were getting, except that she was earning tens of thousands of dollars a year as a child actor. When she finally saved up enough money to buy it, the salesperson wrapped the package beautifully and Elizabeth gave it to Sara as an early Mother's Day present. It was the first piece of jewelry she bought with her own money, and the beginning of a lifelong love affair.

She considered herself a temporary custodian of her jewelry because no one, she reasoned, can ever truly own beauty. She loved spreading pieces out on her bed and admiring them. "There's something so pure about

stones, but not the settings, and not the acquisition or the ramifications, because you know, it's caused wars even, so it can be a source of awful turmoil or regret and not pure at all, but there's something so pure about just looking at the green stuff [emeralds] that came out of the earth. And it has such beauty, and depth, and it's so ever-changing." Her jewelry was so valuable that security expert Gavin de Becker, who traveled with Elizabeth and Richard in the 1970s, said that he put the jewelry in a safety deposit box in Switzerland under his name. Otherwise, he said, someone could have shown up looking like Elizabeth and run off with millions of dollars' worth of jewelry.

Elizabeth wanted to be close to her jewelry all the time, and later in life she stored it in a jewelry closet that was off the dressing room of her Bel Air home. There were banks of drawers with stacks of jewelry trays and separate drawers for earrings and bracelets. There was a small safe on the second floor, and all the most important jewelry was in that safe for easy access. There were other pieces kept in a seven-foot safe in the office on the ground floor. The incredibly expensive jewelry was one reason why she needed twenty-four-hour security.

She could lose interest in husbands, but never in her

jewelry. "Her obsession with jewelry was something otherworldly," said the late fashion journalist André Leon Talley. "Her fashion went from Versace to Valentino, it was from the V to the V, so sometimes it went off the rails. But she collected jewelry like an empress. There was something intuitive about the way jewelry affected her, it was who she was."

Richard, who grew up poor, loved buying her expensive gifts—almost as much as she loved receiving them. No one in the world was more giddy, more joyful, than Elizabeth when she received a piece of jewelry, big or small, though she did especially love the big stones. Richard usually did not give big presents on Christmas and birthdays; he believed in surprises.

"He'll just bring me something absolutely wonderful because it's a Wednesday. But my birthday? Forget it—not a thing usually. I've gotten used to it, but I love it when he surprises me with a bunch of flowers or any kind of present, no matter what it is. Sometimes they are big, sometimes they are tiny, sometimes it's a bunch of flowers that he has picked on the heath."

Demi Moore presented the prestigious Lifetime of Glamour Award to Elizabeth on behalf of the Council of Fashion Designers of America in 1998. Elizabeth thought it was absurd that after decades of being criticized by the insular fashion world she was being given

such an important award. "I just love the irony of the fact that I have been on every worst-dressed list ever compiled," she said in her remarks. "So eat your heart out, Mr. Blackwell!"

Blackwell, the famously acerbic fashion critic, could be very cruel. Once, he wrote of Elizabeth, "In tight sweaters and skirts she looks like a chain of link sausages."

Richard would have none of it and wrote a 1969 mocking letter to Blackwell: "The pain and the agony is further accentuated because it costs me so much to make my wife the annual winner of the World's Worst Dressed Woman award. . . . I have searched my memory profoundly and I cannot ever remember my wife, even in fun, looking like a sausage. Not even a Harrods sausage."

Elizabeth had an eclectic and quirky sense of style and she loved clothes, though she was nowhere near as passionate about fashion as she was about jewelry. She wore Christian Dior, Chanel, and Balenciaga, and she made Halston's caftans famous. She did not have a stylist and her fashion sense was wild and deeply personal. She experimented with colors and patterns and never belonged completely to one designer, as Audrey Hepburn did to French designer Hubert de Givenchy, who created her most iconic looks.

Elizabeth recognized great talent, and just as she had helped raise Bulgari's profile by lending the Italian jeweler some of her stratospheric star power, she helped make Valentino Garavani, who goes by Valentino, a household name. In 1961, when she was in Rome filming *Cleopatra*, she asked the then up-and-coming Italian designer if he would make an evening gown for her. She wore the stunning white floor-length dress he had made to the premiere of *Spartacus* in Rome. Photos of her dancing with Kirk Douglas, the star of the film, were published around the world, and soon celebrities and socialites were clamoring to wear Valentino. She and Valentino, who is now one of the most well-known and revered couturiers in the world, developed a lifelong friendship. She took to calling him "Rudy," after the handsome Italian actor Rudolph Valentino.

Even though Elizabeth did not have any help she always looked like she was ready to be photographed, probably because she lived so much of her life in front of the camera. French fashion editor Carine Roitfeld said, "I always loved the looks she had coming out of a plane!" Photographers captured her walking through an airport with Richard by her side in 1970 wearing white lace hot pants with knee-high boots. It was a bold fashion move for a woman in her late thirties who

had already been subjected to criticism about her appearance, but Elizabeth looked blissfully happy. She was tan and beaming and she exuded self-confidence. Fashion was meant to be fun, after all.

Elizabeth and Demi Moore developed a lasting friendship, maybe because they were both the subject of so much media speculation and criticism. Moore remembered sitting in Elizabeth's bedroom and looking at her incredible collection. She showed her a piece from Richard, and when Moore asked her what it was for, Elizabeth replied: "It was for Tuesday. It was a Tuesday gift."

"What's Tuesday?" Moore asked.

She said, "Just for Tuesday."

"I had a combination of reverence and almost being in two places at one time," Moore recalled. "One part of me felt like a little kid who was in complete awe and the other was just sitting woman to woman."

The most significant pieces in Elizabeth's large and storied collection represent an era of decadence and glamour in twentieth-century Hollywood that no longer exists. It is a time that Elizabeth would want the world to remember and to celebrate because beauty can never belong to just one person. Beauty cannot be contained, or kept hidden away; it is meant to be shared.

Ward Landrigan, the head of Sotheby's jewelry department, was in his twenties when he met Elizabeth and Richard and delivered to them the most magnificent diamond he had ever seen. In 1968 Richard paid $305,000 (or $2.5 million in today's dollars) for a 33.19-carat Asscher-cut stone nicknamed the Krupp because it was owned by Vera Krupp, the ex-wife of Alfred Krupp, a Nazi war criminal whose family was the top weapons manufacturer during both world wars.

"After an auction I always took my staff over to the bar next door from our New York office, and we were sitting there having a drink and it came on the radio that Elizabeth Taylor had bought the diamond. I said, 'Oh, man that's so cool!' About twenty minutes later someone came over from the office and said, 'Elizabeth wants the diamond now.' I said, 'Where is she?' They said, 'She's in London. Her people have booked you on a flight. Go.'"

Several hours later, Landrigan knocked on the door of their penthouse suite and Richard opened it. "Where's the diamond?" he asked.

"It's in my pocket," Landrigan said as he handed Richard the jewelry box.

Richard opened it and he just stared at the diamond for a minute. Elizabeth was in the bedroom.

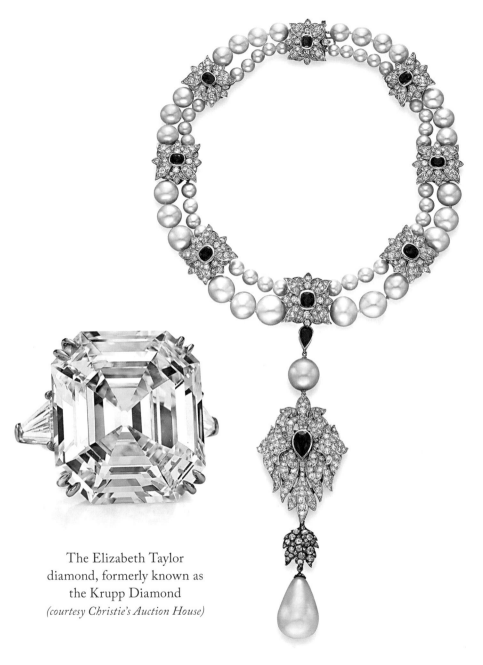

The Elizabeth Taylor
diamond, formerly known as
the Krupp Diamond
(courtesy Christie's Auction House)

La Peregrina Pearl
*(courtesy Christie's
Auction House)*

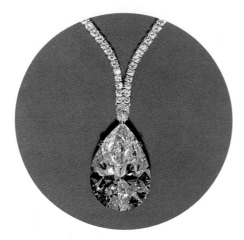

The Taylor-Burton Diamond, also
known as the Cartier Diamond
(courtesy The Elizabeth Taylor Archive)

The Taj-Mahal Diamond
(courtesy Christie's Auction House)

The Prince of Wales Brooch
(courtesy Christie's Auction House)

Five-year-old Elizabeth in 1937 with her mother, Sara, and her older brother, Howard, in Hampstead, England.
(photographer unknown, The Elizabeth Taylor Archive)

Elizabeth riding her horse in the late 1930s in England before her family fled to the U.S. at the outbreak of World War II.
(circa 1938, photographer unknown, The Elizabeth Taylor Archive)

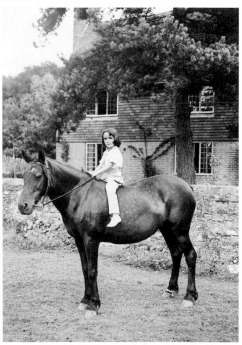

A movie studio portrait of Elizabeth holding two puppies. She had always loved animals and her lead role as Velvet Brown in *National Velvet* made her a star.
(circa 1945, MGM publicity still, The Elizabeth Taylor Archive)

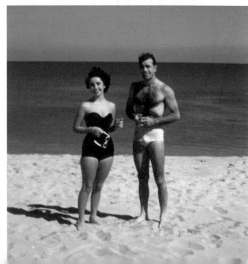

Elizabeth with her then fiancé, William Pawley, Jr.
(circa 1949, photographer unknown, The Elizabeth Taylor Archive)

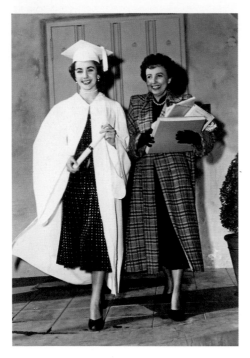

Elizabeth with her mother at her high school graduation in 1950.
(circa 1950, photographer unknown, The Elizabeth Taylor Archive)

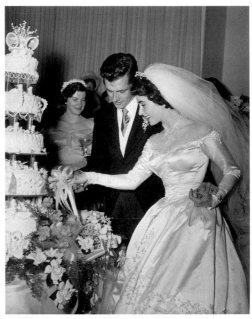

Elizabeth and her first husband, Conrad Nicholson "Nicky" Hilton Jr., on their wedding day in 1950.
(1950, photographer unknown, The Elizabeth Taylor Archive)

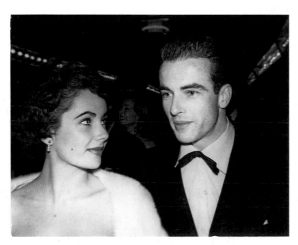

Elizabeth looks adoringly at Montgomery Clift during the premiere of *A Place in the Sun*.
(circa 1951, photographer unknown, The Elizabeth Taylor Archive)

Elizabeth's second husband, British actor Michael Wilding, holds their son Michael Howard Wilding in 1953. *(photographer unknown, The Elizabeth Taylor Archive)*

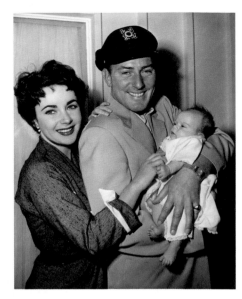

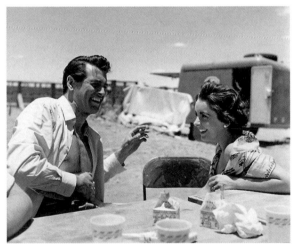

Rock Hudson and Elizabeth laughing together on the set of *Giant* during filming in the small town of Marfa, Texas, in 1955. *(Sid Avery/mptvimages.com)*

Elizabeth taking a nap next to James Dean, another *Giant* costar, during a break from filming. Dean is reading a copy of *Look* magazine with Elizabeth and her two young sons on the cover. They became close and he shared his deepest secrets with her. *(Richard C. Miller/Donaldson Collection/Getty Images)*

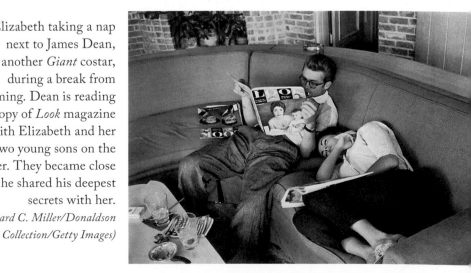

Elizabeth dancing in the rain on location for 1957's *Raintree County* which
was filmed in Danville, Kentucky.
(*Bob Willoughby/mptvimages.com*)

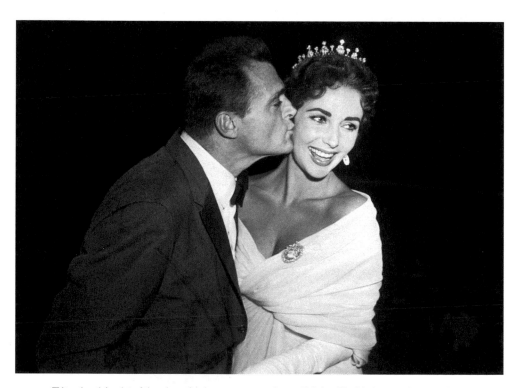

Elizabeth's third husband, the super producer Mike Todd, kisses her at the
International Film Festival in Cannes.
(*Bettmann/Getty Images*)

Images from a home video taken in the south of France showing Mike Todd giving Elizabeth a Cartier diamond and ruby necklace and a pair of matching earrings. Todd's best friend Eddie Fisher is behind them.
(home video from Getty Images)

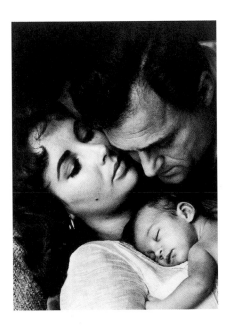

Elizabeth holding newborn Liza Todd on her chest as Mike Todd leans over them.
(Toni Frissell/Reproduced from the Collections of the Library of Congress)

Elizabeth feeding her daughter, Liza, while smiling at her sons Michael and Chris Wilding. She is wearing the 29.4-carat emerald-cut diamond engagement ring Mike Todd gave her on her left hand.
(Toni Frissell/Reproduced from the Collections of the Library of Congress)

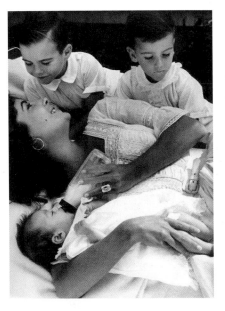

After Mike Todd's sudden death in 1958 Elizabeth married Todd's best friend, Eddie Fisher.
(circa 1959, photographer unknown, The Elizabeth Taylor Archive)

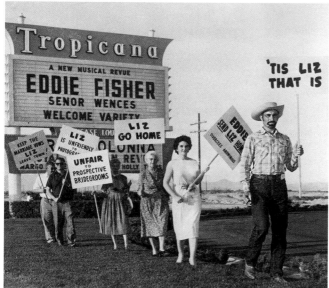

Protestors carrying signs that read KEEP THE MARRIAGE VOWS LIZ, LEAVE TOWN! and EDDIE SEND LIZ HOME, in front of the Tropicana Hotel in Las Vegas where Fisher was performing in April 1959.
(Bettmann/Getty Images)

Elizabeth wearing a floral crown and holding a cigarette sitting between her parents, Sara and Francis Taylor.
(circa 1959, photographer unknown, The Elizabeth Taylor Archive)

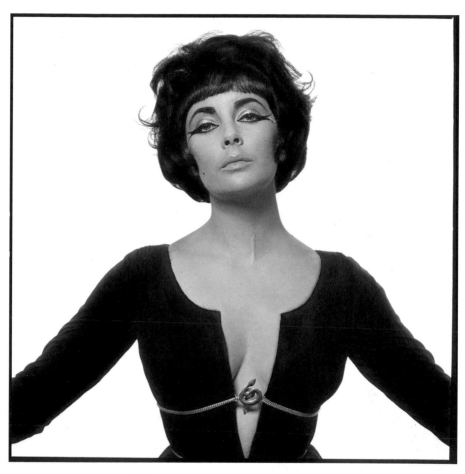

A portrait of Elizabeth for *Vogue* magazine taken in 1962. She demanded, and received, a record-setting one million dollars to star as Cleopatra. The scar from her tracheotomy surgery is clearly visible.

(Elizabeth Taylor as Cleopatra, 1962 ©The Bert Stern Trust Photographs, courtesy of the Bert Stern Trust)

Elizabeth and Richard during their first wedding in Montreal in March 1964. "I'm so happy you can't believe it," she said. *(William Lovelace/Evening Standard/Getty Images)*

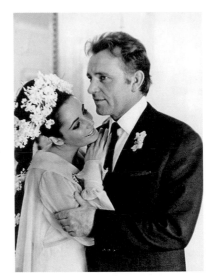

Elizabeth took this self-portrait with a Polaroid camera during the filming of *Who's Afraid of Virginia Woolf?* She was thirty-two years old when she transformed herself into the forty-five-year-old acid-tongued Martha. *(1966, Elizabeth Taylor, The Elizabeth Taylor Archive)*

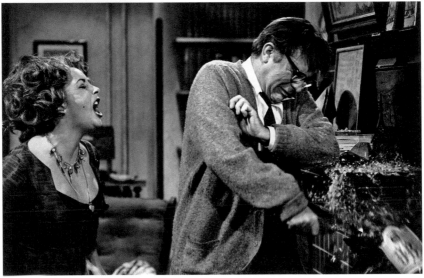

Elizabeth in her Oscar-winning performance in 1966's
Who's Afraid of Virginia Woolf?
(Bob Willoughby/mptvimages.com)

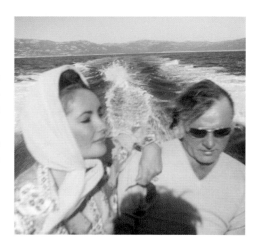

Elizabeth and Richard
Burton in 1967 on board
a speedboat along the
coast of Sardinia, Italy.
*(photographer unknown, The
Elizabeth Taylor Archive)*

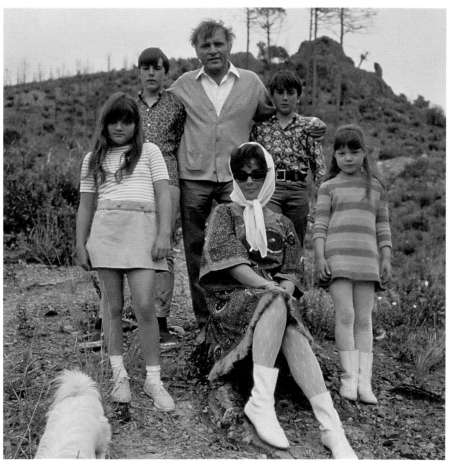

From left, Liza Todd, Michael Wilding, Richard Burton, Chris Wilding,
Maria Burton, and Elizabeth (seated) in 1967.
(Bob Penn/Gamma-Rapho via Getty Images)

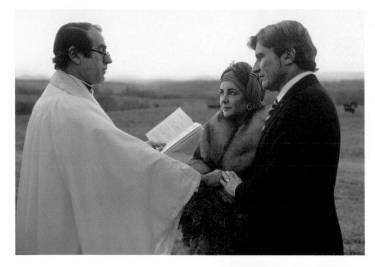

Elizabeth and Senator John Warner in 1976 at their wedding ceremony on a hilltop in Virginia. *(photographer unknown, The Elizabeth Taylor Archive)*

Elizabeth making fried chicken at the farm she shared with Warner, who was her seventh husband. She gained weight and sank into a deep depression during their marriage. *(from the private collection of Chris Wilding)*

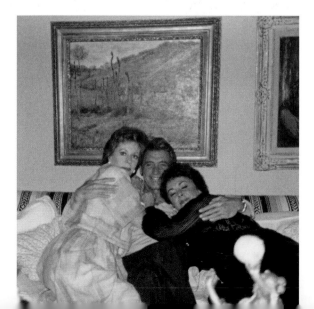

Elizabeth (right) with Rock Hudson (middle) and Carol Burnett (left) at her Bel Air home in 1981. She learned of Rock's AIDS diagnosis before the rest of the world. *(photographer unknown, The Elizabeth Taylor Archive)*

Elizabeth testifying before the Senate in 1986 alongside Dr. Mathilde Krim.
(photographer unknown, The Elizabeth Taylor Archive)

Elizabeth used her long
relationship with the Reagans
to convince President Reagan to
finally address HIV and AIDS.
*(signed photograph from Nancy
Reagan, photographer unknown, The
Elizabeth Taylor Archive)*

Dear Elizabeth—
it's always so good to see you—
love Nancy

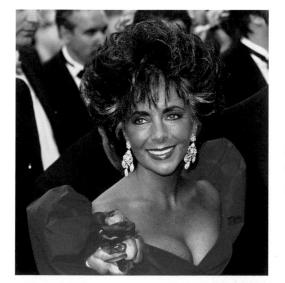

Elizabeth at the 1987
Cannes Film Festival.
(Photo by Avalon/Getty Images)

Chen Sam (lying on the floor), Roger Wall (wearing a striped shirt), and a friend of Elizabeth's. Her assistants became like family to her. *(photo taken by Bradley Anderson)*

Elizabeth's eighth and final marriage was to Larry Fortensky, a construction worker she met in rehab who was twenty years her junior. *(1992, photographer unknown, The Elizabeth Taylor Archive)*

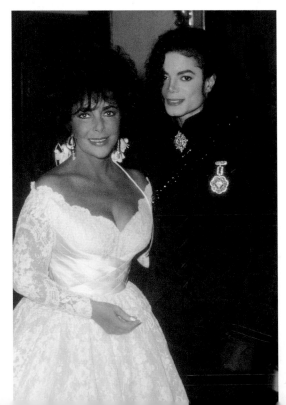

Her wedding to Fortensky took place at her close friend Michael Jackson's Neverland Ranch. Photographers circled the ranch in helicopters during the ceremony. *(The Elizabeth Taylor Archive)*

Elizabeth appeared on a groundbreaking cover of *Vanity Fair* in 1992 holding a condom. She devoted the last three decades of her life to ending HIV and AIDS.

(Firooz Zahedi, 1992)

Elizabeth and Debbie Reynolds stayed close long after Eddie Fisher was out of both of their lives. *(circa 2001, photographer unknown, The Elizabeth Taylor Archive)*

In her final years, the actor Colin Farrell often visited Elizabeth at her home and read poetry to her. He reminded Elizabeth of her great love, Richard Burton.
(2010, photographer unknown, The Elizabeth Taylor Archive)

He leaned over his shoulder and yelled, "Elizabeth, come here!" She came roaring out of the bedroom and he handed the open box to her.

"*Oh, shit!*" she squealed in delight as she tackled him. They fell over the side table knocking over a lamp and landing on the couch.

Landrigan remembered thinking to himself: *Wow, this is so Hollywood.*

"Look at my short fat little fingers now!" she said as she held her hand out in front of her, wiggling her fingers.

There was an innocent exuberance she had about the enormous diamond. She drew the diamond on a postcard to her parents and wrote:

Dear mom and dad,
 Did you read about my ring—it's fab! Love you both, wish you were here.
 Elizabeth & Richard

"When it came up for auction in the late 1960s, I thought how perfect it would be if a nice Jewish girl like me were to own it," she joked.

They could not get insurance on it right away, so Landrigan had to be with them at all times. He stayed in London for a week. He loved the glamorous

assignment. He got to watch Richard learn his lines for a film he was doing without Elizabeth. They were pasted on the walls of his trailer, and he paced the room to learn them. Landrigan traveled with them to Wales to celebrate the purchase of the Krupp. A party was thrown at a beer hall with sawdust on the floor, and all the ladies who had never seen a diamond even a quarter of the size got to try it on.

Landrigan grew up in a blue-collar family in New Jersey. He had never stayed in a hotel as opulent as the Dorchester. Elizabeth felt protective of him. One day, Elizabeth, who always cut Richard's hair, told Landrigan that he needed a haircut. She took out a pair of clippers and told him to sit down. When she was halfway done, Richard walked in.

"*What are you doing? Get out of here!*" he screamed. "This is for family." Landrigan took a walk and found a barber shop where he could have the other half of his hair cut. Richard always felt suffocated by their entourage, but Elizabeth enjoyed being surrounded by people. Landrigan was getting too close.

Perhaps feeling remorseful, Richard asked Landrigan later if he would go with him to his favorite pub, but Elizabeth stepped in. "Do not go with him," she told Landrigan. "You'll be sorry."

"I couldn't of course," Landrigan said, "because I would have had to leave the diamond."

Richard showered her with expensive jewelry as a way to prove his extravagant, abundant, yet deeply flawed love. In one poem he used the cadence of the lullaby "Twinkle Twinkle Little Star" and compared Elizabeth to a "diamond in the sky." All of which is lovely, but the poem takes a darker turn when he refers to a fight they had the night before:

I wish I may, I wish I might (now me)
Forget the things I said last night. . . .

(not drunk. Just old.)
I love you more than anything on the sad face
of this raped earth.

<div align="right">Jenkins</div>

His letters and poetry reveal his misanthropic self-loathing that no number of lavish gifts could disguise.

At a party in London, Princess Margaret took one look at the Krupp and said, "My dear, that ring is positively vulgar." Elizabeth bit her tongue, and after a few drinks Margaret came back over and said, "Excuse me, would you mind if I try the ring on?"

"Of course," Elizabeth said, with her customary chutzpah, as she watched her slip it on her finger. "Not quite so vulgar now, is it?"

She had a sense of humor about her otherworldly jewels. "It's not chopped chicken liver," she joked when the journalist David Frost asked to get a better look at the ring during an interview. She loved seeing the look on people's faces when she let them try on her signature piece of jewelry, which she did all the time.

A few months later, in 1969, in the top-floor apartment of Caesars Palace in Las Vegas, Elizabeth was on her hands and knees searching the carpet for a lost present from Richard. It was one of her most beloved pieces, La Peregrina, which Richard had just spent a fortune on, and it had vanished.

La Peregrina, or "The Wanderer," was discovered in the Gulf of Panama in the late 1500s and sent to King Philip II. It was a Spanish Crown Jewel and appears in many portraits of the Spanish royal family. Eventually the pearl ended up in France and was inherited by Charles Louis Napoleon Bonaparte, the future Napoleon III, president and emperor of France in the mid-1800s. The pearl was sold to the English James Hamilton, Duke of Abercorn, and stayed in their family until Richard bought it for $37,000 (the

equivalent of $290,000 today) at a Sotheby's auction as a Valentine's Day gift for Elizabeth.

Landrigan had just delivered the extravagant piece of jewelry to Elizabeth. It was after midnight and Elizabeth was drinking a salty dog made with vodka and grapefruit juice and offered him one. Five minutes later she came running over to Landrigan holding the chain the necklace had hung on a few minutes before.

"I've lost it!" she whispered, trying to hide the loss from Richard, who was oblivious.

"Did you look in your shirt?" Landrigan asked.

"It's not there," she said, horrified.

She retraced her steps and still nothing. She started humming and walking back and forth in her bare feet. She wanted to look like she had a purpose wandering around the suite, so that Richard would not know what was going on. She noticed one of their Pekingese dogs chewing on a bone.

"It's like the longest, slowest double take in my head. We don't give our dogs, especially the puppies, bones. *What is it chewing?* And I just wanted to put my hand over my face and scream and throw myself on the floor. I just casually went over, opened the puppy's mouth, and inside its mouth was the most perfect pearl in the world. And it was, thank God, not scratched."

That same year, in 1969, Richard had called Elizabeth's hands "large and ugly and red and masculine" during one of their many interminable fights. Elizabeth woke up the next day and said, "You really must get me that sixty-nine-carat ring to make my ugly big hands look smaller and less ugly!"

"That insult last night is going to cost me," he said.

The diamond that Elizabeth was referring to was a flawless 69.42-carat pear-shaped diamond that dwarfed the Krupp and was once owned by the sister of Walter Annenberg, the billionaire publisher who was the U.S. ambassador to the United Kingdom when Richard Nixon was president. She thought the ring so audacious that she rarely wore it and stored it in a bank vault. As soon as Elizabeth and Richard found out that it was available, they asked Landrigan to come to Gstaad to show it to them. If Elizabeth liked something, she loved it, and she loved this diamond. So apparently did Aristotle Onassis, who had dropped by the Parke-Bernet Galleries in New York to inspect the stone, leading the press to speculate that he intended to buy it for his wife, Jacqueline Kennedy Onassis.

Elizabeth and Richard were at their favorite pub in Oxfordshire, near a friend's cottage, when he was on the phone bidding, pint in hand. The bidding started at $200,000 and rose rapidly, but when it hit $1 million

Richard pulled out. The auction record for a diamond up to that point was $385,000. Cartier bought it for $1.05 million ($8.3 million in today's dollars), which made Richard furious because he thought it would go for $2 or $3 million. He negotiated with Robert Kenmore, who was the owner of Cartier New York, to buy it for $1.1 million.

"If you don't sell it to me I'll tell everyone and no stars will wear Cartier anymore. Cartier will be over," he threatened. Kenmore relented and the diamond was Richard's, but only after it was put on display for a week at Cartier's Fifth Avenue store. More than six thousand people a day lined up for the chance to see it.

Gianni Bozzacchi was Elizabeth's personal photographer, and he remembered when the diamond arrived in Monte Carlo, where Elizabeth and Richard were staying on their seven-bedroom yacht named the *Kalizma* (after daughters Kate, Liza, and Maria). It could hold a crew of eight, including a maid, a waiter, and a cook. They had brought important paintings to decorate the yacht's walls, including a Van Gogh. Elizabeth especially loved the Van Gogh and she would stare at it for hours. She said that he was the only artist who could make her cry simply by looking at his paintings. "There's something so desperate, and sad and lonely," she said. When the sea got rough staff rushed to take the

museum-worthy paintings off the walls so they would not be damaged. Elizabeth's favorite bedroom was on that yacht, decorated in shades of white and yellow. She called the yacht the "best toy." Richard quipped that finally he could bring his vast book collection along with him when they traveled.

Elizabeth wanted to wear her new diamond to Princess Grace's Scorpio Ball. Cartier sent three diamonds so that would-be thieves would not know which was real. There were three identical boxes carried by three men who even looked alike, according to Bozzacchi.

One arrived by car, another by helicopter, and a third by boat. It was late at night and Richard was drunk, and he began playing with one of the diamonds and it fell over the side. Elizabeth was screaming, and their chauffeur put on a diving mask and jumped into the ocean. Richard, Bozzacchi said, was laughing the whole time. They had the other two diamonds, but they could not tell which was real and which was fake, so they called Pierre Arpels of Van Cleef & Arpels at 3:00 a.m. in Monte Carlo and woke him up. Arpels came to inspect the remaining two diamonds and said, "This is the one!"

It turned out that Richard had, fortunately, tossed a piece of glass into the ocean. In 1970, Elizabeth wore her 69.42-carat pear diamond, suspended from a Cartier

necklace, to the Oscars, where she presented the award for Best Picture.

Richard enjoyed researching the history of the pieces he bought his wife, and the story behind the Taj Mahal made it irresistible. The inscribed heart-shaped table-cut diamond is set within a red stone and jade mounting and hangs from a gold neck chain set with cabochon rubies and old-mine cut diamonds. The story claims that it was made for Nur Jahan, the wife of Emperor Jahangir, during the Mughal period. Jahangir, was the father of Shah Jahan, and it is said that he inherited the stone and gave it to his favorite wife, Queen Mumtaz Mahal. Shah Jahan built the Taj Mahal in memory of her. "Eternal love 'til Death" is engraved on the stone. It is quite possibly the most romantic, and the most unique, of Elizabeth's exquisite collection.

"Richard would joke that he had intended to buy me the Taj Mahal," she said, "but it was too big to move to our home in Switzerland. Some consolation prize!"

Remarkably, Elizabeth insisted that she loved her smallest piece of jewelry as much as the biggest. Richard paid thirty-eight dollars for a .042-carat diamond ring which they nicknamed the Ping Pong diamond. "Richard is really almost professional at ping-pong. He told me, 'If you can win a game—if you can even

take ten points—I'll give you a perfect gem.' I got him sloshed, and I not only took the ten points, I beat him!" And she got the ring as her prize.

A piece she bought herself had special significance. She met the Duke and Duchess of Windsor when she was eighteen years old and married to Nicky Hilton. Then, years later, after Le Scandale broke, Richard was doing a film in Paris and she got to know them. When King Edward VIII abdicated the British throne in 1936 so that he could marry the twice-divorced American Wallis Simpson, the couple had become as famous and controversial as the Burtons later would. They told Elizabeth and Richard that they could relate to them and the controversy that their relationship had caused, and they invited them to their country house.

"They really did love each other, and his respect for her was so beautiful," Elizabeth said. "He called her Duchess, and if you didn't call her Duchess I think you would have been on your way out. . . . I never called her Wallis, I always called her Duchess. . . . We were coming out for lunch and it would always be the four of us and she was deciding what to wear and her lady in waiting was helping her and she was sifting through her jewelry—what a collection she had—and she started to put on her diamond ring. She said [haughty

British accent], 'Oh, no! I can't wear that. Give me the sapphire. Elizabeth's diamond is much bigger.'" Elizabeth cackled with laughter at the memory. "Which I thought was very cute. So she wore the sapphire not her diamond when I was around because the Krupp was bigger."

Elizabeth noticed a magnificent pin Simpson was wearing that was the insignia of the Prince of Wales, with three feathers and a gold crown made of diamonds set in platinum. When Elizabeth asked if it was the royal insignia, Simpson said, "Yes, and when Monty [Lord Mountbatten, a member of the royal family] came over, he took all the royal pieces back, but he missed this one."

Elizabeth said, "That is so great. That's so romantic that the duke had them made up for you." Simpson offered to let her make a copy of it, but Elizabeth felt uncomfortable with the idea. Besides, she wanted the real thing.

"I really got to love them," Elizabeth said of the beleaguered couple. After Simpson died in 1986 and Elizabeth saw the pin in a charity auction she thought, *The Duchess wants me to have that.* She was sitting by her pool with her family and bidding on the phone. She loved the piece and its history, but she also loved that the money was going to the Pasteur Institute in Paris, a

medical research foundation with a focus on AIDS and cancer research.

She was bidding against someone who wanted it as much as she did, but not for the same reason. "I wanted it because I knew she wanted me to have it, it was like a spooky eerie thing. . . . So I kept on saying, 'More, more, yes, more, more. Yes, yes . . .'" She ended up paying $565,000. "The kids and everybody's looking at me, just staring at me like I'd flipped my wig." When she told her family the astronomical price some of them threw themselves into the swimming pool.

Chapter 13
The End and a New Beginning, 1973–1976

*The tug of love is over and we are one
once more. I'm happy, I hope you are.*

—"Six Days in October," a letter that
Elizabeth wrote to herself about Richard

I n May 1973, Elizabeth started working on *Ash Wednesday*, which was filmed in the ski resort of Cortina d'Ampezzo in northern Italy. The film tells the story of a middle-aged woman who decides to get drastic plastic surgery to win her cheating husband back. It was another case of life imitating art; Elizabeth was forty-one years old and she was trying to hold on to Richard, who accompanied her but who was miserable.

Dominick Dunne was a producer on the film and

remembered suggesting that they have dinner one night with Andy Warhol. Elizabeth initially scoffed at the idea. "That man made millions off of me!" she said, referring to Warhol's iconic silk screens using her image without her permission. She resented that they had helped transform him into a celebrity. (He eventually gave her a small lithograph, which was not one of the originals, and which she hung in the living room of her Bel Air home.) Finally, she agreed to see him.

Their booze-soaked dinner went fine, until after dessert when Elizabeth rose to go to the ladies' room. As she got up off the red leather banquette she felt something hard under her sable coat. Warhol had secretly placed a tape recorder there.

"*You've been recording me while I'm drunk?!*" she screamed. It was another invasion of privacy that made her feel violated. Warhol handed her the tape recorder, but they did not speak another word to each other that night.

Her relationship with Richard had gotten so bad by then that it had descended into name-calling on set. In one scene Elizabeth's character is supposed to be playing bridge. She did not play the game and she got confused and asked, "Four of *what*? What am I supposed to be saying here?"

Richard, whose drinking was getting more and

more out of control, was standing off camera. "You stupid cow!" he yelled. "Just show your big tits!" He even called Elizabeth a "cunt" in front of her children.

From the hotel, Richard wrote during filming: "My beauty girl, woman, member of the opposite sex, will not accept the fact that she is stumbling into middle-age. I'm not surprised. It took me quite a time too."

Dunne thought *Ash Wednesday* was the final blow to their already crumbling marriage. In 1973 Elizabeth wrote:

> Richard
>> Please try.
>> You can.
>> Don't be so bloody predictable
>> Give us a shock . . .

She was exhausted by his alcohol-fueled outbursts and while she loved the jewelry, she was sick of his expensive apologies. She wrote him an undated letter on tear-stained TWA stationery thanking him for the "Tuesday diamonds and the Friday emeralds," but begging him to show his love less lavishly and more genuinely.

> All I need is your back to warm up against, your hand to hold when I'm afraid or cold inside. To talk

to you when the lights are out. . . . I even need you to fight with! I need you—nothing else, so don't give me any more "stuff." I just want you. I give you all of me with all my love.

<div align="right">Elizabeth</div>

But he could never really change. "They were always in love. They were too much in love to stay married and they were too much in love not to be married," said Richard's friend David Rowe-Beddoe. "It was his turn to have a bitch and it was her turn to have a bitch. It was a tempestuous relationship. You couldn't write it, no one would believe it."

Meanwhile, Elizabeth's drinking was getting worse. In the mornings she summoned her butler and asked him for a bloody Mary, at lunch there was wine, and in the afternoon she had a glass full of whiskey or vodka. In the end, she decided they needed to separate, and Richard was so lost in his alcoholism that he acquiesced without a fight.

In a letter dated Monday, June 25, 1973, Richard let her go:

So my lumps,

You're off by God! I can barely believe it since I am so unaccustomed to anybody leaving me. But

reflectively I wonder why nobody did so before. All I care about—honest to God—is that you are happy and I don't much care who you'll find happiness with. I mean as long as he's a friendly bloke and treats you nice and kind. . . .

On July 4, 1973, Elizabeth issued a handwritten statement:

I am convinced it would be a good and constructive idea if Richard and I are separate for a while. Maybe we have loved each other too much (not that I ever believed such a thing was possible) but we have been in each other's pockets constantly, never being apart except for matters of life and death, and I believe it has caused a temporary breakdown in communication. I believe with all my heart that this separation will ultimately bring us back to where we should be—and that is together. Wish us well during this most difficult time. Pray for us.

There would always be a deep connection between them. Richard wrote to her a few weeks after the announcement. He could confide in her about his drinking, as he does in this note, in a way that he could not with anyone else:

I think of nothing but you and when other people are around—as at lunch today—I starve for the sound of your name and if they don't mention it often enough I bring it in willy-nilly. I hope you don't think I am 'holier than thou' which you accused me of, but there was a tableful of drinks and I didn't touch a drop, despite the screaming silent agony in my bowels and heart and brain.

It is clear that he wanted her back. In a letter dated October 7, 1973, he wrote: "It may very well be that this is the last time that your last name will be, in my presence I mean, the same as mine, but I bet you the impossible bet that when I am on my last bed and nearing the eternal shore that the words Elizabeth Elizabeth Elizabeth BURTON will be on my lips."

Their relationship was whiplash inducing, they were on again and off again for months. Chaos, they knew, is always interesting. She could never trust Richard—and rightly so; his infidelity tore them apart before the breakup. Richard and Sophia Loren did eventually work on a film together, which was always a great fear of Elizabeth's.

Before they got married, Richard said, he made one request of Elizabeth and she made one in return. "Do me a favor," he said to her, "everybody has to make

some sacrifices for somebody else when they get married and fall in love and I will cut down on my drinking and lying if you'll cut down on your four-letter words." ("You bet your ass I will," she told him wryly.)

Elizabeth said, "You cannot cut down on your lying because it's instinctive, integral."

"I promise you I'll do it," he told her. And he said that he did. But cutting down was not the same thing as stopping altogether.

When Richard filmed Vittorio De Sica's *The Voyage* a few months before the breakup, he stayed with Sophia Loren and her producer husband, Carlo Ponti, in their guest house. "I thought they were just a little too friendly and I felt left out of their joke," Elizabeth said. "They'd speak Italian in front of me which really made me feel left out. His wasn't fluent, but enough to get through. . . . I mean he was flirting his head off and she was flirting right back, and I thought, *I'm not going to sit here and watch this. Screw them both.*"

Elizabeth left to start working on the film *The Driver's Seat* in Rome, but she missed Richard. Gianni Bozzacchi remembered helping Elizabeth get ready for lunch at Loren and Ponti's villa. "They were trying to find a way to get back together," he recalled. Bozzacchi waited in Elizabeth's seven-room suite at the Grand Hotel while she was getting ready in the

bathroom. Finally, when she emerged he could not hide the look on his face.

"Where are you going dressed like that?" he said. She was wearing all her best jewelry, heavy makeup, and an elaborate updo. "You look like a Christmas tree, for god's sake!"

She slammed the door of the bathroom and began sobbing. "You don't know what I'm going through!" Bozzacchi tried to comfort her, and he told her how beautiful she was when she wore no makeup at all and dressed in jeans and a T-shirt.

"And that's what she did," he said. "She took off all the makeup, and Elizabeth, without makeup, was beautiful. She looked twenty years younger. We drove to Sophia's house and she asked me, 'Do you think Richard had an affair?' I said, 'Richard loves you.'" Sophia came downstairs for lunch in full makeup, dripping in jewelry and wearing a brightly colored caftan. Elizabeth looked so much more naturally beautiful. But she returned to Rome that day, without Richard.

Elizabeth was surprised when a fling from a few weeks earlier (if Richard could do it, so could she), a used-car salesman named Henry Wynberg, checked into the Grand Hotel to see her. She was feeling lonely and insecure, and she made sure that photographers captured them going out for extravagant dinners and

dancing. Those photos, quite clearly, had an intended audience of one.

In the late fall of 1973, she was suffering from terrible stomach pains, and she was convinced she had cancer. She was admitted to UCLA, where she had a benign ovarian cyst removed. Richard was still shooting *The Voyage*, but he left Italy with no luggage and rushed to her bedside when she asked him to "come back home." Wynberg was summarily dismissed.

Richard told her that he had stopped drinking, and he forgave her for her relationship with Wynberg. He had of course had his share of what he called "cathartic infidelities."

"The next thing I know we're squeezing the air out of each other and kissing each other and crying," Elizabeth said. "He said, 'Please come back with me.' You've never seen anybody heal so fast. It was like the Grand Maestro took a hand over my incision and healed me up. He went to Van Cleef & Arpels and came back with this extraordinary pavé diamond heart choker. . . . It's one of my favorite pieces of jewelry because it was given with such love. Boy, that man knew how to make up."

She accompanied Richard to a small town north of Sacramento where he was to film *The Klansman*, and it was there that things began to fall apart again. Richard ogled other women and flirted shamelessly in front

of Elizabeth, which was humiliating. He was tired of her many illnesses and her entourage and the business of *being Elizabeth Taylor*. They decided to spend time away from each other again. In a letter dated Friday February 19, 1974, Richard wrote to Elizabeth from his home in Céligny, Switzerland:

Dearest Long-Loved-and-Lost awhile,

Miss you very much and love you a lot but life now is so much simpler than the past decade. . . . Buying things with my own money, I mean actually having money in my pockets, choosing things with my own choice . . . Meet you 1/2 way any place as ever.

By March, they were back together again. Elizabeth wrote to Richard on their tenth wedding anniversary:

My darling (my still) my husband,

I wish I could tell you of my love for you, of my fear, my delight, my pure animal pleasure of you— (with you)—my jealousy, my pride, my anger at you, at times.

Most of all my love for you, and whatever love you can dole out to me—I wish I could write

about it but I can't. I can only "boil and bubble" inside and hope you understand how I really feel.

Anyway I lust thee, your (still) wife. P.S. O'Love, let us never take each other for granted again! P.P.S. How about that—ten years!

But a month later, on April 26, 1974, they announced that they would be getting a divorce. Two months later, Elizabeth went to a courthouse near Gstaad to finalize it.

Rowe-Beddoe watched helplessly as they tore each other apart. There was, he said, "always too much buggering." Richard had trouble admitting that he was an alcoholic and always thought of himself as a drunk who could stop if he needed to. When they were together, Elizabeth said that she wanted him to stop drinking, even though she still drank in front of him.

When he was not drinking and she was, she found him almost intolerable. On the train once she yelled, "You are a bloody bore when you're sober!" By the time he got off the train he was pissed drunk. It was confusing, he did not know how to make her happy.

The Elizabeth and Richard that Rowe-Beddoe wants to remember come alive in a story from the late 1960s, when they came to stay at his cottage in the English countryside. Elizabeth wanted to have Dom Pérignon,

her favorite drink. In the early afternoon, she walked over to the pub and asked the bartender, who nearly fainted at the sight of her, if they had any. When he told her they did not, she sent her driver to London, which was an hour and a half away, to get some.

"She took several bottles to the pub and insisted on buying it from the pub. They will never, ever forget her. Here was this star standing at the bar buying drinks for everybody, including buying drinks for herself from the bottles she had provided."

The fun of the Liz and Dick show was over before they were. Elizabeth was addicted to the drama of their nearly fifteen-year roller-coaster relationship. And so was Richard. No matter how much he said he wanted to be free, he kept proclaiming his love and adoration in his private letters to her.

Elizabeth was in Rome finishing *The Driver's Seat* and she could not believe what had happened to them. Richard could not either. "I threw Elizabeth out, told her to get out—and to my surprise she went. I couldn't believe it."

She was lonely and asked Gianni Bulgari, who led the family jewelry business, to go to dinner with her, but he did not want the paparazzi harassing him. Finally, he said he would go out with her as long as they were

not alone. He asked a few friends, including a beautiful woman in her twenties, to join them for dinner.

"The minute that Elizabeth walked into the restaurant and saw this girl she refused to sit down at the table because she was younger and very beautiful. Elizabeth said that she was sick and that she didn't feel well."

Bulgari said he spent the entire evening between the dinner table and the ladies' room comforting Elizabeth. "She refused to sit down at the same table with this girl because she felt threatened. She was lonely and spoiled." She was also devastated and insecure. She felt abandoned by the man she wanted to trust most in the world.

In February 1975, Wynberg, who was back in the picture, went with Elizabeth to Russia to film *The Blue Bird*. The film was directed by George Cukor, and it was the first Soviet-American coproduction during the Cold War. The cast, including Elizabeth, spent much of the filming in bed suffering from various illnesses, from the flu to amoebic dysentery. When she received a telegram from Richard saying that he wanted to see her, she got on a plane to Switzerland on August 14, 1975. Wynberg was again dismissed. She ran into Richard's arms crying, both of them saying how much they missed each other. They were officially back together.

She called Bulgari to tell him the news. "I'm in New

York City and I get a call from Rome from someone saying, 'I have Elizabeth Taylor on the line, she wants to speak to you.' She gets on the phone and says, 'I want to tell you that I'm at last getting back together with Richard!' I said, 'Congratulations,' and she said, 'Don't you think I deserve a gift?' She had already chosen a one-hundred-and-fifty-thousand-dollar necklace. I said, 'No.' Sometimes I was very direct with her. I said, 'Why the hell are you calling me at five o'clock in the morning to tell me this?'"

Their reunion was tantalizing tabloid fodder. Doris Romeo ran a household staffing agency for the rich and famous, serving everyone from the Saudi royal family to Frank Sinatra, and said that she was offered two hundred thousand dollars a year—which was an astounding sum in the 1970s and '80s—to divulge Elizabeth's secrets. "I told them the secrets would die with me," Romero said, but the offer shows the lengths the tabloids would go to get any piece of gossip. "They wanted to know who was gay and who was sick," she said. "With Elizabeth it was about her illnesses and how much she was eating." *National Enquirer* reporter Tony Brenna said that he bought the last five first-class tickets from Switzerland to Israel when Elizabeth was reconciling with Richard. "I bought them to keep other journalists away." He got Elizabeth's attention

from across the aisle and offered her a deal she had heard many times before: "There's an easy way and a hard way to do this," he told her. "I just need a couple words from you about a reconciliation and I'll leave you alone."

Elizabeth did not take long to decide which she preferred—she had no reason to make his life easy. "*Fuck off*," she seethed. Then a flight attendant approached Brenna and told him that he had to stop bothering other passengers. "It was fun," he recalled, "it was like a war between the tabloids and celebrities."

Elizabeth was furious when, after she left the cabin briefly, she returned to find Richard and Brenna drinking together. She was used to Richard falling off the wagon, and even as she gave Brenna a scorching look, she could never stay mad at Richard for long. "The one thing that was obvious was that they were passionately in love with each other," Brenna, who followed them around the world, said. "It wasn't a new thing, this was an old flame that had been burning for a long time."

Stories about their passionate and tumultuous relationship made the tabloids very rich. Years later, Brenna said that he paid Elizabeth's old crush, Peter Lawford, to be one of his sources. When Lawford and Elizabeth were in rehab he would ask Lawford to bring

Elizabeth outside at certain times so that the tabloid could snap photos. It was yet another betrayal.

During their reconciliation, Elizabeth and Richard were both still drinking too much, but something happened in October 1975 that convinced Elizabeth that she and Richard had to get married again. They had been traveling around the world, including to Johannesburg, South Africa, where they attended a charity celebrity tennis tournament.

Gavin de Becker, now a security specialist to celebrities, got his start working for Elizabeth and Richard during this period. But Richard was not drinking at this particular time, de Becker said; he was on Antabuse, a pill that makes you sick if you drink.

One day Elizabeth told de Becker that Richard had been drinking and she was worried. De Becker went to their hotel room and saw that Richard was in terrible shape. He must have gone off the Antabuse. De Becker chartered a plane and brought in a doctor who hammered up an IV bag on the wall and sedated Richard. The doctor told de Becker that Richard would not wake up for twenty-four hours.

"We went to the hotel restaurant and midway through the dinner I had a creepy feeling that I should check on Richard because paparazzi had arrived in chartered planes. I walked by the river and I

looked up at the room they were staying in and I see a shadow cross in front of the window of their suite. And it was like the exorcist! I ran back to the doctor and I said that I saw Richard and he said, 'Trust me, that's not him.' And I said, 'Trust me, it's him!' His liver was so bad that he wasn't assimilating the drugs they were giving him."

In Botswana, Elizabeth and Richard met an Italian-Egyptian pharmacologist named Chenina Sam, who was known as "Chen." Elizabeth and Sam became fast friends. She flew back to London with them and out of nowhere Elizabeth made Sam her publicist, even though she had no experience. It made sense, de Becker theorized, for Sam was a pharmacist who could always help her get the pills she thought she needed.

"Here's the complicated part," de Becker said, hesitating for a moment. "Elizabeth would give him alcohol." Throughout his life Richard would try to stop drinking abruptly and completely from time to time, which led to violent trembling, confusion, and nausea. These are all common symptoms of withdrawal. De Becker said that, during the short time he was working for them, Elizabeth could not stand watching him suffer. She knew that Richard hated gin, so when she felt that he needed something de Becker recalled her giving Richard a small glass of gin to drink. She hoped that he would not drink too

much of it, but he would. She thought that a little alcohol might calm his rattled nerves, and her compassion for this man she loved so much made his pain unbearable to witness.

De Becker cleared out the minibars in their hotel rooms, and he made a habit of going through their suite and taking the trash out himself or the housekeeping staff would go through it. "I go into their room and there's Richard's diary sitting on the chair, and I turned it over and see: 'Must get rid of Gavin when we get back to London.' I was not helping with the drugs and drinking and I was very opposed to the Chen Sam hire, I knew what it was about, we were just getting drugs basically."

De Becker was out and Sam was in. Elizabeth's staff was her adopted family, and Sam became her very best friend. It had been difficult for de Becker to watch Elizabeth and Richard's volatile relationship. Four months after their first divorce, Richard was briefly engaged to Princess Elizabeth of Yugoslavia, and he dated model and actress Jean Bell. But he and Elizabeth always wound up going back to each other.

"They had very, very aggressive and hostile arguments that at my age now reveal a highly codependent, coaddict relationship," de Becker said. "Giving alcohol to a guy who can die from drinking was somewhere between passive-aggressive and aggressive-aggressive."

Richard was so different from the man she had married eleven years before; his health was failing and he was trying to be sober. "When one person recovers the other person struggles a lot. So Richard not drinking was actually not a relationship that Elizabeth had ever had with Richard, yet they got back together because he wasn't drinking. It just wasn't enough drama for her," said de Becker.

De Becker traces Elizabeth's addiction to her childhood—though of course no one knows for sure. Addicts do not always have the best childhoods, he said, but they always have the longest childhoods. In some ways Elizabeth had the emotional maturity of a child. When she wanted something, she had to have it. She did not tolerate physical pain well; rebelling against her Christian Science upbringing, she was rarely ever completely unmedicated.

It was in Botswana when a health crisis changed their lives, at least briefly. "I am writing this for [Richard and] myself—while I still remember it," Elizabeth wrote in a long diary entry. She thought she had a cracked or a broken rib, and when she went to have it X-rayed she was told that there were spots on her lungs that were probably scar tissue from one of her illnesses. But they could be something far worse. "My eyes have seen several hundreds of X-rays from every

angle conceivable—but I had never, never seen those spots. I did not want to explain or go into any detail with the doctors. I wanted to come home to Richard."

"Well, first the good news—I don't have a broken rib," she told him.

"Well," he said sarcastically, "I didn't think you had, but good show."

"Now the *bad* news. I have two spots on my lungs!"

She wrote: "Richard's face stopped all expression he just stared at me—and I at him—it seemed so quiet—then he said, so softly 'You're joking.' It was like a frozen frame in my life because I *knew* and I knew that he knew, eyes to eyes—God how much they say." She gave him a Valium, he whispered poetry in her ear, and they kissed that night. "It's funny when you think that maybe you don't have long to live how many things you want to do and see and smell and touch and how really simple they are. God! We take so much for granted!"

Sleep did not make Richard feel any better. "E. is incomparably brave, I love her mindlessly and hope-lessly," he wrote in his diary.

After her doctor told her the next day that she did not have cancer, and that the spots were likely scar tissue from her bouts with pneumonia, she wrote:

I had never—ever—been so glad to be alive. I have my life back (and I mean *you* Richard) and I am going to live in love.

Love—about love last night I felt such an overwhelming sense of love, and release of hang-ups about love, my love for Richard and my old fear of giving 100 percent again—it all seems so silly not to, I love the man—shit or bust! The next day we talked about the ancient subject for hours and came to the conclusion that it was mutual I love you (him) he loves me (me)—"Me Tarzan—you Jane—" Basic, real, no bullshit, love, one in a lifetime love.

It was settled I can't remember the exact words that said we would re-marry I think I brought it up and he shied away—sweetly—then I dropped it. The next time it came up was still in Johannesburg and he asked me! I asked him for an old-fashioned proposal and he actually did it (with no doubt more than a little mirth) and got down on his knees and said "Will you marry me?" I fell about with laughter and said "Sure honey bunny" I don't think he really meant it—maybe it was a left-over from the fear of death—maybe it was to make me feel better or maybe he really *did* mean it.

Anyway the seed was planted in both of our tiny minds, and what a glorious exotic plant it became.

But, she wrote, "fear and doubt" started to creep in. "Will marriage spoil our confident love—make us over-confident and smug and taking for granted all the lovely awareness again? . . . Our relationship is so tender that it almost borders on being fragile. I know we will be together in every Biblical sense forever so why is he (more than me) afraid of that legal piece of paper which the missionaries made necessary to go through the words 'Words, Words, Words' as Hamlet said. It's all in the head and heart—that's all—and it's irrevocable. I hope he feels happy in the morning and excited and looking forward. I love you Richard and I leave it up to you. Please. Answer."

Richard told her he would get married again, if that was what she wanted. He wrote in his diary: "E. talks endlessly about wedding. Can't make up my mind. Might be the cancer scare has given everything an unnatural shape. Also, like being hanged, it concentrates a man's mind wonderfully."

Elizabeth wanted him to want to get married again. "I'll carry you off on a white charger but I'd prefer it if it were the other way around," she wrote. "I'm a hopeless romantic and want to be romantically swept away.

In the meantime we will be loving and sweet—but some day you son of a bitch something will make you realize that you cannot live without me and you will have to marry me otherwise your life will not be complete. It must be passionate on both our sides I agree, don't wait too long in limbo for both our sakes. I love you with my life and I want a lot out of life while I'm still here to enjoy it."

She was angry with him for not wanting it as much as she did.

"I hated you for a while there, you were so bloody cold and unresponsive, even your voice became flat, sooo English, your eyes as dead as an alligator's without an appetite.

I went into the other room and cried, wept—wept from my entire being, wept my guts into an uproar but quietly and deep, deep inside so that when Richard came into the room to pat my head as he would to a faithful animal there was only a tell-tale glisten in my eyes—my heart was salty and bloodied through.

They planned to have a picnic on the banks of a river to pick out where they would get married, but, she wrote, "it had all suddenly become funereal." But

she decided that she wanted to go out anyway, because, just maybe, Richard would change his mind.

I took a quick bath, a long look at my soul in the mirror and decided that I was indulging in self-pity— after all life was not over and I knew we loved each other—so what the hell!

I shouted into the other room where Richard was rather gloomily reading. "Let's go on the picnic anyway." He said, "O.K." in the most human-sounding tone of voice I'd heard all morning,

I chose my t shirt with particular care, a very pretty one, white, with yellow, red and black crest of Amsterdam . . . with my tightest jeans—Defiant! Up yours tilt to my rather red nose.

As we were driving off into the ever glorious wondrous bush I slapped Richard with hard affection and we smiled at each other, I mean really smiled as naturally as two animals sleeping next and around each other.

She asked their driver, "Where is the place we would have been married if we would have been married, if you know what I mean?"

The driver told her there were three possibilities. She gazed out the window and must have had images

racing through her mind of standing with Richard slipping rings onto each other's fingers and getting another chance.

"Everywhere around us was beautiful so untouched, so unspoiled. The rains haven't come yet so it's all a kind of Van Gogh yellow."

A voice, that voice, the voice belonging to the person whose hand I was holding said loud and clear "Will you marry me?" I turned slowly (not whiplashed) around and said steadily (considering what was going on inside), "Are you serious?"

"Yes," his voice-eyes said. "Will you?"

"Yes," said my heart-eyes into his now heart-eyes.

We giggled, we smiled, we grasped each other, we laughed out loud, we grabbed each other's hands, we stared at each other, we loved each other, we held each other again, hard, gaspingly hard (I didn't even mind my rib hurting, we didn't even care that there were two other people in the van).

Who knows why Richard changed his mind, but her decision to go out for that picnic was a fateful one. After ten years of marriage, fourteen months of tempestuous separation and divorce, they would try one more time.

They had a picnic and went home. "The evening our last unmarried evening is a blur of thoughts, colors, smells, nerves, excitement, panic, details blending or crashing into each other. And finally sleep. That strange sleep that doesn't let you sleep I mean, the brain never really turns off and there is that feeling in the stomach that is like ocean waves, some so large they shock you into terrifying wakefulness—then you remember what it is and drift back into a slow-swell and a sweet light sleep and a smile."

The next day, October 10, 1975, she woke up and Richard was blind drunk.

I love him deeply and truly and forever and always have but I do recognize one or two flaws on that immense (self-possession?) personage like getting slightly drunk on his wedding day after being on the wagon for several months. Now that is perverse . . . and having the further audacity to look at me with the reddest and blurriest eyes I have encountered for two years (the last time I saw him sloshed) and telling me, or should I say trying to tell me that he was absolutely sober. . . .

I led the lad back to the bed—he had been up since dawn he told me—and suggested he tried to get a couple of hours sleep so that his eyeballs would

have a chance to change from magenta into a pretty conjunctivitis pink. Now can you get mad at someone so utterly (and charmingly?) outrageous. It was about 8 in the morning and we had the whole day to go!

I crawled into bed beside him and held him very tight (in more senses than one!?) and close and we fell into a deep dreamless sleep. My Welshman is indeed a wizard, he awoke about three hours later as refreshed as if he had just been christened. He has the most remarkable recuperative powers I have ever seen which is probably why he is still alive. Thank God.

She had brought three pairs of blue jeans, many T-shirts, one caftan, and two long dresses. One of the dresses was a Christmas present from Richard's brother, Ivor. "It seemed almost mystically right and happy that I had with me that one dress. I am not very superstitious but it seemed like a loving omen from far away.

"The dress is green and all the colors of pastel dream birds, blending softly into each other. . . . I piled my hair on top of my head and wrapped the necklace around so that it was falling low in the back but held my hair in front in place, like a high pony tail." She

picked some green leaves from a nearby bush and stuck them in her hair. She stuck Kleenex in her purse "in case I got weepy," and lip gloss.

"We must have looked an odd-looking couple leaving the hotel in mid-afternoon, me in a long floaty evening dress and Ricardo at his most elegant best (which is a shock at its *very* best) leaping into a Land Rover and speeding away into the bush. A lady tourist evidently asked someone nearby where on earth we were going and Gavin, our secretary, who overheard said with sonorous and dead-pan seriousness. 'On a picnic of course.' We were legally married in Kasane [a town in Botswana] in a regal looking room by a regal looking gentleman wearing a regal looking dark suit. We repeated the marriage vows after the District Commissioner but slightly more quaveringly—if we'd been auditioning we would have been instantly turned down.

"We exchanged rings, fathomless looks, and were married once again, back where we belonged. Always belonged. But the ceremony wasn't really completed until we went back to our riverbank and repeated our vows again with a Bible and all God's beauty around us."

The sounds of the river and the Hadida bird made the three notes of Beethoven's Fifth Symphony, she wrote. "The ever-present hum of insects, the melo-

dramatic scream of distant fish, eagles crying for God knows what they have lost or are waiting for—this was our spot. 'Ours' for a moment in time because it belongs to anyone who is lucky enough to find it, and we were lucky, and only borrowed the grounds for a few hours and never tried to intrude on them, the beasts and birds, and they in kind trusted us and as if on cue two enormous hippopotamuses snuffled their eyes and ears out of the river as additional witnesses and a rhino stood like an unblinking Buckingham Palace guardsman guarding us—and it was beautiful!"

This time their wedding bands cost just forty dollars each, and the letters they wrote to each other after the ceremony reveal how much they wanted to start a new life together.

Dear Husb.,

How about that! You really are my husband again and I have news for you, there will be bloody no more marriages—or divorces.

We are stuck like chicken feathers to tar—for lovely always.

Do you realize that we *shall* grow old together and I *know* the best is yet to be!

Anyway, my little big one I love you and have a

deep tranquility in my heart and the tug of love is over and we are one once more. I'm happy, I hope you are,

<div style="text-align:right">

Yours Truly,
Wife

</div>

Mr. Burton,

I am the happiest I have been in my whole life.

<div style="text-align:right">

Mrs. Burton

</div>

Mrs. Burton,

You are everything I've ever wanted. Without you I was a ghost. I too am the happiest I have ever been in my whole life.

<div style="text-align:right">

Mr. Burton

</div>

The End

Elizabeth's giddiness was contagious. After they married, Richard said that he felt the same way. "E cured me with loving even lavish attention. This is far better marriage than the first despite its silly (and dangerous) beginning."

Their happiness did not last. Later, the woman who became Richard's final wife, Sally Hay, said that Richard told her that he had suspected that Elizabeth had

made up the lung cancer scare to trick him into getting married a second time. That is how bad things eventually got between them.

The Christmas of 1975 was especially brutal. Elizabeth's children remember how Richard's drinking was at its worst. Richard hated the sentimentality and materialism of Christmas, and the holiday brought out the worst in him. "He could be frightening and mean when he was drunk, but if we stepchildren were adolescents or older we would have known that it was the alcohol talking if one of the barbs was directed at us," Chris Wilding said. "When Richard was sober he was supportive and loving in his own way; he was awkward in situations of emotional intimacy, but he did try hard. If you knew Richard was in his cups you steered clear of him for your own peace of mind."

Wilding wrote Richard a letter pleading with him to get help. On February 10, 1976, Richard wrote Wilding a response that was not an apology, but a rationalization of his drinking. He wrote: "And what indeed is the problem? The reason? Boredom and anger and pain—mental pain I mean. . . . I disagree with you that drinking oneself to death lacks style. Dylan Thomas' death certificate stated that he 'died of a severe alcoholic shock to the brain.' What a magnificent and daring epitaph. . . . I won't die of drink. Nobody in

my family ever has back even unto ten generations. I don't know about yours." But, Wilding said tearfully, Richard knew that he could very well die from it. He had to have a beer to stop shaking most days. Richard felt defeated, but he would never have admitted it.

That Christmas, Richard met a tall blonde named Suzy Hunt who was twenty-seven years old and recently married to Formula 1 race-car driver James Hunt. Richard left a bereft Elizabeth at the chalet in Gstaad and brought Hunt to New York to prepare for his role in the play *Equus*.

Now that he was (temporarily) sober, he told friends, he had no idea why he and Elizabeth had gotten married again. Elizabeth was determined not to wallow in her loneliness, so she became involved in a romantic relationship with a thirty-seven-year-old advertising executive named Peter Darmanin. They met on the dance floor at a disco in Switzerland called the Cave. He lived at her chalet for seven weeks.

"She was obviously not over Richard Burton, she was on the phone with him constantly," Darmanin said. "She was trying to get him to take back that giant diamond ring he had given her. She was crying on the phone, saying, 'Just take it back, Richard. I don't want it. It means nothing to me now.'" Richard called to say that he needed her help rehearsing for *Equus*, he

said that he was struggling. She immediately booked a flight to New York and Darmanin said that was the last time he saw her.

Richard waited nervously at the theater for Elizabeth's arrival. The Burton–Taylor romance was so notoriously poisonous by then that everyone involved, especially Hunt, wanted to keep them apart.

"Oh, *dah-ling*," Elizabeth said as she walked down the aisle of the theater wearing a lavender blouse, full makeup, and her hair styled sky high. Clearly, she had been drinking. "I've arrived! Have you missed me? Why, it's been *hours*!"

As she continued walking toward the stage she said, "But goddammit, I don't have any money for the cab and no one in the lobby has a cent, not even in the bloody box office. How is that possible? Does anyone have any money in this goddamn place?" Of course, one of the stagehands paid the cab fare for her. She watched the rehearsal and exclaimed, "Bravo! Oh, yes! Bravo!" at the end of the scene.

The next day Elizabeth met Richard at the Lombardy Hotel on East Fifty-Sixth street. This was why she had really been invited to New York. When she showed up she saw Richard standing next to Suzy Hunt at the hotel bar. He did not seem like himself.

"What's wrong with you, luv?" she asked.

"I want a divorce, luv," he said quietly.

"Why you *sonofabitch*. You dragged me all the way from Switzerland to tell me *that*?"

"I'm sorry, luv," he said. He and Suzy were planning to get married and they left her alone standing there at the bar. The transatlantic flight had resulted in utter humiliation.

She left and tried to recover. But the world, it seemed, was waiting for her to fail, and rumors of her coming undone and drinking too much were circulating. That summer Elizabeth's lawyer wrote a letter to *Time* magazine asking them to retract a story that implied that she was out of control. *Time* refused and responded with a letter claiming that one of their correspondents was at the same hotel Elizabeth was staying at, and that the reporter had overheard that Elizabeth was looking for a missing package. Somehow the journalist found out that the missing package was a bottle of Glenfiddich scotch whisky. Just as it had been in Rome, when she and Richard first met, nothing in Elizabeth's life was truly private unless she fought for privacy. Elizabeth wrote a note to her lawyer at the bottom of the letter from *Time*, even though she knew that it wouldn't change a single thing that people were saying about her: "Gave away as a gift. Never tasted it." She was always on the defensive because she had to be.

On July 29, 1976, less than ten months after they married for a second time, Elizabeth and Richard were granted their second divorce. "I love Richard with every fiber of my soul," she said, admitting the truth to herself, "but we can't be together."

Kate Burton said of their second divorce: "The only way for my father to survive, or to continue to live, was for him to be by himself." But he was never alone.

Before she set Richard free, once and for all, Elizabeth went to a preview of *Equus*. Suzy Hunt was now the gatekeeper at Richard's dressing-room door, but Elizabeth saw a moment when she could sneak in. She wrote in lipstick on his mirror, just as she had in *BUtterfield 8*: "You were fantastic, Love." The message stayed there for days.

ACT IV

Survivor

The 1970s and 1980s

Pour yourself a drink, put on some lipstick, and pull yourself together.

—Elizabeth

Chapter 14
Political Wife

I was treated a bit like a freak.

—Elizabeth

Elizabeth knew that she would never love anyone the way she loved Richard, and even though she was upset at finding herself alone at forty-four years old, she refused to play the victim. She took ownership over everything in her life. She was an eternal optimist who always believed that her next great love was just around the corner. And in the summer of 1976 she met two contenders.

Lesley-Anne Down was one of Elizabeth's costars in the 1977 film version of Stephen Sondheim's musical *A Little Night Music.* "It was a dark time," she recalled. "She was so miserable and depressed, she didn't want to see anybody, she wanted to stay in her hotel room.

She was really down." But Elizabeth was trying to will herself to move on. "She was dating two separate men and I remember she said, 'I don't know which one I should marry.'"

The two new men in Elizabeth's life were very different. Ultimately their fate came down to dinner with the Queen. One was a southerner named John Warner, who served as secretary of the Navy under Richard Nixon and who was recently divorced from Catherine Mellon, an heir to the Mellon fortune. The other was Iran's ambassador to the United States, Ardeshir Zahedi, who was a fixture of Washington's social scene. Like Warner, he had been married before to a member of an illustrious family; his first wife was the eldest child of the shah of Iran, Mohammad Reza Pahlavi.

Zahedi was forty-eight years old when Elizabeth met him, and he was handsome and worldly. His embassy parties were legendary, and he was known for sending jars of caviar and magnums of champagne to journalists and Washington influencers to curry favor. But he was not looking to settle down, and since his divorce from Pahlavi in 1964 he was enjoying life as a bachelor.

Elizabeth fell in love hard and fast with Zahedi. Although they had only dated for a couple of months, she was thinking about marriage. But the shah, who was Zahedi's former father-in-law and boss, had forbidden

him to marry Elizabeth during his lifetime. Though the shah was relatively progressive, the idea of Iran's ambassador to the United States becoming Elizabeth's seventh walk down the aisle was too much. And on top of that, she was Jewish. If they had gotten married Elizabeth would have been the stepmother to the shah's grandchild. But Zahedi said the real reason they did not marry was because he was not interested in ever getting married again.

In a 2021 interview, Zahedi said that he needed to talk about Elizabeth, even though his health was failing. "I thought, if anything happened to me in the next twenty-four hours, I thought we should talk. . . . I owe it to her. I had to keep my promise."

He had been in love with Elizabeth since he saw her in *The Last Time I Saw Paris* in 1954. "I invited her to my parties, and she would sometimes come stay in the embassy. We became terribly close friends, and more and more I'd see her with my daughter around us. I became more fond of this lady and how wonderful and how intelligent and how dominating Elizabeth was."

They reveled in their differences and spent hours talking about religion. "If you read the Torah or the Bible or the Koran they say the same thing about humanity, which is to respect each other," he said. "She was very open minded and she never said anything bad

about any other religion. She wanted to know about Islam because she was intelligent. The more you know, the more you can inform your judgment."

Even though he would not marry her, the strength of Zahedi's feelings for her is undeniable. "Love is something you cannot buy, it's something you cannot sell," he said. "It's two hearts, it's two minds. It must be respected. Real love is very deep and honest. That was what we had." But it could not last.

He said that he was supposed to bring Elizabeth to a party, but he could not be her date because of the controversy swirling around their relationship. Instead, John Warner escorted her to the glamorous dinner. Nixon had asked Warner to oversee the American Revolution Bicentennial Administration, which meant that he was responsible for organizing events around the nation's two hundredth birthday celebration. One of the final and most anticipated events was a Bicentennial dinner at the British embassy, hosted by Queen Elizabeth II. It was crowded with celebrities and politicians, from President Gerald Ford to Bob Hope. But British ambassador Sir Peter Ramsbotham, who was hosting the dinner, needed help: Elizabeth Taylor would be attending and she needed an escort. So he called his friend.

"You know Elizabeth Taylor, don't you?" Ramsbotham asked him.

"No! I don't know *Elizabeth Taylor*," Warner replied. He had seen her at cocktail parties once or twice, but she was always surrounded by the other guests.

"Well, we need a suitable person to escort her to dinner."

"Who are you thinking about?" Warner asked.

"*You!*" Ramsbotham replied, exasperated. "Now, John, when you escort her you have to have foremost in your mind that there's only *one* Queen. Elizabeth can be quite willful, keep her back a few paces every step of the way. That's your job."

Warner did not know what to expect the night he went to pick Elizabeth up at her hotel to bring her to the embassy. Chen Sam, who was now Elizabeth's most important confidante, opened the door and asked if she could fix him a drink. He asked for a weak scotch and soda, weak because he was driving.

"You're *driving*?" Sam asked.

"Yes." She looked at him as if to say, *Are you kidding me?*

As she walked to the bar, Sam intercepted Elizabeth in the hallway and whispered, "He's very cute. You're going to love him."

When Warner and Elizabeth got down to the curb she asked where his car and driver were. "Well, you're

looking at your driver and your car is right here," he said, pointing to his Lincoln Continental.

Not long after they arrived at the stately British embassy, a Georgian mansion with redbrick walls, there was a problem. "All of a sudden I hear this scream and everybody turns around," Warner recalled, "I mean it was a screech. And it was Elizabeth." She dramatically lifted up her gown to show him that her heel had cut through the hem. She was so loud that she even caught the Queen's attention.

Queen Elizabeth walked over to Elizabeth and said, "Now, Elizabeth, don't you worry, my ladies in waiting will take care of you." They whisked her away to mend her gown. Later that night, as Warner was sitting in the embassy library having a cigar and a glass of brandy, he heard another screech. *"I can't get out!"* Elizabeth yelled. The Secret Service had locked the gates to the garden, where the Queen was personally greeting guests. The cameras that were trained on the Queen turned to follow the commotion that Elizabeth was causing. "She was some kind of mad," Warner said as he laughed at the memory, "hollering at me." He took her hand, got the doors open, and they cut the receiving line.

The next day the ambassador called Warner and said jokingly, "You let me down."

But, from Elizabeth's perspective, the night had gone well. Warner was a handsome Republican with silver hair and chiseled cheekbones who wore tailored suits from Savile Row. She called Warner the next day and asked what he was doing. "I'm going to my farm and I'm not going to shave for a week," he told her.

"Hmm," she said, with a hint of mischief in her voice, "that sounds interesting." She asked if she could come for a visit.

He was sitting in his library when he saw dust and gravel billowing out from a limousine as it sped up his driveway. He gave her a tour of the farm while an assistant unloaded her many, many suitcases.

"This reminds me so much of England," she told him as they walked arm in arm through the fields and visited all his animals. With Warner she returned to her happiest childhood memories, riding her horse in the English countryside.

"I'd like the role of the farmer's wife," she mused. She did not want to be Elizabeth Taylor anymore. And she thought she needed someone to help her get over Richard.

I'll be dead when this is over, Warner thought to himself.

This was no typical farm. Warner owned almost a thousand acres of lush rolling hillside in northern

Virginia, four miles west of Middleburg, where Jackie Kennedy had escaped to ride her horses when she was first lady. Warner lived in a seven-thousand-square-foot five-bedroom home built in 1860 and made of fieldstone. So it was the kind of "farmer's wife" existence that Elizabeth felt comfortable with. And Warner was politically connected, with big ambitions.

Five months after dinner with the Queen, Warner became the sixth of her seven husbands, and she became the first major actress to be married to a U.S. senator and to relocate to Washington. They married on a hilltop at the farm in December 1976. She wore a knee-length cashmere dress and a wool and silk knit coat with a gray fox collar and matching turban. She was, as usual, running late. "There's Greenwich Mean Time, there's Senate time, there's Eastern Standard Time, and then there's Elizabeth time," Warner quipped in a deep voice with a slight southern drawl. "It was a high hill in the back of the main house where you could see down the valley of Virginia, probably for half a mile. It's a beautiful view. We decided to be married on the knob of the hill so that people a half mile away with a telescope could follow the wedding. We were standing there and no Elizabeth."

Playing the role of gentleman farmer he hollered, "Whooo!" to summon the cattle and show his guests

while they were killing time. "One by one the cattle came up around the fence. The minister said, 'What am I going to do with all these people and all these cows mooing and mooing and mooing?' And I said, 'They'll quiet down.' Well, they didn't quiet down. They kept mooing. Once Elizbeth arrived we tried to do the wedding, but finally we had to move a little distance from the cattle, and the minister got really unnerved with that whole episode. He was tensing up marrying Elizabeth Taylor. She thought it was funny as could be . . . we spent our night together in the farmhouse. She loved that farm."

"I just wanted the farm," she joked after the ceremony.

After they were married, Elizabeth brought Warner to her chalet in Gstaad, Switzerland, to meet Richard. She wanted to introduce Richard to the handsome politician she had married. Warner opened the door and there was Richard Burton standing outside wearing a long fur coat. "I see you've made yourself at home," Richard said in his booming theatrical voice. "Do you realize you're wearing my sweater?" Elizabeth had told Warner to pick out whatever he wanted from Richard's old closet to keep warm. After a short pause, Richard, always dramatic, said good-naturedly, "Hell, keep it all!" as he walked inside.

They talked for hours, Warner said, and Richard wondered whether he was husband number five and six, or five and five and a half. Warner told him he thought that he counted for two even though their second marriage was less than a year. Elizabeth laughed along with them, though it must have felt surreal. Before they got there she told Warner, "We're not going to drink." But Richard refused to comply. "This is a very important moment," he said. "I'm passing the title [of being Elizabeth's husband] to this young man. We'll celebrate with a drink." Burton led Warner to his old dressing room, where he had stashed away some whiskey.

"Pay tribute to old number six!" he said as he raised his glass.

"Old number six!" Warner and Burton said in unison as they clinked glasses.

But Warner knew that it was never really over between them. "She never unhooked," he said of Elizabeth's love for Richard. "I knew that."

As she had with all her marriages, she became "Mrs. John Warner" and tried to subvert "Elizabeth Taylor." She rode horses and took part in hunting season. She ordered riding gear from England. After about six weeks of marriage they went riding on a stormy day.

"Elizabeth, you ought to hang back," Warner told her.

"What do you mean *hang back*?" she said, irritated

that he thought she couldn't handle the horse in the rain. "I'm going."

"She was following me and I spotted it but I couldn't signal her fast enough. The fence that she was going to take, that I had just taken, meant that you landed in two feet of mud. She went over and her horse did a beautiful jump, but his feet went deep into the mud and he spun and threw her off. The horse had a bad fall. We had to get the rescue squad out there, and we took her to the hospital and she was sufficiently injured so that she never got on a horse again." She was devastated and in pain.

But there would not be much time for riding. She knew Warner wanted to run for the Senate in 1978, and she knew that she would be an incredible asset. No movie star had ever been a Senate candidate's wife before, and voters clamored to meet her. She came to enjoy campaigning, and people were enamored with how down-to-earth and approachable she could be. Zahedi, looking back, said that he thinks that the reason they got married so quickly was because "Warner wanted her to be helpful and this is why he rushed."

Elizabeth did not question his motives. She was old-fashioned; this is what you do for your man. She campaigned for two months and made up to six stops a day all around Virginia. She went wherever she was told

she could help, including to small towns in southwest Virginia coal country. Her work ethic from the age of nine was evident when, after a fifteen-minute parade ended and the driver of the car she was in turned off the engine, she insisted that he turn the car back on so that they could circle back and do it all over again. The parade was only seven blocks long, and she had gotten a new outfit for it, after all.

Henry James once called Washington "the city of conversation." Elizabeth Taylor was briefly a part of that world and a welcome guest. "Everyone was dazzled," said journalist and socialite Sally Quinn. Even at her lowest point she brought a level of Hollywood glamour that the sleepy southern city had never seen before. At one Georgetown dinner party, Elizabeth marched up to then *Washington Post* executive editor Ben Bradlee to lodge a complaint about the coverage of her husband's campaign. "Bradlee!" she said playfully. "Get off Warner's ass."

A friend of Elizabeth's said: "She'd drink with you, dance with you, play cards with you, pig out with you, and it could just as easily be with a bunch of truck drivers as with Nobel Prize winners." In the southwest parts of Virginia, where religious conservatives were outraged by her six previous marriages, she completely disarmed them when they met her in

person. Of course she had worked hard to win them over. "I was brought up by a very moral puritanical family," she told churchgoing crowds, "and I just couldn't adjust to having affairs."

She shook so many hands that she hurt her own. "I'm not too sure if it was a fracture, but there was definitely a distortion of the muscle," Warner recalled. "I saw it time and time again, the men would take a woman's hand and just crush it, and say, 'I've waited all these years to meet you.' Her hand began to swell up and swell up." But she did not stop. "She shook thousands of hands. She was from the old school—you do it for your man."

Most Senate races last a year to a year and a half. Even with her enormous star power, Warner lost the Republican primary to Richard Obenshain, who then died tragically in a plane crash—an event that shook Elizabeth because it brought back painful memories of losing Mike Todd. Warner replaced Obenshain as the Republican nominee, and he had less than three months to win the race.

Elizabeth went into high gear and kept up an exhausting schedule, with only Sundays off. She had a purpose, and she felt revitalized after the humiliation of another failed marriage to Richard. She knew that people came to see her, but they stayed to listen to

him. One campaign sticker said: "See Elizabeth, vote for John."

Warner never shied away from the chance to brag about her. "I feel just like Ben Franklin. He was born in Boston. Moved to Philadelphia. Met a lady on the street. They got engaged. And then he discovered electricity. Ladies and gentlemen," he said, turning toward Elizabeth, "allow me to share some electricity with you."

But Elizabeth was too dynamic a force to play a supporting role, and she was not the kind of person who could bite her tongue. Warner and his campaign aides wanted her to change who she was. Her star power would draw people to campaign rallies, but her movie-star lifestyle could hurt him. This was during the period immediately following Watergate, and Warner was sensitive about keeping up appearances.

"I made a condition," Warner said, "no jewelry, and she had to get rid of the Rolls-Royce and the yacht. She said, '*The yacht?* Aren't you secretary of the Navy?' I said, 'Yes, but we're going to have a busy enough life.' So the yacht went, the Rolls went." He told her he would never buy her a piece of jewelry aside from the modest engagement ring he gave her. He had plenty of money from his first marriage, but he knew it would look bad in the press. She sold the Taylor-Burton dia-

mond to help finance Warner's campaign, and it was a way of letting go of Richard and committing to a new man. It was a decision she would later come to regret.

Of course trying to change who she was did not work. She gained weight at a rapid clip. There was so much travel, and on the campaign trail fast food was the quickest option. She famously choked on a piece of fried chicken that she ate so fast at a campaign stop because it was her first chance to eat all day.

"So I grabbed a breast," Elizabeth said, "and all of a sudden—aargh! You know these two-and-a-half-inch bones? One of them got stuck in my throat. John Belushi did a whole sketch on it on *Saturday Night Live*. The bastard! Choking on a chicken bone in Big Stone Gap, Virginia!" She was teased for at least a year about the incident.

In a 1978 interview during the campaign, Elizabeth sat next to her husband in a drab mustard yellow dress with an olive green headband and unkempt shoulder-length hair. She seemed like she was half asleep. She was hunched over and her arms were crossed on her lap, obviously fighting her way through the interview. Then the question came like a slap in the face and you can see Elizabeth flinch.

The interviewer asked, "You've heard and read it all, I'm sure. 'Elizabeth Taylor has been married six times,

she's gained a little weight,' on and on and on and on. Does this hurt you to read these things? . . . Can you sort of harden yourself, or does it bother you?"

"No, it doesn't really bother me," she said. "We have this saying, 'Unto thine own self be true.' I feel that I am responsible to and for my direct family and my friends. What people speculate, what people write about me, I don't really think is any of their business. Whether I've put on ten pounds or lost ten pounds is up to me. The main difference between show business and politics is that one is fiction and fantasy and you're speaking somebody else's thoughts and trying to express somebody else's ideas; in politics it's for *real* and you're on your own and there's no chance for a retake."

But criticism about her fluctuating weight took a toll, even though she had endured decades of it. Long before she moved to Washington she had called herself "fat" several times in a series of unpublished interviews for her 1964 memoir. When Richard Meryman told Elizabeth that she was one of the world's greatest beauties, she said, "I might have been considered fashionable . . . say in the day of Rubens or Renoir, a nice kind of fat, chubby-type female . . . my kind of fat was at one time considered beauty."

The hardest part must have been being judged but no longer being able to express herself.

"I had to go along with the party line," Elizabeth said later. The Republican Women's Committee told her not to wear purple, which was her favorite color, because "it denotes royalty."

She said, "So?"

"And it denotes passion."

She said, "What's the matter with that?"

They told her, "You're the candidate's wife!" The subject was closed.

Alan Simpson was a Republican senator who served with Warner and remembered how difficult Elizabeth's life was in Washington. "We went to galas and fundraisers, me and my wife and Senator Warner and his wife," Simpson said. "She was not in her element at all. I think she tried very hard, it was just so different for her. My wife described how life was in the Senate, and she tried to help Elizabeth understand life in the fast lane in politics, where there's ego and self-aggrandizement and adornment and all the rest of the crap that goes on. I thought she handled her tough situation very well." But Elizabeth did understand the world of power and politics, she had grown up in Hollywood, but Warner did not try to make her feel like a true partner.

The couple split their time between the house in

Middleburg and a Georgetown mansion. There was a spot at the top of the stairs in the large entrance of their grand Georgetown home where you could stand and hear everything and not be seen. A political advisor to her husband came to the house one day, and Elizabeth stood in that spot with Mary Conover, who was one of her stepdaughters. "She has got to get her wardrobe together," the person told Warner. "She has to wear some tweed and plaid suits and proper hats." Elizabeth and her stepdaughter were in hysterics and laughing so hard they had to run into a bedroom so that no one would discover them eavesdropping. It was all so preposterous, asking the most glamorous woman in the world to wear "tweed" and "plaid."

Conover remembered how much fun Elizabeth had, even during her years in Washington. She recalled once staying at a hotel in Boston with her father and Elizabeth, and after Elizabeth did her makeup, she had to be driven to get her hair done—normally a hair stylist would come to her hotel but for some reason not on this day—so Conover, who was eighteen years old at the time, offered to drive Elizabeth to the hair salon with some friends in her old, beat-up Subaru. Elizabeth threw on a fur coat over a negligee and got in the passenger seat of the car. They got lost on the way and started driving around Boston. Elizabeth was

having a great time rolling down the window in full makeup and asking people on the street for directions. "I thought one guy was going to have a heart attack," Conover said. "That to me was Elizabeth! She loved to have fun."

There were times when her sense of mischief could not be so tightly controlled. When she and Warner spoke with a journalist, she regaled him with how Warner had proposed to her with a bottle of champagne and caviar. Warner interrupted her and said, "We didn't have any caviar."

She cackled. "Too rich for the Republican stomach?" She continued telling the reporter that the gift was from Ardeshir Zahedi, her old boyfriend.

"That's a terrible story," Warner groaned. "I have no recollection of any caviar."

"Okay," Elizabeth replied with a sly smile, "we went up with some ground groundhog meat. A little moonshine. Oh, that's illegal. What do you call that really cheap wine? Oh, a bottle of muscatel. Virginia muscatel." Warner sat stone-faced. "Virginia caviar," she added. "It's wonderful." She missed her sparring partner Richard more than ever.

She never lost her sense of fun. In 1977 Elizabeth was honored as Woman of the Year by the Harvard Hasty

Pudding Theatricals, a student society. She was happy to be recognized, and she wanted to teach an acting seminar while she was there. She met with thirty students. "I love parts that aren't me, where I can scream and tear up the scenery," she said. Before getting the award she stood on a balcony with one of her stepchildren and Warner. She was waving to the enormous crowd and leaning over the railing, wearing a gorgeous long Cartier necklace with a giant cabochon emerald. When the necklace broke and dozens of pearls and small emeralds scattered on the ground, Harvard students went clamoring on their hands and knees trying to gather them up. Fortunately, the large emerald had fallen on the balcony. Elizabeth did not panic; she seemed almost amused by the spectacle of it all. "Well," she said, holding out the large gemstone, "at least I got the most important part."

After Warner was elected, she got sweet revenge when, during a luncheon thrown for her by the Republican ladies thanking her for her help, she took her purple Halston pantsuit out of mothballs and wore it proudly.

She pulled Warner's campaign office manager aside and said, "I'm wearing this in your honor!"

She had never been shy about speaking her mind. Five months before they married, she made the brave

decision to offer herself up as a hostage in exchange for the more than one hundred Air France passengers being held by terrorists at Entebbe Airport in Uganda. The plane had originated in Tel Aviv and had been hijacked by Palestinian and German terrorists and forced to land in Uganda. The terrorists rejected her offer, and Israeli commandos freed the hostages, but she was willing to trade her life for their freedom. It was what she had done for her good friend Monty years earlier, and it is what she would do for AIDS patients years later—she ran toward the scene of the accident, headfirst into the trauma, never away from it.

Warner chalked it up to her passion. "She often got emotional, and the emotion may have temporarily subdued her judgment about people who are suffering, and she was concerned about the fate of the Jewish people." Warner appreciated her passion. "Giving was her heart," he said. "I used to say, 'Your heart is as big as your bum.' Trying to get a laugh out of her." Though her offer to trade herself in exchange for the hostages was not accepted, she did play a hostage in the 1976 ABC televised dramatization of the Israeli rescue raid, *Victory at Entebbe*.

She was notably more progressive than her husband. Elizabeth supported the Equal Rights Amendment; Warner did not. He did say that she helped expand his

perspective. "She's worked since she was ten years old, worked hard. . . . And this [their marriage] had been an eye-opening experience for me."

They fought over whether women should be drafted into military service. She thought they should. "That dog won't hunt," Warner told her. "I'm not buying into that." At a Republican congressional retreat, Elizabeth spoke up on the women-in-the-military issue in a debate. In the 1970s, political wives were expected to keep quiet. Silence fell over the crowd of 110 lawmakers. When Warner motioned for her to be quiet, Elizabeth told him to drop his "all-domineering hand." A *Washington Post* story described the incident and referred to Elizabeth as "Elizabeth Warner."

"A few minutes later, Elizabeth Warner observed that her own reading of history was that 'women have been in active combat since Year One.' She mentioned the role of women leaders from Cleopatra to Margaret Thatcher and said she saw no reason why women should not be free to volunteer for combat duty. 'Equal rights means equal responsibilities,' she said."

She received a one-word message from Senator Margaret Chase Smith, who was the first woman to serve in the House and the Senate: "Bravo!"

Elizabeth might not have called herself a feminist, but she certainly was one. Her bold and gritty film

choices, beyond the obvious equal rights message in *National Velvet,* make her interest in feminism and social justice clear: *A Place in the Sun* (1951) takes on the issue of unwed pregnancy and its sometimes disastrous consequences and was released twenty-two years before *Roe v. Wade* made access to a legal and safe abortion a constitutional right; in *Giant* (1956) Elizabeth plays Leslie Benedict, a woman who forces the white ranchers' doctor to intervene and save the life of a dying Mexican child and who raises her son to be a feminist; in *Suddenly, Last Summer* (1959) her character, Catherine Holly, is declared mentally ill by the mostly male medical establishment, with no facts to back up their diagnosis; in *BUtterfield 8* (1960) Elizabeth plays Gloria Wandrous, a woman who was branded a "nymphomaniac" by the Production Code; and in *Who's Afraid of Virginia Woolf?* (1966) she plays Martha, a middle-aged woman who is so disillusioned and disappointed by her life that she does not live in reality.

In most of her films, the feminist message is not at all subtle: Leslie Benedict challenges her close-minded misogynistic husband, Bick, who tells her and her friends to leave the room when he and the men start talking politics. "That's right," Leslie says sarcastically. "Send the children on up to bed so the grown-ups can

talk." Her character in *The Sandpiper* (1965), Laura Reynolds, is a single mother who refuses to marry the father of her child because she is not in love with him. An artist who lives alone with her son, she makes this chilling observation about womanhood: "The man is a husband and a father *and* something else, say a doctor. The woman is a wife and mother *and* . . . nothing. And it's the nothing that kills her." Elizabeth did not think that any woman should be limited by these old-fashioned expectations, and by showing a different way to live on-screen she was offering an alternative.

"If you want to talk about Women's Lib, in terms of being self-supporting, then I've been Women's Lib ever since I was a baby," she said. Naomi Wilding said that her grandmother was a role model. "How could you not think of her as a feminist?" Another grand-daughter, Laela Wilding, said that Elizabeth "liked the traditional roles [in her personal life], even though that's not really how she lived."

Elizabeth believed strongly that women should get paid the same amount as men for the same work. She said she was "very proud of women who do professional work and who find the time to balance family life."

She was able to initiate real change on occasions when Warner would listen to her. During the campaign, the governor of Virginia asked Warner and Elizabeth to

come for lunch at the Governor's Mansion in Richmond, which they were happy to do, except there was a foot of snow on the ground. Warner and Elizabeth drove to the airport, but it was closed. So they took a bus to Richmond. The bus driver and several other passengers asked for autographs. "This is interesting," Elizabeth said. "I've never been on a bus in my life! I'm enjoying it."

After a little while, as the bus inched its way through the snow, she pulled on Warner's sleeve and whispered, "I need to go to the bathroom. Ask the driver to spot a restroom and pull over."

"Elizabeth, he has a bus full of people trying to get to Richmond. He can't stop for you."

There was dead silence.

"I know," he said, suddenly having a revelation. "These buses have bathrooms."

"What a relief," she said and walked to the back of the bus. She came back a minute later and again there was dead silence. Eventually, she said, "Why don't you go back and look at the bathroom. It was a sodden mess! Pee everywhere."

More silence.

"The clock is running out," she said, squirming in her seat.

Warner got up and talked to the driver, who offered

to try the Richmond airport, but it was closed, except for a watchman. Warner begged him to open it, and when he refused Warner slipped him a twenty-dollar bill. When the watchman saw Elizabeth, he said, "Why didn't you tell me who it was for?"

She disappeared inside the airport and came back out after only a minute. "Which one of you fellows has a dime?" Some women's bathrooms actually required money before they could be used. No one had a dime. Warner had the governor's driver meet the bus and put on sirens as they raced to the Governor's Mansion. When they finally pulled up, Elizabeth leapt out of the car and almost knocked down the governor's wife on her way to the bathroom.

When she returned she said, "John, do you want to stay married to me? Because if you do, you have five months to get rid of this law that penalizes women." When they got back to Washington, Warner approached Senator Ted Kennedy, who partnered with him on legislation to outlaw pay toilets.

Meanwhile, Elizabeth was trying to balance being one of the world's most famous people, a new marriage, and her four children: Michael, who was twenty-six; Chris, who was twenty-four; Liza, who was twenty-one; and seventeen-year-old Maria. She had to fire an old friend, John Springer, her longtime publicist. Chen

Sam stayed, and lived with Elizabeth and Warner. "John [Warner] wanted very understated work," Sam said diplomatically. "No Hollywood types," which included Springer.

In a November 28, 1979, letter, Elizabeth broke the news to her old friend Springer. "As you may have noticed, I have tried to keep a very low profile and I just think it is better that I don't have show business's finest press agent represent me now that I am in the world of politics with my husband. . . . Love, Elizabeth Taylor Warner."

After Warner won his Senate seat in 1978, he hosted a fundraiser breakfast at their Georgetown mansion and invited twenty-five senators and dozens of lobbyists, who paid two thousand dollars a seat. Their housekeeper came down just as the group was leaving and said that Elizabeth wanted to know if breakfast was still warm. In true Hollywood fashion, she rarely made an appearance before midday. She came down in an almost-transparent negligee. She stood at the bottom of the stairs and told the men who were getting on their coats, "Do the right thing, do a favor for me, whatever you gave, now double it." They did as they were told.

But Elizabeth was growing desperately unhappy in Washington. Warner was a workaholic who rarely missed a vote in the Senate. When the campaign was

over, she felt completely abandoned by him. "I had no function anymore, not even as an ornament." Far from friends in Los Angeles, she ate and drank at home alone, ultimately gaining more than forty pounds. "Every time Liz Taylor goes into McDonald's, the numbers on the sign outside start changing," joked Joan Rivers, who relentlessly fat-shamed her. "When she looks up and sees five billion, she thinks it's her weight."

She was five foot two and weighed more than 170 pounds. Warner had nicknamed her his "little heifer." She pretended not to be offended, but it stung. The *Daily Mirror* added to cruel reviews about her appearance in the film version of *A Little Night Music*: "What brought us all dangerously close to rolling in the aisles was the forlorn attempt to squeeze Elizabeth's quart-sized goodies into a pint-sized ensemble." She thought she had reached a new low when she forced herself to look in the full-length mirror of their Georgetown mansion. She had kept it hidden, but one day, after stepping out of the bath, she looked. What she saw in the mirror that day stunned her.

She found herself in a sort of "domestic Siberia," she said. Before the campaign, she was asked by a journalist if she thought that their marriage could withstand it if he won. "I'll tag along," she said. But she soon learned that she could not go with her husband to

Capitol Hill every day. And she also did not know that when a senator is not voting they are often on the road campaigning for colleagues who are up for reelection or going back to their states to hold events with voters to get reelected themselves.

The separation was killing her. "When I came to the Senate we worked so much at night and she would sit around and watch the boob tube," Warner admitted. He was not doing anything to help her because he did not recognize the problem. "She drank a bit too much, but I never saw any touch of alcoholism."

He would tell her, "Pooters"—another nickname he had for her—"Go pour yourself a Jack Daniel's and go on upstairs and watch TV." Her glasses of Jack Daniel's were getting larger and larger.

She made friends with Senator Howard Baker and his wife, and even with Republican senator Barry Goldwater, whom she enjoyed teasing. But she was a passionate and creative person who had nowhere to put her energy, no way to be useful.

Warner's absence and his mild-mannered temperament were infuriating. At the farm she got so angry once that she threw an entire pot of cooked spaghetti, and some of the pieces stuck to the wall. "We're not removing that," she said, "it's going to stay there." When Warner sold the house a couple of pieces were still there.

But Elizabeth's descent into serious alcoholism and addiction to painkillers was terrifying for her family to watch. Chris Wilding said that his mother genuinely wanted to be a supportive wife, but what that meant exactly "came as a bit of a rude awakening."

Wilding remembers, "Toward the end of my stay at the house in Georgetown, I would occasionally be awoken in the wee hours by the telephone intercom system in my bedroom. My mother would ask if I would like to meet her in the kitchen for a beer. She would sound woozy—like a beer was the last thing she needed—but also genuinely lonely, and I could never turn her down."

Wilding reached a breaking point after one heartbreaking incident.

"One afternoon my mother managed to locate me via the phone intercom system, and she asked if I would please come upstairs to her bedroom to help her with something. She sounded wobbly on the phone, but it wasn't until I saw her that I realized she was already pretty fucked up on something. She was seated on the edge of the bed in her underwear, and she had a syringe of Demerol in her right hand. She pointed to a spot on her thigh and asked me if I would administer the shot for her. Being confronted with this scenario sucked all the air out of me, and I told her that I was sorry, but that

I absolutely could not help her with this. She looked at me with deadened yet disappointed eyes, took a breath, steadied her hand, and plunged the needle into her flesh. I didn't know how to help her turn around the situation she found herself in, but I knew I couldn't stick around to watch it anymore either." Wilding went to California to escape.

Richard had always disapproved of drug use. He saw it as elitist because he had grown up with alcohol as the workingman's salve. When their marriage was over, Elizabeth felt freer to do drugs and take pills without hiding them.

Even though she wasn't talking about him as much, Elizabeth and Richard were still in each other's lives, much like any divorced couple trying to coparent their children. Liza always referred to Richard as her "dad," and Mike Todd, who she never knew because he died when she was so young, as her "father." In response to a letter from their lawyer, Aaron Frosch, explaining that Richard had bought Liza a car, paid for an apartment, and given her a weekly allowance, Elizabeth wrote, "If Richard wants to be the 'Big Daddy' to Liza (and it seems to me he already has by presenting these items) it's O.K. by me."

In a separate letter from her lawyer to Richard she

wrote in the margins: "I'd like to see Richard's reply to this—He does tend to go ahead and do things for my kids without letting me know—which is very generous—but rather confusing."

Even though they were not together as a couple, she relied on him to be a grounding force in her life. She sent him this telegram in 1982: "You don't look a day over 75, stay young at heart, and just because it's your birthday there is no need to get pissed. Love you very much, your double ex-wife. Elizabeth."

They shared a child, Maria, and Richard loved Chris, Michael, and Liza. Richard wrote to Liza when she was a young girl and told her how he felt: "I love you because I love Kate [his daughter with Sybil] and I miss her and you are the perfect reply. I love you simply because I love you, and if anybody except me or Mamma hurts you I will strangle them with my bare hands."

Elizabeth and Richard would forever be bound together, not only because of their kids, but also because of their tremendous love for each other. Before Liza got married to Hap Tivey, Tivey remembers meeting Richard for the first time. They were on their way to Gstaad and they stopped at Richard's home outside of Geneva. Tivey was jet-lagged after the long flight and he was taking a nap when Richard walked into the

bedroom. Before they even shook hands, Richard spotted a copy of *King Lear* resting next to Tivey on the bed and in his booming voice immediately launched into the first monologue of the play. "I'm like, 'What the fuck is going on here?' It was jaw-dropping," Tivey recalled with laughter.

After Richard's impromptu performance, they had a perfectly ordinary conversation. "I think he had a degree of concern wondering, *Who is this? What's this kid's relationship with somebody who I adore?*"

And Elizabeth missed the freedom she had when she was with Richard. In August 1977, before John Springer was fired, he advised Elizabeth not to support organizations fighting for gay rights. Several groups had written to her seeking her help in their efforts against the anti-gay-rights activist Anita Bryant, a gospel singer who launched a crusade against a 1977 ordinance in Miami-Dade County that banned employment and housing discrimination based on sexual orientation. The ordinance was repealed, and Bryant became a well-known figure and part of a national backlash against gay rights. In September 1978, a Field poll found that 61 percent of California voters were in favor of banning gay teachers, which was in line with national sentiment at the time. Elizabeth would have preferred to have spoken out against Bryant, especially

when hard-fought gay rights were being attacked, but as the wife of a Republican senator she felt that she could not. Springer wrote: "Dear Elizabeth: Under normal circumstances, I would imagine you would wish to stand up for this group against Anita Bryant. However, as John's wife, I imagine it would be wrong for you to ally yourself with any controversial issue. I'm sending you these letters [from the groups asking her to speak out against Bryant] for your information but I believe the only thing to do is to ignore them. I can't imagine any answer not being the wrong one." Sadly, she had to stay quiet.

Every trip she took had to be cleared with Warner and his staff. She was invited as the guest of honor at the Cairo Film Festival in September 1979. Aaron Frosch wrote her a concerned letter on September 14, 1979: "I am informed that you will shortly leave for Egypt for a visit to Egypt and Israel. Is John informed of your plan and does he agree that a visit to the two countries would have any damaging effect on his career?" She went anyway.

She tried to hold on to her old self, but she couldn't. André Leon Talley remembered meeting Elizabeth in the 1970s at a party at designer Elsa Peretti's apartment in New York on a Saturday night. "She came in very, very late with Halston, carrying her own bottle of Jack

Daniel's. She sat on the terrace. What surprised me was she came to the party in a caftan. Halston and Liz were like naughty best friends on a college campus." A frequent customer of Halston's, between April and October 1976 she bought twenty-one dresses, four capes, six pair of shoes, and one turban, among other things. She always got at least a 25 percent, and sometimes a 40 percent, discount.

Then, not long after, Talley saw her in a very different setting in Virginia when she was married to Warner. "I was shocked that she had all this weight on her, but that she was able to skip across the country yard, it wasn't like a manicured lawn in a fabulous Beverly Hills mansion, it was country dirt. She was skipping along with all this weight, clip-clopping on the grass."

"I felt I'd become redundant," Elizabeth said. "I think Washington is the loneliest city in the world for a woman, because she has to be so many things and nothing at the same time. Dispensable and totally indispensable." She could not say what she was actually feeling; she described her new role as being "a robot."

On Valentine's Day she and Warner went out to dinner in Georgetown. He kept a pager in his pocket in case he was needed on Capitol Hill. "Elizabeth," he said, "I've got to go vote."

"*You can't!* It's Valentine's Day. *You're going to leave me here?*"

"I have no choice," he told her. He raced to the Hill, then came back to the restaurant, where she burst into tears and had to be taken home. She told Senator Howard Baker the story, and he couldn't believe that Warner would leave his movie-star wife alone on Valentine's Day. Not long after that, Baker asked Warner if he would fill in and make a speech for him at a hotel ballroom. When Warner returned to the Senate after the speech he discovered that a vote had been taken while he was gone. Warner was furious. "I thought you weren't voting!" he said to Baker.

"I did a favor for your wife," Baker said. And that broke Warner's record of being present for every single vote, and now, Baker assumed, Warner would not be so afraid of missing a vote.

But Warner would never change. Life as a senator's wife in Washington, Elizabeth said later, made her "a drunk and a junkie."

Chen Sam lived with Elizabeth, but she drank heavily too and was in no position to help Elizabeth get sober. "She put up with Elizabeth only so far. I had to break up fisticuffs more than once," Warner said. "They each wanted it their way. . . . Elizabeth was so possessive and demanding that Chen had little or no

time for any private life. They used to get into some godawful fights and I'd have to referee. But Chen was invaluable to Elizabeth, and to me."

In a *Today* show interview, Jane Pauley asked Elizabeth why her talent wasn't used in Washington, and she said, "I think they were suspicious of me. I think they thought—sort of the—the Washington crowd thought that I would—[that] I had in mind someplace that I would be the Perle Mesta of Washington. That I had some kind of social ambitions or something. Which was totally untrue, so I became so laid back to prove them wrong that I went inside out, and I had no friends. I was treated a bit like a freak."

She worried that she would die of an overdose if she stayed. She decided to reinvent herself at forty-nine years old. She went to the Palm-Aire Spa in Florida with her friend and celebrity hairdresser Maury Hopson. They nicknamed their cabin "BUtterfield Ate Too Much." "She wanted me to be there as her friend and help her go through it. . . . I don't think she knew what she was getting into . . . She was drinking from a water bottle and said, 'I'm drinking this stuff like it's vodka.'" They were there for three weeks and she lost twenty-two pounds. "She suddenly became Elizabeth Taylor again," Hopson said.

At first Warner was uncomfortable with her gay

friends, and she had a lot of them, but, he said, she helped open his mind. "She converted me. We went to Rock Hudson's house and he introduced us to a gentleman who was clearly his boyfriend, which took me back a little bit."

She was not able to change policy—except for ending pay bathrooms—but she was able to use her career to speak her mind. Rabbi Marvin Hier, founder of the Simon Wiesenthal Center, a human rights organization based in Los Angeles, approached Elizabeth and Orson Welles to narrate a documentary about the Holocaust called *Genocide*.

Welles signed on first and Hier wanted to get Elizabeth, but he did not know how. He knew Warner because they had worked together on a measure ensuring that there was no statute of limitations on Nazi war crimes. He sent the script to Warner, who put it on Elizabeth's night table. She picked it up and she cried all night long. "I've got to do this," she said. A couple of days later, she called Hier and introduced herself to the person who answered the phone as Mrs. Warner. Hier said that he did not know a "Mrs. Warner" but he said to put the call through anyway.

Genocide won an Oscar, and at a dinner held in Elizabeth's honor in 1980, she made a prescient speech about the dangers of forgetting the Holocaust. "Today,

a whole generation is growing up that does not know this, that has no memory of these events, that has no terms of reference to know how close we all came to the final curtain," she said. "Worse, around this new generation can be heard new ominous voices seeking to pollute their minds, to corrupt their values, to impair their future. In Europe and here in the United States, anti-Semitism is on the rise. Haters are running for public office, pitting white against black, Christian against Jew." The audience broke into thunderous applause. Elizabeth Taylor was back, dressed no more in drab clothing and no longer playing a supporting role.

Now that she had found herself again she decided to try something she had never done before. "Our last months together she finally came to me and said there's a play that I'd like to do," Warner said. The play was Lillian Hellman's *The Little Foxes*, and at forty-nine, and after more than fifty films, she took on one of her greatest fears. She knew that she still had a lot to learn when it came to performing on stage. For instance, a red light in the theater is the cue to make your entrance. But when it goes on in a movie studio it means to stop whatever you're doing and stand still. "She would freeze," her costar Dennis Christopher recalled, "like a little girl, she needed people to tell her to go. That's how ingrained it was in her."

When they got together for the table reading of the script, Elizabeth was obviously nervous. "She's looking at everybody and observing everyone. They were all seasoned theater people," Christopher recalled. "Lillian Hellman [who wrote the play] was there. It was decided that Elizabeth needed to rehearse in the theater instead of a rehearsal studio, like you normally would do. She needed to find her stage legs."

When the director of *The Little Foxes*, Austin Pendleton, first met Elizabeth for dinner, she was still married to Warner. Pendleton remembers how deeply affected Elizabeth was by the assassination attempt on Ronald Reagan in 1981. During rehearsals she told him that she wanted to take out a full-page ad in the first section of the *New York Times* calling for gun control legislation, and Warner was furious. "That was a sharp turn for the worse in their relationship," said Pendleton. She saw nothing wrong with what she was doing. After Robert F. Kennedy's assassination in 1968 she got one hundred other celebrities to sign a full-page ad in the *New York Times*, which she paid for, calling for stronger gun control measures. Warner, she reasoned, had always known that she did not share his conservative political views.

Warner wrote Elizabeth a letter on April 1, 1981, beg-

ging her to reconsider. ("Memorandum for Elizabeth" was crossed out and he wrote in "My loving wife.") "We both share a strong belief that steps must be taken to remove the root causes for violence leading to these terrible assassination attempts. However we disagree on the means to affect our common goal. Before you place the advertisement in favor of gun control in the national newspapers, I strongly urge you to consider the following: Emotions are very high nationally and the impact of the ad would be minimal. . . . Should the ad have the reverse effect you desire, and prompt another act of violence somewhere, it would be tragic for all of us including the President and the recent victims, as well as our Nation. . . . Again I fervently urge you to consider your own personal safety and that of the children and those who work around us."

She did it anyway—she had had enough. "I adapt myself one hundred percent to my husband's life, willingly and happily. I can be pushed, I can be shoved, and it's okay: I'm resilient as all hell. Though I admit if I'm pushed too far, even by a husband, something snaps inside me and the relationship is over."

But they tried to stay together long distance for a while. "It got hard for both of us," Warner said. "She still had

a lot of Richard Burton in her system. . . . We decided one day that we were still friends, let's stay friends and not let this pace drive us in the wrong direction."

They sat together on the lawn of their country home, watching the movers load their vans. "All of a sudden I saw a truck coming, towing my car. She had given me a 1934 Ford convertible with a rumble seat. It was a wonderful old car and I loved it. And she said, 'Oh, by the way, you got rid of my car (the Rolls) and I'm going to keep yours.' It went off on the truck and that was the last time I saw it." They finally divorced in 1982.

In 2002, after having decades to reflect on her seventh marriage, she told the *New York Times*: "He knows he wasn't the love of my life. And I know I wasn't the love of his life, but we loved each other."

She and Warner remained in each other's lives until she passed away. Her relationship with him helped lead her to what would become her greatest and most lasting legacy. A few months after their divorce, Elizabeth's children called Warner and said that their mother seemed sad, could he fly up to New York and surprise her for Christmas? So he spent the morning with his family in Washington and flew to New York for the evening. Her kids did not tell Elizabeth that he was coming. They wrapped him up in a red package and put him in the middle of her living room. She came out

of her bedroom at noon and saw this giant package and screamed, "*What is this???*"

"That's your Christmas present," they said. "It's a big one, Mommy." When she opened it, Warner jumped out and she was giddy. After they settled in she took his hand and said, "I want your advice, follow me." He followed her into a room with a peculiar odor and two hundred small bottles of perfume scattered on the floor. "I'm going into the perfume business. I want you to sniff and see which one you like best."

"That's not my bag," he said. "I have no proclivity for perfume, I would not be a good judge."

She said, "Please do a few." He couldn't do it, he said. "I don't want to be in the perfume business."

"Oh come on, it will be fun." After seeing the roaring success of Passion and White Diamonds, he wished he had.

They went to dinner at least two dozen times after they divorced, Warner said. People liked seeing them together.

In 1999, shortly before Barbara Walters was scheduled to interview Elizabeth, she called Shirine Coburn DiSanto, Elizabeth's publicist in the 1990s, and said, "I have to talk to you. This is very, very unseemly, I don't know if you know, and I don't know if Elizabeth knows, but I'm having a relationship with Senator John

Warner, and I don't want Elizabeth to find out and get mad and cancel the interview."

DiSanto called Elizabeth to let her know, and she laughed and said, "I know! She must be on pins and needles, this is hilarious." Elizabeth knew because Warner had told her himself. "Oh good lord, tell her to go for it!"

But the end of every marriage carries a certain melancholy, and Elizabeth was not capable of lying about it. When Warner remarried in 2003, he called Elizabeth from outside the church to let her know.

"I'm happy he's remarried," she said. "I hope he's better to his new wife than he was to me."

Chapter 15
Addict

*It's probably the first time since I was nine
that nobody's wanted to exploit me.*

—Elizabeth's diary entry written
during the seven weeks she was at
the Betty Ford Center in 1983

Acting had always been the one constant in Elizabeth's turbulent life. Approaching fifty, she spent months performing in *The Little Foxes* in Florida, Washington, and New York. "I didn't know where else to go," she told costar Dennis Christopher.

Elizabeth was glamorous even backstage, when she would walk in wearing the Krupp diamond on her left ring finger, as though she were still married; a Cartier cuff with a diamond chevron; and a long string of Bulgari coins. If she was going out after the theater Chen

Sam would sit with the legendary jewelry in Elizabeth's dressing room.

At first her performance was praised. She was drinking, but it was not apparent onstage, according to people who worked with her on the show. The first few weeks went well, until world events changed everything. On October 6, 1981, Christopher was backstage when he heard someone weeping. Egyptian president Anwar Sadat had been assassinated, and Elizabeth was watching television and crying. "He's one of my friends, he's really my friend," she told Christopher as he tried to comfort her. "I loved him." She had once been banned from entering Egypt, but she had forged a real friendship with Sadat. That moment, Christopher said, was when she could no longer hide her alcoholism.

(During a trip to Egypt with her friend Liz Smith, Elizabeth was invited to Sadat's summer residence, which involved driving through the desert. "I remember trying to get her out of the bath and get her there on time, and she said, 'Oh, never mind, he can wait.' And I said, 'No he can't, he really, really, *really* can't.' Somehow we managed to get there on time, we might have been about a quarter of an hour late. Then of course she absolutely was amazing with him. I remember him saying to her, 'Are you going to Alexandria?' and she said, 'No, I mean how could we get there?' He

said, 'Well, you have to because you're my queen.' And she said, 'Well, we still can't get there,' looking at him with those eyes, and he offered her his plane. 'That is so kind of you,' she said. And off we went.")

After Sadat's death she was no longer a functioning alcoholic. She started saying her lines in a singsong way that almost seemed like she was joking. "It went from being a brilliant performance to being a parody," Christopher said. "She wasn't the same woman who accepted the play and wanted to rebuild her career."

Elizabeth was really struggling at the end of *The Little Foxes* run, said Austin Pendleton. "Some people would mistake Elizabeth's shyness for snobbery when, in fact, she was going through a difficult time in her life and she found it hard to be phony." Most of her pain was because of Richard; it almost always was.

Pendleton was at Elizabeth's fiftieth birthday party in London in February 1982. "We were hanging out at the bar, and all of a sudden there were a bunch of flashbulbs, and there was Elizabeth Taylor and Richard Burton walking down two or three steps into the restaurant, and they were clearly there as a couple. At the bar, all these hardened character actors started crying. It was the most beautiful thing I'd seen in my life."

Elizabeth was up to something. In 1983, seven years

after their second divorce, she suggested to Richard that they do Noël Coward's play *Private Lives*. She was a producer, and she saw a chance to make money and, more importantly, to spend time with Richard. The comedy is about a divorced couple who end up staying next to each other in a hotel on their honeymoons with their new spouses. Sally Hay, Richard's girlfriend at the time, called the play "Public Lives" because it was essentially just a campy peek into the "Liz and Dick" show. During rehearsals in New York, Elizabeth moved into Rock Hudson's enormous apartment with views of Central Park. She brought along the new man in her life, her fiancé Victor Luna, a wealthy Mexican attorney who was absolutely devoted to her. He was mild-mannered and businesslike, but he was no Richard. She knew Richard would bring Hay, his new girlfriend, whom he met while filming the 1983 television epic *Wagner*. His marriage to Suzy Hunt had ended predictably the year before.

The two couples went out to dinner the night before they started rehearsing. It was gut wrenching for Elizabeth to see Richard smother Hay with attention in a way he had never done with her. Richard was frightened of Elizabeth, and he tried not to upset her, which made for an uncomfortable formal evening for two people who had been married twice.

"I need a headache pill," Elizabeth told their waiter. "So be a dear and get me a drink. Jack Daniel's on ice."

Then, a few minutes later she said, "I need a pill for my tummy. Another Jack Daniel's, please."

Elizabeth concluded that Richard was just trying to make her jealous. And maybe he was. He had earlier told his brother Graham that he missed her "all the time," but that he was too old and too sick and that he did not want to burden her. "She knows how to take care of an old man," he said of Hay. They lived in Céligny, Switzerland, where, Hay said, Richard was "slowing down." One day they were talking about Elizabeth and he said, "Did I really do all that? Did I really do the jewelry, the yacht, the plane? Did I do that?"

Elizabeth wanted to return to that life, while he wanted to retreat to a more quiet existence. The next day, at their first rehearsal, it was clear that Elizabeth had not even read the play and certainly had not memorized her lines—something she could have easily done because she was such a quick study. Richard knew his own lines as well as hers and found her lack of preparation infuriating. In his diary he wrote that the time ahead would be "a long seven months."

The play opened at the Lunt-Fontanne Theatre in New York, where Richard had been praised for

his performance in *Hamlet* and where Elizabeth and Richard did their well-received poetry reading years before. The critics were ready to pounce. The *Times* said that the show was "Liz and Dick crassly spoofing themselves in public. It's part 'Private Lives' and private joke."

Michael Lonergan, who was the company manager for *Private Lives* and *The Little Foxes*, said that he saw a different Elizabeth than the woman he saw in *The Little Foxes*. She wanted Richard to give her attention, but he would not. They both knew that many people in the audience were coming simply to gawk at them, or to wait for them to stumble on their lines. But Richard was not drinking at the time and he could see that she was spinning out of control. Elizabeth recognized that their chances for getting back together were growing slimmer and slimmer, but she held on to the hope that they might get married a third time. Richard had asked her, as a producer, if he could get out of it when another opportunity presented itself, but she refused. She would not let him go, and it was slowly killing her.

During the course of the show's run on Broadway, an understudy had to step in for Elizabeth more than a dozen times due to illness, but she was also making a point to Richard that she was still in control and that she was still the person who people came to see. Her agent,

Robert Lantz, recalled a dinner with the two couples, when he sat between Richard and Elizabeth.

"Look at my ring, Robbie," Elizabeth cooed, holding out her hand. "From my sweetheart, Victor. Oh, Robbie, we are just so happy," she gushed.

"Why, it's quite nice," Lantz replied.

Richard took one look at it and said dryly, "Hmm. One carat, I see. You are on a diet, aren't you, luv?" It was, in fact, a 16.5-carat sapphire-and-diamond Cartier ring worth almost three hundred thousand dollars. Everyone laughed nervously, except Elizabeth.

One day, Lonergan found Elizabeth hyperventilating into a paper bag with Victor Luna by her side. She had just found out that Richard and Hay had eloped in Las Vegas. He gave her no warning, out of spite. "I think he was fed up with the illnesses and the time off," said Hay. "He was sick of the entourage. It was, *Enough is enough.*"

When the play was over, Elizabeth went back to Los Angeles. In 1981, after she left Washington and Warner, she had bought a house at 700 Nimes Road in Bel Air, which had once belonged to her ex-lover Frank Sinatra's wife, Nancy. The charming $2 million, 7,100-square-foot ranch-style house sat on a 1.27-acre lot. The trees were so close to the windows

upstairs that it felt like being in a treehouse. They helped block the view of Los Angeles, a city she had seen plenty of already. Elizabeth transformed the backyard into a lush English garden brimming with snapdragons, hydrangeas, and lamb's ear. And, of course, there was a pool.

Inside the house, which was cozy and modest by major-movie-star standards, the walls were uphol-stered in silk, and Elizabeth installed white shag carpet on the floors and a large aquarium filled with lavender-colored fish. There was no indication that a major celebrity lived there except one wall with a jaw-dropping array of masterpieces hanging salon-style above a white sofa. A Van Gogh was right up against a Monet, a Rouault was inches apart from a Cassatt. It was breathtaking.

As with her men, Elizabeth committed to the house quickly, even though it was the first one she looked at. When the realtor showed it to her she asked to be alone so that she could walk through it. She wanted to feel the house's energy. She especially loved the primary bedroom, where she spent most of her time. It was a large room along a hallway on the second floor; two other bedrooms had been turned into closets and an-other into a shoe closet that included a shampoo sink and a place for her collection of handbags.

She loved her house—she immediately placed a me-zuzah on the frame of the front door—but she hated being alone in it. She was lonely, and her addiction to pain medicine was growing worse and worse. She sur-rounded herself with assistants and housekeepers who became like family to her and were less likely to call her out on her growing problem. She manipulated her doctors into giving her the pills she wanted, when she wanted them; it was very hard to say no to Elizabeth Taylor.

One of her nurses, who had worked with Elizabeth for more than twenty years, said that she would com-plain about nausea or back pain, two ailments there was no test for. "She knew when the pharmacy closed, so that we could get one last pill for the night. They used to parcel out pills, because she couldn't be given thirty or sixty pills at a time. That would be like Christmas."

In 1983, Chris's wife, Aileen Getty, anonymously contacted one of the regulatory agencies and told them that some of Elizabeth's doctors were overprescribing her medication. But the problem did not stop. In 1990, three of her doctors were accused of overprescribing addictive drugs. They wrote a combined one thou-sand prescriptions for twenty-eight drugs between 1983 and 1988, including tranquilizers, sleeping pills, and painkillers. One medical expert who reviewed

the case assumed the patient was dead because "the dosages were incompatible with life," said Deputy Attorney General Earl Plowman. "It was a classic case of abuse involving multiple prescriptions, multiple controlled substances at different pharmacies at the same time." The doctors were reprimanded but they were not criminally charged.

She was certainly in real excruciating pain at times, and she was accident prone, but the added benefit of any accident was that it came with more painkillers and more muscle relaxants to lessen the spasms that increased the pain, or sleeping pills to help her sleep through the pain. "She would give Oscar-worthy performances on the phone with her doctors, pleading in an anguished, tearful whisper that the dosages they had prescribed were barely scratching the surface of her pain," Chris Wilding said. "It worked." They might not have realized that she was sometimes washing the pills down with Jack Daniel's, champagne, and vodka.

It was not just alcohol, pain medication, and sleeping pills, Wilding said. She was taking street and party drugs such as marijuana, PCP (angel dust), amyl nitrate (poppers), and cocaine. Wilding thinks it was Roddy McDowall who took the first step of contacting the Betty Ford Center. The Betty Ford Center and Hazelden in Minnesota were among the only places using

a twelve-step program to treat addiction, a taboo subject at the time. After Mrs. Ford left the White House, she went public with her addiction to alcohol and pain medication. She opened the now world-famous Betty Ford Center in 1982, on twenty acres in Rancho Mirage, California. Before she could seek treatment, Elizabeth needed to first be convinced that she had a problem.

A small group of her family and friends, including Luna, gathered together in McDowall's garden. The addiction specialist from Betty Ford walked them through ways to make the intervention less painful, for them and for Elizabeth. It was December 1983, and Elizabeth was in the hospital for a bowel obstruction. They decided that the time to do it was when she was already in the hospital.

By that point, she needed at least two sleeping pills a night, and for thirty-five years she relied on several Percodan a day. "I'd take Percodan and a couple of drinks before I would go out," she said. "I just felt I had to get stoned to get over my shyness. I needed oblivion, escape."

McDowall, Howard and his wife, Michael and Christopher Wilding, and Liza Todd Tivey arrived at St. John's Hospital in Santa Monica. They were there to save her life. Elizabeth's children were especially terrified about confronting her, but they thought her

being in a hospital already might make it easier. "My mother's expression quickly turned from one of happy surprise to that of guarded suspicion as more people entered the room, especially when she spied a stranger in our midst," Chris Wilding said. "After the intervention leader explained the reason for this gathering, we one by one recited our preplanned speeches, the atmosphere in the room becoming more uncomfortable and awkward by the minute."

"I was in such a drugged stupor that when they filed into my room I thought, *Oh, how nice, my family are all here to visit*," Elizabeth said later. "Then they sat down and each read from papers they had prepared, each saying they loved me, each describing incidents they'd witnessed of my debilitation, and each saying that if I kept on the way I was with drugs, I would die."

Chris recounted that "the only person who appeared to be progressively in command of their emotions, masterful actress that she was, was my mother. It was as if a veil of steely self-control gradually descended over her face, her cold blue eyes fixed unwaveringly on whoever was delivering their quavering exhortation. When we had all finished, reduced to mounds of emotional Jell-O, it's my recollection that she told us in very measured tones that she would agree to go to Betty Ford, though not today (as had been our plan, with a car and driver

at the ready downstairs), but tomorrow. Then she icily dismissed us from her room. Ever the one in control." She needed time to consider what she was going to do; she knew that rehab would not work if the decision to go was not on her own terms.

What she was not revealing at the time was the tremendous guilt she felt. At fifty-one, she was being forced to evaluate her behavior. "I think the guilt that I had caused my children such pain. That they worried so much about me, whether I would survive or not. That they'd have to help pick me up off the floor after I'd taken sleeping pills on top of booze. How much pain I could see in their faces, and I had caused that, I'd inflicted that. And it killed me."

A doctor wrote her a moving letter around the same time. "What the blood tests and X-rays are showing is that the medications and alcohol are having definite adverse effects on your body," he wrote.

Because of your acknowledged high tolerance to medications, you require higher doses than almost anyone I have seen. The adverse effects you have sustained already from alcohol and medications are still yet reversible. I am genuinely and sincerely concerned that continued use of these substances will cause irreversible damage to your

health. This is what happened to Judy Garland, tragically.

You are certainly recognized as the most famous actress in the world. As such, few doctors will question your need for medication. This is what Betty Ford found—that she could always get medication from doctors for her physical problems and soon began developing adverse side effects herself. She, too, was confronted by her physician about this, and she too reacted angrily and threw him out. Eventually, her health became so impaired that she had to be hospitalized and get treatment. Because of your similar experiences with doctors and both your similar high tolerances to medication and alcohol, I felt you might find it interesting and informative to talk with her.

Elizabeth spent seven weeks at the Betty Ford Center, and she met with Ford; they were both trailblazing women who were not afraid to expose their problems. A couple of weeks later, her family headed down to the center to take part in Family Week, five days of intensive therapy for family members. Wilding was amazed at how relaxed his mother was when she gave them a tour of her room and introduced them to Johnny Cash, who was a patient at the same time. She

had to take out the garbage and hose down the patio. She even had a roommate. It was the first time in her life that she'd shared a room with another woman. It was probably the first time she had ever taken out garbage in her life, and she felt a certain camaraderie with the other patients. They liked to refer to themselves as "inmates."

It was a year after the center opened, and Elizabeth knew that if she did not tell the press herself, someone would find out and leak it. "Betty Ford and I discussed what it would be like to go public," she continued. "She had done it and was the better for it. I just hoped the public would understand. My friends have been totally supportive, and if anything, they feel relief and pride. No one has rejected me."

Elizabeth's mother, who was eighty-eight years old, was in denial and would never accept the idea that her daughter was an addict. "That Christmas of 1983 was a very special one," she wrote in notes for her unpublished memoir. "Elizabeth entered the Betty Ford Center here in Rancho Mirage. She had just finished having her yearly checkup and found out that her blood contained too much codeine as a result of all the bouts of pneumonia she had suffered through the run of *Private Lives*—and before that in *Little Foxes.*"

Detoxifying was painful. "I feel like hell," Elizabeth

wrote in her diary. "I'm going through a withdrawal. My heart feels big and pounding. I can feel the blood rush through my body. I can almost see it, rushing like red water over the boulders in my pain-filled neck and shoulders, then through my ears and into my pounding head. My eyelids flutter. Oh God, I am so, so tired."

During therapy, Elizabeth kept pointing to feelings of being used, first by her family, then by the studio, and then, quite possibly by Richard, who used her fame to enrich himself and then abandoned her. She said that was one reason why she became an addict. She was very protective of her privacy—what little she had of it—and she was furious at people who betrayed it. Her friends knew that if they ever talked about her in the press she would cut them off.

Betty Ford was one of the only places in the world where she did not think of herself as a celebrity. In rehab she was treated "as a drunk and a junkie" and forced to look at herself honestly. She could not bring her hairdresser or her housekeeping staff, and she had to make her bed. Still, she did not admit to herself that she was an alcoholic until she had been at the center for two weeks. "My name is Elizabeth Taylor," she said then. "I am an alcoholic and a drug abuser." But Chris Wilding said that his mother's sense that she was being treated like everyone else was an exaggeration.

"I didn't realize just how powerfully my mother had the staff under her sway until it was my turn to have a one-on-one therapy session with her," he said.

Elizabeth told the therapist that she felt used by her own children. "She enumerated several instances when I had gone to her for financial help," Wilding recalled. "I was actually caught off guard by this, not because what she was saying wasn't true, but because I'd had no idea whatsoever that she had felt taken advantage of in the way that she was now saying. In the moment I felt mortified and ashamed, and my mind was reeling at this bombshell revelation. But what really sent me into a tailspin was the dawning realization that the therapist was quietly, but very openly, weeping in her chair while looking straight at my mother. Jeez. (Was I such a monster, the greedy and thoughtless architect of my mother's misery? Was it because of me that she was a drug addict?) . . . I had to marvel at my mother's ability to snake-charm her."

Elizabeth considered her stay at Betty Ford a triumphant success. She left thinner and happy. When a friend asked what she was most proud of she replied, "Just being alive." She felt she had finally been able to get her addiction, and her fluctuating weight, under control. Everything, it seemed, had fallen into

place. She looked at herself in the mirror at her fifty-fifth birthday party, ran her hands down the zipper of her low-cut white silk dress, and said, "Not bad for a fifty-five-year-old."

She wrote a self-help book, *Elizabeth Takes Off*, about her experience. She went to a few Alcoholics Anonymous meetings, not that she could ever really be anonymous. She always worried that someone at a meeting would record her and sell the tape to the tabloids, so she eventually stopped going altogether. But her twelve-step book was filled with inscriptions from people who were in treatment with her that show that she was trying. One from her 1983 stay at Betty Ford read, "I shall never forget staying up watching old movies until the wee hours with you. What fun. As I told you since I sobered up I've many times prayed that you would find what I have found."

Elizabeth lost forty-five pounds within the first couple of years after leaving Betty Ford. She stopped drinking, but she was still an addict. She rationalized the sleep and pain medication as legitimate because they were prescribed by a doctor. Less than a year after her stay, she was being prescribed massive amounts of drugs, including Percodan, morphine sulfate, and Demerol. She felt comfortable talking about being an alcoholic publicly, but she thought that the pills were

more shameful. And they were much more difficult for her to kick.

Jorjett Strumme worked for Elizabeth from 1984 to 1993 and said that if Elizabeth was not awake by a certain time, no one who worked for her wanted to go upstairs to her bedroom and check on her; they were too afraid that they might find her dead. Her addiction to medication took a heavy toll on her relationship with her children. Liza once called and seriously needed to talk to her mother, but she was told that her mom was unavailable after 9:00 p.m., not because she was asleep, but because she was high.

Liza was used to feeling like this. "My kids call me out on *almost* everything and vice versa. I feel that they are comfortable doing so because of the shared intimacy that is developed on a day-to-day basis of actually growing up with me. When we were with Mom it was for short periods of time—on holidays and breaks from boarding school. You're not going to sabotage the time that you have together by calling her out on things that might seem strange or uncomfortable. You let things go and mind your own business."

One of Liza's favorite memories of her mother were the days spent together before her wedding in 1984. "Hap and I lived in a tiny one-bedroom house with a large barn that accommodated my horses, our [art]

studios, and a guest room, where Mom stayed. The wedding was going to take place in the barn. My studio was a small annex of the barn; not much bigger than a cupboard. I was trying to get a commissioned piece finished and into the foundry by the time of the wedding. She came and sat with me with a book or a chat and kept me on track. It was quite possibly one of the only times that we were able to have an extended amount of time together; just the two of us, without her entourage around, other than family time in Switzerland."

Michael Wilding said that there were some people who worked for their mother who thought that she needed to be protected, including from her own children, and they developed new rules for who was going to be able to access her. "Sometimes, all of a sudden, you'd discover that you were one of the people they were protecting our mother from. That was quite maddening."

Elizabeth was struggling. She made commitments for appearances and then did not always keep them. Often she would manage to become injured in the days or weeks leading up to one of these commitments, which only added to the drama. This happened so frequently—typically as a result of a fall in her bedroom suite—that people around her began doubting whether it was coincidental or on purpose.

The broken ribs and compression fractures to her

vertebrae were painful, but they led her on the path to more pills, which is what she wanted.

"Usually," Wilding noted, "she would barely pull it together (in a swirl of high drama) and honor the commitment." Then, on August 5, 1984, she was shattered when Richard Burton died suddenly at his home in Céligny. The cause of death was an intracerebral hemorrhage, most likely caused by years of heavy drinking. Despite periods of sobriety, there were days when he drank three bottles of vodka. He had kidney disease and cirrhosis and knew he had to stop, but he couldn't. He was only fifty-eight.

Elizabeth was in San Francisco for a weekend when her assistant Liz Thorburn got a call from Sally Burton in Switzerland, giving her the news. She and Elizabeth's other assistant, Roger Wall, had to figure out how to get Elizabeth back to Los Angeles before the press found her. They did not want her finding out what had happened from a reporter. They chartered a private plane and Roddy McDowall came to her rescue again. He went to her hotel in San Francisco, broke the news to her, and brought her home. She was overwhelmed by her grief, and being with Victor Luna only made it worse. They broke up soon afterward.

Sally organized the funeral and decided that Elizabeth should not come.

"Literally you could hear Sally from down the hall-way screaming at Elizabeth," someone who worked for Elizabeth recalled. "Elizabeth was saying, 'Sally, you need to calm down. You shouldn't be saying these sort of things. You're in shock and I understand that.' She was majestic. She was incredibly calm and nice to Sally." This was a crisis and she would run toward it.

Sally Burton said that she does not regret the decision to keep Elizabeth away, because she thought it would become a circus. She felt that everyone, including Richard's family, blamed her for this stance. "I felt very hurt that the Welsh family wanted Elizabeth rather than me. Elizabeth was their celebrity, I was not." The two women did not share their grief with each other. "Elizabeth had her own grief," Sally said. "I don't know if she was in love with him or claimed ownership of him." Richard wanted to be buried in the Old Cemetery in Céligny, a few hundred yards from the villa he bought in the 1950s and named "Pays de Galles"—or Wales. His gravestone, sur-rounded by begonias, is engraved simply: "Richard Burton, 1925–1984."

Elizabeth was not invited to the memorial service in Wales either. "What a load of bull," Richard's brother Graham said. "There was no reason at all why Elizabeth Taylor couldn't have come to the memorial

service." Sally did not want photographers trying to catch a glimpse of a grieving Elizabeth crying beside another husband's casket.

"If he'd lived long enough," Graham said, "he would have married her again."

Still, Elizabeth needed to say good-bye. Norma Heyman, one of Elizabeth's closest friends, said that she remembers Elizabeth being stunned silent by the news of Richard's death. She was unable to get out of bed, and Heyman, who'd known them well as a couple, said "Let's plan, because we've got to go and visit the grave. Sally has no control whether you go to the grave or not." It was painful to be excluded from the formal memorial and burial, and it added a layer of anxiety over when to visit the grave. Heyman and Elizabeth's friend Doris Brynner, Yul Brynner's ex-wife, planned a covert trip to Switzerland and then on to the cemetery.

It was 4:00 a.m., in the pitch black, and Liza, who was there to support her mother and say good-bye to the man she had grown up calling "Dad," suggested they bring umbrellas to shield Elizabeth from the press. The small graveyard is at the edge of a stream, where there is a thirty-foot drop into the runoff water. The caravan of black Mercedes pulled into the eerie, long dirt driveway. Dozens of photographers appeared and their camera flashes lit up the peaceful cemetery.

The gravesite had recently been adorned with beautiful bouquets of flowers, and the paparazzi were trampling all over them trying to get pictures of Elizabeth.

"But she didn't stop, she just walked on," said Heyman. "We all held out an umbrella so they couldn't see her. They never got that photograph that they so wanted." Brynner asked the photographers to give Elizabeth five minutes alone at the grave, but they refused. She knelt before a temporary wooden cross and drew her hands together in prayer. "Oh, Richard, oh, Richard," she moaned.

"I couldn't help thinking that it was one of the few occasions ever that Richard and I were alone," Elizabeth reflected later.

Hap Tivey was there, and he remembered the trauma of that early morning. Elizabeth's friend and assistant Roger Wall was on one side of her, Tivey said, and he was on the other, holding the umbrella. Suddenly, they see the top of a ladder coming up from the canyon. It was leaning against a stone wall. When the photographer was about to get off the ladder and climb over the wall, Roger Wall charged at him, enraged that Elizabeth could not have even a moment of peace. He pushed the ladder off the wall, with the photographer still on it, down into the stream behind the graveyard.

"I hear this guy yelling 'Ahhh!'" Tivey said. "This

is such an incredible moment and it's being invaded in the most disrespectful possible way."

Elizabeth would have to grieve alone for Richard. Shortly after he died, she wrote a poem to him on stationery from the Dorchester Hotel, where they had spent so many years living a fantastically nomadic and lavish life:

You knelt at the cross to mourn your loss
And said good bye again
Burton gave a smile and said a soft Amen

And as you looked upon the stone
And realized now that you were alone
But remember the pleasure that he gave
And would touch you from beyond his grave
Please don't take this in any cruel way
It is a tribute I had to pay
I know it's not much but it's all I can do . . .

The last time that Elizabeth saw Richard was in the spring of 1984 at a pub in London. Richard had started drinking again, but he looked well. Richard told Elizabeth, "You look wonderful, luv," and she told him about her experience at Betty Ford. They reflected on their life together and she told him that she wished that

they had therapy like they have at Betty Ford when they were married; maybe it would have saved their marriage.

"Ah, but then we wouldn't be who we are now, then, would we?" he said with a smile.

At the pub, Victor Luna said that he was looking forward to Elizabeth moving to Mexico, where they would live "a nice, simple life with wholesome Catholic values." Elizabeth and Richard glanced at each other. They both knew that there was no way that Elizabeth was having any of that.

She never stopped loving Richard, and the feeling was mutual.

"You know, Elizabeth and I never really split up," Richard told his brother Graham three weeks before he died. "And we never will."

Her great loves held important places in her home. At the foot of her bed in Bel Air there was a black-and-white photograph of her holding Liza, as a baby, on her chest, and Mike Todd looking down at his daughter, enraptured. And there was a photo of Richard taken the moment that they first saw each other on the set of *Cleopatra*.

She was once asked what she missed most about Richard. Her answer: "His eyes, his voice, his touch. Everything about him."

For a time, Elizabeth was doing well and seemed to be at peace with losing Richard. In 1985, she even helped stage an intervention for Liza Minnelli. She wrote Liza a note in 1993: "From one gutsy lady to another, we both know what it means to hit rock bottom and to seek help to straighten out our lives. And we both know how tough it is to face up to our demons and lick them, painful as it is. You are truly an inspiration to all of us that one can get clean and sober and really stay that way. Your good faith has helped give me the will to keep my own demons away and carry on in my crusade."

Elizabeth may have looked thin and beautiful, but she was still an addict. She was often in her bed propped up by mountains of plush pillows and pills galore.

Finally, in 1988, George Hamilton staged a second intervention. She did not want to go back to Betty Ford, but it was clear to her friends and family that she needed to. She had heard that a repeat visit meant the counselors would be tougher. She was adamant about not returning.

Hamilton sensed that the grief over Richard's death was eating away at her. So much of her life had been defined by their relationship, and she plunged into a deep depression. She gained the weight back and she

started drinking again. Hamilton took her to her chalet in Gstaad, where she had spent so much time with Richard, to try to help her heal. "She was holding on to myths that were deeply ingrained in her soul and memories from Richard's haze of drinking. . . . I think she wanted to revisit it and see how real it was. It was simple enough to do and it was fun. She laughed and cried."

But the cathartic experience was not enough. She decided to try Hazelden, an addiction treatment center in Minnesota, and according to someone who worked for her at the time, she refused to do the work required in the program, and she was asked to leave. One of Elizabeth's assistants called Betty Ford out of desperation and Ford arranged for a second trip to her center. The second visit did not work either.

Elizabeth spent the rest of her life dealing with the mental toll that comes with chronic pain and addiction. And being as smart as she was, she knew what people thought of her.

In a handwritten note regarding hip surgery in the early 1990s, she detailed her anxiety: "The next three weeks of waiting are going to be very hard on me. I shall try to make it easy on those who love me, and not let them suffer, and they will if they know how deep my terror is. So it's up to me. God grant me the

courage to be unselfish . . . the doctors must *also* understand that when the medication is *needed* I'm just an ordinary suffering human being. And when the time is ready, I will clean up my act again. And with God's help, and the help of all the love around me, I will have no fear. . . . My fear of the actual operation washes over me in ice cold waves. *Please* don't let me hang around the hospital too long before knocking me out. Please try to understand my fear of pain. I've had so much—so many operations. And this one I remember is the very worst. I wish to God I hadn't had it before so I didn't know so much about that particular pain. It's like trying to be calm about being locked up with a rabid wolf."

In a separate letter to her doctor she wrote: "How long will the mind blowing, wanting to die, kind of pain last? How long will the excruciating pain last? Are they aware of my pain tolerance? They must promise me, not to treat me as a chemically dependent person because of my addictions. I will go back to the center when the pain is all over—but not *until* it's all over. I will never be an addict again! But I will not live with unbearable pain, and I believe God understands that."

Elizabeth may have never conquered addiction, but she tried to and she fought for her health during key

moments in her life. Sometimes, she could not climb out of the hole she found herself in, but for the rest of her life her rock-bottom experiences gave her access to the kind of compassion and empathy she would feel for those who were suffering from physical and emotional pain.

Chapter 16
Building an Empire

These have always brought me luck.

—Elizabeth, White Diamonds commercial

After Elizabeth and Victor Luna went their separate ways, she began spending more time with the forever-tanned actor and man-about-town George Hamilton. Together they spent days suntanning by her pool. Friends said that she was happy and relaxed around Hamilton, who accompanied her on a vacation to the Costa del Sol in Spain, where they stayed at the exclusive Marbella Club. They were having a late dinner, at 10:30 p.m., with Sean Connery, who had been waiting patiently.

"A hairdresser arrives and he decides that he's going to build an empire in Elizabeth's hair for the evening," Hamilton said. "She's told that Sean is about to leave

and she says, 'I didn't ask him to come, he can go when he wants to. We're attending to my hair.'" In her mind, she was never really late because the party did not start until she arrived.

Elizabeth treated her hair stylists, especially her beloved friend José Eber, like family. She had survived near-death experiences and seven marriages, and she would not be rushed for anyone.

She went to dinner with Hamilton, and even though Connery was long gone, the table was full of other friends. At around 1:00 a.m., a dinner guest told Elizabeth that photographers got shots of her sunbathing in the nude.

Silence descended on the festivities. Elizabeth started quizzing everyone at the hotel and finally learned the name of a photographer who was seen nearby that day with a telephoto lens on his camera. She wanted him brought to her immediately.

"A lot of guys, gangster-type guys went to work, and at five o'clock in the morning they find the photographer," Hamilton said laughing. "They bring him from his home to the hotel, and the guy is shaking, and Elizabeth is seething over this, and we've been up all night."

She asked to see the photos, and the man is pale and obviously fearful that he is going to be beaten up. He

handed them to her, and she started looking through the negatives. A smile slowly crept across her lips.

"Hey," she said, "my tits look pretty good."

She turned to the photographer. "I've never made a deal with the press and I'm not about to now. *Print 'em.*" She handed him the negatives and he ran out of the room as quickly as he could.

Lionel Richie loved that the real Elizabeth was so much more approachable than the star he had grown up watching in films. "When I first met her she said, 'Let's have movies at your place, Lionel. I got home and panicked because I kept thinking, *What does Elizabeth Taylor eat?* We've got to get caviar, I'm thinking about all the froufrou of the froufrou. So finally I call her and ask, 'Elizabeth, please, tell me what you eat?' She said, 'Lionel, here's all you have to do. There's a place called Maurice's Snack 'n Chat on Pico [Boulevard], call Maurice and tell her I want my usual and she'll deliver it to the house, I said thank you and called Maurice."

Her usual was fried chicken, greens, candied yams, macaroni and cheese, and cornbread. "And it was at that moment I realized who she really was. I also realized why she was so popular. Because everything you expected was the opposite. Her personality was

so down to earth it was as if I had known her all of my life."

That evening Elizabeth's limousine arrived two hours late. Richie was a nervous wreck, pacing the floors of his house. George Hamilton came to the door in a jacket and an ascot, "coiffed beyond coiffed," and Elizabeth came wearing a Fila tracksuit with a turban on her head and tennis shoes.

She said, "We stopped by a Seven-Eleven to pick up some quick picks to see if we could win."

Richie looked to Hamilton for some kind of confirmation, and he just rolled his eyes as if to say, "That's my date."

"I dropped my guard from that point on, because I realized the only person in the room who was trying to be pompous was me. She was in the kitchen, it was just like your aunt came by. From that point on I was forever hooked on this beautiful lady. If you're big enough, you don't have to pretend."

Elizabeth was reclaiming a solo identity. She was still taking pain medicine and sleeping pills, but she was drinking less, sometimes not at all, and there were times when she was in complete control of her life. She had lost weight (though it remained a constant battle), and she took to wearing slim-fitting jeans with her jet-black hair teased high and her makeup done meticulously. She

did her own makeup and spent extra time on her eyes, blending different colors together with painterly expertise, and often taking at least an hour. She always applied her makeup before she took a bath and got dressed. When she was running late and she was in the bath, her assistant would breathe a sigh of relief because it meant that she was almost ready.

Makeup was part of her identity. She wrote this note to herself: "The studios wanted me to change my thick eyebrows into Joan Crawford lines and a Joan Crawford square mouth which was fashionable then. My father and I rebelled and my dad told the executives, 'This is the way God made her and this is the way she is going to stay.' When I got older and started experimenting with wearing makeup I followed the natural contours of my face. Later I started experimenting with shading and shadows. I've always been grateful to my dad."

In the late 1980s and early '90s she was enjoying her life. Besides Hamilton, she dated a wide range of men, including the Pulitzer Prize–winning journalist Carl Bernstein. She wanted to keep their relationship private, and some of her friends never even met Bernstein. He dated other celebrities, including Bianca Jagger, but what they had in the mid-1980s was more than a fling. He told Elizabeth that she had helped him discover who he was. According to Tim Mendelson,

Elizabeth ended it when she found out that he had told people about their relationship, which was meant to be kept a secret.

She never stopped looking for love. The director David Lynch described the first time he met Elizabeth, at the Academy Awards in 1987, where she was presenting the award for Best Director. He was nominated for *Blue Velvet*, but Oliver Stone took the award home for *Platoon*. At superagent Swifty Lazar's famous after-party at Spago, Lynch was summoned to John Huston's back-room table, where Huston was sitting with Elizabeth.

I looked at Elizabeth Taylor and I just almost melted to the floor because of her beauty. And I looked at her and she said, "I love *Blue Velvet*." And this just about killed me. And I told her, "I was so upset that Oliver Stone won because he got to kiss you." And she lifted up her hand and wiggled her finger for me to come to her.

And I went over to her and I stood and she sat and she tilted her head back and indicated her lips. I slowly bent down, all the while going closer and closer to her lips but mesmerized by these violet eyes, and I got closer and closer and pretty soon my lips were touching hers. And they were sinking

deeper and deeper and deeper into these pillow lips. . . . I saw those eyes close as we kissed and then mine closed and we went into a dream and I'll never forget it.

They kissed three more times over the years, he said, and one evening during the Cannes Film Festival she called his hotel room at night and asked if he was married. He told her that he was dating someone at the time.

"It was a friendship," Lynch said. "She liked to test the waters and see what was available and if it could go further or not." What she really enjoyed was the cat-and-mouse game, and she never stopped believing that she could have any man she wanted—no matter her age.

She could be impervious to what was happening around her. Elizabeth's agent, Marion Rosenberg, recalled a dinner that Roddy McDowall threw in honor of legendary movie star Bette Davis's birthday in the mid-80s. Davis had once been considered for the role of Martha in *Who's Afraid of Virginia Woolf?* Elizabeth, as usual, was an hour late, and Davis was furious.

"I'm leaving," she told Rosenberg.

"Bette, you can't. Don't take any notice of Elizabeth. It's not out of any disrespect for you."

"Of course it is," Davis said. Davis sat at the table

brooding; she refused any food and drank only black coffee. They could not start dinner without Elizabeth, and she had absolutely no idea about the drama she had caused. Once Elizabeth showed up, she had a wonderful time.

José Eber recalled when Davis sought him out at the end of another dinner party and seethed, "*She* attacked me."

"Who?" he asked.

"*Elizabeth*," she replied.

"What do you mean?"

Davis was horrified that Elizabeth and Pia Zadora were trying on each other's enormous diamond rings as they sat across from each other at the table.

Davis told them they were being "vulgar."

Elizabeth snapped, "*Oh, get over it, Bette.*" If anyone was a match for Bette Davis, it was Elizabeth. To Eber it represented what he loved about Elizabeth, her total lack of snobbery and her joy. "She didn't have an ounce of prejudice in her whole being," said her friend Carole Bayer Sager. "You could go to a party at Elizabeth's where Nancy Reagan was sitting next to Elizabeth's manicurist who was sitting next to John Forsythe who was sitting next to José Eber." After all, this was a woman who, when a friend asked her if she had any recommendations for places to stay in Yugo-

slavia, replied, "I don't know because when I was there I stayed with Tito." Josip Broz Tito was president of Yugoslavia from 1953 to 1980.

While Elizabeth was performing in *The Little Foxes* in the early 1980s, Jeffrey Katzenberg was at Paramount Studios, and he wanted Elizabeth to star in *Terms of Endearment* with Debra Winger. He called her agent to offer her the role, but Katzenberg said that he wanted to meet Elizabeth in person first.

"This was a very delicate situation because Elizabeth was what we call in the business 'offer only,' which means she's not going to read something unless there's an offer on the table," said Rosenberg. Katzenberg knew she could handle the role, but he wanted to see what she looked like since she had not appeared in any films in so long.

But Rosenberg's boss, who had ultimate authority, refused to even let her mention it to Elizabeth.

"Of course they gave it to Shirley MacLaine," Rosenberg said. MacLaine won an Oscar for the role. "It broke my heart. Elizabeth never knew anything about that."

Elizabeth knew that she was not going to get another role like Martha in *Who's Afraid of Virginia Woolf?* Hollywood's deeply ingrained ageism and sexism made that impossible. "My career went away," she told a friend. "They're not looking for the same

thing anymore." And she was not interested in being a character actress; she did not want to age gracefully as an actress.

She occasionally worked for fun. In a 1992 episode of *The Simpsons*, she voiced the first word ever uttered by baby Maggie: "Daddy." Usually, before recording, the room was almost empty, but this time the entire cast and crew were gathered at the recording stage to see her. She came in holding her beloved white Maltese, Sugar, and wearing the Krupp. "I did about thirty takes, even though we probably didn't need that many," said *Simpsons* writer Al Jean. When Jean said, "That's enough," she replied, in Maggie's voice, kidding, "Fuck you!" The entire room broke into hysterical laughter.

"What I remember vividly was, as she was leaving, she walked up to David Silverman, our animation director, and said, 'Where have these beautiful eyes been hiding all day?' He was thrilled."

At times she felt like she did not belong. And she had an incredible ability to spot other people who felt like outsiders or who were struggling. She could tell that Lesley-Anne Down, her costar in *A Little Night Music*, was one of those people. Down was locked in a contentious high-profile custody battle with *Exorcist* director William Friedkin.

Elizabeth met Down in Vienna during two weeks of rehearsals for *A Little Night Music*. "It was pretty evident straight away that I couldn't sing and that I would have to be dubbed, and Elizabeth, to her credit, plowed forward," Down said. "She really couldn't sing either." They were in the rehearsal hall, and Down was so obviously nervous that Elizabeth handed her a glass of orange juice that was heavily laced with vodka and said, "Here, have a sip."

"She was my favorite person from that moment onward," Down said. Elizabeth once gave her the 33.19-carat Krupp diamond to wear all night at a dinner. When Down went to the restroom the ring fell down the toilet. She reached down and retrieved it. "I've never told anybody that before!" she said, horrified at what might have happened.

Years later, Down needed a place to go to get away from the media attention surrounding her divorce. When she told Elizabeth what she was going through, and how worried she was that she might lose custody of her two-and-a-half-year-old son, Elizabeth did not hesitate. "You're coming to me," she said. "You can stay as long as you want." Down stayed for three weeks and brought along her son, her boyfriend, and her mother.

When Down had to have a meeting with celebrity divorce attorney Marvin Mitchelson, Elizabeth suggested

that he come to the house instead of her being hounded by the paparazzi in public. "She was exceptionally good and kind. She absolutely knew what I was going through and she was on my side."

Elizabeth loved taking care of other people, and she wanted to indulge in life's real pleasures: her family, her animals—including Sugar, who she took with her everywhere. She also loved Alvin the parrot, who Chris Wilding called his mother's "principal sidekick" for a time, and who during the 1980s could often be found perched on her shoulder. Elizabeth's friend Bradley Anderson remembered just how eloquent Alvin was. "For example, it could do a Richard Burton impression. You'd be sitting talking to Elizabeth in her bedroom and it's Richard's booming voice coming out of the parrot: 'Elizabeth.'"

Elizabeth's friend Carol Burnett remembered a studio executive coming to visit the set when they were shooting a film together. Elizabeth, Burnett, and the executive were sitting in Elizabeth's hotel suite when Elizabeth let Alvin out of his cage, and he flew around the room excitedly. Alvin eventually landed on the executive's shoulder. "He didn't want to say anything, and we're just sitting there talking," Burnett recalled, laughing at the memory. "Then the parrot started pick-

ing on his glasses and the glasses kind of got crooked on his face, eventually they were half off his face. And the parrot is picking at it, and he didn't want to upset Elizabeth I guess so he let this parrot do what it wanted. And I'm looking at Elizabeth and she's looking at me and we are about to die. We were trying so hard not to laugh, as if this bird wasn't eating this man's glasses right off his face. She had a wicked sense of humor."

Elizabeth's larger-than-life lifestyle cost money, and Chen Sam recognized that Elizabeth had a cash-flow problem. Even though she had one of the world's most valuable jewelry and art collections, she lived very extravagantly. Elizabeth always understood her value and she recognized that she was a brand from a young age. But it was Sam who pushed her to look at creating a fragrance and arranged for Elizabeth to meet with beauty executives to make that happen. It was Elizabeth, though, who created her celebrity perfume empire, and it was Elizabeth who understood that she could capitalize on her name in an unprecedented way.

No movie star had done one successfully since Zsa Zsa Gabor's Zig Zag, but Sam knew that women everywhere wanted to look, and smell, like Elizabeth. Coco Chanel, who was famous for the iconic fragrance Chanel No. 5, had once insisted that she do one when they met

at a dinner party in Paris. Chanel said, "Elizabeth, movies are not forever. Perfume is forever. Promise me you're going to make a perfume."

In 1987, Elizabeth released Passion, which became a hugely popular fragrance. Elizabeth wanted to be involved in every aspect of its creation, from the scent itself, referred to as "the juice" in the industry, to the packaging, to the marketing. She was the first major celebrity to truly harness the power of her own brand in such a way—and she was a perfectionist when it came to anything she put her name on. Elizabeth Arden executives spent more than a year trying to get Elizabeth to do a follow-up fragrance after the success of Passion. But she saw Passion as a signature scent and did not think a second perfume was necessary.

Carlos Benaim, a master perfumer who helped create Polo by Ralph Lauren, visited Elizabeth in Bel Air to help convince her otherwise. He placed ten numbered bottles on a table and asked her to pick the three fragrances she liked best. She chose strong scents like tuberose and jasmine. She said that she liked the scent of the narcissus flower best and he promised her that they could create a perfume that she would love. White Diamonds, which would become one of the most successful fragrances of all time, with more than $1.5 billion in sales, was born.

Once she approved the perfume she needed to approve the marketing plans, and she had a firm hand in them. The glamorous and cinematic black-and-white commercial for White Diamonds was shot in Acapulco, and it begins with a private plane landing on a beach and swarms of photographers rushing to take pictures of Elizabeth. Images of chiseled men playing a card game flash on the screen. In an off-the-shoulder white gown, Elizabeth walks over to them and says, "Not so fast," as she takes off one of her enormous diamond drop earrings and throws it on a stack of money sitting on the table. "These have always brought me luck." Her perfume line was so successful that it made her more money than her movies by far, and White Diamonds is still on the list of the top ten celebrity perfumes.

"The company was not expecting anything like this," said Peter England, who was the president of Elizabeth Arden from 1995 until 2000. "They were expecting fifteen to twenty million net sales. We were doing one hundred million net sales and she was getting fifteen percent. She was getting fifteen million every year. There's been no other fragrance like it."

But her success did not come easy. When there is that much money at stake there will always be complications. Elizabeth had to go to court with her ex-boyfriend, Henry Wynberg. He claimed that she

breached a contract they signed in 1977, a decade before Passion was released, to share 30 percent of the net profits from cosmetics marketed in her name. Given Passion's success, that would be more than $70 million.

They both played dirty: Elizabeth had been granted approval by the court to tell jurors about a statutory rape conviction against Wynberg, and Wynberg was threatening to reveal the extent of Elizabeth's drinking and prescription drug abuse. But Elizabeth refused to be bullied. "I am taking this to trial," she told one of her lawyers. "There is no way that I'm going to settle this."

After four years, they finally reached an out-of-court settlement and, according to another one of Elizabeth's lawyers, Neil Papiano, no money was involved.

Once the deal was reached Elizabeth said, "It means I'm vindicated and it proves the perfume, Passion, is something I worked for a year and a half for. . . . It has nothing to do with Henry Wynberg."

The legal victory came shortly after she almost died in 1990, when she was fifty-eight. She was hospitalized with pneumonia at St. John's Hospital in Santa Monica. She was placed on a ventilator and put in the intensive care unit. Infectious disease specialist Dr. David Ho consulted on the case and said that it was diffuse pneumonia of both lungs. "This was very real," he said.

"She was near death." She recovered miraculously and did what she always did: she got on with the business of *being Elizabeth Taylor.* That included calling out the *National Enquirer* for publishing an erroneous story that claimed that she was drinking in the hospital and had a disease that was disfiguring her face. This time the tabloid had gone way too far with their front-page story: "LIZ DOCS FURIOUS. SHE'S BOOZING IT UP IN THE HOSPITAL." Her lawyers cited another story with the headline: "LIZ'S BEAUTIFUL FACE RAVAGED BY KILLER DISEASE. DOCTORS ORDER SUICIDE WATCH AFTER THEY FINALLY DIAGNOSE THE MYSTERY ILLNESS." She filed a $20 million libel suit in 1990, which was settled a year later. She won an apology and an undisclosed sum of money after her medical records were made available to the *Enquirer,* proving the story was false. "The *Enquirer* gained access to all of Miss Taylor's medical records and is now satisfied that the articles reporting on her medical condition and the report that she was drinking were in error," said Chen Sam. Neil Papiano said, "Miss Taylor is very delighted with it, and small things do not make her happy."

When a friend asked her how she decided which stories were worth suing over, she replied, "When you've got them by the short and curlies."

After that victory, she faced another setback, but she was ready for it. Because she had been through so much in her life she understood that not every fragrance was going to be like Passion and White Diamonds. She released Black Pearls in 1996, and it was not doing well, but she was not about to give up.

Herb Ritts shot the black-and-white commercial. Elizabeth was submerged in a pool, and her hair was slicked back and she was supposed to say seductively, "Black pearls, they're rare, they're this, they're that." Her makeup was perfect and the lighting was perfect and she's standing in the water. Everyone is waiting for the big moment, and Elizabeth says, "Black pearls, they're a fucking pain in the ass." Herb Ritts looked unhappy. But Elizabeth thought it was hysterical.

One of Elizabeth's last on-camera performances was in 1996, when she made cameos in four back-to-back primetime CBS television shows to promote Black Pearls. The premise was that in each show she was searching for her lost black pearl necklace. Then in the early 2000s, Elizabeth wanted to do a fragrance called Gardenia. She told Elizabeth Arden executive Tamara Steele, who she had worked with closely for years, that she loved the fragrance because she used to wear it in Puerto Vallarta when she was married to Richard. But she rejected every fragrance that Steele brought

her that was supposed to smell like gardenias. Finally, Elizabeth asked someone to go into her garden and pick a gardenia. She held it up to Steele's nose.

"*This* is gardenia," she said. Elizabeth put the flower in a Ziploc bag and told Steele: "Take that to your lab and don't come back until you bring me something that smells exactly like it."

Creating a fragrance is a combination of art and science. There is a difference between the fragrance from a fresh flower and a cut flower. Steele decided that the only way to make Elizabeth happy would be if they captured the exact scent of a gardenia from her garden. So they used cutting edge technology and put a globe around a gardenia in Elizabeth's garden and inserted a needle coated with wax into the flower so that the wax could absorb the molecules floating in the air around it. This device could identify the name of the scent components around the flower and how much of each scent was present. Ultimately, Gardenia did not sell anywhere near as well as White Diamonds or Passion, but it was a labor of love.

She knew almost as much about fragrances as she did about jewelry. Said Steele, "She would talk with a lot of knowledge and expertise and enthusiasm about frankincense and myrrh. She knew a lot about ingredients, she knew what she liked. She felt that if people

were buying her fragrance she wanted to be able to say it was something she wore herself and that she could be proud of." She wore her own fragrances so much that she often called Steele for refills.

When they were creating the scent Forever Elizabeth, which was released in 2002, she wanted the packaging to be the exact same color as the Van Cleef & Arpels oval-cut 8.9-carat ruby ring that Richard had stuffed in her stocking one Christmas. Like all her most loved jewelry, the ring was important to her because of the memory of the day when Richard had surprised her with "the most exquisite ruby anyone had ever seen." Richard had spent four years looking for it.

Elizabeth was an early and enthusiastic Twitter user. In 2009 she asked her followers to help her name a new fragrance. She preferred the name Follow Me, but Violet Eyes won, as she put it, "hands down." Two decades after White Diamonds, Violet Eyes was released.

Malls were packed when she went on tour to promote her perfumes. During one stop at a department store in Chicago, there was a bomb scare and everybody took off, except for Elizabeth and Sugar and her security guard, Moshe Alon. She was gutsy; she was not going to let anything stop her.

When Elizabeth went on fragrance tours, she had an advance team travel to whatever city she was visit-

ing ahead of time to scout the best suites in the best hotels. It was almost like preparing for a presidential visit. When they booked her a suite they used the name "Mrs. Norman Maine," the name of Judy Garland's character in *A Star Is Born.*

But all the while, Elizabeth was hiding a life-altering secret. During every single perfume tour, no matter how she was feeling, Elizabeth went somewhere alone, and this time no members of the press were invited. These visits, when no one was watching, redefined her life.

ACT V
True Grit

The 1980s and 1990s

To thine own self be true.

—William Shakespeare, *Hamlet*

Chapter 17
"Bitch, Do Something!"

The most awful thing of all is to be numb.

—Elizabeth

At around 4:00 p.m. on a Friday in 1998, Elizabeth was dressed in her nightgown, applying makeup and showing her friend Dorothy Flagler, a salesperson at Van Cleef & Arpels in Beverly Hills, a magnificent new yellow diamond ring. Flagler sat cross-legged on the floor of Elizabeth's bathroom as they chatted away.

But when Tim Mendelson walked in and told Elizabeth that a friend of a friend had passed away from AIDS that day, the mood in the room changed dramatically.

"He really doesn't have anyone and he has no money," Mendelson told her. There was no money even to bury him.

Elizabeth told Mendelson to get her business manager on the phone, because she wanted to arrange for his burial. Mendelson called his office and was told that it would have to wait until Monday. When he relayed the message to Elizabeth, she threw the brush she was using down on the bathroom counter and her eyes went wild.

"We will *not* fucking wait until Monday. We will do it *right now.* Get him on the phone again. I want to talk to him. No mother's son is going to lay on a cold, hard slab for the weekend when I can do something to stop it."

When Mendelson handed her the phone she lit into her business manager and screamed: "*I don't care what time it is! Get that money over to the funeral home. Now.*" She was just as furious as she had been in 1985, thirteen years earlier, when she became the most high-profile and most dedicated celebrity to shine a spotlight on a virus that was ravaging the gay community and further isolating people who were already ostracized by society.

At first, AIDS confounded the medical community. In the early 1980s, it was called Gay-Related Immunodeficiency Disease (GRID). On July 3, 1981, the *New York Times* published an article, "RARE CANCER SEEN IN 41 HOMOSEXUALS." By the end of 1981,

337 cases of the lethal disease thought to be a rare cancer called Kaposi's sarcoma were diagnosed. In 1982, the U.S. Centers for Disease Control and Prevention (CDC) referred to the virus for the first time as Acquired Immune Deficiency Syndrome, or AIDS. In NBC *Nightly News*'s first report on AIDS in June 1982, the correspondent said, "The best guess is some infectious agent is causing it." In 1984, 130,400 new HIV infections were reported globally. That same year, Dr. Luc Montagnier of France's Pasteur Institute and Dr. Robert Gallo of the National Institutes of Health independently identified the retrovirus that is the cause of AIDS. It was officially named Human Immunodeficiency Virus, or HIV, in 1986, and it could lead to AIDS if left untreated.

At first, no one knew how it was transmitted. The July 1985 cover of *Life* declared: NOW NO ONE IS SAFE FROM AIDS. Once it was shown to be a sexually transmitted disease, the fear and stigma worsened. In 1987, U.S. Surgeon General C. Everett Koop called for the use of condoms and sex education to prevent the spread of the virus, which cripples the body's immune system. By the end of the year, forty thousand Americans had died from AIDS. President Ronald Reagan proudly pointed to the $416 million of federal spending in 1987 on HIV and AIDS research and education, but he had

only requested $213 million in the federal budget. Congress had doubled it.

In 1988, Koop sent a pamphlet, "Understanding AIDS," to 107 million households, the largest mass mailing in the history of the country. He did not submit it for review, knowing that the Reagan administration would have changed the wording and softened the message, which was explicit. Koop used specific language in the report and stated that HIV is transmitted through "semen and vaginal fluids" and during "oral, anal, and vaginal intercourse."

Koop knew that inside Reagan's cabinet there was dissent, with some voices calling for mandatory testing for hospital patients, immigrants, couples getting married, and prison inmates. Almost at the exact time that HIV cases first began to emerge in Los Angeles and New York, the LGBTQ civil rights struggle faced a reactionary backlash led by figures like Anita Bryant and Jerry Falwell Sr., whose "Moral Majority" fought against giving rights to gay people.

Homophobia was rampant, and AIDS was known as the "gay plague." On March 22, 1980, evangelical Christian leaders delivered a petition to President Jimmy Carter demanding a halt to gay rights. "God's judgment is going to fall on America as on other so-

cieties that allowed homosexuality to become a protected way of life," Bob Jones III said. In 1982, when AIDS had already claimed the lives of 853 people in the United States, Reagan's press secretary, Larry Speakes, laughed when he was asked whether the president was tracking the spread of AIDS.

The virus devastated the entertainment community and Elizabeth watched many of her friends die. In 1989, Studio 54 co-owner Steve Rubell, dancer and choreographer Alvin Ailey, and photographer Robert Mapplethorpe all passed away from the disease. A May 28, 1985, *Los Angeles Times* editorial asked: "WHAT TO DO ABOUT AIDS?" It went on to report: "People who contract acquired immune-deficiency syndrome know that they have a terminal illness. About 80 percent of all patients with AIDS have died within two years of diagnosis. . . . Many people with AIDS lose their jobs and friends, and some are thrown out of their homes by frightened landlords."

The disease spread to hemophiliacs and injection drug users as well. By 1988, 61,816 people had died of AIDS in the United States, and by 1995, AIDS was the leading killer of American men aged twenty-five to forty-four. As of 2017, AIDS had killed an estimated 35 million worldwide, according to UNAIDS.

There was no blood test until 1985 and no treatment until 1987. And what treatments there were, including an antiretroviral medication commonly called AZT, which was the first anti-HIV drug ever approved by the Food and Drug Administration, wreaked havoc on the body. It was the most expensive drug in U.S. history and cost ten thousand dollars a year, which made it unaffordable for most patients.

Bill Misenhimer was the director of AIDS Project Los Angeles (APLA), a nonprofit providing health care and counseling for AIDS patients. In the early days of the pandemic, he said, "They needed a very strong support system because they're outcasts. . . . Unlike most terminally ill people, who tend to be old, people with AIDS tend to be young, a group unused to death and dying."

Misenhimer knew that Elizabeth would be able to raise an enormous amount of money. He met with Chen Sam and asked if Elizabeth would agree to chair a fundraising dinner called Commitment to Life, to benefit AIDS Project Los Angeles. Elizabeth was constantly being asked to help raise money and draw attention to different causes, and she wanted to make sure that everything she did had a clear purpose. One of her staff members at the time said that Misenhimer was incredibly persistent. "He was like a dog with a bone,"

the person said. "He would not go away. He called, he wrote, he turned up at the gate. He was determined." In the end, Misenhimer said, he had to present a note from the philanthropist Wallis Annenberg, who was working with APLA, to prove to Elizabeth that they were a legitimate organization committed to helping AIDS patients. Elizabeth was always acutely aware of the value of her physical presence and she knew that she could do things that, at the time, nobody else was capable of doing.

Once Chen and Misenhimer and others told Elizabeth about the ravages of the disease, and once she was convinced that APLA was an honest organization in need of her help, she was on board completely. Elizabeth and Sam worked tirelessly to recruit members of the entertainment community to participate and support the event. They spent nine months and worked the phones day and night. Eventually they put together a star-studded Honorary Benefit Committee with over one thousand people. After Elizabeth got involved, the dinner had to be moved to the ballroom at the Westin Bonaventure because the ballroom APLA had originally booked at the Century Plaza Hotel was too small.

The dinner was the first major celebrity fundraiser in the world for AIDS. The producer of the event,

Gary Pudney, recalled his first meeting with Elizabeth. "When we had the show formulated, there came the moment when it had to be presented to the boss. The show was laid out on cards, so I went to Elizabeth's, armed with my easel. It's hot as hell and I'm standing there by the pool—in my suit and tie—waiting for Herself to appear. When she finally did," he said, "she was wearing a very revealing red bikini and a very large diamond.

"Her body was spectacular. She proceeded to recline on a chaise longue, and at that point I really begin to sweat—because it's a little disconcerting to make a presentation to a major screen goddess in a reclining position. I began to explain the show, and she said, 'Just start flipping the cards.' She wanted to get right down to business. And she was fantastic in her grasp of what we were doing: the show's pacing, her critique of the musical numbers, the speeches. No dummy she. But the interesting thing was she never talked about what she'd be doing or where she'd be in the show. She was more concerned with overall effect."

Actor Bruce Vilanch was a writer for the event and said that Elizabeth made one major request: "Please no Joan Rivers. Enough already with the fat jokes." There were plenty to choose from—Rivers had accumulated more than 850 jokes in her meticulous files written ex-

clusively about Elizabeth, most of which were cruel and designed to wound.

Elizabeth fired the first and most audible shot in the long ongoing war to eradicate AIDS when she hosted the dinner and raised $1.3 million for APLA on September 19, 1985. It was an uphill battle at first but eventually more than 2,500 people, including Shirley MacLaine, Sammy Davis Jr., and Carol Burnett, showed up. There were also AIDS patients at the dinner, who could be easily identified because their tuxedos hung loosely on their bodies.

"She was very, very sweet," Burnett said. "She cared for people. Yes she was rich, yes she was beautiful, yes she was famous. But it did not go to her head."

The conservative author and longtime friend of Ronald Reagan's William F. Buckley Jr. wrote an op-ed in the *New York Times* suggesting that people with AIDS be tattooed to "identify all the carriers." Buckley said that Elizabeth was not a hero but a living example of "self-indulgence." But Elizabeth could not care less what Buckley thought of her. In 1987 she gave a speech at the National Press Club in Washington, D.C., and reflected on what made her become an activist.

"I became so incensed and personally frustrated at the rejection I was receiving by just trying to get

people's attention. I was made so aware of the silence, this huge, loud silence regarding AIDS, how no one wanted to talk about it and no one wanted to become involved. Certainly no one wanted to give money or support and it so angered me that I finally thought to myself, *Bitch, do something yourself.* Instead of sitting there getting angry. Do something." When she was lying on the operating table at the London Clinic in 1961 and she saw Mike Todd, he told her that she had work to do on earth—and this was it. She had to fight when so few people were willing to.

The event was electric. Eight hundred people who never got a ticket were on the waiting list. Ticket prices ran $250 to $500 a person. In his remarks, Misenhimer forgot to thank Chen Sam for her work to make it happen and his heart sank when he realized it. "The next day, Elizabeth let me have it—in no uncertain terms. She was livid, and rightfully so. I was so sorry and had already apologized to Chen. The best I could do was to take out an ad in *Variety* thanking Chen for her work." That seemed to appease Elizabeth.

There were no effective treatments in the early and mid-1980s, so APLA used the money from the dinner to focus on patient care. They arranged to have patients' dogs walked, they provided at-home haircuts,

and they located dentists who would treat patients. At the time, many medical professionals refused to treat people with AIDS.

In the early days, Elizabeth sent fifty thousand dollars to San Francisco-based Project Inform to help get experimental drugs (which were illegal). And she let friends and friends of friends who were sick stay at her Bel Air mansion. She visited hospices and asked caretakers what they needed. Most of the time they would say the patients just needed someone to touch them. She decided to do unpublicized hospice visits so that she could hug patients and talk with them and make them feel human again. She wanted them to know that they were loved. She did not need any publicity, and she did not want the distraction of the press. She wanted to respect patients' privacy and connect individually with each of them. "She gave the best hugs," Tim Mendelson recalled.

Her love and support was necessary during the early dark days of the pandemic. Misenhimer said that at APLA he and his colleagues would do interviews outside their office because television reporters were too afraid to come inside. AIDS patients would sometimes be discharged from the hospital to APLA because they had nowhere else to go. Misenhimer and his staff would put them up in a hotel nearby.

"I do know that she comforted me in tears often," Misenhimer said of his friendship with Elizabeth. "We would hug each other. She was so passionate and so compassionate. I've never been starstruck. I respected the legend of Elizabeth Taylor, but I loved the woman."

In the early days it was a lonely battle. Studio heads who she had made lots of money for hung up on her. Worst of all, her friend and former lover Frank Sinatra turned her down when she first asked for his help. Michael Jackson was also hesitant. So many people made excuses not to help that it shocked her. These were artists, she said, who knew gay choreographers, dancers, musicians, directors, singers, and actors, but they had turned away from them. Some of her friends and advisers told her to stay away from HIV and AIDS because it could end her career.

"Who gives a goddamn about careers," she told them, "when the people, without whom we wouldn't have a career, are dying? People are suffering! We've got to help them, we can't stand by."

Elizabeth must have been thinking of Monty, Jimmy, and Rock. "If it weren't for homosexuals there would be no culture," she said. "The idea that God should choose his children [to suffer]—his geniuses to whom he had given the talent to make it a different,

more beautiful place for us mere mortals—made me so angry."

Barry Manilow remembered Elizabeth's reaction when she called asking him to come to another AIDS fundraiser in the 1980s. "She called me sounding very frustrated and saying that she had called a whole bunch of performers and they had all turned her down. And she said, 'Would you do this?' And I said, 'I have no band, I'm off the road, but yeah, I'll come and I'll just sit at the piano and I'll sing.' And she started to cry because I was the only who said yes." As Manilow recalled, suddenly half the people in his phone book were dead. It did not take any time to make up his mind.

She invited Manilow and his partner, Garry Kief, for Thanksgiving dinner at her house in Bel Air one year. "These days being gay and having a partner is no big deal, but back, even in the nineties, it really wasn't the thing to do. And she invited Garry and me, not just me but *Gary and me*, because she knew that we were a couple. Garry and I have been together over forty years; she knew that we were for real. It was just Elizabeth, her family, and Garry and me. That was the moment when she had become a real friend."

Even though the CDC had made it clear that the virus could not be transmitted through casual contact, such

as shaking hands, hugging, or even kissing, in the 1980s there was intense fear about touching someone with AIDS. Crosses were burned in front of AIDS patients' houses; postal workers refused to deliver mail to people with AIDS, fearful that any human contact could spread the virus; a government worker burned her dress after handling an application touched by a person with AIDS; people would not eat at restaurants if the waiter was gay; children with AIDS were being cast out of their communities. People living with HIV and AIDS were being denied jobs and life insurance, and they were completely alienated from their community. Ryan White, a thirteen-year-old hemophiliac who had AIDS because of a blood transfusion, became an important activist at the time. He drew attention to the casual cruelty and the stigma attached to the disease when he and his family went public with the fact that he was being denied entry into his Indiana school.

"Ryan said I know how the gay community is being treated because people are treating me the same way," said Ryan's mother, Jeanne White-Ginder. "And I don't like it."

Elizabeth hoped that by talking about sexuality the stigma surrounding being gay could one day be erased. She believed in equality. There was never any doubt in her mind that gay couples should be able to

adopt. Trip Haenisch and his former partner Waldo Fernandez, who was Elizabeth's interior decorator, started the process of adoption in the 1980s and were finally successful in 1992. Haenisch said that he confided in Elizabeth that he was scared about how the world would treat a child with two fathers. "If this is what you want, you must do it," she told him. She asked if she could be the child's godmother, and she hosted their baby shower. When their son was ready for kindergarten, she wrote him a letter of recommendation and they were the first gay couple with a child in that school.

"When Waldo and Trip adopted their baby it was one of the very first times two gay people had adopted, and that was Elizabeth fighting for them," said floral designer and perfumer Eric Buterbaugh. "It was a lot bigger than AIDS. To me when that happened it was so early that I couldn't imagine that ever happening."

While she was planning the Commitment to Life dinner, Elizabeth learned that one of her best friends in the world, Rock Hudson, had AIDS. Publicly she said that she found out when the world did, on July 25, 1985, two months before the September dinner. But in reality, she'd learned weeks before. "I thought Rock had cancer. Then one of his doctors called me

and said, 'Listen, I shouldn't be telling you this, but I know how much you love him, and I'm going to because I'm not sure how much longer [he has]. . . . Rock has AIDS.'"

Rock's announcement through a press release helped mobilize Hollywood into action because one of their own was sick. Elizabeth, an optimist, started to become cynical. *Why,* she thought, *do people care more now just because someone who's rich and famous has it?* "When I found out that the ban had been lifted because of Rock, everybody could hardly wait to come [to the dinner], to show that they were broad-minded," Elizabeth reflected later. Rock bought ten thousand dollars' worth of tickets, but he was too ill to attend and sent a telegram that was read aloud that evening. "I am not happy that I am sick," he wrote. "I am not happy that I have AIDS. But if that is helping others, I can, at least, know that my own misfortune has had some positive worth."

Elizabeth was the first friend to visit Rock in the hospital; many others were too afraid. When Rock's doctor, Michael Gottlieb, an immunologist who was the first person to identify AIDS as a new syndrome and report it to the CDC in 1981, first took Elizabeth to visit Rock in the hospital, he snuck her in through a back door. They went up a freight elevator because

the hospital authorities might not have allowed visitors. "We would visit Rock together sometimes and I would pick her up in my 77 Dodge Aspen station wagon. Elizabeth would be wearing her diamonds."

On July 25, 1985, Rock's publicist, Dale Olson, held a crowded press conference announcing the most famous person in the world to have AIDS, and it was viewed at the same time as an admission of his sexuality.

"Did you throw it to the dogs?" Rock asked his friend and business manager Mark Miller.

"Yes," Miller replied.

"God, what a way to end a life," Rock said in an almost-whisper.

Before he was sick, Elizabeth was a frequent visitor to his secluded Spanish-style mansion, the Castle. "We had no secrets from each other, *ever*," she told Barbara Walters. But when Walters pressed and asked her if he had ever told her that he was gay her answer reveals what Hollywood was like for gay actors at the time. "No, but he knew that I knew." She asked Moshe Alon, her head of security, to help take care of him. Alon remembered bringing Rock's trash to the dump daily so that reporters would not rifle through it.

First Lady Nancy Reagan knew Rock from her days as an actress. At a White House party in 1984, she was shocked at how thin he had become. She was

worried and she told him so. She sent photos of that night to the Castle, along with a note suggesting that he get a mole on his neck checked. He took her advice, and on June 5, 1984, the dermatologist who biopsied the mole told Rock that he had AIDS. A year later, the day before Rock went public with his diagnosis, Dale Olson pleaded in a telegram to the Reagans. Rock was in Paris seeking experimental treatments and there was only one hospital in the world, Olson argued, that could potentially save his life "or at least alleviate his illness." Olson asked the Reagans to make a phone call to get Rock admitted into this French hospital that had denied him entry. The Reagans would not help, and they turned their back on their old friend.

Rock kept the news secret for as long as he could, but it made his last acting job particularly heartbreaking. He played Linda Evans's lover on *Dynasty*, and he was devastated that they had to kiss. He worried that he could transmit the virus through his saliva. Studio executives had no idea about his health crisis, and they could not understand why he only wanted to do a brief peck on the lips instead of the passionate kiss the script called for. "In retrospect, it was incredibly touching how hard he tried to protect me," Evans said. "No matter how much the director and producers pressed, he refused to put me at risk.'"

Elizabeth could not stand to watch her friend in pain. When he returned to Los Angeles, she went to visit him at the Castle and found a strange group of Hollywood Christians, including Pat and Shirley Boone and *The Love Boat*'s Gavin MacLeod, praying at his bedside.

"Truly a sight to behold," said George Nader, an actor and friend of Rock's. "*Cleopatra* among the holy rollers."

No one appeared to be getting close to Rock. "Oh, for goodness sake!" Elizabeth yelled, and she jumped into bed with him and held him close, rocking his frail body gently.

They reminisced about the chocolate martinis they made on the set of *Giant*, but then he stopped remembering. Elizabeth watched helplessly as he got worse and worse, until he was reduced to skin and bones, and there was no medicine that could help him get any better.

Rock, Dr. Gottlieb said, was "not horribly distressed by the diagnosis, it wasn't emotional. He was aware that it was a very bad thing, he wanted people who had been his sex partners to know, so he dropped a bunch of unsigned notes into the mail. They said: 'You've been in contact with someone who has AIDS.' His intent was to tell them to go to their doctor and get checked."

"He's such a wonderful man," Elizabeth said. "He deserved happiness in his old age. Not this."

Gottlieb said that he was told by his bosses at UCLA, where he had been treating Rock, that he would be discharged. "Rock Hudson will die at home," they told him. "He will not be readmitted." They did not want to be known as an AIDS hospital.

And he did die at home on October 2, 1985. He was fifty-nine. Elizabeth sat on his bed and held him the night before he died. She said that he started remembering again. "It was like God had taken him into another room and he seemed very at peace, and his memory had sort of channeled itself into the past, and he could remember all kinds of things that tickled him and made him laugh, and we talked about making chocolate martinis and all the things that were fun and wild. . . . He didn't know that he was dying. God had taken that away from him. He didn't know."

Elizabeth planned a memorial service with Rock's favorite people.

She sent a red rose to each guest telling them to save the date and time for the service and letting them know that they would get the address for the memorial the morning of and not to share it. She did not want protesters coming and ruining it.

She wrote her remarks on lined yellow legal paper

in scrawling cursive: "We thought it would be nice if those of you who wanted to, could share some of your memories of Rock with us today so we can remember him as he was—not with pain and suffering but as he was—at some lovely, warm moment in time, particular to each one of us. My recollections are like a bright kaleidoscope jumbled. . . . And oh, his eyes, I can *see* his eyes. The way they scrunched up when he laughed, the way they reflected his inner light, reminding one of sparkling sunshine and sailboats. . . . He made me laugh until I cried but sometimes, when it was just the two of us, he would let me cry . . . he eventually would make me laugh again. . . . I know I will always be able to recall that memory, that feeling. I'm so grateful I knew him. I love you Rock. . . . It was one of Rock's last wishes that on this day, we not be sad. He wanted us to have margaritas and mariachis—so let's all do that. Let's go to the patio and toast him—me, with my Perrier, and you with your whatever you want. And let's celebrate our memories and our love and feel close to him."

A blood test became available to detect HIV antibodies in 1985. Before then, doctors who treated AIDS patients worried that they might be exposing themselves and their families to the virus. Dr. Deborah

Birx, a former U.S. ambassador-at-large responsible for PEPFAR (the President's Emergency Plan for AIDS Relief), launched by former president George W. Bush, was horrified by the effects of AIDS on the military when she worked as a doctor at Walter Reed National Military Medical Center in the 1980s. "These are very fit soldiers, these soldiers would be in the hospital having lost tens of pounds so that they had no muscle mass left. They were a shadow of their former selves. It wasn't just the sheer volume of patients, it was how destructive this virus was to their entire physical state." Often parents would not come to visit their sons because in their eyes an admission of an AIDS diagnosis was also a confession that they were gay. In some cases, that part was even more difficult for families to accept.

Dr. Gottlieb said that he never wore a full bodysuit, like other health-care professionals did, even at the earliest stages of the pandemic in 1981. He did not wear gloves when he took blood. He was convinced from a scientific viewpoint that this virus was not casually communicated. But there was still fear about the unknown. "We did breathe a sigh of relief when the test came out in 1985," he said. "My wife and I had a mono-like illness early in the AIDS epidemic. We

stayed home for two weeks, and the chairman of the immunology department dropped bread and milk off at our front door. It was scary. It was like you're about to collide with something on the freeway and you're sure you're going to die, and then you don't."

For Gottlieb, a young doctor in his thirties, Elizabeth was a maternal and supportive figure in his life. He was seeing people his own age wasting away, their immune systems wrecked, and there was nothing he could do to help them. "I remember my first five patients, including one young man from Oregon who went blind from viral retinitis. The first five are indelibly etched in my memory. . . . I was in a grocery store in the Valley a few years ago and somebody came up to me in line and said, 'I was Chuck's lover.' Chuck was patient number two."

In the summer of 1985, while working on the Commitment to Life dinner, Elizabeth thought about creating a national foundation to improve patients' lives and raise money for a cure. She met with Gottlieb, APLA's Misenhimer, and Chen Sam at an inconspicuous French restaurant in Santa Monica. Misenhimer picked Elizabeth and Sam up in his brown Honda Accord and chauffeured them to dinner.

"We were an unlikely group," Gottlieb said. "Me, a doctor who's spent his life in laboratories; Bill

Misenhimer, a Xerox executive turned activist who was openly gay; and the greatest living movie star in the world. But that night it all jelled. We were like kids, coconspirators. We sat there saying, 'We must do something!'"

Misenhimer told Elizabeth how hard their path ahead would be, and she took his hand in hers and said with tears in her eyes, "Don't worry, I've been through a lot."

This was the moment that led to the creation of amfAR, the Foundation for AIDS Research, the first major nonprofit organization dedicated to supporting research on AIDS. AmfAR's first incarnation was the West Coast–based National AIDS Research Foundation that Elizabeth, Gottlieb, Misenhimer, and Sam created that evening. Rumors of the foundation reached New York. Dr. Mathilde Krim, a well-respected and fiercely dedicated research scientist who was married to movie executive Arthur Krim, a friend of Mike Todd's, had created the AIDS Medical Foundation, which needed money. She reached out to inquire about a merger. Rock had pledged $250,000 to Elizabeth's National AIDS Research Foundation posthumously, and two days after the Commitment to Life dinner, representatives from the National AIDS Research Foundation and the AIDS Medical Foundation met in Los Angeles to try to find a way to join forces.

When they announced the creation of their new foundation—amfAR—at a press conference, the power struggle between the two groups was already evident. It was to be based on both coasts. Elizabeth was the national chairman (she did not want to be called "chairwoman"), and Krim and Gottlieb were chairs. Krim admired Elizabeth's commitment and her dedication to treating AIDS patients with dignity and respect, but her ultimate goal was always to find a cure. She valued Elizabeth's intelligence, and in a 1986 letter, wrote: "Everybody wants to see your beautiful face. I would like, more often, to pick your beautiful brain!"

But in Krim's eyes, Elizabeth was primarily useful as a fundraiser. And she certainly was good at massaging big egos. A favorite line of Elizabeth's when she was trying to get a big check was, "You are the only person who can save millions of lives."

When Elizabeth could get on the phone and make an impact, or travel for an AIDS fundraiser, she did. "People always ask, 'Does Elizabeth Taylor work hard?'" said Misenhimer, who became the first director of amfAR. "You've got to put it in perspective because what's hard work for Elizabeth isn't necessarily what everybody else would call hard work. . . . Once, we had a board meeting at the Bank of Los Angeles. Afterward she said, 'So this is what a bank looks like.' She'd never been in one."

She was practical. She knew that there were some things that only she could do. But now fame, the commodity of Elizabeth Taylor, was being used to save lives. "If you can get a million-dollar donation I will totally go to that dinner," she'd say. She saw her fame as something she could control and manipulate.

At the International AIDS Conference in Florence in 1991, Elizabeth brought dozens of suitcases for the long European trip. "I cannot wear the same thing twice!" she quipped. Valentino Garavani was supposed to arrange for her security, but for some reason it slipped through the cracks, so Gianni Versace said that he would do it. "As an apology, Valentino gave Elizabeth a check for twenty-five thousand dollars for amfAR as a donation," said one of her doctors, Michael Roth. "I thought she was going to blow a gasket. I'd never seen her quite so angry. She gave the opening speech and then she said, 'I would like to take this time to give a special thanks to Valentino for giving a gift to amfAR, a very generous gift, of two hundred and fifty thousand dollars.' And he made good on it."

Sally Morrison, who held top positions at amfAR for thirteen years and worked closely with Elizabeth, said that Krim and Elizabeth were powerful women who had a common goal but different ways of getting there. "Dr. Krim was very empathetic, but to her it was so

clear we needed to address this problem through science," said Morrison. "I think for Elizabeth it was very difficult not to address food and housing and patient services. She had a lot of friends who were sick."

At the Coming Home Hospice in San Francisco's Castro District, nurses were told in hushed tones that Elizabeth Taylor was on her way. If the press showed up she would cancel the visit. She stopped in each of the hospice's fifteen small rooms and she spent several minutes talking with each patient. She asked them if she could arrange to have their dogs walked, she asked if she could call their mothers for them or write letters. She wanted to know, "What is it you need that we don't know about? That the government doesn't know about, that we at amfAR don't know about. You're the only ones who know exactly what you need."

Shirine Coburn DiSanto, Elizabeth's publicist, recalled, "She would sit with patients and hold their hands to let people around them know that it's okay to touch them. She'd place their hands in both of her hands, lean in, and she would ask them to tell her their stories. She'd say, 'Where are you from?' It was never just a superficial celebrity drive-by. She really wanted to connect with them."

Some patients cried when they saw her, said Guy Vandenberg, a health-care worker and AIDS activist

who was at the Coming Home Hospice when she visited. After she met with patients, he said, Elizabeth sat with the handful of staffers in their tiny kitchen and asked them how they were taking care of themselves. "How do you support each other?" she wanted to know.

In their fifteen-bed hospice they averaged three deaths a week. "Sometimes I would get off my three-to-midnight shift and I would come back the next day and one or two people might have died during the night," Vandenberg said, his voice cracking. "The need was so great that the bed would not be empty more than a day at most, sometimes the bed would be filled right away. We didn't have time to process the volume of death."

Even amid all the darkness, there was joy. "A majority of our patients, as they were dying, were quite capable of laughter and gallows humor, and to an outsider that often felt really strange or inappropriate. When the hospice was taken over by a more corporate hospital, we got disciplined for too much laughter, and we were eating with the patients and that was not allowed," Vandenberg said through tears. "She fit right in, she knew that was good. She joked with them. She hugged and kissed every single one of us, the patients and the staff."

After one of her hospice visits a patient woke up and

said, "I had a vision that Elizabeth Taylor came to me in my sleep!"

"No, she was actually here," a nurse told him.

Elizabeth wanted to look perfect for every visit ("I hope I haven't overdone it!" she'd joke) so she always arrived with full hair and makeup and the enormous Krupp diamond on her left ring finger. She wanted the patients to see her the way they had imagined her to be. She wanted them to meet a real movie star before they passed away.

Elizabeth made sure that the perfume company and the department store donated money to the hospices she visited, and she matched their contributions. "It's the major thing in my life now," she said.

She told Jorjett Strumme, who would get emotional, that she could not come into hospices with her because she would start to cry if Strumme cried. She had to keep things light and happy, she said, but she'd get back in the car and she would bury her head in her dog Sugar's soft white fur and be unusually quiet for a while.

Ed Wolf was a counselor in San Francisco General Hospital's Ward 5B in the 1980s. San Francisco was second only to New York in the number of AIDS cases, and 5B was revolutionary as the world's first Special Care Unit for people with AIDS. It was created in 1983 and run by registered nurses who specialized in caring

for AIDS patients. In 5B patients were treated with compassion.

In the beginning nurses and doctors wore so much protective gear that they looked like astronauts. Food trays piled up outside of hospital rooms because no one wanted to touch them. But in 5B things were different. Nurses were not allowed to wear protective medical gear, including gowns and masks. They believed that physical touch was an important way to honor each patient's humanity. They did seemingly little things, like re-creating the décor of patients' living rooms in their hospital rooms, allowing their pets to visit them, and, of course, allowing their partners to stay with them. They even used champagne glasses for water to make mundane parts of life feel special.

"We couldn't cure people, but there was a possibility to heal," Wolf said. "We held weddings for people on their deathbeds years before it would ever become legal. In five minutes families would find out that their son is gay and he has AIDS. One conservative family from a small town came every single day for two weeks until their son died. They saw all these gay people taking care of him and they did a one-eighty. They went back to their homes and started a support group for people whose kids had AIDS. In other cases, people

would bring ministers to get their children to atone. It was a terrible and a beautiful place all at once."

Cliff Morrison created 5B, and he remembered one visit when Elizabeth stayed for several hours. She knocked on doors and said hello to people, and she asked if there was any protocol she should be following. She reached out and touched patients' hands without wearing gloves, and she would leave the room and discreetly wash her hands, not because she was worried about herself but because she knew that they had weakened immune systems and she did not want to give them any germs that could cause them to get very ill. After she visited with each patient, she asked if there was a lounge area so that she could meet with a larger group. Patients who were feeling well enough to leave their beds came and sat in a circle around Elizabeth. She told them to feel free to ask her anything. One patient asked her, "What kind of grief and sorrow have you had in your life and who was the love of your life?"

"I was married to Richard Burton twice and he was the most passionate love of my life. Nobody fought more or loved more than we did," she said. "But Mike Todd was my first true love."

Morrison said that it was like she was having a cocktail with old friends, but in this case it was coffee and

cigarettes. "I couldn't believe how comfortable she was," he said. They named the lounge after Elizabeth.

She wanted to make patients smile. In 1986 someone she had never met wrote her a letter telling her that one of his friends who had done some work on her house was in the hospital dying of AIDs. She had a note delivered with a purple orchid to his hospital bed: "My whole house needs redoing. . . . this time in deep purple and lavender—so you have to get out in a hurry and help me. All my love, ET."

Chapter 18
Ms. Taylor Goes
to Washington

My family and people with
HIV/AIDS are my life.

—Elizabeth

1986 AND 1987

The first time Elizabeth went to Washington to testify before Congress was in 1986. Money for "AIDS ten years from now will be too late," she said as dozens of reporters and photographers fought their way into a normally quiet hearing room on Capitol Hill.

She used every tool she had to get lawmakers' attention—she sent letters to senators on scented lavender stationery with information about HIV, with a

handwritten message: "I think you should read this." Some senators carried those notes around for months. You could see them bringing them out of their jacket pockets on the Senate floor to show each other. Her friendship with her ex-husband John Warner was key. "We kept the friendship until the day she passed on," Warner said.

"She came down to see me and said, 'Listen, I need your help. I want you to invite members of the HELP committee [the Senate Health, Education, Labor and Pensions Committee] into your office and I want to talk to them. And we took a day or two to set this up. A wonderful man named Lowell Weicker, a Connecticut senator, a good friend of mine, I said, 'Lowell, get a couple of your guys and come on over. I'd like to have you listen to Elizabeth. She's got some thoughts on this thing.' When they heard that she was coming, the whole committee came over to my office." He laughed. "She said, 'It's time for Congress to get involved, this is serious. It's not only affecting America, it's killing people all over the world.'" Warner paused for a moment, leaned back in his chair, and added, "Her skills in Congress were honed performing the duties of the Senate wife, there's no doubt about that." Elizabeth was not the least bit intimidated by Washington, and

she felt triumphant returning to the city, this time with a powerful message.

There were very few celebrity activists at the time, and Elizabeth, along with a handful of other actors and musicians, were early influencers who recognized the weight their voices carried. Artists were just beginning to champion causes and draw attention to issues they thought were being overlooked or mishandled. Jane Fonda became one of the most vocal and high-profile antiwar activists during the Vietnam War, and her activism served as an example to Elizabeth. "If it didn't make a difference for famous people to speak out, the right wing wouldn't object. We are like repeaters," Fonda told *Vanity Fair* in 2017. "Repeaters are the towers that you see at the top of mountains that pick up signals from the valley and carry them over the mountains to a broader audience. And that's what celebrities do, if we're doing our job right. We're picking up the voices of people who *can't* be heard and broadcasting their story."

When Elizabeth decided to devote her life to ending HIV and AIDS, she joined this illustrious group, which included longtime activist Harry Belafonte, who helped organize the Selma-to-Montgomery March for voting rights in 1965 and who still works on

behalf of civil rights and social justice causes; Audrey Hepburn, who was an ambassador for UNICEF; and Paul Newman, who was a Democratic activist and philanthropist.

Elizabeth used her relationships to great effect. She kept up her friendship with the Reagans, whom she knew from their days as Hollywood actors, and attended Ronald Reagan's second inauguration in 1985. Eight months later, Reagan finally uttered the word "AIDS" for the first time in public on September 17, 1985. By then more than twelve thousand Americans had died. In response to a reporter's question about the virus he said that AIDS was a "top priority." But it was not until 1987 when he finally talked about it publicly again, and it was largely because of Elizabeth's persistence. She reached out to Nancy Reagan after the creation of amfAR and asked if the Reagans would be honorary chairmen of amfAR's national fundraising drive in San Francisco. Nancy responded in a letter dated January 1986:

Because of the sheer number of requests we receive to participate in AIDS benefits across the country the west wing has advised us to decline. As much as we would like to accept every one I trust that you will understand that it just isn't

possible. If we accepted one invitation we feel it wouldn't be fair to all who write. . . . All the time you are giving to combat this epidemic is worthwhile.

Sincerely, Nancy
Reagan

At the bottom she added in her own handwriting: "P.S. Elizabeth, dear, do hope you understand—can't do them all—but I think what you're doing is great. XX Nancy."

Elizabeth never gave up and worked her pressure campaign from several angles. She asked Reagan to be the keynote speaker at amfAR's fundraising dinner the following March. It was to be held in Washington the night before the largest scientific meeting ever held on HIV and AIDS. At the bottom of her letter, Elizabeth added a note: "P.S. My love to you, Nancy, I hope to see you soon. E." But privately she fumed at the Reagans' silence.

She did some in-person persuasion as well. When Jonathan Canno, a founding director of amfAR, asked Elizabeth how she finally convinced Reagan to speak at an AIDS event, she said, "I went to the Oval Office and it was just the president and me, and Jonathan, this is exactly what I said to him: 'It would be wonderful if you

would be there,' and he said he didn't think he could come and made some excuse." She took off the glasses she was wearing and said seductively, "So I said, 'Mr. President, *Ronnie*, if you can't do this for America, please do it for *me*.'"

And in a letter dated April 23, 1987, she finally got the answer she was looking for: "Dear Elizabeth, The president and first lady have advised me that they have accepted your invitation to participate in the American Foundation for AIDS Research dinner. I am delighted and I hope we have an opportunity to see you. . . . Sincerely, Howard Baker." She had befriended Baker when he served in the Senate with John Warner, and now Baker was Reagan's chief of staff. She had friends in very high places.

Landon Parvin was a speechwriter in the Reagan White House, and he wrote Reagan's speech for the dinner, which came to be known as the Potomac Dinner because it was held along the banks of the Potomac River. The speechwriting office was very conservative, Parvin said, and Nancy Reagan, who was an incredibly powerful influence inside the White House, thought that a conservative message would not serve the president. She knew that Parvin was more moderate, so she specifically asked him to write the speech. She was trying to be supportive, not only be-

cause Elizabeth asked her, but because she thought it was time.

Parvin asked Nancy Reagan to arrange a private meeting between Surgeon General Koop and her husband before the dinner. He was amazed when Koop told him that he had actually not met with the president to discuss AIDS before then. When the meeting finally happened, the room was packed. "I don't think that Mrs. Reagan knew that a lot of people would be there," Parvin said. "But I think she thought that if the president heard personal stories of people with AIDS it would have moved him." The personal stories were drowned out by the voices of those skeptical of more AIDS funding.

Hundreds of people gathered in an outdoor tent for the 1987 dinner, some of whom were HIV-positive. They held candles for loved ones who had passed away. But the booing from the crowd began and got louder when Reagan announced that AIDS would be added to the list of contagious diseases that would keep immigrants from being allowed into the United States. He said that he wanted routine testing of federal prisoners, immigrants, and people applying for marriage licenses. He never once mentioned the need to protect the rights of gay people, and he never said that people who tested positive for HIV should have their rights protected.

"It was a split personality speech," Parvin recalled.

"The first half was compassionate, the second half was policy, and that's where there was division. . . . A lot of people didn't think it was appropriate to go into detail. They said that it was not presidential to deal with certain things like wearing condoms. They said it would be like Eisenhower talking about sex."

Still, it was important that the president finally spoke publicly at length about the virus that was devastating the country. A month after the dinner, Elizabeth sent Reagan a letter thanking him, knowing that in politics it is often better to flatter to get things accomplished than to reproach. She called his speech "very courageous and frank" and thanked him for identifying AIDS "as a challenge which affects all of us." She praised his "call for compassion and against discrimination." Most important, she added, "It would be wonderful Mr. President, if you, Nancy and I could sit and discuss these issues in the future." And she did get the chance to talk to him privately about HIV and AIDS.

Henry Waxman was chair and ranking member of the Energy and Commerce Committee's Subcommittee on Health and Environment when he called the first congressional hearing on AIDS in 1982. Waxman said in those days some of his colleagues brought their own scissors and combs to the barber shop in the Capitol because they were afraid that they would get AIDS. Elizabeth

told Waxman that she had talked to Reagan about all the people they knew in Hollywood who had AIDS and pointed out to him that most of them suffered in silence so they would not face discrimination. At the time they could lose their jobs simply for being gay.

By the time Elizabeth arrived in the Capitol, she had become quite knowledgeable about AIDS. In the mid-1980s she met with Dr. Anthony Fauci, who led government research on the virus. He gave her a tour of the National Institutes of Health. "When I showed her around my ward she had a lot of trouble with her back and she was uncomfortable walking around, and yet she put the smile on and comforted people. She was gritting her teeth walking around . . . [yet] when she met with patients, mostly young men who were wasting away because there was no treatment then, she never showed darkness to them."

He was surprised at how much she knew about the virus and how committed she was to "shaking the cages of the establishment." She was not only rebelling against government apathy, she also wanted to change the way the public was viewing HIV and AIDS. She wanted people to know that anyone, not just gay men, could be infected.

"When you deal with celebrities they sometimes look past you—not Elizabeth. When you looked at

Elizabeth Taylor, she made you feel like you were the only person in the room."

Elizabeth felt a real sense of urgency at the most personal level imaginable. Aileen Getty, the mother of two of her grandchildren, was HIV positive. The granddaughter of John Paul Getty, the billionaire owner of the Getty Oil Company, married Elizabeth's son Christopher Wilding in 1981, and is the mother of Caleb and Andrew. In 1987, she confided in Elizabeth that she had tested positive for HIV after having unsafe sex during an extramarital affair. This is a confession that most mothers-in-law would have trouble hearing, let alone forgiving, but Getty felt comfortable telling Elizabeth, someone she loved dearly.

Like Elizabeth, Getty was an addict. She had a terribly destructive relationship with her father and she resented the weight of her family's extraordinary wealth. She was sober for six years, until her HIV diagnosis, when she sank into a deep depression. She would wake up sweating, she lost weight, and she was in so much pain that she started using drugs again. The shame and the guilt were all-consuming.

She was with Elizabeth in Paris for an amfAR event when she told her. "I remember holding each other and crying," she said, noting the awkwardness of admitting to Elizabeth that she had cheated on her son and

the spectacular irony of getting sick just as Elizabeth was launching her fight against the disease. "I was the beneficiary of that real compassionate, nonjudgmental love at a time when I was filled with so much self-hatred. She was able to keep that little light I didn't know I had in me on, though I masked it with such terrible choices."

Elizabeth's two grandchildren were less than ten years old when their mother was diagnosed. Elizabeth enlisted Dr. Gottlieb to help get Getty in an AZT drug trial. She helped Aileen talk to her father, whom she was deeply afraid of. "I wasn't just a sick addict to her. I think that she recognized that I was a broken child. She never ever took that away from me, she allowed me to be that."

Elizabeth gave Getty the unconditional love that her biological parents could not. "This girl is like my own children," Elizabeth said. "How can I do anything but everything I can to save her life? *I am going to save her.*" There were times when she had to cancel planned events because she had been up all night with Aileen, who stayed at her house many times when she wasn't well.

1990 AND 1991

Elizabeth went to Washington again in 1990 to testify in support of the Ryan White CARE Act to prevent discrimination against people living with HIV and to raise

awareness and money. Michael Iskowitz was Senator Ted Kennedy's chief counsel on HIV and recalled senators practically pushing people with HIV aside to get to Elizabeth when they introduced the legislation. "They could come and stand with her and get their photograph taken," he said, "but they would have to cosponsor the bill first, and if they did not, they could not walk into the room." That is what got the support of dozens of senators, and Jeanne White-Ginder secured the rest. Without Elizabeth it would not have happened.

"She would try to open people up," Iskowitz said, "and hope that he [Senator Ted Kennedy] could go in and close the deal. She knew that senator to senator was powerful for persuasion."

In the 1980s, the disease had affected her so personally, and she would lose even more friends in the 1990s. Elizabeth felt the same way about her even-keeled handsome assistant, Roger Wall, as she did about Aileen Getty. He was like family. Wall had worked for Tom Jones and Barry Manilow before he started working for Elizabeth. "Roger was a down-to-earth country boy. He did not belong in Hollywood, he did not belong in movies, he came from some out-of-the-way southern town," Manilow said. "Everybody loved him because he wasn't from Hollywood or the music business. He was just a great guy."

Friends say that the only time she teared up during her fight against the disease was when she talked about Roger. "I think one of the reasons my mom got along so well with Roger was that he was not a dramatic person," Chris Wilding said. "Even if she tried to whip up drama he was a calm, normal guy. I think she genuinely loved him." Wall told her about his friends who were getting sick, and when he became HIV-positive she did everything she could to help save his life.

Everyone was desperate for a cure, or even treatment that would slow down the progress of the disease. Project Inform, which Elizabeth had donated to, was running an underground trial for an experimental AIDS treatment called Compound Q. The drug was made from a cucumber-like plant that grows in Southeast Asia.

"A number of people who were very close to Elizabeth were keen to get their friends on that trial because, at the time, it was felt to be the only hopeful thing," said Sally Morrison. "AmfAR published the treatment directory, which is where they reported on all the trials, legal or not, tracking any possible drugs. The idea was to empower the patient community to know what was going on with the science. We knew about the Q trial, and we sent someone to observe it because we felt, ethically, even if it was not legal, if there was

a chance of useful information coming out of it, negative or positive, we should report it. Elizabeth arranged for a certain amount of financial support to be taken to San Francisco in order for some people to be able to be enrolled in that trial."

Roger Wall's boyfriend, Bradley Anderson, remembers walking into Elizabeth's kitchen and seeing aluminum Halliburton briefcases full of cash stacked on the counter. That cash, which he believed to be tens of thousands of dollars, was taken to San Francisco. Everyone who was sick wanted to be on that Compound Q trial, and Elizabeth wanted to get Roger—who was getting thinner and thinner and more and more depressed—on it as soon as she could.

When Elizabeth saw Anderson, she said, winking, "Guess what you didn't see?"

He said, "I pretty much can figure that part out. Where did you get the money?"

She said, "Where do you think?"

"Well, you raise money for AIDS," he said.

"They wouldn't pay for this." This was her own money.

"I think Elizabeth would have done anything to save Roger's life," Morrison said. Unfortunately, the treatment did not prove to be effective and the trial was shut down.

Roger was forty-two years old when he died in 1991. He swallowed dozens of Seconal, a powerful sedative, and a third of a bottle of scotch, according to Anderson. It had been about a year since he was diagnosed, and he said if it got to a point where he had few T-cells and sores started to develop on his face—signs that the virus had crippled his immune system—then he would take his own life. "He was trying to push everyone away," Anderson, who discovered his body in their bedroom, said. "I believed that he could kill himself, but we had an agreement that he would never do it in our house and he would never make it so that I found him. I think he was just so backed against the wall. First I called the police, then I called my brother, then my sister, and then I called Elizabeth. It must have been two or three in the morning. She said that when the phone rang she knew exactly what it was." It was one of the hardest losses she had ever faced.

Elizabeth helped the world see that AIDS was not only a gay disease, as it was regarded at the time. Dr. David Ho, who had treated Elizabeth for her double pneumonia in 1990, was also Magic Johnson's doctor. When Johnson was first diagnosed as HIV-positive in 1991, Ho connected him with Elizabeth. She did not want to pressure anyone into going public with their diagnosis; she was supportive of whatever decision

Johnson wanted to make. He also spoke with Elizabeth Glaser, who ran the Pediatric AIDS Foundation and who, being HIV-positive herself, was instrumental in helping Magic deal with his situation early on.

"At that time," said Ho, "it was not so easy to be public with such information, but I could sense from the moment the diagnosis was confirmed that he was leaning in that direction."

Johnson's 1991 announcement stunned the world, because he was the most famous straight man to reveal his diagnosis. It helped change the way people looked at AIDS. Whoopi Goldberg had become friends with Elizabeth when she first became an actress. She was one of the first celebrities to help raise money and awareness about the disease. Like Elizabeth, she had watched so many of her friends die because of it.

"Elizabeth was the first to really shake them up in Washington and at that convention [the Republican National Convention in 1992] Mary Fisher scared all those people because it suddenly meant that you had to stop with the mindset that this is a gay person's disease because anyone can get it," Whoopi said. "When Elizabeth said it they listened. Mary and Elizabeth Glaser and Elizabeth Taylor transformed the conversation. It started with Elizabeth, because she was the highest-profile person who held her head up and talked about

what was happening to her friends. And she wasn't embarrassed, and she wasn't afraid, and here comes these other two women who said, 'By the way, we're all susceptible.'"

1992

Mike Shriver was an HIV positive twenty-eight-year-old AIDS activist when he met Elizabeth. Shriver ran a drug treatment program for gay men focused on prevention and care. He was part of the Communities Advocating Emergency AIDS Relief, an advocacy group known as the CAEAR Coalition. Elizabeth was in Washington for a meeting with Representative William Natcher, an eighty-three-year-old Kentucky Democrat who was a powerful member of the House Appropriations Committee. By this time she was a pro; if an advocate was going to help her lobby, she said, it needed to be someone living with HIV. She and Shriver were there to push for more funding of the Ryan White CARE Act.

Before the closed-door meeting began in Natcher's office, she tapped Shriver on the leg. "Do you prefer Mike or Michael?"

"I was just a kid," he said, "and here I was sitting next to *Elizabeth Taylor*."

Elizabeth knew how the levers of power in Washington worked from her years of being married to John Warner. She knew that she had to be there in person to have the biggest impact, and she knew that she had to dazzle them with her black hair teased high and the enormous Krupp diamond on her finger. Natcher had a policy of never meeting with people who were not his constituents, but he made an exception for Elizabeth. He went on and on in what she immediately recognized as a waste of time, and she saw that he was going to dance around the issue. Putting her hand on Shriver's shoulder, she interrupted Natcher and said, "I just want to know what you are going to do to help my friend Mike. You promised us eight hundred and eighty million dollars and what we got was one hundred and ten million." She was very clear and very focused on the dollar amount, Shriver recalled. Finally, Natcher looked at her and said, "I'm not the problem, it's not the House, it's the Senate. The person you need to have this conversation with is Senator Harkin." So that is exactly where she went, to Harkin's office. Harkin was an Iowa senator who was an influential member of the Senate Health, Education, Labor and Pensions Committee.

On the way she asked Shriver what she needed to know. He called her "Ms. Taylor" again, and she put her hand on his arm and said sweetly, "Elizabeth." As

they reached the Senate side of the Capitol, people were poking their heads out of every office door. As Shriver briefed her, she held on to his arm as if he were her escort.

Harkin had been called to an emergency meeting, but before she left Elizabeth ordered all his staff to come into the front vestibule of his office, where she and Shriver were standing. With complete authority, she said, "Let your boss know that whatever my friend Mike says goes for Elizabeth Taylor also."

The older white men who made up the vast majority of Congress were crawling all over themselves to catch a glimpse of her. She had bad memories of Washington, she told an amfAR staffer. "They're not very polite," she said, adding that when some of them lined up to have their photo taken with her they'd let their hands wander a little too low down her back, or they'd hug her too long and too tightly. "She thought that she would not have to worry about them doing that because they were public figures," the person said, "and she assumed there was some level of sophistication there. She found it disgusting." But she did what she had to do.

Congressman Henry Waxman, whose jurisdiction included West Hollywood, which was being ravaged by HIV, said that because Elizabeth had been married to

Warner, "Republican senators could pretend that she was a Republican."

In 1992, she testified in the Senate to press for additional funding for the bill, which had been inadequate and lagging. Veteran HIV and AIDS advocate Sandy Thurman testified alongside Elizabeth, and she remembered looking at her and being distracted for a moment from her own testimony. "These old guys were just totally enchanted," she said. "They were hypnotized. She walked in and it was deafening with the click of the cameras and blinding with the flashing lights. But the minute she sat down you could have heard a pin drop. The way she delivered her testimony was so demanding and critical that everyone paid attention to what she said. She commanded respect."

Elizabeth helped win funding for the Ryan White CARE Act. "We were waiting to go to the podium at the Capitol and I was behind Elizabeth," Jeanne White-Ginder recalled. "I was a nervous wreck, and I was impressed looking over her shoulder, her notes were all marked up. Ryan couldn't be there [he died on April 8, 1990, when he was eighteen years old], so it was important that she was there."

Elizabeth took these public appearances incredibly seriously. Sally Morrison helped write her speeches.

Elizabeth often handed back a draft and said that the speech needed to be more explicit about safe sex. "I see the facts," she told Morrison. "I need to convey them using my personality." She had been a film actress for so long that she would underline words and syllables with beats and intonations. She knew the rhythm, she broke up sentences into smaller bits—that was what White-Ginder was seeing when she looked over Elizabeth's shoulder at her notes.

"She was not embarrassed, she'd talked about semen, anything to make the point to practice safe sex," Morrison said. And she was someone who played to big stadiums. That year, she also spoke in front of seventy thousand people at the Freddie Mercury Tribute Concert at London's Wembley Stadium. "Protect yourselves. If you have sex, every time you have sex use a condom. Every single time. Straight sex, gay sex, biscxual sex, use a condom whoever you are. And if you share drugs, don't share a needle. . . . I have a message for each and every one of you," she said, her voice shaking with emotion: "Protect yourselves, love yourselves, respect yourselves, because I will keep on telling you until you do and I *won't* give in and I *won't* give up because the world needs *you* to live."

That same year, she appeared on the cover of *Vanity*

Fair wrapped in tangerine-colored satin and holding a condom. The photographer, Firooz Zahedi, remembered getting a call from an editor saying that if Elizabeth agreed to hold a condom then the story inside the magazine, "Liz's AIDS Odyssey," would make the cover. She agreed immediately.

There were so many big and small things that Elizabeth did during the AIDS crisis that made lasting impressions on the people around her. Elizabeth was good friends with Sammy Davis Jr. (he lovingly called her "Face"), whose business manager had AIDS. Elizabeth had her pool covered so that it became a dance floor and threw a last birthday party for him.

She was an early proponent of controversial needle exchange programs to help limit the spread of the virus through intravenous drug use. Some conservatives argued that needle exchanges encouraged people to use drugs. "It's called needle exchange," she said incredulously, "the person already has the needle, he's already a junkie, he's already taking heroin. Keep him using a clean needle so that he doesn't pass it on to his woman and his child. . . . It could save hundreds of thousands of lives. It's the same thing about being squeamish about using condoms—teachers, parents we have an obligation, they have a duty as a parent to

talk to their children because their children are experimenting with sex."

In 1987 the AIDS Memorial Quilt was displayed in Washington, commemorating the lives of the forty thousand people who had died from the disease. Each panel is three feet by six feet, approximately the size of a grave, so that when it was laid down on the National Mall visitors could visualize the devastation that the disease had wrought. When it was first displayed, the quilt was bigger than a football field, with 1,920 panels. By 1989, there were more than 12,000 panels, and by 2020 it had nearly 50,000 panels and weighed fifty-four tons.

Elizabeth led the candlelight march in October 1996, when the quilt returned to the National Mall. The actress Judith Light walked with Elizabeth from the U.S. Capitol to the Lincoln Memorial. Before the march started, Elizabeth told Light that her hip was really bothering her. "If you will do this," Light told her, "we will do whatever we can to support you. I will get the strongest, most powerful gay men in the community to carry you if we have to."

Elizabeth laughed and said, "Okay, I'll do it!"

According to Light, she was "luminescent." Elizabeth went to visit Roger Wall's panel, which she helped write. It read: "We remember the laughter, we feel the tears, and we will *never* forget the rest."

It was not until 1996 that HIV became a chronic disease for patients who have access to antiretroviral therapy containing protease inhibitors, a class of antiviral drug. Many of the patients who made it to 1996 are still alive today, including Aileen Getty and Magic Johnson. Today, people living with HIV and AIDS can achieve viral suppression, meaning that they cannot transmit the virus if they are taking the proper medication. The power of the research that Elizabeth helped fund through her activism was key.

Elizabeth is credited with raising well over $100 million over a quarter century for the cause that became the single most defining chapter of her epic life. Being an actress, she realized, paled in comparison to being an activist.

ACT VI

A Legacy
of Love

The 1990s to 2011

*If the knife slips tomorrow, I'll die knowing
I've had AN EXTRAORDINARY LIFE.*

-——Elizabeth, *Life*, April 1997

Chapter 19
Searching for Neverland

There is something in him that is so dear
and childlike—not childish, but childlike—
that we both have and identify with.

—Elizabeth on Michael Jackson

It was a circus, even by Hollywood's over-the-top wedding standards. A dozen helicopters circled over the sprawling estate. Each was packed with photographers who were craning their necks out the windows looking for a good view. A dozen or so purple and yellow balloons dotted the sky in a vain attempt to stop them. A parasailer almost got clipped by a helicopter's blades as he floated above the spectacle.

It was October 6, 1991, and this was Elizabeth's eighth and final walk down the aisle. She was marrying the most unusual of all her husbands: Larry Fortensky,

a construction worker who was twenty years her junior. She was close friends with Michael Jackson, who had gladly offered to host the wedding at his Neverland Ranch, 120 miles north of Los Angeles.

Moshe Alon had sent interns to essentially work as spies at some of the biggest entertainment magazines before the wedding so that he could prepare for the onslaught. "It was like an operation for Mossad," said Alon, who once worked for the Israeli Secret Service. He positioned one hundred security officers at Neverland. "I was spreading rumors that there would be guards there with Uzis [an Israeli machine gun], to scare people. The tabloids hired waiters to carry cameras on their tuxedos and parachutists to wear cameras on their helmets. Because of the helicopters, I went to the FAA to get permission to put up weather balloons. At some stage of the wedding it was very dangerous, because the helicopters were flying so close to the balloons."

For Elizabeth, the wedding was a mix of business and pleasure. She started The Elizabeth Taylor AIDS Foundation (ETAF) with money she received from selling wedding photos to *People* magazine for $1 million. Guests were welcomed with a huge sign that read: "NO CAMERAS."

At this point she thought that amfAR had become too corporate, and she wanted ETAF to focus on pa-

tient care and education while she continued to support amfAR. "Now I have the best of both worlds," she said. "I raise money; it's hard cash and goes directly to the source." She also did not appreciate amfAR's decision to bring in Sharon Stone to fill in for her when she was not feeling well. According to a close friend, she thought that Stone treated her like a doddering old lady at events they did together. She had always hated seeing older people talked down to and she was not going to put herself in that position.

Elizabeth met Fortensky during her second visit to Betty Ford in 1988. He had been arrested for DWIs several times and had gone to Betty Ford on his Teamsters Union insurance. "We were at our most vulnerable," Elizabeth said of their first meeting. "They knock you down [in therapy], kick the shit out of you, then give you the tools to build yourself up. Larry felt very protective toward me. He told me later that there were times he wanted to kill the counselor."

Fortensky, then thirty-nine, grew up in a working class family in Stanton, California, the eldest of seven children. He dropped out of high school and was twice divorced. He had never been on a plane before he met Elizabeth. And his occupation as a construction worker added to his allure. He even kept working for a while

after they were married. She would wake up with him at 6:00 a.m., have breakfast in a glamorous caftan, and then, when he left for work, she would go back to bed. He rode a motorcycle and was completely artless. He gave her the sense of normalcy that she had always craved. Needless to say, he probably would have settled for a far less extravagant wedding.

The couple said their vows under the white gazebo on the grounds of Jackson's 2,700-acre Santa Ynez Valley estate. The 160 high-profile guests, including Nancy Reagan and Brooke Shields, watched in astonishment as one photographer jumped out of a helicopter, pulled his parachute, and appeared to be gliding toward the altar. He had a camera mounted to his helmet and he was cruising at a low altitude, trying to catch a glimpse of Michael Jackson. At one point it looked like he might land on Mrs. Reagan. Suddenly, security guards ran out of the bushes with their weapons drawn. One of them grabbed the parachutist's legs as he came crashing down to the ground. They yanked his helmet off and began checking him for explosives and weapons. It all happened in less than thirty seconds, then he was whisked out of sight. Reagan never moved. Eight years as first lady had apparently trained her for this kind of thing.

Elizabeth, then fifty-nine, was an hour late and wore

a pale yellow $25,000 Valentino gown; her mother, Sara, sat in a wheelchair in the front row. She was escorted down the aisle by Jackson on one side, and Michael Wilding Jr. on the other. Her hair stylist, José Eber, was the best man.

Elizabeth understood the absurdity of it all. She later told celebrity journalist Baz Bamigboye, who was one of the reporters leaning out of a helicopter in a harness trying to catch a glimpse of the wedding, that all was forgiven.

Bamigboye recalled, "When she heard that I had covered her wedding to Larry Fortensky, she approached me at a function a few days later and told me I was foolish to risk my life to cover her nuptials. Then she grabbed me and hugged me. 'I'm glad you're safe and I'm privately glad you were, in your own way, at the wedding.' Now that was a hug by a real star that I have never forgotten."

Brooke Shields was good friends with Michael Jackson, and he insisted that she come as his date, even though she did not know Elizabeth well. She said that Jackson acted like the father of the bride. She remembered being with Elizabeth and her assistants as she was getting ready. Elizabeth asked if someone could score her shoes.

"Then she went into the bathroom and closed the door. Her assistant looked at me and said, 'What does that mean?' I said, 'Score the bottom so that she doesn't slip.' She said, 'I don't know what that means.'" Shields grabbed a fork and scratched the bottom of the shoes in a patchwork pattern, which is an old modeling trick.

"Here, give her these," she said as she handed the assistant the shoes.

"Oh my God, you're destroying the Valentino shoes!" she said.

"No, I'm not, I'm scoring them."

"Then *you* give them to her!"

"I'm not going to give them to her, she doesn't want me to do it, she wants *you* to do it."

"Well, I'm not giving them to her. They're Valentino shoes!"

Shields knocked on the door and Elizabeth opened it and stuck her hand out for the shoes.

Adding to the surrealness of the day, bestselling self-help author and Hollywood spiritual adviser Marianne Williamson officiated at the wedding. "There was a deep sweetness that came from her, it was an almost childlike quality," she said about Elizabeth. "She was like a porcelain doll locked in a prison." She was surrounded by assistants, who, Williamson said, were overprotective of her—though Elizabeth clearly

wanted her assistants to act as buffers and protectors between her and everyone else—and who did not take Fortensky seriously. They would wait this marriage out, like they had her other relationships.

"Then," she added, "you add to that the dark energy of Neverland."

There was an eerie quality to the estate, which was more like an amusement park than a private home. It was often filled with children, many of whom were young boys. There was a jumbotron that played cartoons in a loop, a railway station, loudspeakers made to look like gray rocks that played show tunes, and statues of smiling children lining the gravel roads and golf-cart paths. Peter Pan iconography was everywhere.

Jackson and Elizabeth would go on picnics together, two broken adults trying to recapture their stolen childhoods. "We try to escape and fantasize," Jackson said. "I can really relax with her because we've lived the same life and experienced the same thing." That life, he said, is "the great tragedy of childhood stars." They like the same things, he added in his breathy voice, "Circuses. Amusement parks. Animals."

The house itself had dark shingles, mullioned windows, and a statue of Mercury (god of merchandise and merchants) in front. There was a guest book in front of the bedroom door, like a guest book for a wedding,

said Bradley Anderson, who visited Neverland with Elizabeth. Anderson noticed two sleeping bags with images of Peter Pan on them in front of a large fireplace in Jackson's bedroom. Jorjett Strumme went to Neverland half a dozen times. She said an alarm would go off in the hallway outside the bedroom when someone walked by, which she always thought was odd.

At the reception, Jackson danced with Elizabeth and Shields had to dance with Fortensky. "So, the minute we started dancing I went over to Michael and Elizabeth and I was like, 'Can I cut in?' So I just danced with Michael and gave her to her husband." Shields ended up feeling sorry for Elizabeth that night. She remembered how much Elizabeth enjoyed the Heath Bar Crunch ice cream cake and how quick she was to laugh, but their wedding was the furthest thing from personal and private imaginable.

"I think there was still a little kid in her, and there was part of her that I felt was hidden," Shields said. "Because it was such a big wedding and such a big deal she could also disappear into it, she could put on the Elizabeth Taylor hat. Then there was the person sitting next to me eating ice cream cake."

Michael's closest celebrity relationship was with Elizabeth. They met after he invited her to one of his concerts. She had brought several friends along, but

they could not see the stage well so they left early. "Michael heard that I had left halfway through, and he called me the next day, and he was in tears because he had heard that I'd walked out. I hadn't walked out. I just couldn't see anything," she told Larry King. "And then we talked on the phone for about three hours, and from there on in, we talked more and more on the phone."

One day Michael suggested that he might drop by and visit her. Elizabeth said that sounded fine.

"May I bring my chimpanzee?" he asked. He showed up at her door holding hands with his chimp, Bubbles. "We have been steadfast ever since," Elizabeth said. "We told each other everything."

They shared acute cases of arrested development. "Well, working at the age of nine is not a childhood," Elizabeth said. "He started at three, and that certainly isn't a childhood."

Jackson was abused by his father and Elizabeth felt deep sympathy for him. She knew what it was like to be used by your family for money and fame. Jackson called Elizabeth "a warm cuddly blanket that I love to snuggle up to and cover myself with. I can confide in her and trust her. In my business, you can't trust anyone." Elizabeth, he said, "is someone who loves— really loves me." When a journalist suggested that he

and Elizabeth were like Peter Pan and Wendy, Jackson said, "But Elizabeth is also like a mother—and more than that. She's a friend. She's Mother Teresa, Princess Diana, the Queen of England, and Wendy."

George Hamilton remembered how concerned she was about Jackson; she always wanted to get him out of his bubble. Once, she invited him to watch the horse races, and even though Jackson said he did not bet because it was against his religion—he did, and won five thousand dollars.

"I was thrilled," Hamilton recalled. "I said, 'Michael, this is unbelievable!' You would have thought that I was the antichrist coming up to him. He wouldn't take the money, and he ran from me." Eventually Elizabeth took it and stuffed it in her bra.

Early on in their marriage, Fortensky was very protective of Elizabeth and loving, but by the end of it, five years later, they no longer shared the same bedroom. Most of her friends thought that he was dull and completely incompatible with someone as vibrant as his wife. Moshe Alon told Fortensky to be careful. "These people are not your real friends," he said. There was an expiration date on their marriage and everyone knew it. At the end, Fortensky had started drinking again;

he was unshaven and wore a dirty bathrobe around the house.

Peter England, the president of Elizabeth Arden, recalled late-night conversations with Elizabeth, and how unhappy she seemed. "I think he was physical with her. She said that he pushed her around." Two people who worked for her said that they saw purple bruises on her arms and chest at this time.

Elizabeth's friend Bill Misenhimer said that Fortensky was the jealous type, and that he certainly understood that he did not have the money, the fame, or the intelligence of a Richard Burton or a Mike Todd. When Elizabeth went on *The Arsenio Hall Show* in 1992, Fortensky was in the greenroom when Hall asked her about her ex-husbands.

"I hate it when they do this," Fortensky seethed. Before the 1993 Oscars, producers wanted to make sure that Elizabeth would not be offended by a joke about her many marriages, particularly one at the expense of Fortensky. She paused for a moment and said, "Who's Larry?"

She introduced Fortensky to places he would never have seen. Her close friend, media mogul Malcom Forbes, let her and Fortensky use his house in Morocco for their honeymoon. In 1992, for her sixtieth birthday,

Disneyland closed for the night and a thousand of her friends were invited to celebrate. The famous amusement park was decorated with columns of violet and yellow balloons and a violet carpet at the castle entrance. Guests included Cindy Crawford, Richard Gere, David Bowie, Iman, Carrie Fisher, and then Disney CEO Michael Eisner, who escorted Elizabeth and Larry around all night. The intense media coverage made it seem like a royal wedding. Guests were taken from the parking lot by horse-drawn carriages to the gates and fireworks exploded high above Sleeping Beauty's castle.

Elizabeth was indeed attempting to reclaim her childhood. "I worked all during my childhood, so except for riding horses and getting away I was at the studio amongst adults. My peers were all grown-ups, so the child in me was really suppressed. I worked and I was paid and it was on the screen but it wasn't me, it wasn't mine."

Elizabeth and Fortensky looked happy that night at Disneyland, but cracks in their marriage were already beginning to show. She had given him a makeover and had his hair highlighted, she gave him lessons in manners, and even got him speech lessons. She got him a motorcycle, a BMW, and put a basketball hoop in her driveway. "When he stopped working and became

Mr. Elizabeth Taylor," Tim Mendelson said, "that was when it was over." He started micromanaging her household and crossed the line between being protective and being controlling.

She was fed up with his lack of curiosity and interest in the remarkable places they went together. Elizabeth did not have full-time security until 1994, when she decided she needed more protection because Larry was scaring the staff: three people who worked in the office, three housekeepers, a chef, a security guard, a masseuse, and groundskeepers. He kept guns in a cabinet in the house, which worried her.

Elizabeth was usually stoic in public, but she could be fragile when she remembered certain people. Jorjett Strumme remembered how emotional she could get. Elizabeth, Fortensky, and Strumme went to London to reunite with Richard Burton's relatives, who came to have lunch with her. "We're in a large private dining room, and Richard's Welsh family started singing and it was absolutely beautiful. She was at the head of the table and I was in the middle and I looked up at her and I was choking back tears. We locked eyes and we both started bawling."

Mendelson said, "Elizabeth worked really hard to make that marriage work, but she finally realized there

was no way to save it." She told Fortensky, "Eventually the curtain drops and once that happens, it's over and there is no way to pull it up again."

But Elizabeth took care of the people she loved; she never abandoned them. A letter from Mike Todd's son, Michael Todd Jr., opens by thanking Elizabeth for paying to fix the heating in his house. The letter was dated November 28, 1995, thirty-seven years after Mike Todd's death. And she clung to her role as a dutiful and loving daughter and supported Sara during her remarkably long life. Sara died in 1994 at age ninety-nine. But Elizabeth did not cry over her mother's death for a year. In 1995, a photograph from her mother's house showed up in her office. It was of her and her mother from the 1960s, and it left her sobbing for an hour. The large photograph looked like it had been damaged somehow. Looking at it made Elizabeth think about her stolen childhood, and how much her mother's life was intertwined with her own. Sara's identity was always "the mother of Elizabeth Taylor," and Elizabeth was her most treasured creation. And now Sara was gone.

After that day, when she broke down after seeing the photograph of her younger self with her mother, she and Fortensky were already close to the end of their marriage. After they separated, Fortensky kept calling Elizabeth and pleading, "Elizabeth, I want to come

home." She would tell him, "Larry, you *are* home.'"
She meant that he was where he belonged, where he
no longer felt threatened by her past loves or her way
of life. George Hamilton was relieved when Elizabeth
broke it off with Fortensky. "Poor Larry," he reflected
mockingly.

But even after their marriage ended in 1996, Eliza-
beth never stopped taking care of him. She left him
money in her estate documents and they spoke a couple
of times a month after their divorce. In an undated
letter she wrote, "Dear Larry, I've been thinking of
you often lately, and I worry about you. I don't know
why—just one of my feelings. I don't know if you're
working or not. I have no idea of how you're doing so
I'm going to rely on my gut feelings. I think you could
use a little help, so I would like to send you a thousand
a month for the rest of my life or until I go broke. It
comes with my love and every hope that you are well
and happy. Love, Elizabeth."

In 2010, she wrote him a letter that read, "Dearest
Larry, I think of you always with great affection and
caring. Take care of yourself. You are very dear to me
and always will be. You're a part of my life that cannot
be carved out nor do I ever wish it to be and I see that
you still remember me. That touches me no end. Love
you, Babe, Elizabeth."

Whenever Marianne Williamson saw Elizabeth after the wedding, Elizabeth apologized for divorcing Fortensky, which Williamson thought was funny. "I think she was saying it in case I felt bad, like I hadn't tied a tight-enough knot!" And Elizabeth always ended their conversations, as she often did with friends and acquaintances, by asking if Williamson knew any eligible bachelors to set her up with.

Elizabeth's relationship with Michael Jackson was simple, but the circumstances surrounding it were not. Beginning in 1993, Jackson was the subject of several sexual abuse accusations and police investigations, including an indictment on ten criminal charges, ranging from child molestation to abduction. In 2005, his case went to trial, and it became a media circus, in part because he was one of the most famous people in the world at the time but also because of his bizarre behavior, which included showing up late to court in his pajamas. He was acquitted of all charges, but suspicion remained.

Elizabeth never believed it and remained fiercely loyal to him.

Charlie Nicholson worked for Elizabeth and remembered seeing her with Jackson in the late 1980s. They were sitting at the dining-room table and she was hand-

feeding him salad. "She was lovingly feeding him, like a mother would feed a toddler." Mark Harmon saw Elizabeth and Jackson at a dinner in 1990. "Michael was sitting next to her and he hid under the table when we approached them. He stayed there until we left. Elizabeth said, 'What are you doing under there, Michael?' But he wouldn't lift his head."

Arthur Allen Seidelman, who was directing Elizabeth in a television movie, remembered going to a party at Carole Bayer Sager and her then-husband Burt Bacharach's house. "At one point, Gladys Knight came over to me and said, 'Can you go talk to Michael?' Elizabeth hadn't arrived yet and Michael was nervous." When Seidelman sat down with Jackson, he asked him over and over when he thought Elizabeth was going to arrive. "He was like an adolescent who had been left by a parent and wasn't sure if the parent was ever going to come back to get him."

She would do anything for him, and she did. In 1993, Elizabeth organized a one-woman intervention for Michael. She went to Mexico City, where he was performing, and after he got off the stage she escorted him to his private dressing room and convinced him to get treatment. She had already called Elizabeth Arden executive Joe Spellman and told him that she needed a two-bedroom plane to take her friend somewhere.

"The only problem is that we can't tell the captain where we're going," she said. Moshe Alon arranged for someone who looked like Jackson to serve as a decoy. Right after Jackson's performance, a security guard who was about Jackson's size wore a robe and a hood and pretended to be Jackson, returning to his hotel. A police escort followed the car to make the scene even more believable. It was then that the real Michael Jackson was boarding a plane. "I am getting you out of here," Elizabeth told him.

Alon accompanied them. "We saw news reports with sightings of Michael in different places," Alon recalled. "Elizabeth was having fun because she was in the middle of it." First they flew to Switzerland, where they stayed at Elizabeth's friend's house for one night, and then they flew to London, where Michael checked into a rehabilitation facility. Michael needed help and she was there for him. There was nothing she wouldn't do for someone she loved.

Jackson, then thirty-five, was going through a professional and personal crisis. He abruptly cancelled the "Dangerous" tour, and PepsiCo ended his endorsement deal because of the child sex abuse allegations against him. His attorney at the time, Bertram Fields, said that his painkiller addiction was becoming all-consuming: "He was barely able to function adequately on an intel-

lectual level. I'm not going to talk about his individual symptoms, but they were manifest."

According to Alon, members of Jackson's family were furious at Elizabeth because they did not want him admitting to his addiction. Jackson's life was so carefully controlled that Jackson had to ask his head of security for his own passport. Like Elizabeth's experience at Betty Ford, institutional life was humbling for Michael, who learned how to use a vacuum cleaner and how to perform other mundane tasks in treatment. But for all the planning and subterfuge, nothing came of Jackson's attempt to stop using.

Even as Elizabeth was trying to help Jackson with his addiction, she was fighting her own. Bernadeta Bajda was Elizabeth's longtime housekeeper. "I cried all the time when she asked for pills. Sometimes she wanted to have alcohol. Someone told us not to give her alcohol, so we hid it very high and she couldn't find it. She was desperate. She was searching, searching, but she didn't find it. Soon enough she did find the champagne."

A couple of years before Jackson died, Bajda said, she discovered a terrible secret. "Michael was in Mrs. Taylor's restroom and a moment later he ran downstairs. I was in the bedroom and he didn't see me, he ran past me. I went into the bathroom and I found an obviously used syringe on the floor. But I didn't touch

it, I was scared to death. Then I heard him coming upstairs to pick it up so I hid and he took it and ran back downstairs. That moment to me was so, so sad."

On June 25, 2009, Jackson died at his home in Holmby Hills, California. His personal doctor, Conrad Murray, was found guilty of having given him a lethal dose of anesthetic and propofol. Elizabeth began hearing that Jackson had been taken to the hospital, and she asked Mendelson to call one of Jackson's assistants to find out how he was really doing. There had been rumors like this before. Finally, Mendelson was able to connect with someone who knew what had happened. "We lost him," he was told. Mendelson had no idea how he was going to break the news to Elizabeth. He went into her bedroom and put his arms around her and told her that Michael was gone. She screamed, *"No! No!"* She was hysterical and heartbroken. He sat holding her for hours.

Later, after she had absorbed the shock, she decided not to attend the star-studded public memorial at the Staples Center. "She didn't want to put her grief on display for the public by going to the memorial," Mendelson said. "She didn't feel like that was something that Michael would have wanted." Months later, she attended his private funeral service at Forest Lawn Memorial Park. She decided then that she wanted to

be buried there too, because she thought that it was so peaceful.

Lionel Richie said that when he asked Jackson why his friendship with Elizabeth was so important to him, he replied, "She understands."

"I can understand what a safety blanket she was," Richie said. "But you couldn't be there all the time. As long as he was able to be near her or able to talk to her, that's one thing, but as time went on he got so big that it was almost kind of impossible to counsel him at a certain point. There was a danger to his innocence, there was also a sweetness to his innocence. . . . Without her in his life it might have been a disaster much sooner than it was."

As she had after Richard's death, Elizabeth wrote Jackson a letter that he would never read but that helped her grieve: "My Beloved Michael, I hope you remember how much I love you—and miss you. You are in my thoughts and heart continuously. It is like a high-pitched scream is in my heart. I mourn you. I am in pain. When will I ever see you again? I love you *too* much and always will. Yours, Elizabeth."

Chapter 20
Forgiveness

Debbie is one of my favorite people in
the world, and she always will be.

—Elizabeth

In the late 1990s, Todd Fisher, the son of Debbie Reynolds and Eddie Fisher, sat on his big sister Carrie's sofa in her Spanish-style mansion on Beverly Hills' Coldwater Canyon Drive. He listened intently to the woman he once blamed for wrecking his parents' marriage explain herself. "I was fascinated that this woman, who'd technically been my stepmother for about ten minutes—okay, to be accurate, more like five years—and who, along with my father, had dealt my mother one of the most devastating betrayals of her life, seemed to feel connected to me," said Fisher. "Maybe,"

he said, "it was because I was named after the greatest love of her life."

She took both of his hands in hers and looked right in his eyes as she sat next to him on the sofa. Fisher was in his thirties then, but she wanted him to know why she had done what she did so many years before. She told him that Mike Todd had been everything to her, and she felt lost without him.

"It was disarming, I was frozen," Fisher recalled. "This is the most beautiful woman in the world and she wanted me to understand what happened and why. She started to explain to me the state of mind that she was in after the plane crash. I was almost going to say, 'You don't have to tell me this,' but then I realized that it wasn't just for me."

She told him how Fisher had been there for her when she needed him. "Your dad was so sweet to me and he was what I needed at that time," she said. "I hope that doesn't sound selfish, but I was falling apart and he was there for me and he really loved me."

She wanted to make sure that he knew how touched Mike Todd was that Eddie and Debbie had named their son after him. "You have no idea what that meant to Mike."

Elizabeth told him that his mother was her only real

friend at MGM. She and Todd were his godparents. It was as if she were saying, *We're family.* Carrie Fisher had laid the groundwork for that conversation when she got Debbie and Elizabeth together. In true Hollywood fashion, it was a script that brought them closer.

Carrie Fisher wrote a movie that was meant to be the female version of *Grumpy Old Men.* It turned into 2001's made-for-television movie *These Old Broads,* and Fisher cast Elizabeth and her mother in the film. The film's producer, Ilene Amy Berg, said that Elizabeth had bought an incredibly important piece of jewelry and told her that she wanted to buy earrings that matched it, and that she was doing the film so that she could buy the earrings. "But I came to understand and believe that the real reason she did the movie was to help Debbie," Berg said. "My understanding was that Debbie was in financial trouble and Elizabeth wanted to help her get the money without writing her a check. If she had read the script I don't think she would have done it."

Elizabeth had asked Tim Mendelson to read it, and when he recommended that she pass, her agent, Marion Rosenberg, tried to talk her into it. Elizabeth stood firm and said that she did not want to do it.

"Okay," Rosenberg said. "Who's going to tell Debbie?"

Elizabeth said, jokingly, "*You bitch.*" Of course she

could not let Debbie down; she knew that she had to do the film.

Growing up, Carrie Fisher had felt abandoned by her father, and she was angry at Elizabeth on her mother's behalf. But she channeled her pain into her comedy.

In her HBO standup show, *Wishful Drinking*, she joked: "My mother was Elizabeth's matron of honor. She even washed her hair on her wedding day. Now later I did hear her mumble that she wish she'd washed it with Nair, but she's not a bitter woman really." But the dark humor masked a real friendship she, and her mother, had struck with Elizabeth. In 2000, Fisher presented the GLAAD Vanguard award to her "stepmother Elizabeth Taylor" for her "bold support of the gay and lesbian community before the invention of the gay movement and her superhuman fight against AIDS."

She said in a 2004 interview, "The best thing Elizabeth Taylor did for me was to get Eddie Fisher out of our house."

The truth was, the seeds of Debbie and Elizabeth's reconciliation were planted long before *These Old Broads*. Years after the betrayal, and long after Elizabeth and Eddie Fisher had divorced, Debbie was on her way to London on the *Queen Elizabeth* when she noticed suitcases piled up and birdcages being loaded on board. "I

realized Elizabeth was on the same ship as me," Debbie said. "I almost changed my mind about going, but my husband [Harry Karl] said, 'Don't be silly; we won't be on the same floor.'"

But, of course, they were, and it was Debbie who made the first move.

"I sent a note to her room, and she sent a note back to mine saying that we should have dinner and get this over with and have a good time," Debbie explained. "And we had a wonderful evening with a lot of laughs."

Debbie forgave Elizabeth, and both of them channeled their anger into their disgust with Fisher, who treated them both badly in the end. In his 1999 memoir, Fisher wrote intimate details about his relationship with Elizabeth: "Sexually, she was every man's dream; she had the face of an angel and the morals of a truck driver."

In an interview on *The View*, Debbie said, "I always miss a real true friendship. When you're young girls in school and you kind of grow up together, why should it be broken up by a man that doesn't really matter in the end?"

But there was an edge to how she really felt about Elizabeth, and she revealed it from time to time. In 2013, at an event at the 92nd Street Y, when the interviewer said that Fisher was in New York playing cards while she was home taking care of their kids, she

snapped, "No, he wasn't playing cards. He was fucking Elizabeth."

More than once, late in both of their lives, Todd Fisher had heard his mother on the phone with Elizabeth late at night. When he asked her what they were talking about she'd say: "Just girl stuff." After all, they were among the only people left who remembered what it was like being celebrities in the 1950s.

These Old Broads was shot on the back lot of MGM. Before they filmed one ironic scene that had to do with Elizabeth's character stealing Debbie's character's husband, Elizabeth asked Debbie to come to her dressing room. With tears in her eyes Elizabeth revisited the past one last time.

"Debbie," she said, "I'm so sorry for what I did to you."

Debbie said, "That was another lifetime. You and I made up years ago."

Elizabeth's voice cracked. "I just feel so awful when I think of how I hurt you and your children."

She tried to make it up to Debbie bit by bit. Debbie had an extraordinary movie memorabilia collection, and when she heard that one of Richard Burton's costumes from *Cleopatra* was being auctioned for a price that she could not afford, she called Elizabeth, who said that she would help her get it.

Debbie won the bidding and called Elizabeth. "How much was your winning bid?" Elizabeth asked.

Debbie cleared her throat and said, "Sixteen thousand dollars."

The next day a sixteen-thousand-dollar check arrived from Elizabeth.

Elizabeth was atoning for the perceived sin of breaking up a marriage that was already over. Whether Elizabeth forgave Debbie for playing into the false narrative of the wronged woman and feeding into the portrayal of Elizabeth as the villain is unclear.

A decade after *These Old Broads*, Debbie called her. "Getting old is really shitty," Debbie said. When she told Elizabeth to stay strong, Elizabeth replied softly, "I'm really trying."

But when Mendelson walked into Elizabeth's room as the conversation ended Elizabeth said, "*Oh God!*" after she hung up the phone. "That was so depressing. I really hate having conversations about growing old." Mendelson said that Elizabeth rarely complained about getting older. "She loved life too much," he said.

Elizabeth remembered Debbie, Todd Fisher said, and when she died she left her a pair of spectacular sapphire earrings and a matching bracelet and necklace.

Debbie's friend and fellow actress Ruta Lee asked

her how she could be friends with Elizabeth. "We have a lot to talk about," Debbie said.

"Like what?" Lee asked her.

"Like what a shit Eddie was."

"Obviously," Lee said, "the rope that either one of them wanted to use to hang the other one was broken. And it became bury the hatchet, not in each other, but in Eddie."

Before she turned sixty Elizabeth told *Life* magazine: "I've been lucky all my life. Everything was handed to me. Looks, fame, wealth, honors, love. But I've paid for that luck with disasters, terrible illnesses, destructive addictions, broken marriages." She had lost so many friends to AIDS, and when Chen Sam, who was like a sister to her, was battling cancer, Elizabeth had her fly from New York to stay with her in Los Angeles before she passed away in 1996. Sam had dedicated her life to Elizabeth, and Elizabeth wanted to be with her.

"I think that she went there to die," said Shirine Coburn DiSanto. "I think that part of her wanted Elizabeth to take care of her for a change." Elizabeth provided twenty-four-hour nursing care for Sam.

"I had gone to her room to say good night and found her breathing laboriously," Elizabeth said. "I kissed

her and held her and talked to her. After a while, I left. Five minutes later, she was gone."

She experienced more pain in 1997, when Princess Diana died in a car accident after being chased down by the paparazzi in a tunnel in Paris. It reminded Elizabeth of so many near-death experiences she had been through.

"I know what it's like to be chased in a car by the paparazzi, and it's one of the most frightening, claustrophobic feelings in the world. You're in a car, you're going faster and faster trying to get away from them. They can shoot through darkened windows, and you end up in a corner of the car," she said with tears in her eyes. "She must have known such fear. It makes me so angry."

DiSanto and a colleague, Maria Pignataro, had taken over for Sam after she passed away, and Elizabeth said that she wanted to put out a statement right away saying that the paparazzi had murdered Diana. Before she released it, DiSanto asked Elizabeth if she wanted to rethink the word "murdered." Elizabeth said, "No, I have to say murdered."

Moshe Alon said that a few weeks before Diana's death, they were in Paris staying at the Ritz, and they had the same drunk driver that Diana had. "I recall that he wanted to drive fast and I recall that I said, 'No way.'"

That year, Elizabeth suddenly found herself unable to speak; she was stammering and unable to form a sentence. Because of her history with addiction, her doctor slapped her face and asked, "Elizabeth, what have you taken?"

She fell back on her bed. It was then that he realized that she was having a seizure and took her to the hospital. "They came up to my room looking all terribly doctor-ish and somber and they said, 'Elizabeth, you have a brain tumor. And you've had a seizure.'" It was less than a month before her sixty-fifth birthday, and she needed surgery immediately.

She had already committed to a televised black-tie gala to celebrate her birthday in order to raise money for The Elizabeth Taylor AIDS Foundation. She was so proud of the foundation she had created, with its focus on direct patient care, and which has granted approximately $32 million since its inception. She felt that even though she was facing brain surgery she could not back out because the event was raising money for AIDS, so she scheduled the surgery for the the day after the gala.

After the surgery she was in her element. She had been in hospitals so many times, and she knew that this time she could help other people going through brain surgery feel less afraid.

The photographer Harry Benson first shot Elizabeth in 1960 on the set of *Cleopatra*, and when an editor at *Life* magazine called to tell him that she was about to go to the hospital for an operation to remove a brain tumor, he called her publicist and asked if he could document it.

"How could you ask such a thing?" her publicist said, shocked by the request.

"Do yourself a favor and ask Elizabeth, because I know she marches to her own drummer." Within an hour he heard back that he was welcome to. Elizabeth knew how powerful images of her after surgery would be for people going through something similar.

"It wasn't more than a day after surgery that I got a call to come to Cedars-Sinai Hospital," Benson said. "When I walked into her room, a nurse was sitting in the corner and Elizabeth was propped up in bed with her dog in her arms. Her head was completely shaved. There was a scar that stretched across the top of her head that looked quite like the stitching on the top of a football. Elizabeth asked me what she looked like, and I said she looked fine. She said, 'Come on, Harry, what do I look like?' And I answered, 'Sinéad O'Connor.' She let out a howl and roared with laughter. She told me to come closer as she wanted to show me something and asked if I could see any scars behind her ears. When I

couldn't, she told me it proved she hadn't had a facelift. She was pleased, as she said people had been accusing her of having had a face lift for years." In truth, she had had liposuction and a partial face lift over the years.

Later, in an interview with Barbara Walters, she said, "When they cut it and I came to and I had this shaved head with this little tiny stubble of snow white hair coming in, it was a giggle. But the scar was seven inches long."

"Could you really giggle?" Walters asked.

"Well, it was funny. I mean, I looked funny," Elizabeth said. "And I always wondered what kind of shape head I had. I wondered whether I had a flat egg, or a pillow head in the back, and I said, 'Oh, can I see what the back of my head looks like?'"

"Were you pleased?" Walters asked.

"Yes!" she said. "I have a round head. It wasn't like an egg head at all."

When Walters said how incredible it was that Elizabeth could laugh at it all, Elizabeth replied, "What else are you going to do?"

And was she worried that the tumor might grow back? "I'll smack the hell out of it if it does," she said.

Liberated from the constraints of having to live up to other people's expectations of how she should look, Elizabeth was happy. Norma Heyman said that after

the surgery was "one of the best times" of her life. "She drove out of the hospital and she had her head shaved. She thought that was fabulous. And of course she just looked so gorgeous!"

But she struggled after her surgery. Mendelson called Madonna, who had worked with Elizabeth as a fellow AIDS activist. Mendelson said, "I need help. Elizabeth is not doing well." Madonna was already known for her interest in a version of Judaism called Kabbalah, and she put Elizabeth in touch with Rabbi Eitan Yardeni, a high-ranking rabbi at the Kabbalah Centre, who brought an energy healer to the house.

"The healer came up in the afternoon to Elizabeth's bedroom," Mendelson recalled. "Elizabeth had to sit upright in a chair, she put her hands on her shoulders and it was forty-five minutes to an hour and a half, and Rabbi Eitan and I stayed in the room. There was no talking at all. Afterward, when she was done, she said, 'I need to wash my hands,' which is typical. They need to clear the energy for themselves. I took her into the dressing room to wash her hands, and she began sobbing. I hugged her and could feel her whole body shaking."

"Elizabeth is in so much pain," the healer said. "She's carrying so much sadness. I cannot believe how much she is carrying."

Throughout her life Elizabeth opened herself up to other people's trauma. In the late 1990s, she visited the Lower East Side Needle Exchange (now called the Lower East Side Harm Reduction Center) and met a woman named Deidre Bell Finley, known as Dee; she was in her thirties but had no teeth. Elizabeth sat with her and held her hands and asked for her story. Afterward, she told her publicist, "Contact the director of the shelter and make sure she gets her teeth fixed. And don't tell anybody where the money is coming from." She knew that Dee would have a hard time finding a job without any teeth, and she spent tens of thousands of dollars so that she could help her get her life in order. "Every time I smile, I think of her," Dee said years later.

Elizabeth was sensitive and empathetic, but she would not let the physical and the emotional pain she saw destroy her. She still enjoyed entertaining, even if she sometimes stayed in bed and did not always attend her own parties. Forty or fifty people would come by for Sunday barbecues and holiday parties. Her chef, Neil Zevnick, said, "You didn't get invited because you were a celebrity, you got invited because you were a friend." Almost every Easter she threw a massive Easter egg hunt, and occasionally Cirque du Soleil performed in her backyard. She loved a spectacle and

good food. There were plenty of celebrities, including Lauren Bacall, John Waters, and Madonna.

According to Zevnick, in the early 2000s Madonna came to one of Elizabeth's gatherings and was supposedly rude to members of Elizabeth's family, which was a transgression that Elizabeth could not forgive. "Elizabeth was told about it. She was a broad. She would not put up with bullshit. She said what was on her mind."

Sometimes she paid a price for speaking her mind so freely. When a journalist asked her how she thought President Bill Clinton was handling AIDS, she said, "He's disappointed me. He's had the opportunity to turn around the government and come forward and help, like he said he would at the beginning. He hasn't. He's waffled."

In 2001, she received the Presidential Citizens Medal from Clinton, the same year that legendary boxer, activist, and poet Muhammad Ali was given the award. "They immediately established a connection. Clinton was playfully shushing them," said Michael Iskowitz, who escorted her to the ceremony.

The day was special, but bittersweet for Elizabeth. The cofounder of amfAR, Dr. Mathilde Krim, had received the Presidential Medal of Freedom, a higher honor, from Clinton the year before. Moshe Alon said that Elizabeth carried some resentment about the

slight. "She did care about the credit for AIDS work. Elizabeth felt the Medal of Freedom was hers too."

Elizabeth and Debbie Reynolds were in New York for concerts honoring Michael Jackson's thirty years as a solo artist. While they were there, on Tuesday, September 11, 2001, the world changed forever.

Like the rest of the country, Elizabeth was in mourning, and she felt powerless to help. Dr. Leroy Perry, her chiropractor, was on the trip with her. His niece worked in a building right behind the Twin Towers, and she had no place to stay because she lived in a block adjacent to the fallout zone. Elizabeth suggested that she stay at the St. Regis Hotel with them. She needed shoes, clothes, a hot bath, and food, all of which Elizabeth provided. Elizabeth was unable to get a flight back to California, so she had no choice but to stay. While in New York, she went to St. Patrick's Cathedral and prayed for the victims of the attack.

Afterward, Elizabeth wanted to do something for the police and the firemen at Ground Zero. She went to the armory next to Ground Zero so she could comfort people. There, family members and friends of the missing walked around with photos of their loved ones and posted their photos on the walls with signs asking if anyone had seen them. Elizabeth wanted to visit

the World Trade Center site. Friends traveling with her were worried about her health, but she charged forward, walking toward the tragedy, and joined in a prayer circle on the way.

When Elizabeth came back from Ground Zero it was 1:00 a.m. She was very pale and she was having a hard time breathing. She went to bed and slept most of the next day. "I had to bring oxygen in to help her breath, her blood pressure and pulse were elevated," said one of her doctors, LeRoy Perry, who was on the trip.

Debbie Reynolds was staying at the Plaza Athénée, and Elizabeth invited her to stay in a suite on the same floor at the St. Regis so that they could be together. They flew out of town several days later, but Elizabeth became frighteningly ill.

"During the first hour of the flight, I took her blood pressure, which was high, and she had a racing pulse," said Perry. "Her breathing was shallow. I had to lay Elizabeth down and put an oxygen mask on her. I told her if she did not relax so that her vital signs could improve, I would have to instruct the pilot to land at the nearest airport and hospitalize her. That is all she had to hear. She kept quiet and closed her eyes."

That Elizabeth and Debbie found themselves together during such a traumatic moment in history, and how

they comforted each other, is a testament to forgiveness. It takes a certain amount of grace on both sides.

Near the end of Elizabeth's life, she was lonely and sometimes spent most of the day in her bedroom. Elizabeth Arden executive Peter England said that she called him at his home in Australia. "She said, 'Peter can you get me some of my money?' I said, 'What do you mean?' She said, 'They're not giving me any.' We talked for an hour. I really felt for her. At that time her money wasn't being managed properly."

She confided in friends about how lonely she felt. "People never think to call me," she said, "they think I'm always busy, but I sit home night after night alone." A year after September 11, she had dinner at Il Cantinori in New York with friends, and when given the choice between visiting a jazz club in Harlem or going to a fire station that had lost many of its firefighters at the World Trade Center, she chose the fire station. She sat on a fireman's lap and another came down in his boxer shorts and a T-shirt and said, "Somebody told me that Elizabeth Taylor is here?"

"You bet your ass I am," she said flirtatiously. She fit in at the fire station just as well as she did in Bel Air.

When she was honored at the much anticipated Kennedy Center Honors in Washington, her health

was deteriorating. That morning when she got out of bed and stood up, her blood pressure must have suddenly changed, she said, causing her to collapse. "The full weight of my body went on my foot, which was under me, and I heard it go *crack*," she said. "I let out a scream of pain." But she knew this was one event she could not cancel.

"I kept saying, *I am strong, I am strong, I am brave, I am brave. I am brave, I am strong.* And I got dressed and made up, had my hair done, and all the time my foot is getting bigger and bigger. . . . And it bulged up on other side of the shoe. . . . You cannot see one trace of pain on my face [during the show]. I kept saying to myself, *I am strong, I am strong, I am strong, I am brave, I am brave, I am brave . . .* like a mantra, and with that mantra I managed to get through the evening."

And she managed to get through what was her last performance in 2007 onstage at Paramount Studios in Hollywood. She was seventy-five years old when she performed A. R. Gurney's play *Love Letters*, with James Earl Jones, which was benefiting The Elizabeth Taylor AIDS Foundation. She was in a wheelchair, but she was as glamorous as ever in a Michael Kors gown, a fur-trimmed cape, and Van Cleef & Arpels diamond, coral, and amethyst earrings from Richard Burton.

It was the first time she had been on stage in twenty-three years, and she was terrified.

A group of antigay protesters from the Westboro Baptist Church Religious Ministry gathered outside Paramount. She was not thrown off; Elizabeth had been picketed before, including when she was supporting Eddie Fisher in Las Vegas and was told to go home by an angry mob. "Our traditions of free speech are to be revered and protected, and that extends even when a group uses this freedom to monger hatred of innocent people," she said. "This reminder of such ignorance and hatred of our fellow human beings forces us to redouble our efforts to address HIV and AIDS. Please pray for hearts which are filled with hatred . . . when the greatest need is God's love."

Leading up to the performance, she had to negotiate a pause in a writer's strike because she would not cross the picket line. The strike had gone on for about a month, with picket lines set up at every studio every day. Patric Verrone, who was president of the Writers Guild at the time, remembered his assistant telling him that there was an urgent call from Elizabeth Taylor.

"Immediately I stand up because that's what you're supposed to do when you're talking to royalty," he said.

When he answered she said, "Hello, I'm Elizabeth Taylor." He paused, not knowing what to say. "Do you

know who I am?" she added without any trace of arrogance, genuinely asking the question.

"The first thing that popped into my head was *National Velvet*. So I said, 'Of course, *National Velvet*.'" She seemed relieved.

"She was remarkably humble," Verrone said. She wanted to know if it would be all right if they performed during the strike. "She talked about how long she'd been in the business and how supportive she was of writers and the labor movement, but she said this was very important because it was a benefit for AIDS. No convincing was necessary." He told her that he would get back to her with an answer, and within an hour he told her that she could go ahead with the performance. They would not be picketing the Paramount Pictures lot that night. More than five hundred people paid $2,500 per ticket for the one-night-only performance. The play's director, John Tillinger, said there was lots of anxiety up until the night before about whether the show would go on. They had rehearsed with Elizabeth and James Earl Jones in Elizabeth's bedroom. "She was covered in jewelry in bed and her hands were shaking," Tillinger said. "Her hands were shaking because, she said, 'I'm so nervous about this.'"

Tillinger tried reassuring her and said, "You don't have to put all that jewelry on for us."

She replied, "I wear these for *me!*"

"I laid down on the bed next to her and turned the pages of the script because she had trouble turning them," Tillinger said. "The next thing I knew I was sitting next to her feeding her Ensure to keep up her strength."

Her first standing ovation seemed to stun her, but by her second she knew she had nailed the part.

There were aspects of her personality that became more exaggerated when she grew older, including her love of gifts and the game she made out of getting them. "She got in this habit throughout her lifetime of trying to get gifts out of people. I'm not sure what that was all about, but she was pretty shameless about it at times, and to be in her presence when she was trying to push someone to give her something was pretty embarrassing," said Chris Wilding. She asked Tom Cruise for a diamond tennis bracelet, and he was not sure exactly what she wanted so he sent her money instead. "I think it was, *Do I still have it? Can I still charm people?* Very few people were strong enough to say, 'Are you fucking kidding me?'"

Joan Collins was one of the people who could. Elizabeth wanted to borrow some of her bangle bracelets, but she wouldn't let her take them. "She had quite a reputation for wanting to take people's jewelry."

Anyone who came for a visit was expected to bring a present, said Chris Wilding. "Prince came to visit one day with a huge bodyguard who came in ahead of him. When Prince walked in he was clutching, rather defensively, a rose, like it was protection. And my mom came down and he seemed a little starstruck. And she went, 'Oh, thank you, you brought me a rose.' But it wasn't a gift, it was a Prince prop."

She had kept him waiting for a while. As she got older she spent ages doing her makeup, because, as Liza Todd Tivey said, "it seemed that it was increasingly painful to actually be in front of people."

She may not have dwelled on the past, but she enjoyed reliving it from time to time. She always kept Richard close to her heart; she loved it when the chandelier flickered in her bedroom, because she said that it was Richard coming to visit her.

Chapter 21
Dame Elizabeth

I'm not a movie star anymore. I guess I'm
still famous, but I can't really help that.

—Elizabeth

When the late Queen Elizabeth II made Elizabeth a dame, the female equivalent of a knight, in 2000, Elizabeth did not want to give back the brooch that signified the honor. Not even for one minute.

At Buckingham Palace, an aide to the Queen gathered the group of honorees, which included Julie Andrews, before the investiture ceremony to tell them what to expect. The Queen would fasten the brooch, shake their hand, and they were expected to curtsy and walk to a cross hall. There the brooch would be taken off and put into a box and handed back to them later.

"I want to wear mine!" Elizabeth interrupted.

There was nervous laughter and the aide seemed surprised. "You can wear it the rest of the week, the rest of the year!"

"I don't want to . . ."

He seemed puzzled and said, "You want to feel it in your hand so you can look at it and feel it."

"I want it on my chest," she said.

Andrews chimed in in a slightly scolding tone: "Elizabeth . . ."

The palace aide seemed amused. He looked at Julie Andrews and said, "You look after her." Marc Cherry, who created the series *Desperate Housewives*, drove Elizabeth to a July Fourth party in Malibu in 2000 and she told him, "Becoming a dame was the most exciting thing that had ever happened to me. Julie acted like it was something that happened every day of her life."

That was Elizabeth being herself no matter how grand the surroundings. She loved gifts, and that brooch, a testament to her years as an AIDS activist and humanitarian, was something she wanted to wear and admire immediately.

"Well, I've always been a 'broad,'" she said in a statement. "Now it's a great honor to be a dame!"

A palace official told Marion Rosenberg that everybody who was supposed to be off work that day came in to catch a glimpse of Elizabeth. "The entire palace

was in an uproar," he said. To him, Elizabeth Taylor was the most exciting person ever to set foot in Buckingham Palace. What she represented was old Hollywood magic.

When Moshe Alon did a walkthrough before the ceremony, he asked the palace how Elizabeth could get up to the second floor for the ceremony.

"Well," he was told, "we can carry her."

"There's no way that she's going to want you to carry her up the stairs. Don't you have an elevator?"

"Yes, we have a lift here."

"What's the problem with letting her go on the lift?" Alon asked.

"Oh," he was told, "nobody goes on the lift except the Queen Mother." Later that day, Elizabeth got permission. She was, after all, someone who had exchanged wits and jewelry with Margaret and was tended to by the Queen herself in 1976.

She hated being late, Mendelson said, but of course it happened all the time. She warned him when he was first hired that when she was getting ready for an event, she would be nervous and she might snap at him. "Don't take it personally, please," she said. "It doesn't mean a thing." But being late was out of the question when it was time to see the Queen. Elizabeth's reputation preceded her. Mendelson met with representatives

from the palace, who said that she needed to be there on time or else the gates would close. The Queen, obviously, was not going to wait for her.

"I literally took her mascara out of her hand and shoved her out the door," he said.

Elizabeth asked her friend Sarah Ferguson, the Duchess of York, who was once married to Prince Andrew, for an explanation of the difference between the official titles of "Lady" and "Dame." Dames are not allowed to use the title of Lady, unless they are married to a knight or a baron or are a life peer, whose title cannot be inherited. Because she lived in the United States, Elizabeth never thought she could have the honor and wanted to understand what it meant.

Trish McCaldin, who ran Malcolm Forbes's ten-bedroom mansion in London, Old Battersea House, remembers Elizabeth and her family coming for dinner after the ceremony. Elizabeth asked for a pair of slippers and a cardigan, and she requested her favorite English dinner: roast pork with double crackling, potatoes mashed with plenty of butter and cream, and green beans topped with a generous portion of gravy. She had bread-and-butter pudding with cream for dessert and seemed happily exhausted. After dinner she went back to the Dorchester, where she and her party were staying, clutching a doggie bag of leftover crackling.

When her grandson Quinn came to visit and he called her "Grandma," she corrected him in a play-fully teasing tone and said, "That's '*Dame* Elizabeth' to you."

"It was tongue in cheek at home, but I know it meant so much to her," Quinn recalled.

As she got older, in her seventies, Elizabeth got sick of being confined to her bedroom suite. She wanted to get out of the house, so Tim Mendelson would take her to the Abbey, a sprawling gay bar in West Hollywood, where she would sit in the back wearing her rhinestone sunglasses and knee-high boots, the more over-the-top the outfit the better, and discreetly sip watermelon martinis. Her security guard at the time, Ziv Ran, said that she was able to see how her work as an activist had helped change the reality for a generation of gay men. "I can't tell you how many gay men came up to her—dozens and dozens." Many had tears in their eyes and went on bended knee so that they could be on eye level with her as she sat in her wheelchair. They said, "You don't know this, but you saved my life."

"Thank you, love," she told them, clearly moved. "It was my pleasure."

When Elizabeth told the founder of the Abbey, David Cooley, that it was her favorite pub, he had a

plaque made in her honor. "People steal it," he said. "We've screwed it on. We've glued it on. Nothing works. I think it's a symbol to people—that she loved us as much as we loved her."

Even though these later years were much quieter, she had access to a rich emotional life as she drew from her memories. Every Yom Kippur, the holiest day of the year for the Jewish community, she would call Ziv Ran into her bedroom and ask him to light a candle and read the Kiddush prayer for Mike Todd. "She wore huge crosses on her neck [later in life she took to wearing large bejeweled ones], but she considered herself Jewish," Ran said. "I always made sure that I was working on Yom Kippur so that we could do this together."

Another deeply emotional experience took place at Buckingham Palace in 2010, when a bust of Richard Burton was unveiled at a gala marking the sixtieth anniversary of the Royal Welsh College of Music and Drama. She was seventy-eight years old and wheelchair-bound, and it had been three decades since she had divorced Richard for the last time and more than twenty years since his death, but the striking bronze that was made for the foyer of a new theater named in his honor at the college in Cardiff, Wales, overwhelmed her.

Prince Charles asked her, "Do you think it's a good likeness?"

"Marvelous," she said as she dabbed her eyes with a tissue.

She kept busy and she still loved life, but it became harder for her to get around and she was in pain much of the time. Her manager and friend, Jason Winters, helped her create House of Taylor jewelry, a signature line of midrange and high-end jewels. Winters and Elizabeth had fun together, and Elizabeth loved using her vast knowledge and passion for jewelry to create new designs. She liked to test-drive her creations.

"The whole housekeeping staff was decked out," said her lawyer Barbara Berkowitz. "I had never seen people scrubbing toilets wearing diamond bracelets before."

Elizabeth traveled to Hawaii with Winters and his family and swam with sharks when she was seventy-four years old and mostly in a wheelchair, but, Mendelson said, "You could not talk her out of it. She loved animals, and that included sharks." When she was told to take off her diamond jewelry because the light from the stones might attract too many sharks, she said, "But isn't that the point?" She kept the diamond bangles on. She wanted to show people that even with incurable heart failure, osteoporosis, three hip replacements, and agonizing back pain she was enjoying her life.

"She grabbed life by the neck and shook it pretty hard," said her friend Robert Wagner.

Mendelson and others helped her get into the 10-x-6-foot plexiglass cage and watched in astonishment as she plunged under the surface of the Pacific Ocean. "The tabloids had been trying to put her in the ground for years," he said, "but she loved life too much. She wanted to live it to the fullest until the very end." She liked to say that she was "a full-fledged person," no matter her age or how she was feeling.

"During her last years," said her grandson Quinn, "she was committed to living."

But she was also afraid of loneliness. So when her old flame Bill Pawley, the first man she was ever engaged to, called her when he was in his eighties and Elizabeth was in her seventies, she called him back. She wanted to see if there was anything worth salvaging. But by the time they started talking again she had grown so accustomed to being used and manipulated that she came to question his motivations.

When he visited her in Bel Air she was in bed—where she spent much of her time—and he presented her with the letters that she had written him when they were young and in love. It was a sweet gesture to know that he had saved them, until he suggested that she buy

them back from him. She was disgusted. "Now I realize why I stopped going out with him," she said.

Colin Farrell, who had once dated Britney Spears and who is known for his rugged good looks, was an unlikely companion for Elizabeth, who was more than four decades his senior. But in 2009 they met when Tim Mendelson introduced himself to Farrell while Elizabeth was at Cedars-Sinai having a heart procedure and Farrell was at the hospital for the birth of his son. Afterward, Farrell got in touch with his agent and asked if she could arrange a visit with Elizabeth; he could not stop thinking about her after he got home from the hospital.

Elizabeth was intrigued. His Irish brogue and reputation as a nonconformist reminded her of her beloved Richard. In Richard, she had once said, she discovered "that sense of poetry and wildness."

Farrell needed to meet her. He asked his agent if she could send Elizabeth flowers, and she told him that Elizabeth had just sent him orchids. "I thought that was fucking amazing. It's on! I don't know who threw down the gauntlet, but it was thrown and it shall be answered," he recalled with a playful smile. A few weeks later they met.

He went to Nimes Road on a Saturday afternoon and brought along a book of poetry by William Butler Yeats, which he had inscribed to her. He waited an hour in her back garden before she came downstairs. "She came out looking so magnificent. Hair fucking as high as the Sears Tower, made up beautifully. She was just gorgeous and radiant and vital. She was in a wheelchair, Tim brought her out to me. There was dynamism there until the end that was just extraordinary."

As he was leaving he leaned down next to her for a photograph, and he told her that if she ever wanted him to come back and read poetry to her he would happily oblige.

She grew quiet, nodded and whispered, "Richard used to do that."

Afterward, Elizabeth wrote to Farrell, "What a pleasure it was to meet you. And thank God . . . you really are a true Celt. You remind me of so many good things . . . so many happy things. Thank you for being so very real."

He came again and again to read to her. He sat in an armchair beside her bed and she occasionally played recordings of Richard reading poetry. His booming voice was piped in through speakers in the room, and Farrell said that it felt as though Richard were there. She would close her eyes and relive her life with him.

When the applause of a live audience came through the speakers she smiled.

"I fell in love with her," Farrell said. "In my short time with her I got a sense of how magical it may have been to have loved her in a romantic way. And to have felt the romance of her romantic love." Though she was in increasingly poor health, Farrell talked about planning lunch at Big Sur and a helicopter ride to Santa Barbara for the afternoon. He wanted her to have something to look forward to—but he also genuinely wanted to do those things with her.

They were both insomniacs, and sometimes he would call her house at two or three in the morning, and her security guard would answer and thirty seconds later she would pick up. "I was aware that I was a thirtysomething fellow from Dublin that was on the phone with one of the most amazing human beings to walk the planet." They sent hundreds of texts to each other during the course of their two-year-long friendship. Elizabeth's grandson Quinn, then in his twenties, remembers teasing Farrell and calling him "Papa Colin."

"I think she probably hoped that she might get him into bed, but he played along in a sweet flirtatious way," said Elizabeth's son Chris. "Even when she was old, she was still young at heart."

Farrell remembered how upset she was during a

phone call after he came back to Los Angeles after a trip to London. He was going through a difficult period in his life, he said.

"Where are you?" she asked him.

"I'm here in Los Angeles," he said.

"When did you get back? I thought you were still in London," she said, sounding annoyed.

"I got back a few weeks ago," he told her.

"Why didn't you call?"

"I was in a place where I wasn't in a good mood, I wasn't in a good headspace and I didn't want to burden you with that."

"How am I supposed to be your friend if all you ever are is in a good mood and sunny?"

"You're right," he said. "It's just times like these I don't enjoy my own company."

She replied, "That's when you need friends and people to lean on, and that's what I'm there for. So if you want to be friends, cut that shit out."

He was giving her something extraordinary in return, vitality at a time when she was feeling old and sick. Elizabeth loved how brash and tough and yet kind and romantic he was; it was the same with Richard, who could be tender and loving one minute and brooding and cruel the next. She wanted to see the younger

version of herself in his eyes. Yet once, when he was visiting her at home, he sat next to her as she was lying in bed and he stroked her hand. "Stop rubbing me," she snapped. "I'm not a pet." She did not want to feel like he was taking care of her and he got the message.

Mendelson remembered watching Farrell take Elizabeth out on a dinner date to the Polo Lounge. "Moving Elizabeth had become a group effort at this point in her life. Just going out took a nurse, security, and me. But Colin picked her up, threw the wheelchair in the back of the car, and they sped off alone. It was really cool to see. Seeing them interact with each other was magical."

When they walked into the Polo Lounge, a restaurant that she had been going to since she first became a star in *National Velvet*, everyone turned to look at her. "She wanted to have chocolate-covered strawberries and caviar and all the things a woman like Elizabeth should be dining on the regular. She was a sensualist," he said. "Her figure was so womanly and Rubenesque and feminine yet she could outcurse, outshine, outlove, and I'm sure outfuck. She was just such a huge power. That was reflected in all her appetites."

Of course jewelry was a great love of her life, and Farrell gave her a diamond pendant necklace by Harry Winston. He knew that lavishing gifts upon her, just

as Richard had done decades before, would make her smile, and that is what he wanted to do more than anything.

Elizabeth longed to give people what they wanted to see, but it was hard to put the pieces of the puzzle back together. She had been diagnosed with incurable congestive heart failure years before and she was in a great deal of pain. Joan Collins, who spent much of her life being compared to Elizabeth, put it well when she said, "The problem with beauty is that it's like being born rich and getting poorer." There was no way to escape it. And though she may not have spent time wallowing in that reality, Elizabeth missed her youth.

Society photographer Richard Young got his big break when he took a photograph of Elizabeth kissing Richard at his fiftieth birthday at the Dorchester Hotel in London in 1975. Elizabeth noticed him and told him in no uncertain terms to leave. But he sent her the photograph, and she loved it so much that she started inviting Young to events to photograph her. But he remembered seeing her the last time at an amfAR event at Cannes in a wheelchair and looking unwell. He refused to photograph her.

"She looked at me as if to say, 'Why aren't you taking my picture?' I looked at her and the look on my face I

think said it all: 'I love you, and I don't want to photograph you like this. I'm sorry. This is not how I want to remember you.'"

People wanted to remember her as she was. Thirty years after *Raintree County* was released, Bob Dylan wrote Elizabeth a note from a hotel he was staying at in Chapel Hill, North Carolina. In it he captured how meaningful her life and her memories were to the story of Hollywood and the movie industry itself.

"I want to see you and talk to you again," he wrote. "I want to talk about Montgomery Clift, James Dean, George Stevens, all that stuff . . . this was just a quick note to say that I'm thinking about you and all the history that you carry with you." He wrote that he had just watched her in *Ivanhoe*. "In every movie you're a queen. In real life too."

To Dylan, and to so many of her fans, Elizabeth was captivating, not only because of what she personally accomplished as an actress, but also because of the legends who were her friends and who, at least in George Stevens's case, were occasionally her enemies.

The last time the photographer Gianni Bozzacchi, who captured so much of Elizabeth and Richard's wild romance in the 1960s and early '70s, spoke with Elizabeth was a few weeks before she passed away. She had always loved his dirty jokes.

"Gianni, do you have a new one?" she asked during a phone call in a small tired voice so unlike herself.

"Of course," he said. "I saved this one just for you."

"What are you waiting for then?"

"We're in a small town in Sicily, you understand?" She was already laughing.

"Two old men, very old men."

"*Vecchi!*" she said, the word for "old" in Italian.

"Yes," he said. "*Vecchi!* Well, these two old guys are sitting outside a bar in the center of town. 'Have you heard about this new medicine?' says one to the other. 'It's a blue pill, blue like our sea.' 'What are you talking about?' 'Viagra!' 'Ah, Viagra, and what does it do?' 'Well, they say it keeps your dick hard for a full two hours!' 'Okay, so it's a sedative.'"

Elizabeth's great cackling laughter came roaring back. "You don't happen to have that second guy's number, do you?"

She kept in touch with John Warner and Ardeshir Zahedi from her Washington years. Zahedi remembered their last conversation too. "I talked to her about ten days before she passed away when she was in the hospital. She said she was tired, and I was actually in tears." No one wanted to see her suffer any more than she already had.

Mendelson broke down crying when one of Elizabeth's nurses called him from the hospital to say that

her kneecaps had shattered. "I cried because I knew that it was the end." She had late-stage osteoporosis, and she could not walk or move around with shattered kneecaps. The pain was intense. He took her on weekly trips to the hospital to get her lungs cleared, but inevitably her body was breaking down. Still, Elizabeth was preparing for a trip to New York for a fundraiser for her beloved amfAR, where she was being honored along with Bill Clinton and Diane von Furstenberg.

But she never made it. The day that she went to the hospital for the last time she was told by her doctor that the numbers from her bloodwork were so bad that she should be rushed to the emergency room immediately. She went, but not before José Eber teased her hair high, just as she liked it, and she did her own makeup, as usual.

Her children went to visit her in the intensive care unit—and so did Colin Farrell. He wanted to get her home so that she could pass away there. Mendelson said that he did too, but she remained in the hospital. Once they learned that there was no chance of survival, Farrell said to Mendelson, "Let's get a fucking ambulance and I'll just wheel her out. They can't stop us." But they could. Elizabeth was in the hospital for six weeks before she died of congestive heart failure on March 23, 2011, at seventy-nine years old.

She had been in and out of the hospital so many times that it was hard to believe that she was gone. The people who worked for her, including Mendelson, were completely devastated. "I had been trying to prepare myself. How was I going to deal with the fact that one day that gate [leading to her home in Bel Air] was not going to open for me? I could never get enough of her."

He wished she had been able to die at her home, which was so warm and inviting, instead of in a sterile hospital room. "I was there when Chen died and we held hands. I asked Elizabeth then if it bothered her being in the room with a dead body and she said that it didn't," Mendelson said. "When Elizabeth was dying I held her hand in the hospital. It was so heartbreaking that she couldn't die at home. She was never done living." She had so many great loves, and yet she was buried alone. In her heart, she wanted to be buried with Mike or with Richard, but Sally Burton would not have been happy with the idea of her being buried with Richard in Céligny. Elizabeth knew it was out of the question, so she dreamed of being buried in Wales; at least it would give her a connection to him. And while she talked about wanting to be buried with Mike, she could not escape the horrifying memory of what had happened to his remains. She did not want what happened to him to happen to her.

She had been struck by the peaceful beauty of Forest Lawn Memorial Park in Glendale when she attended Michael Jackson's service there. Other celebrities are buried within its lush three hundred acres, including her friends Spencer Tracy and Sammy Davis Jr. So that is where she was ultimately buried, behind an enormous white angel with outstretched arms.

Following Jewish tradition, a service was held with fifty members of her family and her closest friends right after she passed away. There were threats from members of the Westboro Baptist Church to protest the funeral—the daughter of the group's leader launched attacks on Twitter: "No RIP Elizabeth Taylor who spent her life in adultery and enabling proud fags." Elizabeth, it seemed, was still rankling them, even after her death. She would have loved it. She was always herself—in her will she stipulated that any funeral or memorial service start fifteen minutes late. At the funeral, surrounded by her closest friends and family, Colin Farrell recited Elizabeth's favorite poem, which was also Richard's favorite, "The Leaden Echo and the Golden Echo" by Victorian-era poet Gerard Manley Hopkins. It is not difficult to see why Hopkins's poem, with its theme of surrendering mortal beauty to God, meant so much to Elizabeth, who had always refused to be defined by her physical beauty alone. After the

funeral a small group gathered in Bungalow 5 at the Beverly Hills Hotel, which had once been Elizabeth's sanctuary and the place she ran to when she was trying to get away from the press.

Seven months after she passed away, there was a private memorial held on the Warner Brothers lot in Burbank. Farrell was the master of ceremonies, and before he walked into the service, he sat in his car in the parking lot going over what he was planning to say again and again. Elizabeth had meant so much to him, he wanted to get it right for her. "It's easy for me to forget that we were friends," he said, "or to think of it as a fever dream." A rendition of one of her favorite songs, "You'll Never Walk Alone" from the musical *Carousel*, was played and Sir Elton John sang in front of an audience of four hundred guests, including Michael Jackson's children, who paid tribute to Elizabeth's grace and unshakable humanity.

"To say that the world got smaller, emptier, darker, and lonelier when we lost Elizabeth is an understatement," said John. "She was a true rock, a pioneer, a pathfinder, a trailblazer, and a star who will always burn bright and always had time to laugh at herself."

Elizabeth wanted to be buried in all white and she was, in a white Badgley Mischka embroidered caftan and a white evening coat with a white fox collar, an

outfit that she had planned to wear to the amfAR event where she was to be honored shortly before she had to go to the hospital.

She told Mendelson that she did not want to be buried with any of her beloved jewelry. "Jewelry was such a passion for her that I couldn't imagine it," he recalled. "It made me sad to think that after all those years of helping her choose jewelry, I wouldn't get to do it for her one last time. I asked again, 'Not even costume?' and she shook her head and said, 'No.'"

Chapter 22
The Auction: "The Memory Always Brings Back a Stab of Joy, of Love"

*As I look at my jewels, I realize
what a lucky girl I am.*

—Elizabeth

She had always thought of herself as a temporary custodian of her magnificent jewelry collection, and she put most of it up for auction. "I wanted to share my collection with others so that they could get a glimpse of the joys, the thrills, and the pure happiness that these beautiful creations have given me," she said.

A record-breaking auction of her belongings was

held at Christie's in New York between December 13 and December 16, 2011, less than a year after her death. Elizabeth is believed to have had the most valuable private jewelry collection in the world. The auction was so important that Christie's employees who were considering retiring or switching jobs waited until it was over because they wanted the event on their résumés.

The first night was the evening jewelry sale, the auction of her most celebrated jewelry, which included eighty pieces. Christie's opened the auction with home-video footage of Elizabeth sitting poolside in Bel Air bidding on the Prince of Wales diamond brooch. There was an electric feeling in the room.

The most coveted pieces were gifts from Richard and Mike, including the La Peregrina pearl, the Taj Mahal diamond, and the dazzling ruby Cartier earrings, necklace, and bracelet that Mike Todd had given her poolside when she was pregnant with their daughter Liza. There was a frenzy, with buyers from thirty-six countries vying for the chance to own a piece of Hollywood history. The 33.19-carat Krupp diamond, renamed the Elizabeth Taylor diamond, sold to a South Korean conglomerate for $8.8 million, about three times its estimate, setting a record price per carat for a colorless diamond. The sixteenth-century pear-shaped La Peregrina pearl sold for $11.8 million; the estimate

had been between $2 and $3 million. The tiara from Mike Todd went for $4.2 million, breaking the world record for a tiara.

That evening alone took in almost $116 million. The black-tie auction lasted for more than eight hours as the auctioneers traded positions in a room that was crammed with close to five hundred people. Her total estate, including clothing, topped a hammer price—the winning bid for lots sold at an auction—of more than $183 million. It was the most valuable sale of jewelry in auction history at the time. Most items sold for more than ten times their highest estimate. The low estimate for the entire sale was approximately $20 million, but the total for her jewelry alone was $144.2 million. Her art was sold separately at Christie's in London in 2012. Three of the most valuable paintings sold for nearly $22 million, including a landscape by Van Gogh for $16 million.

Christie's jewelry specialist Daphne Lingon called it "the most memorable auction of my career." Thousands of people flooded Christie's in New York every day to get a glimpse of the world-famous jewels on display. The most coveted jewels were the blingiest, but some of the less expensive but very personal items sold well over their estimate, including an ivory-and-gold necklace of eighteenth- and nineteenth-century engraved ivory opera passes that costume designer Edith Head

left Elizabeth in her will. The necklace was estimated to sell for between $1,500 and $2,000 and ended up going for $314,500. The retro costume pin Elizabeth bought her mother for $25 ($380 in today's dollars) in the 1940s, and was the very first piece of jewelry that Elizabeth had ever bought, sold for $74,500. It was estimated to sell between $1,000 and $2,000. But the pin included a touching thank you note from Elizabeth's mother.

"The most extraordinary part of the sale was the room of jewelry boxes," said André Leon Talley. "The jewelry boxes alone were works of art." Each box was meticulously labeled and each label told the story of Elizabeth's exuberantly lived life: "Mike Todd Diamond Tiara," "Ping Pong Diamonds," and "Granny necklace" (inside was a Van Cleef & Arpels gold-and-diamond choker with a diamond lion's face set with marquise-cut emerald eyes that Richard had bought her when she became a grandmother at thirty-eight years old). Elizabeth lived the life of a princess or a duchess from another country and everyone wanted a taste of it.

She had the best of everything made by the best jewelers in the world, including Boucheron, Bulgari, Van Cleef & Arpels, Jean Schlumberger, JAR, and Cartier. Hers was one of the most perfect jewelry collections there ever was.

"This was a mix that I have never seen in my fifty years at Christie's," said Christie's Europe chairman François Curiel. "I've seen important jewels belonging to anonymous people, or people who did not want to have their names made public, I've seen famous people selling jewelry of often average quality, but I have never seen a famous person selling top-quality jewels."

The chairman of Christie's, Stephen Lash, was struck by how smart Elizabeth was. "She brought to collecting jewelry the disciplines instilled by her father in collecting art. You don't get a lot of sympathy when you say that collecting is hard work, but collecting can be hard work if you're going to do it well. And she did it very well."

The groundwork was laid for this historic auction decades before Elizabeth passed away. In the late 1970s, Lash began conversations with Elizabeth's business advisers that continued for years, and they discussed her legendary jewelry and also her paintings, including a very valuable Frans Hals. In 1998, Curiel, who was then head of Christie's jewelry department, went to Elizabeth's Bel Air home to look at her collection and offer an estimate of its auction value. Sotheby's, Christie's biggest rival, also sent specialists to her home.

Curiel and two of his colleagues arrived at her home at 9:00 a.m. and sat at a large dining-room table with

jewelry boxes covering absolutely every inch of it. They began taking photographs and cataloguing each piece.

"I didn't dare ask whether she would come, but from time to time we heard some noise on the second floor of the house," he said. "And suddenly, at eleven o'clock, Elizabeth Taylor comes down the staircase in a caftan. She sat down with us and spent the rest of the day looking at each piece of jewelry. And what fascinated me most is that she knew each piece extremely well. At one point we were looking at a sapphire and she said, 'This sapphire looks like a Kashmir sapphire but in fact it's not a Kashmir, it's a Burma stone. The inclusion tells me it's Burmese. It was sold to me as a Kashmir and I'm not happy at all about it.' I was fascinated. It was like talking to a professional. The whole day was like that, she knew every jewel by heart, she knew who gave this one to her, who gave that one to her. She said that Eddie Fisher didn't understand anything about jewelry. 'He thought he was giving me a great gift, but look at the quality of the stone,' she said as they examined a piece. 'It looks big, but it's bad quality and the poor man didn't know. I'm sure that he was taken advantage of.'"

She knew the geographical origin of the stone, the quality of the stone, the way they are cut, and Curiel was astounded. "I spent a day there with someone who really

knew stones and with whom I could have very interesting discussions. Normally people say this is by Van Cleef & Arpels, or this is by Cartier. They don't really know their stones. It was like sitting with a jeweler."

Every jewel that had been offered to her by Mike Todd or another husband had a little tag with her handwriting on the box. The jewelry boxes labeled "Richard Burton" and "Mike Todd" had a certain effect on her—the memories came rushing back. They were never far from the surface in the first place. She told Curiel when each gift was given to her and what each one meant to her. It struck him that it might have been the first time that every single piece was laid out on a table all together.

Christie's went all-in trying to clinch the deal to be her auction house. Nancy Valentino, who worked for Christie's and who had worked on the then record-breaking auction of "The Personal Property of Marilyn Monroe" in 1999, went to Elizabeth's chalet in Gstaad in 2000 to take inventory. "She hadn't been there in seven years, and it was like someone had made toast in her kitchen that very morning. There was hair in the hairbrush. It was like they [the Burtons] never left!"

Chalet Ariel represented her life with Richard, a life of marriage and children. Valentino was accompanied by Chris Wilding, Liza Todd Tivey, and Tim Mendel-

son, and they had Elizabeth on the phone as they went through the house deciding what should be kept and sent to Bel Air, and what to sell. Elizabeth knew exactly where every piece of furniture was. They had only five days to clear out the entire house, which had already been sold, and to find out what was worth including in the auction. It was emotional for Elizabeth's children, who had considered Gstaad their refuge from the world and their mother's immense fame and tumultuous personal life. It was the only home they had known; the rest of the time their mother lived on a yacht, in elegant hotels, and in homes that she did not keep for long.

There was a room devoted to jewelry, and Valentino catalogued well over three thousand pieces. The house was jammed with Elizabeth and Richard's possessions, including seventy-two wigs from the 1960s kept in one of the closets.

Christie's was working hard to win Elizabeth's trust and even threw a party at Christie's in Rockefeller Center to celebrate the release of her 2002 book, *My Love Affair with Jewelry*. They understood that her jewelry told the story of her life. To mark the publication of the book, some of her jewelry was supposed to go on display in Europe, but she could not let them go, so the pieces were sent back to Los Angeles. Each piece was like one of her children, she said. She would

part with them eventually, but only after she was gone. They meant too much to her.

Jennifer Tilly, a major jewelry collector, remembered the excitement of the auction. "I always wanted a piece of jewelry from her *Cleopatra* period because I'd read about how she used to hang out on the Via Veneto in Rome and go into the Bulgari store, where they'd open vats of jewels. That was when she was falling in love with Richard Burton, so I wanted something from that period." But the auction prices were getting too astronomical, she said, with Bulgari buying back some of its pieces, so she ended up buying a yellow-and-white diamond brooch that was from Eddie Fisher. "When they split up, she paid off the bill for the brooch, which was amazing because she never paid for her own jewelry. So I figured she must have really loved this brooch!"

She put it on her bedside table. "I had sparkly glittery dreams of being a huge movie star desired by millions of men, walking down the Via Condotti, sitting in the money room with Gianni Bulgari. I woke up and I went, *It's a magic brooch.* I felt like Elizabeth loved it. In a weird way I felt like she came to me in a dream and said, 'I'm so happy you have this.'"

Elizabeth would have liked to know that her jewelry was being appreciated by its new custodians. Before the sale, the jewels went on an eight-city global tour—

Moscow, London, Los Angeles, Dubai, Geneva, Paris, Hong Kong, and New York—over three months, with record crowds in each city.

For Elizabeth, jewelry was always about where she'd been and the people she'd loved. Since she did not put her jewelry in a vault and save it for special occasions but wore it every day, it felt like a part of her, and everyone wanted a piece, even after she was gone.

Afterword
Lust for Life

In my life, I have never, God knows,
done anything by half measures.

—Elizabeth

When John Warner talked about Elizabeth his eyes shone with a faraway look, as though he could see something in the distance that no one else could. "We cut a good figure together, didn't we," he said during an interview in 2019, as we sat in his elegant wood-paneled home office outside of Washington, D.C. He was ninety-two years old, and they had been divorced for thirty-seven years. He was remembering how smart and wickedly funny she was. One morning, Warner said, he was rushing out the door to the Senate, and he cut his face shaving so he put a piece of toilet paper on it to stop the bleeding.

She said, "What's that?" He told her, and she said, "Dammit, from here on think of your face and cut your damn speech!"

"God, she was so quick on the draw," he said, shaking his head in admiration.

Elizabeth was not perfect, she never claimed to be. But she tried to be a good person. Roddy McDowall's dying wish was for Elizabeth and Richard's first wife, Sybil, to make amends. He was friends with both of them, and in 1998, as he lay in bed in his Los Angeles home near death, they fulfilled his wish. On the way to his house Elizabeth was nervous; it was hard to find the words. Sybil and Elizabeth sat on either side of him each holding one of his hands. She and Sybil cried and hugged each other, and when Elizabeth left she felt relieved. Elizabeth left Sybil a pearl-and-diamond bracelet in her will that Sybil's daughter, Kate Burton, inherited. Her life had indeed come full circle.

She was a very real woman whose alter ego, the commodity created when she was twelve years old, was the most famous actress in the world during the twentieth century. As the gossip columnist Liz Smith once noted, "Whenever somebody says, 'So and so is a big star,' I say, 'Have they been condemned by the Vatican?'" She had a hunger for more love, more jewelry, more men, more food, more painkillers—everything was always more,

more, more. More fun. You never knew what she was going to do, and her kind of joie de vivre was infectious.

John Travolta remembered her doing the best imitation of a mutual acquaintance at an afternoon party at her house. "I realized that, like Marlon Brando, she was about the fun of life and not the seriousness of it. If you're going to get together, let's laugh and let's enjoy. It defined her for me in that moment. It's what I confirmed in Brando and it's what I confirmed in her: It's the spirit of play that's more important than anything else, it keeps you going because the seriousness is going to be there. Let's face it, tragedy and drama is all around us, and whether we like it or not, it happens. But you can create humor and happiness. The other happens whether you like it or not, but the joy of life has to be invented. And she was great at that, she was creative with the parties she threw. It's a rarefied energy. She went outside the box of what life offers."

Elizabeth never took herself too seriously. During the 1999 interview, Barbara Walters asked her what she wanted written on her tombstone, and Elizabeth replied, "'Here lies Liz, she lived.' No, I don't like Liz, I hate that name. 'Here lies Elizabeth, she hated being called Liz'"—she said with her signature exuberant laugh—"'but she lived.'"

She and Whoopi Goldberg became friends, and

Elizabeth imparted one important piece of advice that Whoopi never forgot. After she did the epic film *The Color Purple* in 1985, she met Elizabeth at a book party. She suddenly heard "Psssst" over her shoulder and turned around to see Elizabeth. "I'm thinking to myself, *Did Elizabeth Taylor 'Pssst' me?*" She walked over to Elizabeth.

"I was almost going to yell your name out," Elizabeth said. "How the fuck are you?"

"I'm fine, how the fuck are you?" she said.

"I know your manager is Sandy Gallin. You need to tell him that you should get a gift every time you work, and you know you're black, right?"

"Ummm, yeah," Goldberg replied.

"A career goes up and down and your career may go up and down a little more than everybody else's [because of how racist Hollywood can be]. You want to be able to look around and see the things that you've been able to amass because, quite frankly, you will have put your agent's kids through college, you will have put a new face on your publicist's wife, everybody will be doing well because of you. I want you to be able to look around and see that you did well too."

"I love that," Goldberg said, "but you're Elizabeth Taylor and you can probably do that, but they're not going to do that with me."

The next day Gallin called Goldberg and said, "What did you say to Elizabeth Taylor?"

"She was explaining to me that I need to get a gift every time I worked because everybody would be making money off of me," she told him.

"You realize what's happened, right?" he said.

"No," Goldberg replied.

"She's called all of her friends and told them that if you go to work for them that they're to make sure that you get a little something."

Years later, Goldberg still loves to tell that story. "I look around my house and I see what's here and it's because of her," she said. "I never would have thought to do anything like this for myself. I would never have art, I would never have moved my mind forward to see what the future could bring. No one teaches you that. When you have a genuine movie star say to you, 'Kid, this is what you need to do,' there's nothing better than that. From that point on there was always a little cash put aside for me and I would tell them what I wanted and they would get it. It was kind of fantastic."

It was Elizabeth's understanding of who she was, apart from her appearance, apart from the commodity of Elizabeth Taylor, that gave her the ability to survive Hollywood's unforgiving standards of everlasting youth and never-fading beauty. She had this

advice to share with younger women in the business: Keep your own identity and don't try to be anyone else. She knew instinctively that in order to survive, and to thrive, she needed to keep parts of herself private. She always seemed to know innately how capricious the public was, how quickly they could turn on someone—especially a woman. After the trauma of Mike Todd's death she saw firsthand how life can change in an instant. She told Richard Meryman, "I lived in a world of gauze, it's very deceptive that kind of world because I think you probably get hurt much easier because you haven't learned to build up your own resources. You haven't learned how to take care of yourself, and there's always a moment when there's nobody but yourself to fall back on."

She helped other women when she saw that they were being mistreated, including women who were not in show business. Barbara Berkowitz, now one of the trustees of Elizabeth's estate, met Elizabeth in 1989 when she was a young lawyer working at a prestigious Los Angeles law firm that represented Elizabeth. It was primarily run by men, and Berkowitz said that she and the other women in the office were paid less for the same work as their male colleagues, and they were strongly encouraged to wear skirts so that their legs could be ogled. "I became skilled at ducking be-

cause the senior partner would throw things at me and scream," Berkowitz recalled. She felt sick to her stomach every day on the drive to the office.

Without telling Elizabeth why, Berkowitz explained that she was looking for a new job. They spent hours sitting by Elizabeth's pool strategizing what to do and "just as she dealt with the studios," Berkowitz recalled, "she was going to deal with my boss." Elizabeth told Berkowitz's boss that the only person she wanted to work with at the firm was Berkowitz.

It appeared that Berkowitz's boss was promising young female lawyers that they could work on Elizabeth's matters, and meet her, with the hope that they would date him. Elizabeth was disgusted. "No more young women to accompany him to meetings, to her house, or to do her work. And no more him. Just me," Berkowitz said. "She would not tolerate his behavior." Elizabeth encouraged Berkowitz to open her own law firm soon after and, Berkowitz said, "as scary as that was, at her insistence I opened my own doors right after Independence Day weekend 1997. How appropriate, as she was my liberator." Elizabeth became her first client.

"She appreciated strength in people. She was so strong—she taught me to watch what was going on and that you don't have to be loud to be effective. Watch

more, listen more, and speak less. And don't take shit from anyone. . . . Above all else—she taught me the profound effects of being kind, and to use whatever resources you have to help someone."

Her giving spirit is what strikes so many people who knew her. Tim Mendelson remembered Elizabeth insisting that his mother, who was very ill, move into her house. She went from the hospital straight to Elizabeth's Bel Air mansion, and she stayed in a beautiful bedroom on the first floor overlooking the garden. "If I could think of somewhere where I would like to take my last breath, I would choose that very room," said Colin Farrell.

She told Mendelson, "I want to be here for you." And she was.

Elizabeth rarely apologized for what she wanted. If she was in a movie and her character was wearing a fur coat, she made it clear that she would be taking it home with her. Once, John Warner said, when the director had the temerity to try to take it back, she refused. She may have anticipated his reluctance, so in that scene she only had on a bra and panties underneath the coat. She opened the coat to show him, closed it, and whispered in his ear, "Good-bye old boy," before walking triumphantly off the set.

She enjoyed her excessively glamorous lifestyle.

Dominick Dunne remembered attending one of Swifty Lazar's Oscar parties in the 1980s and the good fortune he had to be sitting at a table with Elizabeth Taylor and Audrey Hepburn. He watched as they called out each other's names and leaned across the table to kiss each other's legendary faces. Hepburn, waif-thin, was wearing a black Givenchy evening gown, and Elizabeth had on her biggest jewels.

"Kenny Lane?" asked Hepburn, referring to the famous costume jewelry designer Kenneth Jay Lane and pointing at the huge diamond necklace decorating Elizabeth's décolletage.

"No, Mike Todd," Elizabeth answered.

"Kenny Lane?" asked Audrey, pointing at the giant diamond ring.

"No, Richard Burton," she said. They squealed with laughter and leaned in for another kiss on the cheek. Life, in Elizabeth's eyes, was meant to be enjoyed and very few things, including incredibly expensive jewelry, were to be taken too seriously. "I know it's vulgar," she said of the Krupp diamond, "but would you have me any other way?"

Berkowitz remembered, "Even at her funeral I tried to keep it together and be professional," she said. "But when I handed the Krupp diamond to Christie's in preparation for the auction, I lost it. She wore it every

day—whether she lounged in bed or went out on the town. And she loved to let people try on her jewelry—especially the Krupp. The Krupp was so Elizabeth, and taking it out of her house after she died was heart-breaking for me."

Elizabeth's glamour is still intoxicating. "It's spectacular," said her makeup artist, Francesca Tolot. "The image of Elizabeth Taylor all made up with hair and makeup lying in a bathtub before going to the Academy Awards. To me, it can't get any better than that!"

Warner said that one of Elizabeth's favorite phrases was "Let's kick on," a British phrase which means "carry on" or "persist." And that is what Elizabeth had done throughout her life: She persisted, no matter how much pain she was in. After Mike Todd's sudden death she showed up to work to support her family even though the psychological pain lasted for the rest of her life; no matter how much physical pain she was in, she showed up to work; and when she knew there was a group of people who were being ostracized and dying alone, she would not look away.

From the age of nine, her life was defined by camera angles, stage marks, and call sheets; the way she survived was by keeping a part of herself private and realizing how unreal the world of tinsel and cellophane always was. Elizabeth's advocacy helped save tens of

thousands, if not hundreds of thousands of lives. Her life was always about so much more than being a celebrity. According to the World Health Organization, since the beginning of the pandemic, 79.3 million people around the world have been infected with HIV and 36.3 million people have died of AIDS. At the end of 2020, 37.7 million people worldwide were living with HIV. When new treatments were introduced in the midnineties, deaths from AIDS started to decline. Now a person in their twenties who is diagnosed as HIV positive, who has access to the newest medication, can have a normal life, which includes not being able to sexually transmit the virus to others. Elizabeth contributed to this sea change.

She wanted to make sure that her work would continue even when she was gone. She provided that a portion of the revenue generated from her name and likeness, including her fragrances, go to The Elizabeth Taylor AIDS Foundation. Her foundation is focusing on an issue that Elizabeth would have wanted addressed: overturning controversial HIV criminalization laws created in the 1980s that make transmitting HIV a crime in thirty states. It does not matter if the person actually spreads the virus or had the intention of spreading it, the only thing that matters is that they know they are HIV positive. Now people who

are HIV positive can receive effective treatment that limits the virus's transmission. Yet these discriminatory laws are still on the books and stop many people from finding out their status and seeking care. Most of the people who are convicted under these arcane laws are poor and eventually sent to jail because they are unable to afford good legal representation. Some are subjected to possible felony convictions, and they can be sentenced to decades in prison. If Elizabeth were alive today she would surely have fought against such rampant injustice.

She wanted to help the world, not just the United States. Designer Kenneth Cole spent thirty years as a board member of amfAR and fourteen years as chair, and he said that a divisive issue at every board meeting was always Elizabeth's desire to make amfAR international. "She felt that HIV was a global problem and unless you were dealing with it globally you weren't dealing with it effectively."

In 2008, she brought mobile health clinics to the rural areas of Malawi so that people there could access treatment, including treatment for malaria and tuberculosis. The units also offer HIV testing; in 2020 alone they tested one hundred thousand people for HIV. There have been more than two million clinic visits in Malawi, and it is estimated that one life a day is saved

every day in that country because of the treatment and HIV testing offered by the mobile units.

Cinema Against AIDS was Elizabeth's idea as a way for amfAR to branch out internationally, starting with the event during the Cannes Film Festival. For a fundraiser, amfAR came up with the idea of auctioning off dresses that celebrities wore to the Oscars. Elizabeth donated the periwinkle blue dress designed by her friend Edith Head that she wore to the 1970 Academy Awards. The dress sold in the auction for $165,000 to Mattel, who made a doll wearing a tiny replica of the dress to sell at the perfume counter with her fragrances. The dress has since been acquired by the Academy Museum. It was the second-highest price for a dress at that time. Elizabeth also donated a light-pink Nolan Miller gown that she wore to the Oscars in the 1980s.

Unlike most celebrities of her era, Elizabeth's fame was never diminished. People would try to steal her hair and even take cocktail glasses with her lipstick marks on them. The public's fascination never waned. Paparazzi even dressed like doctors and nurses to try to get into her hospital room. Toward the end of her life, she often wondered aloud why

anyone was still interested in her. "I don't get it," she marveled.

Elizabeth's appetite for life left her with an insatiable hunger. Her friend Lesley-Anne Down said, "I don't know that Elizabeth was ever NOT lonely." From a young age gratification was immediate; there were movies and travel and a menagerie of pets. But real life is the antithesis of that. It is boredom and frustration and sometimes, for those who are lucky, a peaceful existence.

Elizabeth was conditioned from childhood to need that adrenaline rush that celebrity had always provided. Joe Mankiewicz, who directed *Cleopatra*, said that Elizabeth and Richard were "two actors who don't know how to get offstage." She looked for that same level of excitement and intoxication in her relationships because the relationship was like a drug. Her great loves, Mike Todd and Richard Burton, were the men in her life who gave her that thrill. Their sensuality and passion excited her. When you have a career that is so astronomical, real life is dull by comparison.

"She was an intelligent, yet simple human being, who was put into the torture chamber of the movie industry, and she wasn't allowed to have a normal life from the age of twelve," Down said. "By the time she

was in her twenties they had created a sort of cyber person, and that cyber person isn't going to know what to do with all this stuff that happened to them." Elizabeth's insomnia, Down said, is completely understandable. In the daylight she did not allow herself to look inward; at night she was left alone with her thoughts.

Elizabeth played many roles in her family life: daughter, sister, wife, mother, grandmother, and great-grandmother. When she could, daughter Liza brought her sons Quinn and Rhys from rural New York to visit their grandmother in Bel Air. They lived very quiet lives in upstate New York, and for the boys Hollywood was a different world. At their grandma's house, cooks and housekeepers were on hand to cater to their every whim. Elizabeth loved being a grandmother, even though she had complicated relationships with her own children. She hung the crayon drawings made by her grandchildren in her bedroom, not far from the work of world-renowned painters.

"There was an atmosphere of anxiety about going up those stairs to her bedroom suite," recalled her former son-in-law Hap Tivey, Quinn's and Rhys's father. "It didn't matter who it was, it could be someone who was working there, it could be someone who was inter-

viewing her, but Rhys and Quinn were never denied that staircase, and they went up and down it like little kittens. I remember that Quinn would go somewhere and disappear and I'd find him sitting in bed with his grandmother watching a movie under the covers. In spite of all this stuff that happened throughout her life there was a kind of central character there that didn't get whacked."

Grandchildren of celebrities do not carry the baggage that their children do. "They didn't experience the shell shock that we did," said Liza. She can remember being terrified as a child of the crushing crowds that swarmed around her mother. She remembers being passed overhead by members of her mother's and Richard's entourage to the awaiting getaway limo. Elizabeth described these terrifying scenes as a deck of cards; if one fell they all could have fallen and been trampled.

The paparazzi were relentless and would stop at nothing to get their photos, including physical force. One photographer even went as far as following Elizabeth into a public bathroom and placing a camera under the stall. "We all hated them," Liza said. "The fans would get in such a frenzy that they too would become violent, throwing themselves and banging on the car to get a better view."

Liza did not share her mother's love of jewelry. For her, jewelry symbolized glitz and gawking. In Liza's mind, the jewelry represented Elizabeth the commodity and not her mom. Instead, she connected with her mother over their shared love of animals and artwork. Elizabeth's favorite painting was one of Mary Cassatt's depictions of a mother and child that she hung above her bed at 700 Nimes Road—clearly her role as a mother was key to how she defined herself, even if her enormous life sometimes got in the way. On occasion she and Liza would draw together. Liza has since become a renowned equestrian sculptor and is determined to live her own life.

When Elizabeth looked at her grandchildren they reminded her of the men she had loved. Liza's son Quinn, who has Elizabeth's vivid blue eyes and the square jaw of his grandfather, lived with his grandmother when he was in high school and was taking a film course at the University of Southern California. Being the grandson of Mike Todd, one of the greatest producers of all time, he decided to play the role of a producer in film school. "I would sit in her jacuzzi underneath her balcony and bark on the phone all day for two weeks doing fake deals. At the end of it I brought her the trophy I won for best producer."

Elizabeth told him that he reminded her a little bit of Mike.

To Elizabeth's granddaughter Eliza Carson, the daughter of Maria Burton, Elizabeth was not a tabloid fixture but a survivor who cherished life. She felt that she could talk to her about anything, including break-ups. "She taught me that you can fall in love more than one time in your life, that it's something that can happen over and over again, if you're lucky."

Still, there was a wariness about her. When he was a teenager, Quinn's brother Rhys was visiting Elizabeth, and he brought up a project he was working on to collect his family history. "What would you think about doing an interview where I ask you for stories about your life and we record it?"

Suddenly, he said, her face hardened and she looked at her beloved grandson as if he were a complete stranger. "For a second it was like this person has no idea who I am. She had this look like she wanted to say, 'You devilish bastard, how dare you try to trick me.' I think she immediately had this vision of me recording her and selling it. It was so shocking and bizarre." It provided a revelatory glimpse into the hyperparanoid ivory tower that she had lived in for so much of her life.

When Quinn was starting film school at USC he felt the weight of his grandmother's celebrity acutely. He went with Elizabeth to a party where they saw Steven Spielberg.

"Please," Elizabeth prodded him, "go introduce yourself to him."

But Quinn felt uncomfortable. "Why would he want to talk to me? I'm a nobody."

"Just tell him that you're my grandson and that I say hello," she said.

"I'm not going to do that," he said, not wanting to use his family connection to meet the legendary director.

She was hurt and asked, "Are you embarrassed of me?"

"No," he said. "I'm proud of you and I love you."

Eventually, one of Elizabeth's friends introduced Quinn to Spielberg as the grandson of Elizabeth Taylor and Mike Todd. Spielberg looked at Quinn, patted him on the shoulder, and said, "That's a lot of weight on your shoulders. Good luck!"

There is no doubt that one of Elizabeth's greatest legacies is the deep and abiding love of her large family. It is complicated and messy, like it is in most families, but it is also very real. At Elizabeth's small funeral service at Forest Lawn, Rhys played "Amazing Grace" on his trumpet. "That was one of two, maybe three times when I felt like it was a perfect performance. It felt

like Grandma's presence was there. The air was buzz-ing the whole time; something was being channeled through me."

Maybe Elizabeth, who believed that one day she would be reunited with Rhys and Quinn's grandfather, was looking down on her family, finally free from the public gaze, reunited forever with the people she loved and lost along the way.

Acknowledgments

This book would not have been possible without the support of Elizabeth's incredibly tight-knit and loving family. Her son Chris Wilding was forthcoming and encouraging at every turn, and I'm grateful that the late Senator John Warner put us in touch. Elizabeth's other children, Liza, Michael, and Maria, were so generous with their time and their thoughts about their extraordinary mother. I cannot imagine how difficult it would be to share such intimate memories with a journalist, and I am deeply indebted to them.

My weekly calls and open dialogue with the trustees of Elizabeth's estate were crucial to my understanding of who she was beneath her public image. They were ready and willing to answer any question they could and they made me think of aspects of her life, including the massive weight of her celebrity, that I had

never considered before. The trustees include Elizabeth's close friend and assistant of two decades, Tim Mendelson, who loved Elizabeth unconditionally; her grandson Quinn Tivey, who shared touching memories of the woman he knew simply as "Grandma"; and her wonderful longtime lawyer and friend, Barbara Berkowitz. Erin Dawkins, who is the vice president of brand operations at the House of Taylor, seamlessly coordinated all of our collaboration.

I want to especially thank Elizabeth's family: Chris and Margi Wilding, Liza Todd Tivey, Michael Wilding, Maria Burton, Rhys Tivey, Laela Wilding, Hap Tivey, Naomi Wilding, Eliza Carson, Simeleke Gross, and Tommy Taylor. I'm also grateful for Richard Burton's family, especially his daughter Kate; his wife, Sally; and his great-nephew Guy Masterson. I appreciated Sally's unflinching perspective.

When I needed to double-check something that happened in Elizabeth's personal life, Jorjett Strumme, who worked for Elizabeth, was quick to answer and give me perspective. Mitch Erzinger is the archivist at the Elizabeth Taylor Archive. Mitch is an encyclopedia of all things Elizabeth, and he directed me to the most interesting letters, diary entries, and photographs—most of them unpublished negatives. I'm also thankful for the help and guidance of Catherine Brown, the ex-

ecutive director of The Elizabeth Taylor AIDS Foundation, and Janice Holmes, who is the fashion specialist at the House of Taylor. Elizabeth's friends, including Carol Burnett, George Hamilton, Robert Wagner, Doris Brynner, Liz Smith, Brooke Shields, Lionel Richie, Demi Moore, John Travolta, and Colin Farrell, painted a portrait of a hopeful woman who was full of life and love until the very end.

Thank you to the activists and scientists who fought against the devastating impact of AIDS, both on the body and on society, including Dr. Anthony Fauci, Bill Misenhimer, Dr. Michael Gottlieb, Dr. Michael Roth, Dr. Deborah Birx, Guy Vandenberg, Ed Wolf, Cliff Morrison, Sally Morrison, Sandy Thurman, Mike Shriver, Michael Iskowitz, Deborah Hernan, Tom Sheridan, Congressman Henry Waxman, and Aileen Getty, who bravely shared her story. Bradley Anderson talked about his partner, Roger Wall, so openly and beautifully. Bradley made me laugh during the dark days of another pandemic that we were living through at the time I was writing this book. There were often so many tears during calls about those early days of the AIDS pandemic that any excuse for a moment of levity was welcome.

One of the bittersweet realities of writing a book about someone who has passed away is that some of

the people I interviewed are no longer with us. It saddens me that they will not get to read the book, because their contributions were so crucial to it. The late senator John Warner and his wife, Jeanne, invited me into their home, and they were so incredibly generous—especially Jeanne, who sat next to her husband as he described his marriage to the most glamorous woman in the world. She seemed as interested in his stories as I was. I enjoyed going through the papers that Senator Warner left to the University of Virginia, which document his three decades in the Senate. Firooz Zahedi put me in touch with his cousin, the late Ardeshir Zahedi, who was the Iranian ambassador to the United States when he met Elizabeth. Ardeshir was clearly still very much in love with her when we spoke in 2021. The late Moshe Alon was the head of her security team, and he shared many private moments with Elizabeth.

Maury Hopson provided a rare glimpse into who Elizabeth was without the trappings of Hollywood. Andy Budgell, who posts daily at Elizabeth Taylor Archives on Instagram, is a gifted observer of Hollywood history. Private security specialist Gavin de Becker agreed to talk to me only after he got permission from Elizabeth's family. He provided important insight into the circumstances surrounding Elizabeth's second marriage to Richard. Eric Buterbaugh and the musi-

cian Michael Feinstein were incredibly helpful putting me in touch with people who knew Elizabeth. Margaret O'Brien and Eva Marie Saint offered important perspective on the Hollywood of Elizabeth's era.

I am deeply grateful for the speedy and thorough help and guidance of Cristina Meisner at the Harry Ransom Center at the University of Texas, who sent me wonderful material from *Who's Afraid of Virginia Woolf?* producer Ernest Lehman. Genevieve Maxwell at the Academy of Motion Picture Arts and Sciences sent along incredible papers from Joseph Mankiewicz, Richard Brooks, Hedda Hopper, Mike Nichols, and George Cukor. Nailah Holmes at the New York Public Library shared files from John Springer's collection. Each of these researchers was patient and generous with their time and helped me collect a treasure trove of material. Jerry Rafshoon worked at 20th Century Fox during the making of *Cleopatra* and he brought me back to the excitement of those days.

My agent, Howard Yoon, believed in the power of Elizabeth's story from the very beginning. Celeste Fine and her team at Park & Fine Literary and Media were essential partners. My brilliant editor, Gail Winston, brought the story to life, along with her diligent assistant Hayley Salmon.

My incredible husband, Brooke, and our children,

Graham, Charlotte, and Teddy, made me realize the immense responsibility Elizabeth carried as a mother, a wife, an actress, and an activist. I am in awe of her. My mother, Valerie—who is a skilled editor—and my father, Christopher—who is an incredible writer— provide the kind of unconditional love to me and my fabulous sister, Kelly, that I want to show our kids. Malou Morales is a loving part of our family, and I'm grateful to her for her steadfast warmth and support.

More than anything, I want to thank Elizabeth for her tremendous courage and for her indefatigable spirit.

Sources and Notes

A Note on Reporting

It took almost a decade after her death in 2011 for Elizabeth's closest friends and family members to feel comfortable enough to trust a journalist. I happened to be in the right place at the right time. They had spent Elizabeth's entire life protecting her from a rabid press eager to revel in her heartache after eight failed marriages; her weight gain after binges; and her trips to rehab as she battled her addictions. She knew since childhood that she was a valuable commodity. Her real friends, her children, and her former husbands did not want her to feel like she was a commodity to them.

It was Senator John Warner who, after telling me all the reasons why he loved Elizabeth, put me in touch with her son Chris Wilding. Chris wanted his mother's

work as an actress and as a humanitarian to be remembered. It was through the generosity and dedication of the trustees of Elizabeth's estate that I was given access to unpublished material, including Elizabeth's private letters, notes to herself, and never-before-seen photographs, and granted interviews with the people who knew her best. I spent three years working on this book, and I interviewed more than 250 people. It was a great honor to be a voyeur into the life of one of the most powerful cultural influencers of the twentieth century. Her strength, vulnerability, and resilience are best expressed in her own words. I'm thankful to have the chance to share them.

Prologue

Interview subjects include Joan Collins, Todd Fisher, Aprile Millo, Barbara Davis, André Leon Talley, and Pippo Zeffirelli. Material includes: Elizabeth Taylor, A love letter to Richard Burton, 1987, Elizabeth Taylor Archives; Richard Meryman tapes, 1964 and 1965, Elizabeth Taylor Archives; Pete Martin, "I Call on Debbie Reynolds," *Saturday Evening Post*, March 26, 1960; John B. Allan, *Elizabeth Taylor* (Derby, CT: Monarch Books, 1961); "Lady Lawmaker Asks U.S. to Bar Liz," *San Francisco Examiner*, May 23, 1962; Dick Sheppard, *Elizabeth: The Life and Career of*

Elizabeth Taylor (New York: Doubleday, 1974); Walter Wanger and Joe Hyams, *My Life with Cleopatra: The Making of a Hollywood Classic* (New York: Vintage Books, 1963); Kevin Sessums, "Elizabeth Taylor Tells the Truth," *POZ*, November 1, 1997; and Jack Brodsky and Nathan Weiss, *The Cleopatra Papers: A Private Correspondence* (New York: Simon and Schuster, 1963).

Introduction: Elizabeth the First

Interview subjects include Chris Wilding, Laela Wilding, Naomi Wilding, Demi Moore, Sally Burton, John Travolta, Liza Minnelli, Chris Willoughby, and George Hamilton. Published and unpublished material includes: "Barbara Walters Special," 1999, Elizabeth Taylor Archives; Paul Theroux, "Liz Taylor Looks Back on Men, Money & Michael Jackson," *Talk*, October 1999; Dick Sheppard, *Elizabeth: The Life and Career of Elizabeth Taylor* (New York: Doubleday, 1974); Elizabeth Taylor, *Elizabeth Taylor* (New York: Harper & Row, 1964); Bronwyn Cosgrave, *Made for Each Other: Fashion and the Academy Awards* (New York: Bloomsbury, 2006); Sam Jashner and William J. Mann, *How to Be a Movie Star* (New York: Houghton Mifflin Harcourt, 2009); John Springer Associates records, Billy Rose Theatre Division, New York Public

Library; Elizabeth Taylor speech at Jean Hersholt Humanitarian Award at the 1993 Academy Awards; Ruth Waterbury with Gene Arceri, *Elizabeth Taylor: Her Life, Her Loves, Her Future* (New York: Bantam Books, 1964); Truman Capote, *A Capote Reader*, excerpted in *Ladies' Home Journal*, 1974; Ernest Lehman's journal during *Who's Afraid of Virginia Woolf?*, Harry Ransom Center at the University of Texas; Philip M. Boffey, "Reagan Urges Wide AIDS Testing but Does Not Call for Compulsion," *New York Times*, June 1, 1987.

ACT I: THE MOST BEAUTIFUL CREATURE

Chapter 1: A Star Is Born

Interview subjects include George Hamilton, Margaret O'Brien, Eva Marie Saint, Robert Wagner, Russ Tamblyn, Jill Schary Robinson, Chris Wilding, Liza Todd Tivey, Michael Wilding, Barbara Berkowitz, Tim Mendelson, Jorjett Strumme, and Janice Holmes. Published and unpublished material includes: Sara Sothern Taylor, "Elizabeth, My Daughter," *Ladies' Home Journal*, February, March, and

April 1954; Elizabeth Taylor, *Elizabeth Taylor* (New York: Harper & Row, 1964); J. Randy Taraborrelli, *Elizabeth* (New York: Grand Central Publishing, 2006); interview with Nick Simmons, Elizabeth Taylor Archives; Kitty Kelley, *The Last Star* (New York: Simon & Schuster, 1981); Elizabeth Taylor, *My Love Affair with Jewelry* (New York: Simon & Schuster, 2002); House of Taylor Archive interview with Norma Heyman, June 4, 2015, Elizabeth Taylor Archives; Loew's Incorporated contract with Elizabeth Taylor, February 10, 1943; Dick Sheppard, *Elizabeth: The Life and Career of Elizabeth Taylor* (New York: Doubleday, 1974); Robert Hofler, *Money, Murder, and Dominick Dunne: A Life in Several Acts* (Madison: University of Wisconsin Press, 2017); Ernest Lehman's journal during *Who's Afraid of Virginia Woolf?*, Harry Ransom Center at the University of Texas; Karina Longworth, "Hollywood's First Gay Marriage," *Slate*, October 16, 2015; Kevin Sessums, "Elizabeth Taylor Tells the Truth," *POZ*, November 1, 1997; Gerald Clarke, *Get Happy: The Life of Judy Garland* (New York: Random House, 2000); Dr. Howard Markel, "The Day Judy Garland's Star Burned Out," PBS, June 21, 2019; PBS, *Great Performances*, "Elizabeth Taylor:

England's Other Elizabeth," Elizabeth Taylor reminisces about some of her Hollywood experiences, also includes interview with Angela Lansbury, and more, season 29, episode 9, PBS, April 4, 2001; "My Washington: The White House and Mount Vernon, Souvenirs and a White Fur Coat—for the Enchanted Journey of Elizabeth," *Photoplay*, May 1946; Richard Meryman tapes, 1964 and 1965, Elizabeth Taylor Archives; Elizabeth Taylor, "Deception," March 5, 1948; J. Randy Taraborrelli, *Elizabeth* (New York: Grand Central Publishing, 2006); John B. Allan, *Elizabeth Taylor* (Derby, CT: Monarch Books, 1961); Sara Sothern Taylor, "Elizabeth, My Daughter," *Ladies' Home Journal*, March 1954; Charles Casillo, *Elizabeth and Monty: The Untold Story of Their Intimate Friendship* (New York: Kensington Publishing Corp., 2017); As told to Brad Darrach, "If the Knife Slips Tomorrow, I'll Die Knowing I've Had AN EXTRAORDINARY LIFE," *Life*, April 1997; Elizabeth Taylor, *Elizabeth Takes Off* (New York: G. P. Putnam's Sons, 1987); and transcript of George Stevens interview with Ruth Waterbury on September 7, 1962, from Margaret Herrick Library, Academy of Motion Picture Arts and Sciences. This chapter also includes excerpts from the unpublished manuscript by Sara Sothern Taylor for her biography

of Elizabeth Taylor, *Taylor-Made Memories*, 1985, Elizabeth Taylor Archives.

Chapter 2: Young Love

Interview subjects include Tim Mendelson and Margaret O'Brien. Material includes: A typed personal letter from William Douglas Pawley to Elizabeth Taylor, dated December 1, 2003, Elizabeth Taylor Archives; letters from William Douglas Pawley to Tim Mendelson, dated October 10 and December 1, and photocopy of letter from Elizabeth Taylor to Clifton Pawley, dated September 29, 1949, Elizabeth Taylor Archives; handwritten "farewell" letter from Glenn Davis to Elizabeth Taylor, dated September 22, 1949, Elizabeth Taylor Archives; Tara Johnson, "Elizabeth Taylor: A Life-Changing Portrait," Life.com; John B. Allan, *Elizabeth Taylor* (Derby, CT: Monarch Books, 1961); Sara Sothern Taylor, "Elizabeth, My Daughter," *Ladies' Home Journal*, March 1954; Bill Pawley letters from Bobby Livingston at RR Auction; Luisa Yanez, "Liz Taylor's Love Letters Reveal an Innocent Time," *Sydney Morning Herald*, May 6, 2011; Dick Sheppard, *Elizabeth: The Life and Career of Elizabeth Taylor* (New York: Doubleday, 1974); Gianni Bozzacchi, *My Life in Focus: A Photographer's Journey with Elizabeth Taylor and the Hollywood Jet Set*

(Lexington: University Press of Kentucky, 2017); Brenda Maddox, *Who's Afraid of Elizabeth Taylor?* (New York: M. Evans and Company, Inc., 1977); interview with Nick Simmons, December 26, 1978, Elizabeth Taylor Archives; letter from Elizabeth Taylor's publicist John Springer to Pat Lowry at *Women's Wear Daily*, December 26, 1978, Elizabeth Taylor Archives.

Chapter 3: Bessie Mae

This chapter includes interviews with Tim Mendelson and Eva Marie Saint. Published and unpublished material includes: David Wigg, "Liz Taylor Talks About Her New Love, New Life, and Keeping Her Famous Looks," *Good Housekeeping*, February 1977; Paul Theroux, "Liz Taylor Looks Back on Men, Money & Michael Jackson," *Talk*, October 1999; Patricia Bosworth, *Montgomery Clift: A Biography* (New York: Bantam Books, 1980); Charles Casillo, *Elizabeth and Monty: The Untold Story of Their Intimate Friendship* (New York: Kensington Publishing Corp., 2017); Elizabeth Taylor receives the Vanguard Award at the 11th Annual GLAAD Media Awards, presented by Carrie Fisher, April 15, 2000; Anne Helen Petersen, "Scandals of Classic Hollywood: The Long Suicide of Montgomery Clift," *Vanity Fair*, September 23, 2014;

J. Randy Taraborrelli, *Elizabeth* (New York: Grand Central Publishing, 2006); The Daily Dish, "Tell Mama All," *The Atlantic*, March 24, 2011; Kitty Kelley, *The Last Star* (New York: Simon & Schuster, 1981); William J. Mann, *How to Be a Movie Star* (New York: Houghton Mifflin Harcourt, 2009). This chapter also includes excerpts from the unpublished manuscript by Sara Sothern Taylor for her biography of Elizabeth Taylor, *Taylor-Made Memories*, Elizabeth Taylor Archives, 1985.

Chapter 4: "He Will Kill Her"

Interview subjects include Russ Tamblyn, Eva Marie Saint, Margaret O'Brien, Jorjett Strumme, Gavin de Becker, and Barbara Berkowitz. Published and unpublished material includes: Elizabeth Taylor, *Elizabeth Taylor* (New York: Harper & Row, 1964); unpublished handwritten notes by Sara Taylor [on Dorchester Hotel stationery, housed in hotel folder], possibly notes for her memoir, dated March 23–24 [year unknown]; Richard Meryman tapes, 1964 and 1965, Elizabeth Taylor Archives; Christopher Andersen, *An Affair to Remember* (New York: William Morrow & Co, 1997); J. Randy Taraborrelli, *Elizabeth* (New York: Grand Central Publishing, 2006); John B. Allan, *Elizabeth Taylor* (Derby, CT: Mon-

arch Books, 1961); Dick Sheppard, *Elizabeth: The Life and Career of Elizabeth Taylor* (New York: Doubleday, 1974); Mary Neiswender, "Manson Cult Plan to Kill Liz, Burton and Sinatra," cielodrive. com, October 9, 1970; Paul Theroux, "Liz Taylor Looks Back on Men, Money & Michael Jackson," *Talk*, October 1999; Brenda Maddox, *Who's Afraid of Elizabeth Taylor?* (New York: M. Evans and Company, Inc., 1977); copy of the Federal Bureau of Investigation file on Elizabeth Taylor, requested by Barbara Berkowitz under the Freedom of Information Privacy Acts, Elizabeth Taylor Archives, processed February 25, 1997; letter from Steve McQueen to Edward Rubin, October 17, 1970; statement from Elizabeth Taylor regarding a Taylor look-alike who had to be escorted away by the police following an incident with Taylor at Cannes; the unpublished manuscript by Sara Sothern Taylor for her biography of Elizabeth Taylor, *Taylor-Made Memories*, Elizabeth Taylor Archives, 1985; and Elizabeth Taylor's interview with David Hartman on *Good Morning America*, 1984.

Chapter 5: Love and Marriage

This chapter includes interviews with Chris Wilding, Liza Todd Tivey, Michael Wilding Jr., and Maria

Burton. Published and unpublished material includes: Charles Casillo, *Elizabeth and Monty: The Untold Story of Their Intimate Friendship* (New York: Kensington Publishing Corp., 2017); Patricia Bosworth, *Montgomery Clift: A Biography* (New York: Bantam Books, 1980); This chapter also includes excerpts from the unpublished manuscript by Sara Sothern Taylor for her biography of Elizabeth Taylor, *Taylor-Made Memories*, Elizabeth Taylor Archives, 1985; and Philip Potempa, "Hollywood Hopper Hat at Symphony's 2018 May Wine Brunch," *Chicago Tribune*, April 18, 2018.

ACT II: PASSION AND PAIN

Chapter 6: Rock, Jimmy, and Monty

This chapter includes interviews with Carol Burnett, Tim Mendelson, and Eva Marie Saint. Published and unpublished material includes: David Wigg, "Liz Taylor Talks About Her New Love, New Life, and Keeping Her Famous Looks," *Good Housekeeping*, February 1977; Paul Theroux, "Liz Taylor Looks Back on Men, Money & Michael Jackson," *Talk*, October 1999; Elizabeth Taylor receives the Vanguard

Award at the 11th annual GLAAD Media Awards, April 15, 2000, presented by Carrie Fisher; Phyllis Gates and Bob Thomas, *My Husband, Rock Hudson* (New York: Doubleday & Company, Inc., 1987); Michael Hoinski, "On the Shoulders of Giants," *Texas Monthly*, July 15, 2016; Brenda Maddox, *Who's Afraid of Elizabeth Taylor?* (New York: M. Evans and Company, Inc., 1977); Elizabeth Taylor, *Elizabeth Taylor* (New York: Harper & Row, 1964); J. Randy Taraborrelli, *Elizabeth* (New York: Grand Central Publishing, 2006); Kitty Kelley, *The Last Star* (New York: Simon & Schuster, 1981); Patricia Bosworth, *Montgomery Clift: A Biography* (New York: Bantam Books, 1980); Charles Casillo, *Elizabeth and Monty: The Untold Story of Their Intimate Friendship* (New York: Kensington Publishing Corp., 2017); Anne Helen Petersen, "Scandals of Classic Hollywood: The Long Suicide of Montgomery Clift," *Vanity Fair*, September 23, 2014; Elizbeth Taylor's interview with Diane Sawyer, *Good Morning America*, 2000; and Truman Capote, *A Capote Reader*, excerpted in *Ladies' Home Journal*, 1974.

Chapter 7: Mike Todd: "He Was My King"

Interviews with Liza Todd Tivey, Quinn Tivey, Eva Marie Saint, Moshe Alon, Todd Fisher, and George

Hamilton. Published and unpublished material includes: Kitty Kelley, *The Last Star* (New York: Simon & Schuster, 1981); *My Love Affair with Jewelry* interviews, tape 1, November 27, 2001, Elizabeth Taylor Archives; Richard Meryman tapes, Beverly Hills, August 7, 1965, Elizabeth Taylor Archives; Elizabeth Taylor, *Elizabeth Taylor* (New York: Harper & Row, 1964); *Great Performances*, "Elizabeth Taylor: England's Other Elizabeth," Elizabeth Taylor reminisces about some of her Hollywood experiences; also includes interviews with Jeanine Basinger, Angela Lansbury, and more, season 29, episode 9, PBS, April 4, 2001; *Lifetime's Intimate Portrait of Elizabeth Taylor*, 2015; Todd Fisher, *My Girls: A Lifetime with Carrie and Debbie* (New York: William Morrow, 2018); "Simple Acapulco Ceremony Unites Elizabeth Taylor, Producer Todd," *Los Angeles Times*, February 2, 1957; Bronwyn Cosgrave, *Made for Each Other: Fashion and the Academy Awards* (New York: Bloomsbury, 2006); Elizabeth Taylor, *My Love Affair with Jewelry* (New York: Simon & Schuster, 2002); "Elizabeth Taylor: An Intimate Portrait," narrated by Peter Lawford; Richard Meryman tapes, SS *Michelangelo*, June 21, 1965, Elizabeth Taylor Archives; Elizabeth Taylor and Mike Todd interviewed at home by Edward R.

Murrow on *Person to Person*, one of the original celebrity interview programs, season 4, episode 30, CBS, April 5, 1957, Elizabeth Taylor Archives; Prometheus Entertainment/Foxstar Productions documentary about Elizbeth Taylor, February 17, 2003; and Debbie Reynolds interview on *The Joy Behar Show*, 2011.

Chapter 8: Eddie Fisher: "He Kept Mike Todd Alive"

Interview subjects include Todd Fisher, Tim Mendelson, Chris Wilding, and Maria Burton. Published and unpublished material includes: Charles Casillo, *Elizabeth and Monty: The Untold Story of Their Intimate Friendship* (New York: Kensington Publishing Corp., 2017); *Great Performances*, "Elizabeth Taylor: England's Other Elizabeth," Elizabeth Taylor reminisces about some of her Hollywood experiences, also includes interview with Jeanine Basinger, Angela Lansbury, and more, season 29, episode 9, PBS, April 4, 2001; *My Love Affair with Jewelry* interviews, tape 5, side A; Todd Fisher, *My Girls: A Lifetime with Carrie and Debbie* (New York: William Morrow, 2018); "Larry King Interviews Debbie Reynolds About Elizabeth Taylor, Their Friendship, and the Very Public Affair with Eddie Fisher," *Larry King Live*, CNN, 1991; John B. Allan, *Elizabeth*

Taylor (Derby, CT: Monarch Books, 1961); "Elizabeth Taylor: An Intimate Portrait," narrated by Peter Lawford; Richard Meryman interviews John Springer, 1964, Elizabeth Taylor Archives; Kitty Kelley, *The Last Star* (New York: Simon & Schuster, 1981); and Eddie Fisher and David Fisher, *Been There, Done That* (New York: St. Martin's Press, 1999).

Chapter 9: Trailblazer

Interview subjects include Todd Fisher and Joan Collins. Published and unpublished material includes: Charles Casillo, *Elizabeth and Monty: The Untold Story of Their Intimate Friendship* (New York: Kensington Publishing Corp., 2017); Walter Wanger and Joe Hyams, *My Life with Cleopatra: The Making of a Hollywood Classic* (New York: Vintage Books, 1963); Jack Brodsky and Nathan Weiss, *The Cleopatra Papers: A Private Correspondence* (New York: Simon and Schuster, 1963); Bronwyn Cosgrave, *Made for Each Other: Fashion and the Academy Awards* (New York: Bloomsbury, 2006); Gary Baum, "Why Century City Ranks Among the Worst Real Estate Deals in Hollywood History," *Hollywood Reporter*, September 26, 2013; Elizabeth Taylor, *Elizabeth Taylor* (New York: Harper & Row, 1964); Richard Burton,

Meeting Mrs. Jenkins (New York: William Morrow & Co., 1966); Mike Janela, "1962: First Actor to Break the $1 Million Threshold for a Movie Role," Guinness World Records, August 19, 2015; and Truman Capote, *A Capote Reader*, excerpted in *Ladies' Home Journal*, 1974.

ACT III: LAVISH LOVE

Chapter 10: Le Scandale

Interview subjects include Maria Burton, Sally Burton, Joan Collins, and David Rowe-Beddoe. Published and unpublished material includes: Jack Brodsky and Nathan Weiss, *The Cleopatra Papers: A Private Correspondence* (New York: Simon & Schuster, 1963); Todd Fisher, *My Girls: A Lifetime with Carrie and Debbie* (New York: William Morrow, 2018); Walter Wanger and Joe Hyams, *My Life with Cleopatra: The Making of a Hollywood Classic* (New York: Vintage Books, 1963); Richard Meryman interview in New York City, July 1964, Elizabeth Taylor Archives; notes for Maria Burton and Elizabeth Taylor interview, 1980, Elizabeth Taylor Archives; Richard Meryman tapes, 1964 and 1965, Elizabeth Taylor Archives;

Bronwyn Cosgrave, *Made for Each Other: Fashion and the Academy Awards* (New York: Bloomsbury, 2006); Richard Burton, *Meeting Mrs. Jenkins* (New York: William Morrow & Co., 1966); Dick Sheppard, *Elizabeth: The Life and Career of Elizabeth Taylor* (New York: Doubleday, 1974); Sara Sothern Taylor, "Elizabeth, My Daughter," *Ladies' Home Journal*, April 1954; "Liz on Liz: To Hell with Critics, Calories and Career, Says a Fat and Happy Politician's Wife," *US*, April 1978; Charles Collingwood, "Interview with Liz and Burton," *60 Minutes*, 1970, Elizabeth Taylor Archives; Sam Kashner and Nancy Schoenberger, "How Richard Burton Vowed Never to Betray Elizabeth Taylor . . . Then, Days Later, Seduced His Co-Star," *Daily Mail*, June 7, 2010; *The Richard Burton Diaries*, edited by Chris Williams (New Haven, CT: Yale University Press, 2012); *Great Performances*, "Elizabeth Taylor: England's Other Elizabeth," Elizabeth Taylor reminisces about some of her Hollywood experiences, also includes interview with Angela Lansbury, and more, season 29, episode 9, PBS, April 4, 2001; Eddie Fisher and David Fisher, *Been There, Done That* (New York: St. Martin's Press, 1999); Richard Meryman, SS *Michelangelo*, June 21, 1965, Elizabeth Taylor Archives; Christopher Bagley, "Elizabeth Taylor: La Liz," *W Magazine*,

December 1, 2004; Richard Meryman tapes, August 1965, possibly at Smith College, Elizabeth Taylor Archives; and Bruce Weber's private tribute video to Elizabeth Taylor, Elizabeth Taylor Archives.

Chapter 11: Crazy, Stupid Love, 1964–1973

Interview subjects include Chris Wilding, Liza Todd Tivey, Kate Burton, Todd Fisher, Tim Mendelson, Demi Moore, Sally Burton, David Rowe-Beddoe, John Tillinger, Joan Collins, Ward Landrigan, Gianni Bozzacchi, Jorjett Strumme, Waris Hussein, Tommy Taylor, Simeleke Gross, Giancarlo Giammetti, Gavin de Becker, Morgan Mason, Joanna Poitier, John Warner, Arthur Allen Seidelman, Guy Masterson, and André Leon Talley. Published and unpublished material includes: Letters between Richard Burton and Elizabeth Taylor, Elizabeth Taylor Archives; Ruth Waterbury with Gene Arceri, *Elizabeth Taylor: Her Life, Her Loves, Her Future* (New York: Bantam Books, Inc, 1964); Andrew Denton interview with Sir Michael Caine, June 10, 2019; Douglas Kirkland Archive interview, August 26, 2015, Elizabeth Taylor Archives; Walter Wanger and Joe Hyams, *My Life with Cleopatra: The Making of a Hollywood Classic* (New York: Vintage Books, 1963); Sam Kashner, "A First-Class Affair," *Vanity Fair*, July 2003; Sara Soth-

ern Taylor, "Elizabeth, My Daughter," *Ladies' Home Journal*, April 1954; Dick Sheppard, *Elizabeth: The Life and Career of Elizabeth Taylor* (New York: Doubleday, 1974); Marion Faisel, "The Taylor Burton Diamond's Other Name," *The Adventurine*, August 31, 2016; Bob Willoughby, *Liz: An Intimate Collection: Photographs of Elizabeth Taylor* (New York: Merrell, 2004); Mark Harris, *Mike Nichols: A Life* (New York: Penguin, 2021); Ernest Lehman's journal during *Who's Afraid of Virginia Woolf?*, Harry Ransom Center at the University of Texas; *My Love Affair with Jewelry* interviews, tape 3, Elizabeth Taylor Archives; Gianni Bozzacchi, *My Life in Focus: A Photographer's Journey with Elizabeth Taylor and the Hollywood Jet Set* (Lexington: University Press of Kentucky, 2017); Rock Brynner, "Elizabeth in Dublin, a Brief Remembrance by Rock Brynner for Her Family Members and Closest Friends," Elizabeth Taylor Archives; Richard Meryman tapes, 1964 and 1965, Elizabeth Taylor Archives; from Richard Meryman tapes, August 1965, possibly at Smith College, Elizabeth Taylor Archives; *The David Frost Show*, March 19, 1970, Elizabeth Taylor Archives; archive interview with Norma Heyman, June 4, 2015, Elizabeth Taylor Archives; Elizabeth Taylor interview on Aspel & Company, 1988, Elizabeth Taylor Archives;

Elizabeth Taylor, *My Love Affair with Jewelry* (New York: Simon & Schuster, 2002); Charles Collingwood, "Interview with Liz and Burton," *60 Minutes*, 1970, Elizabeth Taylor Archives; Robert Hofler, "Booze-Soaked Shoots, Hot Gay Sex, and Elizabeth Taylor's Poop Problems: On Dominick Dunne's Infamous Last Film," *Daily Beast*, 2017; Truman Capote, *A Capote Reader*, excerpted in *Ladies' Home Journal*, 1974; a love letter written in pencil by ET to Burton on their tenth wedding anniversary, March 15, 1974, Elizabeth Taylor Archives; *The Richard Burton Diaries*, edited by Chris Williams (New Haven, CT: Yale University Press, 2012); Eddie Fisher and David Fisher, *Been There, Done That* (New York: St. Martin's Press, 1999); and Brenda Maddox, *Who's Afraid of Elizabeth Taylor?* (New York: M. Evans and Company, Inc., 1977).

Chapter 12: The Loot: Elizabeth's Extraordinary Jewels

Interview subjects include Tim Mendelson, Demi Moore, Ward Landrigan, Gianni Bozzacchi, Jorjett Strumme, Giancarlo Giammetti, Gavin de Becker, and André Leon Talley. Published and unpublished material includes: Letters between Richard Burton and

Elizabeth Taylor, Elizabeth Taylor Archives; Sam Kashner, "A First-Class Affair," *Vanity Fair*, July 2003; Marion Faisel, "The Taylor Burton Diamond's Other Name," *The Adventurine*, August 31, 2016; *My Love Affair with Jewelry* interviews, tape 3, Elizabeth Taylor Archives; Gianni Bozzacchi, *My Life in Focus: A Photographer's Journey with Elizabeth Taylor and the Hollywood Jet Set* (Lexington: University Press of Kentucky, 2017); Richard Meryman tapes, Elizabeth Taylor Archives; *The David Frost Show*, March 19, 1970, Elizabeth Taylor Archives; Elizabeth Taylor, *My Love Affair with Jewelry* (New York: Simon & Schuster, 2002); Richard Meryman tapes, 1964 and 1965, Elizabeth Taylor Archives; Truman Capote, *A Capote Reader*, excerpted in *Ladies' Home Journal*, 1974; "Elizabeth Taylor Gets Brooch for $565,000: Buying Romance—at 100 Times Value," *Los Angeles Times*, April 3, 1987; a love letter written in pencil by ET to Burton on their tenth wedding anniversary, March 15, 1974, Elizabeth Taylor Archives; *The Richard Burton Diaries*, edited by Chris Williams (New Haven, CT: Yale University Press, 2012); *My Love Affair with Jewelry* interviews, tape 4, Elizabeth Taylor Archives; Richard Meryman tapes, interview with John Springer, 1964, Elizabeth Taylor Archives; and post

card from Elizabeth Taylor to her parents regarding the Krupp diamond, 1968, Elizabeth Taylor Archives.

Chapter 13: The End and a New Beginning, 1973–1976

Interview subjects include Gianni Bulgari, Kate Burton, Liza Todd Tivey, Chris Wilding, Maria Burton, Tim Mendelson, Sally Burton, Joan Collins, David Rowe-Beddoe, Gianni Bozzacchi, Tommy Taylor, Giancarlo Giammetti, Gavin de Becker, Jorjett Strumme, Gianni Bozzacchi, Waris Hussein, Tony Brenna, Doris Romeo, Shirine Coburn DiSanto, Michael York, Denis Ferrara, and Firooz Zahedi. Published and unpublished material includes: Sam Kashner, "A First-Class Affair," *Vanity Fair*, July 2003; Dick Sheppard, *Elizabeth: The Life and Career of Elizabeth Taylor* (New York: Doubleday, 1974); Rex Reed, "Elizabeth Taylor Lets Her Hair Down," *Ladies' Home Journal*, October 1975; *The Richard Burton Diaries*, edited by Chris Williams (New Haven, CT: Yale University Press, 2012); Six Days in October, in Elizabeth's words, 1975, Elizabeth Taylor Archives; letter from Richard Burton to Chris Wilding, February 10, 1976, courtesy Chris Wilding; J. Randy Taraborrelli, *Elizabeth* (New York: Grand Central Publishing, 2006); an interview with Richard

Burton by Hebe Dorsey, fashion writer at the *International Herald Tribune*, circa 1973; and Ellen Stern, "Chen Sam I Am," *New York* magazine, August 8, 1994.

ACT IV: SURVIVOR

Chapter 14: Political Wife

Interview subjects include Senator John Warner, Virginia Warner, Chris Wilding, Naomi Wilding, Laela Wilding, Tim Mendelson, Ardeshir Zahedi, Demi Moore, Austin Pendleton, Liza Minnelli, Lesley-Anne Down, Firooz Zahedi, Rabbi Marvin Hier, Maury Hopson, Shirine Coburn DiSanto, and Dennis Christopher. Published and unpublished material includes: Letter from Aaron Frosch to Elizabeth Taylor, September 14, 1979, Elizabeth Taylor Archives; letter from John Springer to Mrs. John Warner, August 1, 1977, Elizabeth Taylor Archives; *The Andy Warhol Diaries* (New York: Warner Books, 1991); Paul Theroux, "Liz Taylor Looks Back on Men, Money & Michael Jackson," *Talk*, October 1999; Phil Donahue interview with Elizabeth Taylor, 1988, Elizabeth Taylor Archives; letter from Senator Margaret Chase

Smith to Elizabeth Taylor, February 7, 1980, Elizabeth Taylor Archives; Richard Meryman, SS *Michelangelo*, June 21, 1965, Elizabeth Taylor Archives; Jane Pauley interviews Elizabeth Taylor, *Today*, 1988; William J. Mann, *How to Be a Movie Star* (New York: Houghton Mifflin Harcourt, 2009); letter from Aaron Frosch to Elizabeth Taylor, September 14, 1979, Elizabeth Taylor Archives; letter from Elizabeth Taylor to Richard Burton, November 10, 1982; Associated Press, "John Warner Met Liz Taylor at Dinner—with Queen Elizabeth," May 26, 2021; Memorandum for Elizabeth (crossed out, My loving wife), April 1, 1981, Elizabeth Taylor Archives; Elizabeth Taylor letter to John Springer, November 28, 1979, Elizabeth Taylor Archives; Letter 96th Congressional Wives Club, June 12, 1979, Elizabeth Taylor Archives; Chen Sam letter to Aaron Frosch, September 20, 1980; "The Warners: A Candidate's Lifestyle," with Libby Fitzgerald, local television interview, undated, circa 1978; Christopher Bagley, "Elizabeth Taylor: La Liz," *W* magazine, December 1, 2004; "Elizabeth Taylor Offered to Be Hostage, Dinitz Discloses," *JTA Daily News Bulletin*, June 16 1977; Jon Wiener, "Elizabeth Taylor, Al Jazeera and the Raid on Entebbe," *The Nation*, March 25, 2011; David S. Broder, "Warner vs. Warner on the Draft," *Washington Post*, February 3, 1980; and Eliz-

abeth Taylor, *Elizabeth Takes Off* (New York: G. P. Putnam's Sons, 1987).

Chapter 15: Addict

Interview subjects include Chris Wilding, Michael Wilding, Liza Todd Tivey, Tim Mendelson, Sarah Ferguson, Barbara Berkowitz, Michael Feinstein, Liz Smith, Sally Burton, George Hamilton, Jorjett Strumme, Doris Brynner, Hay Tivey, Sally Burton, Dennis Christopher, Louis Fishman, and Austin Pendleton. Published and unpublished sources include: William Skinner undated letter to Elizabeth Taylor, circa 1983, Elizabeth Taylor Archives; Nancy Collins, "Liz's AIDS Odyssey," *Vanity Fair*, November 1992; John Duka, "Elizabeth Taylor: Journal of a Recovery," *New York Times*, February 4, 1985; Dominick Dunne, "The Red Queen," *Vanity Fair*, December 1985; Elizabeth Taylor's interview with David Hartman, *Good Morning America*, February 1984; J. Randy Taraborrelli, *Elizabeth* (New York: Grand Central Publishing, 2006); *The Phil Donahue Show*, 1988; John H. Lee and Virginia Ellis, "Taylor Doctors Are Accused of Prescription Violations," *Los Angeles Times*, September 8, 1990; "Three Doctors Reprimanded for Falsifying Actress' Patient Record," Associated Press, August 11, 1994;

David Ng, "Revisiting 'Private Lives' with Elizabeth Taylor and Richard Burton," *Los Angeles Times*, February 13, 2013; Jane Scovell Archive interview, May 4, 2015, Elizabeth Taylor Archives; Archive interview with Michael Lonergan, May 4, 2015, Elizabeth Taylor Archives; C. David Heymann, "Taylor Faces the Anguish and Triumph of Sobriety," *Sun-Sentinel*, April 29, 1995; *A Current Affair* reports and gossip on the life and loves of Elizabeth Taylor, features extensive interview with Richard Burton's brother, Graham Jenkins, WNYW-TV, November 28, 1988, Elizabeth Taylor Archives; Phil Carradice, "The Death of Richard Burton," BBC, August 5, 2014; M. G. Lord, *The Accidental Feminist: How Elizabeth Taylor Raised Our Consciousness* (New York: Walker and Company, 2012); letter from Zev Buffman to Sally Burton, August 24, 1984, courtesy Sally Burton; Catherine Opie, *700 Nimes Road* (New York: Prestel, 2015); "In Vogue: The Editor's Eye," HBO; handwritten notes by Elizabeth Taylor, detailing her anxieties before a surgical operation, 1991, Elizabeth Taylor Archives; birthday telegram from Elizabeth Taylor to Richard Burton, signed "your double ex-wife," dated November 10, 1982, Elizabeth Taylor Archives; handwritten tribute poem to Richard Burton, 1984, Elizabeth Taylor Archives;

Andrew Morton, *Diana: Her True Story—In Her Own Words* (New York: Simon & Schuster, 2017); and letter from Elizabeth Taylor to Liza Minnelli, January 22, 1993, Elizabeth Taylor Archives.

Chapter 16: Building an Empire

Interview subjects include Sarah Ferguson, Lionel Richie, David Lynch, Tamara Steele, George Hamilton, Lesley-Anne Down, Shirine Coburn DiSanto, Moshe Alon, Peter England, Jorjett Strumme, Marion Rosenberg, Morgan Mason, José Eber, Carlos Benaim, André Leon Talley, Fran Drescher, Tony Brenna, Al Jean, Vicky Tiel, Carole Bayer Sager, Delphine Hirsh, Debbie Nesset, and Dr. David Ho. Material includes: George Hamilton Archive interview, August 25, 2015, Elizabeth Taylor Archives; *My Love Affair with Jewelry* interviews, tape 5, side A, Elizabeth Taylor Archives; Nancy Collins, "Liz's AIDS Odyssey," *Vanity Fair*, November 1992; Joe Spellman Archive interview, May 5, 2015, Elizabeth Taylor Archives; Elizabeth Taylor, *My Love Affair with Jewelry* (New York: Simon & Schuster, 2002); Michael White, "Elizabeth Taylor, Ex-Beau Reach Out-of-Court Settlement over Passion," Associated Press, December 6, 1990; "Elizabeth Taylor Hospitalized, 'Seriously Ill' with Pneumonia," UPI, *Los*

Angeles Times, April 24, 1990, and Richard Sanders, "Director Billy Friedkin and Lesley-Anne Down Make a Home Movie—Divorce Hollywood Style," *People*, September 2, 1985; Associated Press, "Elizabeth Taylor Sues National Enquirer for $20 Million," September 26, 1990; and Susan Heller Anderson, "Elizabeth Taylor Has Settled Her $20 Million Lawsuit Against the National Enquirer," *New York Times*, May 29, 1991.

ACT V: TRUE GRIT

Chapter 17: *"Bitch, Do Something!"*

Interviews include Tim Mendelson, Aileen Getty, Jake Glaser, Carol Burnett, Whoopi Goldberg, Michael Gottlieb, Anthony Fauci, Bradley Anderson, John Warner, Dorothy Flagler, Guy Vandenberg, Demi Moore, Eric Buterbaugh, Barry Manilow, Bill Misenhimer, Jeanne White-Ginder, Dorothy Flagler, Bruce Vilanch, Michael Roth, Gary Pudney, Wes Wheadon, Lesley-Anne Down, Moshe Alon, Deborah Birx, Cathy Brown, Landon Parvin, Cliff Morrison, Ed Wolf, Jorjett Strumme, Trip Haenisch, Waldo Ferandez, Sally Morrison, and Deborah Hernan. Published

and unpublished material includes: Mark Griffin, *All That Heaven Allows: A Biography of Rock Hudson* (New York: Harper, 2018); Randy Shilts, *And the Band Played On: Politics, People, and the AIDS Epidemic* (New York: St. Martin's Griffin, 2007); Chris Geidner, "Nancy Reagan Turned Down Rock Hudson's Plea for Help Nine Weeks Before He Died," *BuzzFeed News*, February 2, 2015; Archive interview with Dr. Mathilde Krim, May 6, 2015, Elizabeth Taylor Archives; handheld camera footage of Elizabeth Taylor on a monitor, preparing for and giving an interview regarding her new perfume/fragrance, Black Pearls, Tim Mendelson and Firooz Zahedi, March 7, 1996, Elizabeth Taylor Archives; uncut, unedited interview with Elizabeth Taylor in which she recounts stories from her early acting career, talks about the strength of her bond with Richard Burton, and more, Foxstar Productions & Prometheus Entertainment from A&E *Biography*, 2003, Elizabeth Taylor Archives; Aljean Harmetz, "Hollywood Turns Out for AIDS Benefit," *New York Times*, September 20, 1985; "President Reagan Delivers First Major Speech on AIDS Epidemic in 1987," ABC, April 1, 1987; *Larry King Live* interview with Dame Elizabeth Taylor, CNN, February 3, 2003; undated audiotape of Elizabeth Taylor reflecting on her friendship

with Rock Hudson, Elizabeth Taylor Archives; The
Elizabeth Taylor AIDS Foundation, ETAF Timeline;
handwritten notes for Rock Hudson's memorial,
1985, Elizabeth Taylor Archives; William F. Buckley
Jr., "Crucial Steps in Combating the AIDS Epidemic;
Identify All the Carriers," *New York Times*, March 18,
1986; Nancy Collins, "Liz's AIDS Odyssey," *Vanity
Fair*, November 1992; Ingrid Sischy interview with
Elizabeth Taylor, *Interview* magazine, February 2007;
Holly G. Miller, "Elizabeth Taylor's Crusade Against
AIDS," *Saturday Evening Post*, September 1987;
Karen Tumulty, *The Triumph of Nancy Reagan* (New
York: Simon & Schuster, 2021); and Elizabeth Taylor
on *Larry King Live* talking about HIV/AIDS, CNN,
July 22, 1996, Elizabeth Taylor Archives.

Chapter 18: Ms. Taylor Goes to Washington
Interview subjects include Whoopi Goldberg, Tim
Mendelson, Barry Manilow, Barbara Berkowitz,
Aileen Getty, Anthony Fauci, Quinn Tivey, Hap
Tivey, Liza Todd Tivey, Henry Waxman, Sandy
Thurman, George Hamilton, Tom Sheridan, Jonathan
Canno, Cathy Brown, Deborah Hernan, Moshe Alon,
Mary Fisher, Cornelius Baker, Michael Gottlieb,
Cathy Brown, Jorjett Strumme, Pam Turski, Firooz
Zahedi, Bradley Anderson, Judith Light, Jeanne

White-Ginder, John Warner, Landon Parvin, Mike Shriver, Moshe Alon, Mike Iskowitz, Tom Sheridan, Sally Morrison, George Hamilton, Shirine Coburn DiSanto, Charlie Nicholson, Pam Turski, Charlie Nicholson, and Mark Harmon. Published and unpublished material includes: Elizabeth Taylor letter to the late Herb Ritts, 2002, Elizabeth Taylor Archives; Nancy Collins, "Liz's AIDS Odyssey," *Vanity Fair*, November 1992; Holly G. Miller, "Elizabeth Taylor's Crusade Against AIDS," *Saturday Evening Post*, September 1987; Dana Walker, "Elizabeth Taylor Crusades on AIDS," UPI, May 9, 1986; Karen Tumulty, *The Triumph of Nancy Reagan* (New York: Simon & Schuster, 2021); a compilation of news reports on AIDS, includes segment of Elizabeth Taylor giving a speech critical of President Bush's inadequate action to fight against AIDS, at the International Conference on AIDS in Amsterdam, Elizabeth Taylor Archives; Elizabeth Taylor on *Larry King Live* talking about HIV/AIDS, CNN, July 22, 1996; letter from Elizabeth Taylor to Bradley Anderson, Elizabeth Taylor Archives; Sheila Marikar, "Elizabeth Taylor's Legacy: AIDS' First Famous Advocate," ABC News, March 23, 2011; at the Freddie Mercury Tribute Concert, Elizabeth Taylor delivers a speech about preventing the spread of HIV and AIDS, and helping

those living with the disease, April 20, 1992, at London's Wembley Stadium, Elizabeth Taylor Archives; Simon Doonan, "'Liz Taylor Was My Tooth Fairy!' Talk About a Set of Pearls!," *Observer*, October 28, 2002; Elizabeth Taylor at the 11th Annual International AIDS conference in Vancouver, 1996, Elizabeth Taylor Archives; and "AIDS Quilt Draws Huge Crowds To Nation's Capital," CNN, October 12, 1996.

ACT VI: A LEGACY OF LOVE

Chapter 19: Searching for Neverland

Interview subjects include Quinn Tivey, Hap Tivey, Tim Mendelson, Lionel Richie, Brooke Shields, Moshe Alon, Gianni Bozzacchi, George Hamilton, Robert Wagner, Marianne Williamson, Bernadeta Bajda, Bruce Vilanch, Moshe Alon, Michael Feinstein, Arthur Allen Seidelman, Barbara Davis, Michael Roth, Morgan Mason, Shirine Coburn DiSanto, Bradley Anderson, Charlie Nicholson, Doris Brynner, Jorjett Strumme, Bill Misenhimer, Louis Fishman, Delphine Hirsh, Mark Harmon, and Firooz Zahedi. Material includes: An unpublished note that Elizabeth wrote after Michael's death, Elizabeth Taylor Ar-

chives; handwritten notes by Elizabeth Taylor, detailing her anxieties before a surgical operation, undated but thought to be from 1991, Elizabeth Taylor Archives; Anastasia Tsioulcas, "Michael Jackson: A Quarter-Century of Sexual Abuse Allegations," NPR, March 5, 2019; Joe Spellman Archive interview, May 5, 2015, Elizabeth Taylor Archives; letter from Elizabeth to Larry Fortensky, Elizabeth Taylor Archives; handwritten letter from Elizabeth Taylor to Larry Fortensky, unclear whether written draft or letter never sent, attached Post-it dated 2010, Elizabeth Taylor Archives; Paul Theroux, "Liz Taylor Looks Back on Men, Money & Michael Jackson," *Talk*, October 1999; Caroline Graham, "She Put on a Fur Coat over Her Nightdress and Fell Giggling in the Snow: Elizabeth Taylor's Builder Ex-Husband on Their Truly Bizarre Marriage," *Daily Mail*, April 23, 2011; Carla Hall, "For Liz, Larry, a Taylor-Made Wedding," *Washington Post*, October 7, 1991; C. David Heymann, "Taylor Faces the Anguish and Triumph of Sobriety," *Sun-Sentinel*, April 29, 1995; "Larry King Interview with Elizabeth Taylor," CNN, May 30, 2006; Enrique Limon, "Madonna and Michael Jackson: 30 Years Later, This Iconic Oscar Date Remains to Be Topped," Independent, April 26, 2021; "Michael Jackson 'Barely Able to Function,'" *Los Angeles*

Times, November 16, 1993; George Hamilton Archive interview, August 25, 2015, Elizabeth Taylor Archives; Hailey Branson-Potts, "Dr. Arnold Klein Dies at 70; Dermatologist to Michael Jackson and Other Stars," *Los Angeles Times*, October 23, 2015; and Baz Bamigboye, "The Day I Sang for Elizabeth Taylor, by the Mail's Baz Bamigboye," March 23, 2011, *Daily Mail*.

Chapter 20: Forgiveness

Interview subjects include Liza Todd Tivey, Chris Wilding, Tim Mendelson, Todd Fisher, Joan Collins, Shirine Coburn DiSanto, Lionel Richie, Robert Wagner, George Hamilton, Maria Pignataro, June Pagan, Ilene Amy Berg, Patric Verrone, Ruta Lee, Neil Zevnick, David Ho, Mike Iskowitz, Moshe Alon, John Tillinger, Leroy Perry, Peter England, Cliff Morrison, Bruce Weber, and Gary Pudney. Published and unpublished material includes: As told to Brad Darrach, "If the Knife Slips Tomorrow, I'll Die Knowing I've Had AN EXTRAORDINARY LIFE," *Life*, April 1997; Liz Smith, "Liz Taylor Performs 'Love Letters,'" *Variety*, December 3, 2007; "Barbara Walters Special," 1999, Elizabeth Taylor Archives; uncut, unedited interview with Elizabeth Taylor in which she recounts stories from her early acting career,

talks about the strength of her bond with Richard Burton, and more, Foxstar Productions & Prometheus Entertainment, from A&E *Biography*, 2003, Elizabeth Taylor Archives; Kimberly Nordyke, "Debbie Reynolds Reveals How She Forgave Elizabeth Taylor," *Hollywood Reporter*, March 24, 2011; Kevin Sessums, "Elizabeth Taylor Tells the Truth," *POZ*, November 1, 1997; House of Taylor Archive interview with Norma Heyman, June 4, 2015, Elizabeth Taylor Archives; Harry Benson, "Elizabeth Taylor, Photographer's Muse: Harry Benson Remembers the Actress," *Daily Beast*, March 24, 2011; Rex Reed, "Elizabeth Taylor Sees Red in 'The Blue Bird,'" *Ladies' Home Journal*, October 1975; interview with Elizabeth Taylor, *60 Minutes*, 1997; interview with Elizabeth Taylor, *CBS Sunday Morning*, 2004.

Chapter 21. Dame Elizabeth

Interview subjects include Tim Mendelson, Quinn Tivey, Chris Wilding, Colin Farrell, Robert Wagner, Barry Manilow, Barbara Berkowitz, Sarah Ferguson, Lil Heyman, Marion Rosenberg, Ziv Ran, Guy Masterson, David Rowe-Beddoe, André Leon Talley, Richard Young, Marc Cherry, and Trish McCaldin. Published and unpublished material includes: A private letter

from Bob Dylan to Elizabeth dated September 15, 1988, Elizabeth Taylor Archives; Elizabeth Taylor Proust Questionnaire (her answers handwritten by Tim on yellow legal paper, not dated, circa 2000–2009), Elizabeth Taylor Archives; letters between Elizabeth Taylor and Colin Farrell, 2009, Elizabeth Taylor Archives; handheld camera footage of Elizabeth Taylor on a monitor, preparing for and giving an interview regarding her new perfume/fragrance, Black Pearls, Tim Mendelson and Firooz Zahedi, March 7, 1996, Elizabeth Taylor Archives; John Kass, "Unearthing of Taylor's 3rd Husband's Grave Still a Chicago Mystery," *Chicago Tribune*, March 24, 2011; Simon Cable, "The Bust of Richard Burton That Made Liz Taylor Burst into Tears," *Daily Mail*, April 30, 2010; Meredith Melnick, "Elizabeth Taylor's Killer Beauty," *Time*, March 26, 2011; Brooks Barnes, "Gay Bar Mourns Elizabeth Taylor," *New York Times*, March 24, 2011; Clemmie Moodie, "Elizabeth Taylor Fed to the Sharks," *Daily Mail*, September 19, 2006; Edecio Martinez, "Elizabeth Taylor Funeral to be Protested by Westboro Baptist Church, March 24, 2011; Elizabeth Leonard, "Elizabeth Taylor Remembered at Private Memorial," *People*, October 17, 2011; Elizabeth Taylor's full interview on *Larry King Live*, January 15, 2001, Elizabeth Taylor Archives; and

Gerard Manley Hopkins, "The Leaden Echo and the Golden Echo."

Chapter 22. The Auction: "The Memory Always Brings Back a Stab of Joy, of Love"

Interview subjects include Tim Mendelson, Barbara Berkowitz, André Leon Talley, Stephen Lash, François Curiel, Daphne Lingon, Rahul Kadakia, Marc Porter, Heather Barnhart, Jennifer Tilly, and Nancy Valentino. Material includes: Anthony DeMarco, "Elizabeth Taylor Jewelry Sale Is the Most Valuable in Auction History," *Forbes*, December 15, 2011; handheld camera footage of Elizabeth Taylor on a monitor, preparing for and giving an interview regarding her new perfume/fragrance, Black Pearls, Tim Mendelson and Firooz Zahedi, March 7, 1996, Elizabeth Taylor Archives; Chris Michaud, "$116 Million Auction of Liz Taylor Jewels Breaks Record," Reuters, December 14, 2011; Elizabeth Taylor, *My Love Affair with Jewelry* (New York: Simon & Schuster, 2002); and Elizabeth Taylor's full interview on *Larry King Live*, January 15, 2001, Elizabeth Taylor Archives.

Afterword: Lust for Life

Interview subjects include Liza Todd Tivey, Quinn and Rhys Tivey, John Warner, John Travolta, Lesley-Anne

Down, Chris Wilding, Naomi Wilding, Eliza Carson, Barbara Berkowitz, Whoopi Goldberg, Francesca Tolot, Kenneth Cole, and Aileen Getty. Published and unpublished material includes: Sam Kashner, "A First-Class Affair," *Vanity Fair*, July 2003; Robin Lennon-Dearing, "Spreading HIV, the Virus That Causes AIDS, Is Against the Law in 37 States—With Penalties Ranging up to Life in Prison," *The Conversation*, September 22, 2021, Dominick Dunne, "Oscar Galas to Remember," *Vanity Fair*, March 2005; Ruth Waterbury with Gene Arceri, *Elizabeth Taylor: Her Life, Her Loves, Her Future* (New York: Bantam Books, 1964), and *My Love Affair with Jewelry* interviews, tape 4, Elizabeth Taylor Archives.

Selected Bibliography

Allan, John B. *Elizabeth Taylor*. Derby, CT: Monarch Books, 1961.

Bosworth, Patricia. *Montgomery Clift: A Biography*. New York: Bantam Books, 1980.

Bozzacchi, Gianni. *Elizabeth Taylor: The Queen and I*. Madison: University of Wisconsin Press, 2002.

Bozzacchi, Gianni, with Joey Tayler. *My Life in Focus: A Photographer's Journey with Elizabeth Taylor and the Hollywood Jet Set*. Lexington: University Press of Kentucky, 2017.

Brodsky, Jack, and Nathan Weiss. *The Cleopatra Papers: A Private Correspondence*. New York: Simon & Schuster, 1963.

Burton, Richard, edited by Chris Williams. *The Richard Burton Diaries*. New Haven, CT: Yale University Press, 2012.

Burton, Richard. *Meeting Mrs. Jenkins.* New York: William Morrow & Co., 1966.

Casillo, Charles. *Elizabeth and Monty: The Untold Story of Their Intimate Friendship.* New York: Kensington Publishing Corp., 2021.

Casillo, Charles. *Marilyn Monroe: The Private Life of a Public Icon.* New York: St. Martin's Press, 2018.

Christie's. *The Collection of Elizabeth Taylor.* New York: Christie's, 2011.

Cohn, Art. *The Nine Lives of Michael Todd.* New York: Random House, 1958.

Cosgrave, Bronwyn. *Made for Each Other: Fashion and the Academy Awards.* New York: Bloomsbury, 2006.

Fisher, Eddie, with David Fisher. *Been There, Done That.* New York: St. Martin's Press, 1999.

Fisher, Todd. *My Girls: A Lifetime with Carrie and Debbie.* New York: William Morrow, 2018.

Gates, Phyllis, with Bob Thomas. *My Husband, Rock Hudson.* New York: Doubleday & Company, 1987.

Griffin, Mark. *All That Heaven Allows: A Biography of Rock Hudson.* New York: HarperCollins, 2018.

Harris, Mark. *Mike Nichols: A Life.* New York: Penguin, 2021.

Kashner, Sam, and Nancy Schoenberger. *Furious Love.* New York: HarperCollins, 2010.

Kelley, Kitty. *The Last Star.* New York: Simon & Schuster, 1981.

Lord, M. G. *The Accidental Feminist: How Elizabeth Taylor Raised Our Consciousness.* New York: Walker and Company, 2012.

Maddox, Brenda. *Who's Afraid of Elizabeth Taylor?* New York: M. Evans and Company, Inc., 1977.

Mann, William J. *How to Be a Movie Star.* New York: Houghton Mifflin Harcourt, 2009.

Morton, Andrew. *Diana: Her True Story—In Her Own Words.* New York: Simon & Schuster, 2017.

Opie, Catherine. *700 Nimes Road.* New York: Prestel, 2015.

Sheppard, Dick. *Elizabeth: The Life and Career of Elizabeth Taylor.* New York: Doubleday, 1974.

Shilts, Randy. *And the Band Played On: Politics, People, and the AIDS Epidemic.* 20th Anniversary Edition. New York: St. Martin's Griffin, 2007.

Taraborrelli, J. Randy. *Elizabeth.* New York: Grand Central Publishing, 2006.

Taylor, Elizabeth, with Dick Meryman. *Elizabeth Taylor.* New York: Harper & Row, 1964.

Taylor, Elizabeth, with Jane Scovell. *Elizabeth Takes Off.* New York: G. P. Putnam's Sons, 1987.

Taylor, Elizabeth. *My Love Affair with Jewelry.* New York: Simon & Schuster, 2002.

Tumulty, Karen. *The Triumph of Nancy Reagan.* New York: Simon & Schuster, 2021.

Wanger, Walter, and Joe Hyams. *My Life with Cleopatra: The Making of a Hollywood Classic.* New York: Vintage Books, 1963.

Waterbury, Ruth, with Gene Arceri. *Elizabeth Taylor: Her Life, Her Loves, Her Future.* New York: Bantam Books, Inc., 1964.

Willoughby, Bob. *Liz: An Intimate Collection: Photographs of Elizabeth Taylor.* New York: Merrell, 2004.

Zahedi, Firooz. *My Elizabeth.* New York: Glitterati, 2016.

About the Author

KATE ANDERSEN BROWER is the author of the #1 *New York Times* bestseller *The Residence* and *First Women,* also a *New York Times* bestseller, as well as *Team of Five, First in Line,* and the children's book *Exploring the White House.* She is a CNN contributor and covered the Obama administration for Bloomberg News. She is also a former CBS News staffer and Fox News producer. Kate has written for the *New York Times, Vanity Fair,* and the *Washington Post.* She lives outside of Washington, DC, with her husband, their three young children, and their wheaten terrier.

HARPER
LARGE PRINT